Alberto Giacometti

English Edition

Editorial Director: Kate Mascaro
Editor: Helen Adedotun
Translated from the French by David Radzinowicz and Kate Robinson
Copyediting: Lindsay Porter
Typesetting: Claude-Olivier Four
Proofreading: Sarah Kane

Printed in Canada by Marquis

Originally published in French as *Alberto Giacometti*
© Flammarion, S.A., Paris, 2017

English-language edition
© Flammarion, S.A., Paris, 2018

87, quai Panhard et Levassor
75647 Paris Cedex 13

editions.flammarion.com

18 19 20 3 2 1

ISBN: 978-2-08-020379-3

Legal Deposit: 06/2018

Catherine Grenier

Alberto Giacometti
A Biography

Flammarion

Acknowledgments

I dedicate this book to the Fondation Alberto et Annette Giacometti, to its board and staff.

My gratitude goes to all of those who work daily with me at the Fondation Giacometti. The present publication draws its material from a collective effort among the archives and in collections. I would like to thank all the institutions that are fostering research on the artist by making their archives and documents available, in particular the Alberto Giacometti-Stiftung, Zurich, and the SIK-ISEA, Zurich, which house a part of the correspondence between Alberto Giacometti and his family, the Cuno Amiet archives, the Morgan Library & Museum (Pierre Matisse Gallery archives), the Beinecke Library (James Lord Papers), the Yanaihara archives, and the Bibliothèque Jacques-Doucet (Breton archives).

I would especially like to express my gratitude to Christian Klemm, incomparably erudite on the subject of Alberto Giacometti and who was kind enough to draw my attention to a number of salient pieces of information. The works of Casimiro di Crescenzo, together with his detailed knowledge, also proved invaluable. I would like to thank in particular Serena Bucalo-Mussely, Michèle Kieffer, Mathilde Lecuyer-Maillé, Thierry Pautot, all experts in the various disciplines practiced by the artist; Michael Brenson, whose studies on Giacometti's surrealist period informed my own researches; as well as all the eyewitnesses I have been able to meet.

Contents

Introduction 9

Chapter 1 Childhood 13
Chapter 2 Becoming an Artist 25
Chapter 3 Death Up Close 33
Chapter 4 Settling Down in Paris 37
Chapter 5 An Artist's Life 45
Chapter 6 Rue Hippolyte-Maindron 55
Chapter 7 Between Cubism and Surrealism 63
Chapter 8 Decisive Encounters 69
Chapter 9 A New Phase 77
Chapter 10 Joining Surrealism 81
Chapter 11 Eroticism and Violence 93
Chapter 12 Interior Decoration and Objects 109
Chapter 13 *The Palace at 4 a.m.* 115
Chapter 14 The Death of the Father 123
Chapter 15 The Break-Up with Surrealism 135
Chapter 16 A Return to the Model 139
Chapter 17 The Accident, then the War 151
Chapter 18 Astonishing Dedication 165

Chapter 19 *Walking Man* 173
Chapter 20 The Death of T. 181
Chapter 21 A Time of Change 187
Chapter 22 *Falling Man* 193
Chapter 23 Relentless Work 201
Chapter 24 Doubt Returns 209
Chapter 25 Success Arrives 219
Chapter 26 Yanaihara 227
Chapter 27 A Unique Friendship 237
Chapter 28 Giacometti the Painter 245
Chapter 29 Caroline 255
Chapter 30 Chase Manhattan Plaza 261
Chapter 31 The Venice Biennale 271
Chapter 32 The Shadow of Death 281
Chapter 33 Consecration 289
Chapter 34 The Final Months 295

Notes 301
List of Works Cited 329
Index of Proper Names 331

Introduction

Born on October 10, 1901, in Borgonovo (Stampa), a mountain village in Italian Switzerland, Alberto Giacometti moved to Paris on January 1, 1922. Except for wartime and regular visits with his family, he was to live and work in the artistic district of Montparnasse all his life. He later explained why he chose the French capital: "My father reckoned it would be a good idea for me to go and work in a free academy, as he himself had in his youth at the Académie de la Grande Chaumière, to draw and to paint. At first I rejected the idea, in response to which he simply dropped the subject—it was this that made me determined to go after all."[1] This testimony reveals two distinct characteristics of the artist's personality. On the one hand, it reveals the importance of his artistic affiliation: his father, a painter famous in Switzerland, initiated him into art at a very early age, following his son's career step by step and lavishing encouragement and support on him. On the other, the manner in which the artist recalls this memory is a sign both of his intransigence and his paradoxical nature. If Alberto Giacometti is one of the very greatest artists of the twentieth century, he is also one of its most outstanding and most original personalities. All those who spent any time with him, knowing him well or just in passing, attest to his individuality and to his unyielding nature, characteristics that over the years gradually seem to have been carved into his facial features. "Giacometti, granitically subtle and full of astounding perceptions, at root very wise, wanting to convey what he sees, which is perhaps not as wise as all that when you can see as he does," wrote Samuel Beckett.[2] The title of his first work to attract attention, *Gazing Head*, seems to sum up the man. Deep down, in the highly individual exercise of looking, man and artist converge. His gaze was described by friends, lovers, and models many times: at the same time seductive and penetrating, mocking and bewildering. No one

could remain indifferent to his presence. Whether in his tiny studio or on the terrace of a Paris café, his unmistakable figure, like his insatiable curiosity and love of contradiction, made him the focus of attention. "Unfeigned in his open-heartedness and an enthusiastic conversationalist who readily juggled paradoxes, Alberto Giacometti was fond of playing devil's advocate, and generally took up a position contrary to what the other person said," Michel Leiris recalled.

This spirit of resistance was also a hallmark of his art and his trajectory through the art of the avant-garde. "Never let myself be influenced by anything,"[3] he wrote in one of his notebooks. Giacometti acknowledged that he had learned from his father, and then from Bourdelle, but that he outgrew them all, rejecting any sign of subordination. Later on, he freed himself from his early mentors, Zadkine, Lipchitz, and Brancusi, by turning to surrealism. In spite of the almost instant recognition of his work, and André Breton's admiration and friendship, he soon abandoned constructing the surrealist objects that had made him famous and returned to the model. This refusal to join any school or adopt any backward-looking ideology has tended to relegate him to the margins of art history. Yet Giacometti is a man rooted in his own time, a committed modern, even when swimming against the tide or finding himself out of step with current trends. The lesson he absorbed from modernity was one of freedom and a commitment to truth. And it is this which, as he edged away from modernism, led him back to the wellspring of art. Perfectly at home in prehistoric, ancient Egyptian, or Sumerian art, his work is a cross between the daily encounter with the live model and the timeless forms of archaic prototypes. "The entire art of the past, from all epochs, all civilizations, emerges before me; everything occurs simultaneously, as if space has taken the place of time."[4] Space and time, proximity and distance: these are the coordinates that his entire oeuvre strives to juxtapose, to fuse, even. As Jean Genet observed: "Their beauty [of Giacometti's sculptures] seems to me to stem from the incessant, uninterrupted to-and-fro movement from the most extreme distance to

the closest familiarity: this to-and-fro doesn't end, and that's how you can tell they're in movement."[5]

The rejection of stability, of authority, of monumentality is the salient character of an oeuvre whose foundations the artist questioned daily. Straining towards an accomplishment that lay forever in the future, Giacometti made the expression of artistic doubt the mainspring of his creativeness. Carving, sculpting, painting, drawing, writing were all facets of the same tireless quest that kept him on the alert, mobilizing all his many powers. His deliberately frugal lifestyle, his relentless work-rate, his angst, and his constant dissatisfaction may have ruined his health, but they never sapped his optimism or his faith in art. His ultimate goal, at once elementary and paradoxical, was to represent what he saw. To do this, Giacometti did not limit himself to the customary tenets of realism nor to a face-to-face with the model that kept him cooped up in his studio day and night. Every moment confirmed the experience that truth is fleeting, as he had foretold in his youth: "The world really is a sphinx before which we are forever standing, a sphinx that stands forever before us and which we question."[6]

An artistic inquiry become matter and form—this could be the definition of this singular oeuvre, the work of an artist who was always expanding the confines of fixed identity: "I don't know who I am, or who I was. I identify with myself, and I don't. Everything is completely contradictory, but perhaps I have remained exactly as I was when a little boy of twelve."[7]

Chapter 1

Childhood

Alberto retained fond memories of his childhood all of his life. After him came Diego, a year younger (1902), Ottilia (1904), and Bruno (1907). In the rustic living room of their house in the village, where they played their earliest games and first learned about the world, the siblings' life revolved around their mother, Annetta. A protective and loving presence, this formidable woman kept the core of the family together for as long as she lived. The house was flanked by a barn that had been converted into a studio and stood opposite the Piz Duan inn, established by Alberto's paternal grandfather and run by Uncle Otto. A network of cousins spread throughout the valley. Both Annetta and husband Giovanni's families had had roots in the Grisons region for generations. Stampa is located in Italian Switzerland, in the heart of the valley of Bregaglia, a few miles from the Italian border. With a population of about a hundred, the village nestles between two very steep and narrow mountainsides, along the banks of a river. In daily life the family spoke a mix of Italian and *bregagliotto*, the local patois. The road to the mountain pastures for the sheep ran past the windows of the Giacomettis' house. The villagers all took their water from a communal well, a meeting place where people would pass the time of day. At that time, the isolated village entered hibernation during the snowy months, when the cold is crisp and daylight scarce. In fine weather, however, visitors would flock to the chalet in Maloja, the upper village of the commune of Stampa, on the banks of Lake Sils, where in 1910 the family started to stay for the summer. There, the Giacomettis would receive friends and also rub shoulders with the international clientele at the Palace hotel, as famous for its setting as for the well-heeled crowd frequenting it. Guests describe the family atmosphere as cheerful and welcoming.[1] Italian or Swiss cousins would cross paths with friends and artists passing through.

In adulthood, Alberto would return every year until his mother's death, two years before his own. He would continue to work there in the large studio that remains intact today.

Drawings by Giovanni and Alberto provide a glimpse into everyday life at Stampa. The family would gather in the main room, lit by a large gas-lamp giving out a greenish glow.[2] (The Giacomettis were the first in the village to be supplied with the new fuel, evidence of their relative financial ease.) The low ceilings and walls are all paneled in wood. Giovanni's pictures—landscapes and portraits of his children, mainly—line the room. A very large oriental rug of a dull red covers the floor in the living room. The furniture is rustic, except for the exotic touch introduced by the two Bugatti armchairs in the studio. The Alpine décor, like being inside a marquetry box, is the epitome of provincial tranquility. Mother sews at the corner of the table, leaning towards any source of light. Life is ordered by the tick-tock of the "sun and moon" clock that hangs by the door. The children gather round a boardgame, the counters spread over the table, while Bruno practices his violin. Everyone poses for Father while he draws. The house is surrounded by snow, immersed in whiteness. The mountain landscape is steep and wild. The significant days in the year are religious festivals, birthdays, and anniversaries, as well as their father's exhibitions.

The forest nearby is a place of adventure as well as a playground. Alberto would talk about his experiences and familiar landmarks, in scenery that could be in turn protective and threatening. The most important element was the snow, which he waited for impatiently and which was occasionally so deep that he dreamed of building an underground nest. "I would have liked to have spent all winter there, all alone, all shut away."[3] Enormous boulders, one of which he would use as a hiding-place, stood on the edge of the forest undergrowth, sometimes friendly, sometimes disturbing. "I remember that for two summers at least, the only thing I could see in my surroundings was a large stone about eight hundred meters [875 yards] from the village." Eroded by water, the block had a

View of Stampa, 1961.

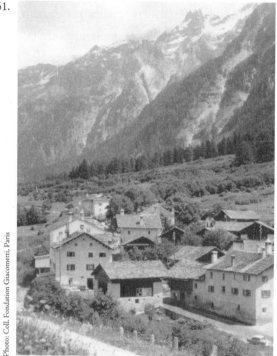

Photo: Coll. Fondation Giacometti, Paris

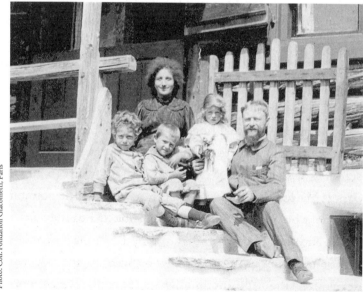

Photo: Coll. Fondation Giacometti, Paris

The Giacometti family (Alberto, Annetta, Diego, Ottilia, and Giovanni) on the steps of their home in Stampa, c. 1906.

hole hidden at its base where the children would slide. "I was overjoyed, crouching in the little cave in the bottom. I could hardly fit; I couldn't ask for anything more." Another block, on the other hand, reminded him of "a narrow and pointed pyramid," and was seen as an opaque and frightening mass. "The stone immediately looked to me like a living creature, hostile, menacing. It threatened everything: ourselves, our games, our cave. Its very existence was unbearable to me and I immediately felt—since I was unable to make it disappear—that it was better I ignore it, forget it, and speak about it to nobody."

Like many children in the countryside, Alberto's relationship with nature verged on the animistic. This feeling of a rapport between natural objects and the human body lasted well into adulthood and is reflected in the works of his maturity. He used images such as "a woman like a tree, a head like a rock" in describing certain sculptures, establishing a system of equivalence between humankind and nature. During vacations, Alberto would visit his relatives with his brothers and sister. "No road leads through the village. There, in a house with a white rosebush growing up the wall, lived an elderly member of the family. I can see her now, sitting close by the window with a large illustrated Bible on her knees. A crowd of happy children would gather around her and listen to the beautiful stories from that magnificent book. We all loved little David and all pitied poor Absalom. Many hours would pass but our sweet old lady never got tired. When the children left her, she once again became absorbed in reading that huge book to herself."[4]

Between Stampa, with its hundred inhabitants, and Bregaglia, a village standing at an altitude of eighteen hundred meters (5,900 ft.) near the pass at Maloja, the children lived the lives of remote mountain dwellers, centered on domestic activities and connected to the outside world by letters and the radio.

The family lived in the shadow of Giovanni, whose artistic career developed smoothly. Increasingly successful, he was soon garnering national honors. Although he lived way out in the country, he maintained

regular contact with many artists, such as Giovanni Segantini, who lived in Maloja, Cuno Amiet, who was Alberto's godfather, and Ferdinand Hodler, who was Bruno's. Hodler, whose impact on Giovanni's early work is palpable, was on the way to becoming a Swiss national treasure. Giovanni also greatly admired the already famous Segantini, adopting his divisionist style and Alpine themes. Amiet was a friend from way back and had been a fellow student in Munich and Paris. In the living room hung a picture from Amiet's Pont-Aven period, given to Giacometti as a wedding present.[5] Traveling regularly, Giovanni also remained in contact with various outposts of modernity. In 1907, he visited Paris, where he saw the Cézanne retrospective and the Fauves' room, the two salient events at the Salon d'Automne. The following year he met up with the expressionists of Die Brücke, which Amiet had joined. In 1911, together with Fauve artists, he took part in the annual exhibition of the Berliner Secession, with works in a Fauvist style. Giovanni's appearance of self-confidence, his russet-red, neatly trimmed goatee and piercing blue eyes concealed an extremely gentle individual, one who was utterly devoted to his children and to their education. Both studio and house were filled with books. Giovanni's cultural legacy, a blend of the three languages of Italian, German, and French, which all spoke fluently, lay at the intersection of these three zones of influence on both sides of the Alps. Years later, Alberto was to find that he shared this particular culture with Balthus. It was a culture in which Romanticism and symbolism continued to play a role, even in avant-garde art movements. Philosophy and literature were also hugely important, as was tradition, which was fundamental to education. This culture left a lasting mark on Alberto, and lay behind many of the choices that foreshadowed his artistic career.

During the aesthetic polemic, which, within the modern movement in Switzerland, set followers of Hodler against Cézanne,[6] Giovanni remained faithful to his onetime master and friend, even though his painting seemed more in tune with that of Cézanne. He never tired of depicting the Piz Duan inn—his own personal Montagne Sainte-Victoire—while

his groups of peasants are redolent of Cézanne's famous *Game of Cards*. After passing through an expressive phase of intense colorism with similarities to the Fauves, Giovanni's work settled down to a relatively classic synthesis between neo-impressionism and Cézannism that he was never to abandon. This position reflects his character, at once inquisitive about advanced artistic thought and anchored to a traditional conception of art. Writing about futurism, he remarked: "The post-impressionists, synthetists, cubists, and others have been left far behind. What I like about the futurists is that they have devised, on the level of theory, a completely novel conception of art and life; but what they have managed to do on the artistic level rather seems to prove to me that intriguing theories do not yet constitute a work of art."[7]

During the course of World War I he had certainly been aware of the Dada movement, which was making waves in Zurich; his cousin, Augusto Giacometti, occasionally participated in the group's activities. Later, however, neither he nor Alberto ever referred to it. Giovanni focused instead on artists or movements that could bring him not just new theoretical conceptions but also ideas about art he might adhere to. For Alberto's father, the question of representation was central. The organic bond between art and nature was the essential lesson he was to inculcate into his son, though he left him free to take up his own aesthetic position.

Alberto was not afraid of asserting his individuality even as a child. "He read a great deal and drew all the time, never playing with others, or very seldom," his younger brother Diego recalled.[8] Still very young, Alberto would follow his father into the studio, making models and painting. "I had seen some reproductions of small busts on a base and I immediately wanted to do the same. My father bought me some Plasteline and I got started."[9] Among his brothers and sister, who all benefited from free access to the studio, he was noted for his artistic gifts and industriousness. "Alberto has made progress in drawing and painting. He has a lot of energy, and everything he undertakes, he does it seriously, even

games,"[10] his father observed. Open-minded and tolerant, Giovanni even forgave his son the occasional childish eccentricity, as when, for instance, Alberto "finished off" with a lick of paint a bust of his father made by his friend, the sculptor Rodo.[11] "I painted the eyes in blue, the hair, the moustache, and the beard in red, the skin pink," Alberto related, adding: "My father was a little surprised. Perhaps he thought I lacked respect for Rodo's work, but I didn't get into trouble."[12] In the Protestant middle school at Schiers, where Alberto was sent as a boarder from 1915 to 1919, his classmates admired Giovanni's art, engaging in animated debate about the new painting. Alberto took part, without taking up a position in the arguments. His classmates remember him as being both reserved and self-assured, friendly but remote. When he was passionate about something, however, he could show immense concentration and patience. Reading extensively, he had a burning enthusiasm for German Romantic literature and adored Shakespeare and Ibsen. He also plunged into the great bildungsromans: Goethe, Gottfried Keller, Thomas Mann, and Hermann Hesse. He devoured art books, and, blessed with a first-rate visual memory, he amassed an iconographic knowledge on which he drew throughout his career. Once he spent his return bus fare on a book on Rodin and exhausted himself on the long walk back in the freezing cold. At boarding school his artistic talent was soon noticed and encouraged. Exceptionally, he was even allotted a space to create a studio, where he spent his spare time and where he drew and carved portraits of his classmates, such as Simon Bérard and Lucas Lichtenhan, his closest friends. So intense was his drive to draw the world around him that everyone had to put up with his demands to draw them. "This desire to give visual witness was so strong," his brother Bruno observed, "that sometimes it become almost harassment for those on the receiving end. When Alberto used to draw me playing some child's game, there was always a moment when I felt the intensity of his gaze had transformed me into his prey. He would stare at me so fixedly it was like being trapped in a web, while the spider prepared to grab me and never let me go."[13]

Alberto already possessed the stubbornness and hypnotic power that his models would later mention. "Usually so gentle, so kind, and generally easy to live with, as soon as he found himself in front of a model, he would become tyrannical. You couldn't move an inch. He'd be saying constantly, 'Look! look! look! don't move!' It was already essential for him to capture the glance of his model. The first bust he made of me, when I was about eight, I remember it well: he wanted it to be exactly life size, and he had an old, rather rusty iron compass which he used to take measurements of my head. When he brought the points of the compass toward my eyes, it would terrify me. I felt like he was about to stick it into them, while Alberto, thinking solely about his work, had no idea that a child might be frightened by something that seemed so normal to an adult."[14]

If Alberto had little hesitation in following in his father's footsteps, it was chiefly because he was already satisfied with his earliest sketches. "Rather quickly, I started to draw after nature and I had the impression that I'd mastered my craft so well that I was doing exactly what I wanted."[15] Although later Alberto suffered serious self-doubts, remaining unsure of his ability to translate into his art what he saw, initially he experienced a sense of achievement. "I followed the haymaking. I drew the peasants. I drew to communicate, to dominate. My pencil was my weapon. I became arrogant. Nothing could withstand me." This was a success that, as an adult, no amount of effort could ever recapture; indeed, he was to turn away from it as sterile "pretension."[16] The sculpture portraits of his brothers and sister modeled out of Plasteline at the age of thirteen do indeed bear witness to a precocious gift for portraiture. He also produced many drawings and watercolors, copies of works by old masters and landscapes, as well as sketches of his friends. "I can see myself in Stampa near the window, in about 1914, engrossed in copying a Japanese print. I could describe its every detail."[17] Many of these copies have survived. Taken from art books discovered in his father's studio or at school, they show his perseverance and a great fidelity to the

model. Engravings, in particular those of Dürer, were a fruitful source of inspiration. In addition, pen-and-ink portraits of his classmates and his family reveal a use of lines and incisions characteristic of engraving. If these drawings possess little of the atmospheric quality of his father's works, his watercolors seem closer, in both their treatment of volume and color scheme. Thus, the young artist's aesthetics would vary according to the technique deployed: naturalist for sculpture, in which he sought resemblance above all; divisionist in painting, following his father's lead; and classical for drawing, which he considered primarily as a tool to train the eye and hand. In Schiers he also got to know wood-engraving, a traditional technique which his father was fond of. If Giovanni encouraged his son's artistic proclivities, he also left him free to adopt his own manner. "Even when my way of working became increasingly different from his, my father was always understanding of everything I was doing and very interested in what I was working on."[18]

Giovanni understood that if Alberto was to pursue his artistic path, his son would have to shake off his father's influence and forge his own style. He always encouraged his son in this direction, without ever failing to remind him of what, in his eyes, constituted the essential nature of art.

Looking back on his past, Alberto acknowledged: "I cannot imagine a childhood and youth happier than those I spent with my father and all my family."[19] Recalling his happy childhood surrounded by a loving, carefree family, he still could not quite blot out the darker premonitions that already dogged him. Solitary and anxious, Alberto was an extremely willful child. Angst-ridden, he felt compelled to impose order on the world around him. Bruno revealed some of his elder brother's manias; strange little compulsions he relied on and that he sometimes would impose upon his entourage, like arranging shoes in order of size or laying out his socks completely flat.[20] When he reached adulthood, Alberto's mania for order appeared significant enough for him to refer to some of its manifestations himself. "But why, when I was a child, did I find it so hard and so annoying when sawing up logs in the kitchen in the

evening to put the bits of wood in the case? The biggest just had to be at the bottom, with the lightest on top and all the other various weights in between. How many times must I have emptied the case to be quite sure that there wasn't one crushed at the bottom or in the middle. All this effort drove me mad and I would have liked to have given up; but no, and, though impatient and beside myself, every time I would start over."[21]

Such fixation on details testifies to an obsessive nature that resurfaced throughout his life. He described himself prey to similar symptoms even in the indescribable chaos of his private studio: "It never seemed to end, I was overwhelmed, crushed by the task, then, disgruntled, I'd leave it and get going on something else, but it would often start again a second later with the shoes the socks the doors I'd close too gently or too loudly or with any old objects on a table if they touched, a bit of paper, a piece of string, an inkwell. Quickly, I would clean up whatever was just in front of me, not daring to look any further (otherwise I'd be lost), I'd move the objects away from one other, but at what distance should they be placed? They were always slightly too near or slightly too far apart, then I would imperceptibly move a small, torn piece of paper, not thinking for a moment of throwing it in the waste basket, I knew that there everything would begin again. Still today I often move objects apart and the excruciating feeling I have in front of the Jewish wife,[22] one of Rembrandt's last pictures, has to come from the same source. At one time I had a photograph of this picture pinned to the wall, but I couldn't bear the two hands laid over the woman's eternally unmoving bust."[23] These irrepressible fears and phobias originating in childhood and that the traumas of life would rekindle, together with the familiar exorcisms the artist would perform to fend them off, reappeared in various circumstances throughout his life.

Like many children—although with him it was to last well beyond childhood—Alberto was haunted by morbid thoughts. His early draw-ings show an interest in folk tales, through which he often expressed an unbridled violence. He drew Snow White's transparent coffin and

enjoyed tales of chivalry and knights, whose battles he depicted. Traces survive in his working notebooks, where armed soldiers or men hanged or shackled appear among sketches for sculptures. The accounts of his dreams when he was a child, such as he recorded them in some of his writings, teem with violence and cruelty. If the surrealist nature of such a literary exercise might lead one to suspect deliberate exaggeration, it is revealing that he retells one particularly violent dream in detail: "I remember that, around the same time, for months I could never fall asleep at night without first imagining myself walking through a thick forest in the twilight until I'd reached a gray castle standing in a remote and uncharted place. There I would kill two defenseless men, one of whom, aged about seventeen, always looked pale and frightened to me, while the other wore armor, the left side of which shone with something like gold. Then, after ripping off their dresses, I would rape two women, one of thirty-two, dressed all in black and with a face like alabaster, then her daughter, over whom floated white veils. The whole forest would resound to their screams and whimpering. I killed them, too, but very slowly (it had grown dark by this time), often beside a pond of stagnant, green water in front of the castle. Each time with minor variations. I then burned down the castle and, content, fell asleep."[24]

Alberto, it should be said, was not afraid of provocation. Although timid, he liked to dominate in his relations with other people. "No one can purse their lips in such a friendly yet disarming way, nor let slip a wry smile, as well as Alberto can," a classmate was to write, also hinting at his "strange superiority" in the academic and artistic fields.[25] Throughout his life he remained determined to assert his independence and was loath to justify his actions. Only a man who wants to see himself as indifferent to the judgment of others can expose his innermost fantasies, as he was to on several occasions and in spite of his horror of shocking his parents. Both in writing and in conversation he would confess boldly to his manias and irrational fears, or to a morbid obsession which had roots in the unfathomable depths of childhood and which fed into his

nightmares. It was in Schiers, where the echoes of the war were but a rumble, that he had his first personal experience of death. In March 1917, he was left distraught by the sudden death of his young Latin teacher. "It seems impossible that such a man has gone in this way, death is a great mystery."[26] The following year his school principal passed away.[27] His correspondence with his classmate Lichtenhan, begun after the latter left the school, expresses his anguish at the threat these two deaths seem to represent to him. Simultaneously, he is fascinated with the depiction of mortality in literature. "I particularly liked the passage in which Wilhelm Meister's young friend drowns. It is written in such a way that I often reread the story, each time finding it more beautiful."[28]

This tormented imagination did not prevent him from being a happy-go-lucky child generally, one who enjoyed a joke and who filled his sketch-books with caricatures. In his letters to Lichtenhan he would also express outpourings of emotion in front of nature. His walks through countryside and in the mountains stimulated poetic sentiments in keeping with his reading of the Romantics. Artistic discoveries, in books or during visits to exhibitions, were another source of excitement. Yet, among a wide range of emotions, which veered between extremes of poetic ecstasy and irrational terror, one feeling was more powerful and more comforting than all others: family love. This affection translated into regular letter-writing, which continued unabated well beyond his childhood, indeed, until his mother passed away two years before his own death.

CHAPTER 2

Becoming an Artist

In 1919, Alberto asked his parents to let him leave the school at Schiers for a while to work with his father and put his artistic calling to the test. By then he was eighteen, and, in spite of sailing through the first semester examinations and the special arrangements made for him to practice his art, he had lost all enthusiasm for the teaching at the college and for studying in general. His brother Diego had joined him in the school and he had made friends with several pupils. Yet even this positive environment was not enough to pull him out of one of the low periods that periodically affected him. Giovanni took his teenage son's dissatisfaction, along with his unwavering determination "to turn the light upon myself,"[1] seriously. Giovanni realized that nothing could be gained by keeping Alberto in school against his will, since his son's artistic vocation appeared real enough. With the principal's approval, he agreed to take his son into his own care for three months, after which Alberto would return to school. During this time, Alberto's skill and passionate commitment to an artistic career became clear. Although Giovanni would have preferred him to finish his schooling before starting studies in fine art, nothing could convince Alberto to return to Schiers, so his parents offered to enroll him at the École des Beaux-Arts in Geneva. Alberto jumped at the chance, but soon found himself reluctant to attend courses whose teachers did not have his father's strengths. (Several years later, Alberto claimed to have spent no more than three days at the art school and erased the months in Geneva from his memory.) His mother considered this condescending and unthinking, and, in an exchange of letters that reveal the influence she held over her son, threatened to send him back to Schiers.[2] So, despite his initial reservations, Alberto continued to attend the school, but on his own terms, as Giovanni put it to Amiet. As one of the professors, his friend James Vibert, announced: "Your son, Alberto, after attending my class and that

25

of Estoppey five or six times, suddenly left the school, only saying to the administration that he regretted having to leave us."[3] Vibert was reassuring, however: "I'm comforted by the thought that, with a temperament like his, even among savages, nothing will prevent him from finding his way." Alberto then registered at the École des Arts Industriels, mainly attending courses on sculpting given by Maurice Sarkissoff, who belonged to the Archipenko circle in Paris. The only classes he seems to have followed with any dedication at this school, and which he continued even after leaving the establishment, were the sessions in life drawing. He showed little respect for the instructions given, however, and refused to employ the recommended techniques, as an anecdote, relayed by one of his fellow students, testifies. "A sturdy, somewhat doughy girl, Loulou, would pose naked. The routine was to lay the entire nude onto the sheet: head, arms, and legs. Giacometti had no truck with that. He was set on doing only what interested him. On the sheet of Ingres paper—and to the immense irritation of the teacher—he stubbornly drew, gigantic, one of the model's feet."[4] This resistance, however, was less a sign of self-assertiveness than a feeling of powerlessness when faced with capturing the real. A virtuoso copier, Alberto found life drawing on the other hand extremely demanding. Frustrated by the challenge, he would return incessantly to the task, as if it were the be-all and end-all of the artistic process. Giovanni followed his son's development, keeping Amiet informed. He did not hide Alberto's half-hearted attendance at the school from his friend, and it does not seem to have caused him any particular concern. The young man left Geneva before the end of the term, as his father explained, "because he would like to be here for Easter."[5] In fact, his departure was final. Before joining his family, Alberto made a detour via Oschwand, visiting his godfather. During this stay, Amiet made a portrait of his godson, and together they painted landscapes in the outskirts of Bern. The apprentice artist also did drawings in silverpoint, as well as watercolors. Amiet introduced him to the work of Gauguin, who was a huge influence on Amiet. "I became convinced that the sky was blue only by convention, but red in reality,"[6] Alberto later said

of this period. He then stopped off in Soleure to see Josef Müller, a friend of his godfather's, who had put him up several times in Geneva during the semester. A son of a Swiss industrialist, Müller studied with Amiet and was to become a shrewd collector, going on to assemble a pioneering collection of non-Western art in the 1920s. The break in Stampa was short. By May, the young man was setting off for Venice with Giovanni, who had been officially appointed to the Swiss selection committee for the Biennale. Something of a voyage of discovery, this first journey with his father began auspiciously. The Swiss section was received favorably, Giovanni recorded, "because one finds here artists who have remained faithful to themselves, to their nature, and because they bring a note of freshness."[7] This judgment encapsulates Giovanni's vision of art, one which he handed down to his son. Together they walked around the national pavilions. Alberto was most impressed by the Soviet stand, dedicated to Archipenko, and it was probably on this occasion that he met the Russian artist, in whose studio he would later stay in Paris. However, it was not contemporary art that caused the seminal shock during the Venetian trip, but exposure to classical painting. He was bowled over by Tintoretto above all: "I spent the whole month running all over the city, worried there might be just one of his canvases hidden away in a church corner or elsewhere. For me Tintoretto was a marvelous discovery; it was a curtain opening onto a new world, yet one which reflected the real world around me. I loved him with an exclusive, partisan love, I had only hostility and antipathy for the other Venetian painters, for Veronese and Titian (not for Bellini, I admired him from afar, but he wasn't necessary to me at this time)."[8] The journey in Italy was essentially an artistic baptism. Referring to this aesthetic experience thirty years later, Alberto once again could barely contain the enthusiasm and lyricism it had stirred within him. It was so important to him that he entitled the article recalling the event with just the date, "May 1920," as if to indicate a turning point, a rebirth. On the way back he visited Padua. There, he was captivated by the discovery of Giotto, to the point that even his love of Tintoretto cooled. "On entering the Scrovegni Chapel in Padua

and standing before the Giotto, I received a punch right in the chest. I lost my bearings and didn't know where I was, immediately feeling both immense sorrow and huge regret. This punch also hit Tintoretto. I was irresistibly overwhelmed by Giotto's power, crushed by these immutable figures, as dense as basalt, with their precise and matchless gestures, heavy with expression and often infinite tenderness, like Mary's hand touching the cheek of the dead Christ."[9]

The way the artist describes the powerful emotional shock of these aesthetic discoveries shows how different he was from his father, who described the same event as follows: "And so to Padua. Here is Giotto. What strikes you first and foremost is the calm and clarity of the composition, the grandeur and roundness of the forms. One cannot tear oneself away from this inner truth, from such an unwavering gaze. A window opened in my eyes. To still dare handle a brush myself seems human and excusable."[10]

Giovanni's measure and humility were far from being shared by Alberto, who, almost violent in his emotional response, was enthralled exclusively by aesthetic forms that were "necessary at that moment" for him.

Autumn saw him on a second journey to Italy, this time alone, first spending a month in Florence. Visiting the archaeology museum, he particularly admired the Egyptian department. "Over these last few days I've been going to the museum of Egyptian art. Now that's real sculpture. They subtract everything they have to from the whole figure, there's not even a hole to put a hand in. One has, however, a truly extraordinary impression of movement and form."[11] This reference to Egyptian art was crucial to his later sculpture.

Copying Michelangelo's sculptures in the Medici Chapel, he encountered the art of Bernini. Baroque statuary generally, which he had never seen prior to this journey, was to join the pantheon. He then went on to Assisi, where he admired Cimabue's frescos, and to Perugia. Throughout this lengthy tour, he filled several sketchbooks with copies of the works that struck him, noting his impressions. Traveling through Italian cities on a quest for new experiences, he did not forget to ask about art classes

to avoid interrupting his apprenticeship for too long. "I was in Florence a month, but because I wanted to work there and didn't find anything, I came via Perugia and Assisi to Rome in the hope of finding plenty of academies and open painting schools here. Of course, the first few days I just wandered from one corner of the city to the other, but, when I began to look for something, I didn't find anything, nothing at all: the academies were overflowing, the free courses had ended, the evening courses were impossible to attend—no one bit better in Florence, in other words. But the city is wonderful…. You can find everything you want here: museums, churches, wonderful ruins … lots of theater, lovely concerts almost every day … for the present, I'm staying here."[12]

Although they lived in the countryside far from all cultural entertainment, Giovanni and Annetta had transmitted a taste for music and the performing arts to their children. In the family's letters there are many references to plays and especially to classical music concerts that delighted both parents and children. It was a love Alberto never lost and, as he claimed, for a while it detained him in Rome. In fact, he was to spend nine months in the city, put up by his uncle, Antonio Giacometti, for most of 1921. It wasn't just cultural life and artistic marvels (Byzantine mosaics, Rubens, the *Laocoön*) that retained him; there was also his cousin, Bianca, with whom he fell in love. No sooner had he arrived than he ran to the museums, filled with wonder at what he saw and filling his sketchbooks with copies. "It is incredibly rich and always new! And, although I've not worked much, not much at all in fact, all these things will not be lost, and one or other will always float back into my memory. Anyhow, I've never been as impatient or as eager to draw, paint, and sculpt after such a long time doing nothing."[13]

In spite of his enthusiasm, the following months were not especially productive. Painting most of the time, he did also some skillful drawings of his aunt and of members of a family he befriended, the Singers, as well as sculpting some portraits. He spent several weeks struggling to model a bust of Bianca, but was unsuccessful. Impervious to his advances, the young

woman found the sittings tedious. Alberto soon lost the self-confidence that had guided his hand when he started sculpting, now encountering the same problem that had beset him in Geneva at life-drawing classes. Representation, for which he was naturally so gifted, started to elude him. "I was off track, everything slipped through my fingers, the model's head before me resembled a vague cloud without limits.... I found it completely beyond me to capture the general shape of a head."[14] Destroying or abandoning these fruitless attempts, the whole sorry episode left him embittered. He realized that the artist he was so intent on becoming would have to overcome problems that the enthusiastic and naive beginner had been completely unaware of.

Alberto mentioned this stumbling block to his father, who reassured him and advised him to take his cue from artists of the past (from whom the moderns, as he explained, had wrongly turned away) and embark on his own personal creative path. "Now you have seen so many things, you must grow accustomed to working and producing yourself. The great masterpieces of every era are the best masters, combined with the eternal inspiration, Nature."[15] This exchange also gave Giovanni the opportunity to warn his son against some of the more recent artistic advances, such as "metaphysical abstract painting" of which he did not think highly. "Certainly, the artist has always been confronted with new problems and art is a flowing current that should not be left to stagnate. Every period has its own art and an artist cannot and should not keep his distance from the spirit of the age. Yet, for all that, it doesn't seem wise to me to push theories to absurd limits, leading to results that our healthy judgment can no longer understand."[16]

Living in Rome also meant learning to be an autonomous adult and discovering political issues. If in letters to his parents he concentrated on his artistic discoveries and personal uncertainties, Alberto was far from cut off from the real world. Watching Fascism begin to take root, he noted its progress with concern. "The Fascists are flexing their muscles and gaining ground and it is possible that D'Annunzio might also make an entrance

on the political stage. One Sunday I saw a Fascist demonstration, it was grandiose and it made me shiver, thousands of people so united and compact. Naturally, with my friends and acquaintances, we defend bolshevism and socialism as best we can."[17]

The two sojourns in Italy proved seminal on many levels, and his experiences at this time remained etched in his memory. The masterpieces he had up until now only admired in books revealed all their power, and he developed an ability to navigate in the present between different historical epochs and in very different styles. He also flirted with a new way of life—that of the city, of discussions with friends in cafés, of politics. Discovering love, he also frequented brothels, where he had his first sexual experiences. Leaving off his country dress, he now wore the clothes of an elegant city dweller. It was at this time that Alberto adopted the look he was to keep for the rest of his life: tweed jacket, shirt and tie, and holding his inevitable cigarette. This is the outfit in which he depicts himself—brush raised and proudly staring down the viewer—in his first self-portrait as an artist he painted once back in Stampa.

Chapter 3

Death Up Close

On the train during a trip to Paestum and Pompeii with a friend in early spring 1921, Alberto got talking to an elderly man. He could not then have known that this friendly encounter would leave an indelible stamp on his existence. Some time later, the gentleman, a Dutch librarian, suggested Alberto accompany him on a trip he was thinking of taking to the Italian Alps and Venice. Alberto agreed and joined Mr. Van Meurs on September 1 as they set off together through Italy. They got off to a good start and Alberto's first letters to his parents are upbeat: "The gentleman is very refined and cultured, he knows so many things and thus our time passes agreeably enough,"[1] he wrote shortly after their departure. On the second evening they arrived at Merano, taking rooms in a good inn. "Mr. Van Meurs is very nice and very cultivated, he is a great one for the mountains and knows Switzerland ten times better than I do. He is also keen on flowers and plants, teaching me about them at every step, I've learned practically all their names! And then he protects animals, which, he says, are all our brothers, so that he doesn't even eat meat!"[2] But an utterly unexpected event was to occur. On the fourth day, Alberto sent his parents a letter in a completely different tone: "My dear ones, I am still full of terror and astonishment, I feel lost. Fate can be so inexplicable and terrible. Less than three hours ago, Mr. Van Meurs died in the presence of me and a chambermaid. It's appalling, it seems incomprehensible."[3]

Deeply shocked, he described the circumstances of this sudden death: "Until 10.30 pm., he seemed fine, in a good mood, happily puffing at a cigar and chatting about the journeys he wanted to go on. He was one of the most delicate and dignified people I've ever met, as I already wrote to you, very cultivated and of rare kindness and nobility of spirit. An hour before we got there he'd had a little stomach pain, then, at 2 o'clock

in the morning (I had the room next door), I heard him groan awfully, and I found him sitting on his bed writhing in agony. It was a horrible night, and finally at 7 we managed to get a doctor to come. He did not seem so bad, but from time to time he would wail in a terrifying, atrocious, indescribable way, so the doctor gave him an injection and he fell asleep." Following an uneventful morning, Alberto found his companion in a bad way. "I went in and found him lying on the floor, his eyes wide open, ghastly. I put him to bed. He was really bad, but he was conscious and did not speak about death." As the doctor could not be contacted, it was the despairing Alberto who took care of the dying man. "Van Meurs was a royal archivist, he was sixty-four and full of life and hope. How dreadful it is, dreadful, dreadful, life is like this."

This first face-to-face with death—rendered particularly violent by its dramatic and unexpected character—proved a defining experience. It was to leave a deep scar, not only on the young man of twenty, but also on the artist he became. His letters to his parents reveal the paradoxical nature of his personality: anguished but not apprehensive—he had no qualms about accepting an offer to travel with a total stranger—precocious, yet still naive and immature. Following his first trip to Italy, this was a second experience of adulthood, an initiation that expelled him from the land of his childhood. Unlike the first trip, an outpouring of enthusiasm and joy, this journey taught him a profound lesson about life: "it is dreadful, dreadful, life is like this...." Continuing his journey regardless, he traveled to Venice, taking without permission, "as a precaution,"[4] money his parents had put aside. He went out all night, frequenting cafés and prostitutes. Life returned to normal, but he was deeply affected by his experience and its memory was to haunt him. Years later, in an article, he described the death of Van Meurs as a crucial stage in the myth of his artistic trajectory. "The Dream, the Sphinx, and the Death of T.," published in 1946,[5] illustrates the way in which Alberto would re-examine certain events, perceived in retrospect as significant, and use them to shed light on the motivations behind his art. His account

of the death in the article differs from how he described it at the time, projecting an aesthetic quality onto the whole experience. "I watched as Van M.'s head underwent a transformation (the nose became more and more prominent, the cheeks grew hollow, the almost motionless, gaping mouth could hardly breathe, and, toward evening, as I tried to draw his profile, I was seized by the sudden fear that he was going to die)."

Writing some time after the incident, Alberto chose to add a note to the text in which he confirms the importance of the original memory. "The journey I made in 1921 (the death of Van Mr. and all the events surrounding it) was for me like a hole right through my life. Everything looked different and the trip remained an obsession for a whole year. I would talk about it endlessly and, although I often wanted to write about it, I always found it impossible."[6] That the ordeal felt like an initiation was exacerbated by the artist's retrospective evocation of certain premonitions. Alberto recalled that, at Van Meurs's bedside, he read a letter from Flaubert to Maupassant containing the following passage: "Did you ever believe in the existence of things? Isn't it more likely that everything is an illusion? The only true thing is our rapport with reality, that is, our perception of things."[7] In reality, the young artist had not immediately grasped Flaubert's insight concerning perception. It took him several years to understand how decisive the experience of Van Meurs's death—together with his disappointments in Rome—was to be for his vocation. It was only through the filter of several similar experiences that he was to understand that his artistic personality was forged through such trials. His artistic path was not to be determined by his early talent for imitation, but by the struggle to create.

CHAPTER 4

Settling Down in Paris

Once Alberto had recovered from the appalling experience of Mr. Van Meurs's death, it was time once again to think about how he could continue his studies. His stint in Geneva had been unfruitful and going back to the school was out of the question. He had acquired a few friends, however, including Kurt Seligmann and Hans Stocker, whom he was to meet up with later in Paris. Although he was inclined to choose Vienna to continue his artistic training, his father convinced him to move to Paris instead. Giovanni advised him to enroll in a "free" academy, instead of the École des Beaux-Arts, where the teaching had become fossilized. Alberto decided on the Académie de la Grande Chaumière that his father had attended twenty years before. Opting for sculpture, he registered at the studio of Antoine Bourdelle. Alberto arrived in Paris on January 9, 1922. His father recommended he arrange to meet some Swiss artists in the city, who could help him find his feet, and indeed a number of countrymen were among his first friends. He had barely settled in before he became a regular at the Louvre and the ethnography museum at the Trocadéro. He kept up a regular correspondence with his family and soon received a visit from his father. Though delighted to be in Paris, Alberto nonetheless suffered from homesickness that his mother attempted to assuage with her affectionate letters. That summer, he had to leave for Switzerland to undertake his military service and was barracked at Herisau until mid-September. Making the most of the soldier's life, he spent his leave visiting museums and exhibitions in St. Gallen and Winterthur. Then, before returning to Paris, he stopped off in Stampa where preparations were being made to celebrate Diego's twentieth birthday.[1] It was on this occasion that Alberto painted a full-length portrait of his brother.[2] In the course of this first year, he had spent nearly five months in Switzerland. On his return to Paris, where,

at the beginning, he had lodged in boarding-houses, he finally obtained a studio—Archipenko, about to move to Berlin, sublet him his. He wrote to his parents expressing his joy at finally getting his hands on a studio of his own. His mother replied: "I've so often tried to picture you in your studio. I can see you stoking the stove amid complete chaos. I'd love to make your bed, perhaps I'd scold you too, but I'd still love you all the same."[3] At the Grande Chaumière he was particularly assiduous at life-drawing classes and sketching and modeling. Bourdelle visited the workshop once a week, giving a talk and making corrections. His personality, like his teaching, was held in great respect. A former assistant of Rodin's, the sculptor's style was at once more traditional and lyrical than his master's. He was particularly thorough regarding theory and sought to stimulate his students' curiosity and reflection. They, in turn, both appreciated and feared his diktats. "Thursday. Eleven thirty. Sound the alarm. A taxi has just drawn up in front of number 14 rue de la Grande Chaumière. A Pole with cornflower eyes runs from group to group with his finger over his mouth: 'M. Bourdelle's here!' The master appears wearing a short, loose-fitting, slate-gray smock. He can scarcely cut a path through the forest of sculptor's stands and tunics. 'Before correcting your works, my friends, I would like to read to you a few thoughts I jotted down a moment ago under the title: "To understand completely is to equal!" To truly see an object does not consist in checking if the model's nose is cute or not; it is to see where precisely the nose attaches to the base of the forehead, its exact relationship to the eyes, to seek for things in all their depth. It means, in short, cleaving close to truth, and that, that's a great strength. That is the role of intelligence. Be advised that somebody able to copy an object exactly (see here, this clay ball I've just crushed in my fingers), he would be a great, a very great artist. To see, in the true meaning of the word, an object just as it is, one needs to observe astutely, to possess an ordered mind.'"[4]

To his pupils Bourdelle praised the qualities of Greek, Mesopotamian, and Egyptian art and also of non-Western traditional arts. He was fond of

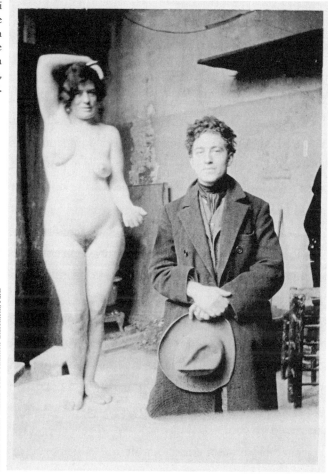

Alberto Giacometti posing next to the model Carmen Damedoz, at the Académie de la Grande Chaumière, c. 1922.

Photo: © Marion Walton. Coll. Fondation Giacometti, Paris

challenging his students' academic prejudices. During one class, he extolled the perfection of the form of a car, to which Alberto reacted with indignation. More open-minded than his practice might suggest, the master also introduced them to the formal advances of cubism: "You hear every sort of imbecility about cubism! The poor public! Modern tendencies in art deserve to be watched carefully. Cubism was not only far from the "madness" the art pontiffs declared it to be, it was a necessary corrective to the disordered fantasy from which the drawings suffered.... We should be

thankful to cubism for the healthy results it had, even if they consisted only in creating a brusque reaction against the pomposity of academic art. Perhaps we will experience a new renaissance one of these days!"

Contrary to what Alberto later claimed, the teaching at the Grande Chaumière was useful for his development, and he benefited greatly from both the life-drawing classes and Bourdelle's observations. The sculptor was lavish in his advice and encouragement. "Bourdelle came to the workshop and was very pleased with my work, and, as we are Swiss, with three others who are very good too, he came up to me to look and joked 'Yes, long live Switzerland.'"[5]

The sculptor's specific method of teaching drawing, which consisted in subjecting the object to a prismatic geometrical decomposition and reconfiguring it as a faceted volume, aided Alberto in overcoming his difficulties in representation. He attended the courses regularly for three years, from 1922 to 1925, then less diligently over the following two years. Even though he took a critical view of some of Bourdelle's theories, Alberto was always interested in his observations, reporting the main thrust of his remarks to his father. "Tomorrow, we've got Bourdelle. He's always got something new to say."[6] Later, when his work had turned down a path completely at odds with Bourdelle's, Giacometti remained attached to some of the fundamental values promoted by his master. These included the primacy of the work of the mind over that of the hands, the importance of drawing for a sculptor, an interest in the arts of early antiquity, in particular Eastern antiquities, and the importance of cultural memory, which all remained constants in his oeuvre.

The Académie de la Grande Chaumière provided him with a friendly environment that offered some distraction from his loneliness. The private academies of Paris were hotbeds, which attracted students from all over the world. Alberto was thrown into a community of young artists from Serbia, Russia, Croatia, Sweden, Denmark, the United States, China, and Japan. Closest to him were his Swiss classmates, Otto Bänninger and Arnold Geissbuhler. "For a foreigner," he was to explain later, "nothing

is harder than forging contacts with the French. There's this wall....
Arriving in Paris I knew people at the Grande Chaumière, that is, just
foreigners, except for one Frenchman (who, in any case, I saw very little),
and it got to about 1930 without my getting to know any French people,
or 1928, and even then...."[7]

Alberto never lost his strong accent and for a long time felt he did not
belong to any community. "I felt really lonely, yet I made no complaint."[8]
As compensation for solitude, though, came freedom. The young artist
was by now twenty-one, and, free of responsibilities, he was set on dis-
covering life. He never competed with fellow students at the academy,
concentrating instead on his own endeavors. "Giacometti was different
from all the other students in that he seemed to have no need to be one
of the best. He sometimes gave the impression of being lazy and passive,"[9]
one fellow student, Bror Hjorth, recalled, adding: "With his brown curls,
quietly introspective, and with a tendency to philosophize, he made
an unusual acquaintance."[10] Alberto, however, became sufficiently well
integrated to sit for several fellow students. In 1922, he posed for a bust
by a classmate, Sreten Stojanović, and the following year his features
appeared on one of the figures on a war memorial by Geissbuhler. In
exchange, he also used his friends as models, writing to his sister that
he was carrying out a bust of an American "with black hair."[11] He also
sat for himself in a self-portrait and made anatomical studies, such as a
"torso with arms and head."[12] During this period of training he would
regularly visit the Louvre, and he also rubbed up against more modern
currents. "The other day it was the Salon d'Automne. There were some
interesting paintings and sculptures, but all in all it gave the curious
impression of a mass meeting of the unbalanced, deliberately naive, and
more or less ill, and yet basically interesting."[13]

The year 1923, however, began with Giacometti in dire straits, and
he was often utterly disheartened. For the first time he had not spent
Christmas with his family, and, by the beginning of March, he was telling
his parents how deeply discouraged he was. In a concerned and insightful

letter, Giovanni did his best to encourage him. "I've known periods of discouragement and dissatisfaction, but they are perhaps the most advantageous time for study. It is as if nothing goes right, you see only insurmountable difficulties, and then, one fine day, you suddenly realize that you have made progress, that you have reached another step on the interminable ladder toward perfection, though you can never reach the top. Art is like that. It's like a Fata Morgana[14] that's always hovering in front of your eyes, but which always keeps its distance. Of course, you should not be satisfied easily nor be afraid of destroying and redoing, but, in the same way as you cannot reach the top of a mountain in a single stride, but only by climbing from peak to peak and stopping to catch your breath, with just one work you cannot achieve the perfection, or relative perfection, you are aiming for. So I believe that, when you have made meaningful advances in a study, it is better to keep the sketch for its good qualities, and to start a new one to advance still further, relying on previous experience. Certain studies are also useful for comparison and are like the foothills where you get your breath back before continuing to the summit. But all life is like that. I can't wait to see your work."[15]

Obliged to leave Archipenko's studio in February—the artist left to settle permanently in the United States—for more than a year Alberto had a frequent change of address. In support, his parents came to spend Easter in Paris, visiting the museums and spending a day at Chartres. Alberto also spent the summer with the family in Maloja. During the last trimester, his anguish receded and he got back to work.[16] Seeing as sculpture eluded him, he returned to painting. For several weeks, he concentrated on a skull that absorbed him completely. "By chance I came upon a skull someone lent me. I so wanted to paint it that I dropped the academy for the whole winter. I spent days trying to find the root, the starting point of a tooth that goes up very high, close to the nose, to follow it as closely as possible, in all its changes of direction, to the point that, if I'd wanted to do the entire skull, it'd have been completely beyond me, so I was practically reduced to doing the lower section, that

is, the mouth, the nose, and what surrounded them at most, and nothing above."[17] If he did not stop attending the academy entirely, he began the habit of working more outside school. He continued to share his thoughts about Bourdelle's teaching with his father, who, for the most part, would share his son's viewpoint. "Bourdelle's observations, when he claims that a car's bodywork is as artistically significant as a cathedral, is a 'gag' that even he himself cannot take seriously," he had replied after Alberto's clash with his teacher.[18] In December, Alberto added a new chapter to what Giovanni called his "dialogue slash argument" with Bourdelle. During one drawing class the master had called into question the importance his students attached to life drawing.

Much put out, the young man confronted his master, reasserting his belief in the inherent and absolute bond between art and nature. "Bourdelle says: 'Tell me, does the model interest you?' As nobody answered and he continued to wait, I said 'yes,' in good faith. Him: 'Me, not at all.' Me: (open-mouthed). Him: 'You can't do anything interesting with it, it becomes a tedious thing, never a work of art.' Me: 'But an artist who senses the beauty of the model and who is really strong, can't he make a work of art?' Him: 'Not if he's just strong with his hands.' Me: 'Of course. I mean someone who can really see what's interesting in the figure.' Him: 'That's not seen with the eyes, but with the spirit.'"[19]

Cut to the quick, the artist commented: "My ideas were not so puerile as to deserve such a puerile answer; I knew that seeing meant something other than dumbly staring at things." And the dialogue continued, without pupil and master ever seeing eye to eye. Giovanni again offered consolation: "Your thesis was right: art is in nature, everything lying in knowing how to look, that's Dürer's dictum, 'Art is in nature, it is for those who know how to extract it,' confirmed by Ingres in his aphorisms."[20] Bourdelle, who, in the above exchange, displays a contrarian spirit not dissimilar to Alberto's later on, was fond of driving his students into a corner. Still, even more than these sallies from his master—whose works, no matter what he may have said, remained faithful to nature—Alberto

was shocked by the new concepts of art advocated by the avant-garde. With his father and godfather, he had been brought up with a school of modernism that was tempered by respect for the classics. Cubism and abstraction, with which he was by now very familiar, seemed in total contradiction to the romantic view he held so dear. This conception of an art based on the perception of nature bound him to his father and was also fostered by the family's common culture, as illustrated by the messages of solidarity sent from his mother and from Diego following the argument with Bourdelle.

Chapter 5

An Artist's Life

Alberto started making polychrome sculptures and applied himself seriously to painting.[1] Satisfied with the progress he was making with his drawing, he had altered his style over the previous few months. Traditional portraits, were being outnumbered by more constructed drawings that focused on volume. The faceted appearance of the object, which was, from the beginning, a result of his adopting the construction method for volume, soon became the salient feature in a new idiom that brought him to the frontier of neo-cubist aesthetics. A series of self-portraits, in particular, displayed characteristics which would recur throughout his drawing: the concentration on part of the body, of which only a few details are emphasized, and the isolation of the motif on the page, often delimited by an inner frame. "Geissbuhler saw them the other day and said he liked them, they are much less systematic than those of last year. I try to build them as precisely as possible, without lapsing into abstraction or construction."[2]

He applied an identical principle in the many drawings of mountains he produced in Maloja. Considering his new works sufficiently accomplished, he presented them to the master. "Yesterday I showed my drawings to Bourdelle. I've been drawing a lot these last months, I've got at least fifty. During this whole time I haven't shown them to anyone; once I had reached more or less where I wanted, I showed them to several friends who found them very good. So, I thought of presenting them to him, especially because I hadn't shown him anything for a long time. But, last Friday, although he had only dropped in for a moment and was not doing corrections, he made a remark about modeling: 'Nobody here can put three correct points on a figure.' And then, catching sight of my work and pointing to it: 'Monsieur knows how.' That made quite an impression in our American girls' boarding school!'I find these drawings

good'—this he repeated several times,—'he can draw very well, he under-
stands drawing, he has real ability, a sharp eye, great speed in analysis, etc.'
He also said that I have not advanced as far in sculpture as in drawing,
but that it could be imagined that, with the skills I have, I'm sure to get
there. I then told him that sculpting had become almost impossible for
me (you literally can't take a step, you can't naturally circle around the
model, not even around the figure you are working on, I have to find
a better means of working). He understood, saying that he realizes it's
really difficult to do anything under those conditions. Meanwhile, the
sculptures I've done might be of some use, I've learned a lot. He told
me to keep all drawings of any worth. So now I am known as the best
draughtsman in Bourdelle's academy and today everyone was much nicer
than usual (it's true that there were mostly women)."[3]

A month later, however, in April 1924, he was once again overcome
with doubt. Regularly thrown off course by Bourdelle's teaching, he
also complained of the master's quirks. During one lengthy argument,
Bourdelle had claimed that the pyramids "were built by Negroes [*Nègres*]
and that the Egyptians only restored them later."[4] Although Egyptian
antiquity remained the young artist's ultimate benchmark, he was begin-
ning to grow familiar with contemporary art, telling his father that he
had seen works by Picasso in Paul Rosenberg's gallery. These were works
of the Rose period, together with recent pieces with neo-Ingresque han-
dling, whose line and simplicity he praised. "They are things done directly
after nature and very alive. It is, all things considered, simply an art that
does not tell stories. These are the best modern things I've seen since
I've been in Paris."[5] The doubts he voiced in letters to his family do not
seem to have affected his application to work. He gave up polychrome
sculpture, finding it frustrating. "I haven't touched my colored stuff since
my return. I saw that the form is insufficient and, before going back to
that idea, I think I first need to attain a more or less finished form."[6] He
did not abandon all interest in painted sculpture, however, and it would
become a constant throughout his career. "The other day a Japanese man

who works at the academy spoke to me about the statues of his country and I was amazed to learn that they all are painted."[7]

Although he made fun of the Grande Chaumière by calling it an "American girls' boarding school"—the academy being very fashionable among heiresses from the other side of the Atlantic—he was not above joining student get-togethers. On May 21, 1924, he took part in a soirée for Caresse Crosby's birthday, held in a private room at Le Canard Amoureux, with eleven other guests, including friends Apartis, Noguchi, and Sato, who were also students at the academy. His social circle widened, and he became acquainted with the young Italian painter Massimo Campigli, who remained his closest friend over the years to come and who introduced him into Italian society in Paris. Alberto had become a regular at the cafés of Montparnasse, such as La Coupole and Le Dôme, where Campigli went daily. Alberto became more talkative and threw himself into political discussions.[8] He was beginning to worry about his future, however, and was increasingly toying with the idea of quitting the school. For this he would need greater autonomy and to earn his own living. In a kind yet firm letter, Annetta suggested it would be good for him to stop being financially dependent on his family and to begin to make his work better known.[9] Although he started selling a few small works, Alberto remained reliant on his parents for at least three more years. Annetta also encouraged Diego, who had just finished a business course, but who had no firm plans, to embark on adult life without delay. Toward the end of the year, Diego decided to try his luck in Paris. Annetta confided her concern to Alberto, asking him to keep an eye on his younger brother.[10]

In January 1925, Alberto transferred his studio to an upper floor on rue Froidevaux. At the end of the month, he visited Bourdelle's private studio, giving an account of his impressions: "There were several large things and bronzes, but I didn't like them as much as I expected, none of them. I find their effect a little too literary and brimming with

pathos. Today, on the other hand, I saw some small figures by Maillol that impressed me more."[11]

He become acquainted with Ossip Zadkine, in whose work he was greatly interested, and who invited him to the private view of his retrospective.[12] Alberto, like many young artists of the time, was caught up in the whirlwind of the competing aesthetics that cohabited within the Paris art world, and he still found it hard to situate himself in the avant-garde. "I also get to see a lot of modern stuff, but it's a kind of Tower of Babel, there are so many different things, dissipating in every conceivable direction, that it's difficult to get a clear overall view."[13] Once again, he made clear his interest in Picasso's oeuvre, now that he had seen the artist's different styles. A visit to an exhibition of Van Gogh then revived his liking for colorism, translated into landscape and portrait paintings where the "colors are pushed to the height of their power."[14] Regaining all his enthusiasm for work, he even put off a trip to Maloja in order to finish two sculptures he was working on at the academy. After that, he explained, he would start on new works in his own studio. Not long afterward, he began to neglect the academy to work in his studio, all the while continuing to attend life-drawing classes in the evening and showing his efforts to Bourdelle.[15] He was now in the habit of having his works cast in plaster, placing a further drain on his funds.[16] A number of sculptures were in progress and some, such as a large "seated figure" mentioned on several occasions,[17] called for months of work.

Diego had joined him in Paris at the beginning of the year, staying in a nearby hotel, because Alberto's studio was too small to put him up.[18] They still spent a great deal of time together, and the young sculptor went back to his old habit of getting Diego to sit for him. As the latter explained to his parents, Alberto's life was extremely orderly. In the morning he would work on a full-length figure, either at the academy or in the studio whenever he had enough money to pay a model, and in the afternoon he would work on a bust. The two brothers would dine together in a nearby restaurant at 7.30 p.m. They almost never ventured

outside Montparnasse, the site of their regular haunts and where all their artist friends lived. A visit to Montmartre, Diego recounted, seemed like a major excursion.[19] "On the rare occasions I cross the Seine," Alberto likewise explained, "it seems as if I've come back to Paris after a long absence and all the movement fills me with wonder, as if I were seeing it for the first time. There one is almost ... in the countryside."[20] Accompanying Alberto on his routine activities, Diego also shared his friends, in particular Bänninger, Campigli, and Milunović,[21] all fellow students at the Grande Chaumière. He was also immediately enlisted at the studio: he transported the works to the caster, and, once Alberto had started exhibiting, dispatched them to the Salon. This was not enough to fill his time, however, and he was earning no money. His parents feared that, with so much time on his hands, he might fall back into bad company. "In the universal confusion that reigns today in art, politics, and religion, it is essential to find a focus for one's concentration and a firm basis that calms and reassures," Giovanni declared.[22] In May their father spent two days in Paris. He saw the sculptures in progress, in particular the ones Alberto was planning to show at the Salon des Tuileries, such as *Head of Diego* and *Torso*. This would be the first time the artist exhibited his work in public.[23] Bourdelle, who was the initiator of this new salon and one of the members of the selection committee, advised Alberto to show two works, one more academic, the other conforming to a modern canon.[24] Alberto was in fact in a transitional period, during which the lure of innovation vied with faithfulness to the real. Another anecdote featuring Bourdelle also probably refers to this early foray into modern sculpture. The master, standing before a work of a modernist aesthetic, allegedly said: "You can do that at home, but you shouldn't show it."[25] This taunt, recalled by the artist many years afterward, may or may not be faithful record of the master's remarks, but it does capture a genuine facet of Alberto's work, when, for a time, he practiced two different styles in tandem.

That summer, before leaving for another period of military service, Alberto spent more than a month in Maloja, where he embarked on a bust of Ottilia and a granite sculpture.[26] As with his drawings, his choice to depict just one part of the body offered an antidote to the difficulties he experienced organizing entire figures. "I reckon the most difficult thing is to create a satisfactory sculpture from a model, because each day one sees the model differently, there are always new things and one can never know how it is really, and one finds oneself constantly obliged to sacrifice one thing to do another. But, little by little, it falls into place almost without one realizing it, like the needle of a compass quivering before finally stopping once and for all at one point."[27]

He tried his hand at the modern idiom in a series of *Torsos*.[28] One of these, which he was to sell to his friend Serge Brignoni,[29] a pupil of Léger's, is very close to the stone *Torso of a Woman* of 1925 that he might have seen at the Zadkine retrospective. Another, the only one to have survived, reveals the more radical influence of Brancusi in its reduction to essentials. This evolution towards abstract form was gradual. Drawing up in one of his notebooks a personal list of the best contemporary sculptors,[30] he awarded top marks to Lipchitz and Laurens. Significantly, he also highlighted artists whose practice remained traditional, such as Bourdelle and Charles Despiau. In parallel with the experiments in modernism, he was long to continue making sculptures in a more academic style and was never to lose his respect for representatives of modern classicism. Although he had already dipped a toe in the art world, he continued at the Grande Chaumière for a few more months. Yet, from the *Torso* sold to Brignoni still embedded in morphology to the abstract version of the *Torso* closer to Brancusi, he had crossed the Rubicon and was now resolutely embarked on the road to modern sculpture.

Alberto was by now quite used to life in Paris. He had many friends, would go out on the town and regularly went to the movies. Partial to American cinema, he especially rated the films of Charlie Chaplin. At the beginning of 1926, he was astounded by one of first movies in

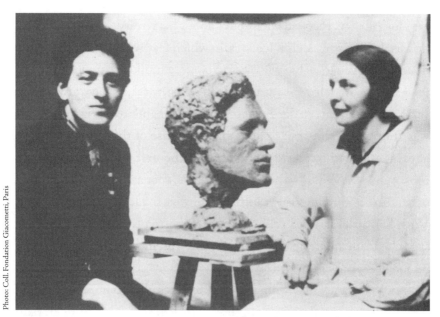

Alberto Giacometti and Flora Mayo, c. 1925.

color. "It is the first film of its kind to come out and it's amazing. All the colors match and are just right, the images powerful and as finished as paintings. It's really incredible that such a thing is possible."[31] "Still," as he exclaimed, "this will not stop painting from existing!" In spring, he saw Jean Cocteau's tragedy, *Orphée*, which delighted him.[32] It was at this time that he embarked on his first affair of any length, with one of the female students at the Grande Chaumière, the American Flora Mayo. Flora was a free-spirited and modern young woman, who had had several love affairs since her arrival in Paris. Beguiled by this freedom, Alberto nevertheless found it hard to get over her confession of a one-night stand. Their relationship survived, but the young man's jealousy made things difficult. Although Flora remained attached to him and would have not objected to settling down, he gradually drifted away. Nevertheless, the affair continued, on and off, until Flora left for the United States in 1929. Although he was attractive to women, relationships were never

easy for Alberto. Plagued with doubt about his virility, fickle but jealous, he was prey to paradoxical feelings, in which fear would often overcome desire, and even love. He was later to confess frankly that when it came to sexuality, he felt more at ease with prostitutes. "I have always felt very inadequate, sexually speaking. When I came to Paris, in 1922, I was always wriggling out of love affairs because of this. That's why I've always preferred to go with prostitutes. The first woman I had was a prostitute. It suited me. The concept of 'love,' that ambiguous, sticky mix of sentiment and physical gesture, has always made me uncomfortable. With her, at least, it was clear that there existed the mechanics of sex, separate from anything emotional. When you live with the problem of impotence, a prostitute is ideal. You pay, if you mess it up or not, it doesn't matter. With a 'normal' woman, when feelings also come into play and you want to leave after an hour, it's awkward, she doesn't understand and failure has its consequences. This is why, when I was twenty-five, I couldn't bear to spend the night with a woman I loved. At Le Sphinx, on the other hand, which was for me the most marvelous place imaginable, you didn't have to go up with a woman. You could stay down in the lounge, chatting with friends. The relations I forged with whores were almost better than in normal life. I did not sleep with any for four or five years, and yet I remained on friendly terms. I've been friends with one since 1921."[33]

Years afterwards, Flora recalled the emotional fragility of the angst-ridden young artist, who could never sleep next to another person, even one he loved.[34] Up until then, Alberto's love affairs had been fleeting, or unhappy, like his experience in Rome with his cousin Bianca, or else unsettling, as in the case of Flora, whose readiness to get married was perhaps what scared him off the most. His personal notebooks contain brief notations in which he opens his heart, and show him haunted by the female figure, but also express what he saw as the difficulty in relationships between men and women "When I was very young, I already thought that between man and woman there could only be

incompatibility, war, violence. The woman would not let herself be pos-
sessed without a struggle, and the man would rape her...."[35] All his
friends recall a number of outrageous remarks by Giacometti, who liked
to shock by expressing sentiments totally at odds with his benevolent
and placid nature. Yet such exaggeration betrays the angst lurking within
him. It is indicative of a genuine impediment, and one that was to affect
him for a long time, since, in spite of these acerbic remarks, he never gave
up trying to forge meaningful relationships.

In June 1926, he introduced himself to Jacques Lipchitz whom he met
on the terrace at Le Dôme, later visiting him in his workshop. Alberto
was glad to learn that the cubist sculptor had noticed and appreciated
two plasters presented next to his own works at the Salon des Tuileries.[36]
"I'll be able to go to his place next week. I reckon he's the most interesting
and brilliant sculptor in Paris today."[37] The works Lipchitz noticed were
a portrait of Flora Mayo[38] and a neo-cubist composition with two figures
(*The Couple*).[39] Breaking all relation with the model, the two figures in
The Couple are in the shape of steles, on which male and female attributes
are represented symbolically by schematic forms. Seen from the back, the
two figures transform into two heads, strongly reminiscent of African
masks. In spite of early reservations, Alberto had become interested in
what he then called the "exotic arts". This had been fueled by visits to
the ethnographical museum at the Trocadéro, combined with frequent
contact with Müller, who had settled in Paris and who, following a year
spent in Africa, had begun collecting traditional objects, examples of
which Alberto also saw in the studios of Zadkine and Lipchitz. A new
object was soon to appear on his work table: a Kota reliquary.[40] Alberto
had bought this African sculpture from Brignoni, who was beginning to
build up a collection of ethnographic artifacts of his own. This interest
in unfamiliar forms of representation, whether African, Pacific, or Pre-
Colombian, had repercussions on several of his sculptures. In particular,
he drew from them elements that permitted a reappraisal of the human
figure and which enabled him to overcome his difficulties in depicting

the live model. His modernist experiments thus drew on two sources: the schematization of the human figure, inspired by non-Western works and by the art of early antiquity; and the structural decomposition of volume under the influence of cubism. The painted *Stele*, inspired by a Cycladic sculpture, and the totemic-looking *Crouching Figure* belong to a series of sculptures with flattened volumes. The second, redolent of a menhir figure, shows a curious, stylized personage, characterized by an asymmetrical arrangement: blessed with just one, wide-open eye and a single breast, it manifests an attraction for irregularity and ambiguity that typifies the majority of these new pieces.

The previous two years had been a time of discovery and familiarization with creations by artists far removed from Bourdelle's artistic practice. It was time for the young sculptor to assert his status as a modern artist and to free himself from the comfortable family atmosphere at the academy. To do this, he had to find himself a real studio. During the summer, while Alberto was in Maloja, Diego scoured the city for a studio without stairs, to make it easier to move the sculptures. It proved a tall order. Having hoped in vain that a ground floor might become vacant on rue Froidevaux, he found a large space through Bänninger, but it turned out to be too expensive.[41] When Alberto returned, however, the two brothers visited an affordable studio, which had once been occupied by another student at the Grande Chaumière, Bror Hjorth.[42] Although not as conveniently located as its predecessor, it was still quite near Montparnasse. Modest but affordable, the studio was the artist's first step toward total independence.

Chapter 6

Rue Hippolyte-Maindron

On December 1, 1926, Alberto and Diego moved into a studio at 46, rue Hippolyte-Maindron, an address that was to become legendary. Located on the ground floor, it formed part of a cluster of craftsmen's workshops spread over two stories around a small courtyard. The surface area of the room, whose picture window gave onto the courtyard, was only twenty-four square meters (258 sq. ft.), plus a small mezzanine. Creature comforts, except for a coal stove, were sparse. The water supply and the toilets were both outside. The two brothers moved in during a particularly bitter winter. "The water's frozen everywhere, including in our courtyard, and we have to collect it at the public fountain, where it has to be pumped. In the morning, hardly out of bed, we set a fire, and it's only after that that I can even think of washing and dressing properly."[1]

Alberto slept in a bed at the back of the room, with Diego on the small mezzanine. The young artist was pleased with his new studio, even if he deplored its small size. He soon got used to it, however, and, in spite of a few unsuccessful attempts to find another when he became more successful, he eventually felt at home there and stayed until his dying day. Diego, who previously had had to put up with hotels, now shared in his daily life. The brothers both hung out in cafés, where political debates raged. It was an agitated time and the atmosphere was often electric. The extreme right-wing movement, Action Française, denounced the recent wave of immigration, stigmatizing foreigners with xenophobic slurs.[2] The situation did not look good, and many were already afraid of war breaking out. Diego had found casual work in an export company, which gave him a degree of financial independence. In dire financial straits and living in the most basic conditions, Alberto applied to the Swiss authorities for a scholarship. After several months of anticipation, he was hugely disappointed not to have been selected. He began to resent

his homeland, a feeling that, like an unhealed wound, still hurt many years later. He did, however, come across a little job that kept him from going under: making heads for clothing mannequins. "I have to make heads for fashion store windows; if it all works out, I'll be earning enough money. I've already started."[3] This activity did not last long, but it was his first experience of earning money alongside his art.

That year, Diego went back to Stampa for Christmas, while Alberto chose to stay in Paris in the new studio. Faithful to family tradition, however, he attended mass at the church of Saint-Sulpice with a friend. "The crowd was enormous, but we stayed on because the carols were beautiful and sounded lovely. It was much better than at Saint-Eustache's last year, because they didn't try to make it into a concert and attract an audience just for the music. Afterwards, we went off to Le Dôme."[4]

He spent New Year's Day with Campigli, who had invited a group of friends. Although he enjoyed going to the parties, he was protective of his own space and his peace and quiet. "For myself, I'm careful never to invite company back to the studio in the evening."[5] Even if he was prepared to receive a close friend there from time to time, the studio was first and foremost a place of work, one he was determined to keep tidy, and the most frequent visitor was the molder.[6] Most of his social life involved going out: during the day at the academy and in the evening in cafés or at a friend's house. Alberto's personality was highly individual. At once friendly and talkative, yet reclusive. A new student at the Grande Chaumière, Emmanuel Auriscote, remarked: "He had already that lined face, that mop of hair like wire wool that he would keep his whole life. He terrified me. His brisk voice, his uncompromising air and independence of mind with respect to Bourdelle and our friends in the studio seemed to create an unbridgeable divide between me and him. Yet he fascinated me."[7]

Although fiercely independent, Alberto threw himself into any social situation he was part of. He can be seen in several photographs taken at the Grande Chaumière, particularly in those showing students with

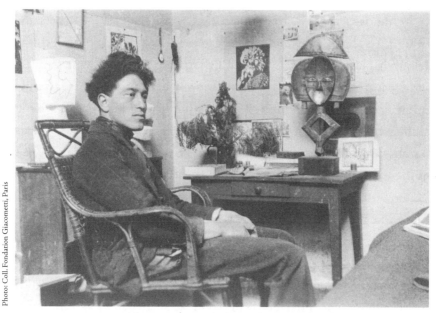

Alberto Giacometti in his studio on rue Hippolyte-Maindron, 1927.

Bourdelle during the period he was at the school. Among the undifferentiated mass of apprentice sculptors, one thing made him stand out: he was the only one never to wear a smock. Similarly, there are no photographs taken in his studio showing him in work clothes. Whatever the circumstances, he was always to be seen in a suit. Long after he left the academy, Alberto continued seeing some of its former students. Even if very few of them ventured down the path to modernity as he did, during those years of training and experimentation they formed a kind of substitute family for him. He remained attached to them, even if, retrospectively, he was keen to minimize the importance of both his time at the academy and Bourdelle's teaching.

The year 1927 started off well. In January, he took part in the Salon des Indépendants, sending his father a damning description of what was a vast and over-populated show, where the works were presented in alphabetical order. "Out of four thousand pictures, three thousand

eight hundred, at least, are very, very poor. For sculpture, it's the same thing."[8] Yet, for himself, he felt he had made a good job of it and was relatively pleased. "In spite of it all I should be happy enough, because in a great crowd like this you're usually drowned out. My room is hardly magnificent, but I'm exhibited in the middle, and people can see my stuff from every side. In theory I'd wanted to exhibit two torsos, but, as it's not wise to send two newly finished things without having looked at them calmly, I preferred to hold them back for the Tuileries, it'll be better. So I'm showing two rather large compositions. The effect they make is a good one and I'm glad to see that people like them and are very interested in them."

He then added an interesting aside, which indicated he was already interested in outdoor sculpture: "I'm sure the most recent work I've done, which is also at the Salon, would look really good executed in stone and erected in a garden or courtyard." Campigli reviewed the Salon in the press, praising the "two abstract sculptures that are not placed as visibly as they deserve."[9] Alberto sent the article to his parents and made a point of reassuring them that the word "abstract" was exaggerated and that he had not cut all links with reality. "My intention is to make figures that are alive and genuine."[10] The *Neue Zürcher Zeitung*, a Swiss review sent by Giovanni, called his works a "cubist fantasy."[11] Offended, the young man responded: "I know the critic at the N.Z.Z., he understands absolutely nothing about painting or sculpture, and 'cubist' is a meaningless word."[12] Nonetheless, while it may be pithy and pejorative, the observation is not far from the truth. These new works do come from "fantasy"; that is, they are imaginative sculptures that deviate from respect for the model and which indeed borrow their analytical and constructive dimension from cubism, combined with Cézanne's idea of folding back volumes on to the plane. In these most recent works, even portraiture is subject to this influence. With these works, Alberto differentiated himself from his classmates at the Grande Chaumière—who remained adherents of a neoclassical or naturalist aesthetic—and embarked decisively on his own, increasingly radical path. Works in volume, the "compositions" reveal a

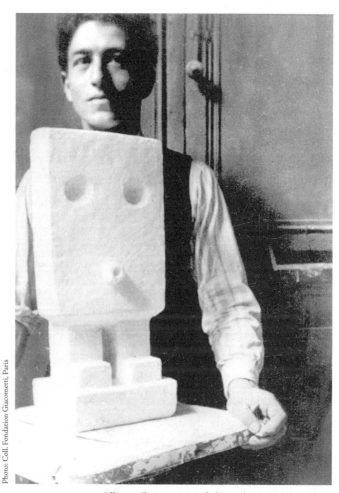

Photo: Coll. Fondation Giacometti, Paris

Alberto Giacometti and the sculpture *Man*, c. 1927.

neo-cubist influence. The motif is still present, but it is simplified, sometimes to the point of abstraction, and embedded in a composition of heterogeneous elements. In the wake of the Salon des Indépendants, a newly established gallery signaled its interest.[13] It was to show just one work, "a small composition", which did not sell. Still, the young artist derived some satisfaction from this, and his output began to be received favorably. He then showed at the Salon des Tuileries, presenting for the first time a large-scale work in plaster,

Spoon Woman.[14] This simplified female figure, whose broad, incurved belly is based on anthropomorphic spoons from African countries, also echoes the outline of a dressmaker's dummy, thus hinting at the metaphysical universe of De Chirico. Alberto was delighted with the manner in which his work was exhibited. "I am in the most modern room at the Salon, which this year they've put in the middle, near the large sculpture hall. I think it's the most interesting room, the one that makes the most striking impression. In the center there's a sculpture by Brancusi in polished metal. On one side there's a Zadkine and I'm on the other. On the wall there are large paintings by Léger and Gleizes, among others."[15]

The sculpture shown by Brancusi, *Bird in Space*, impressed him greatly and he copied it in his sketchbook, next to a drawing of *Spoon Woman.* "The thing by Brancusi (who's already an elderly sculptor with a white beard) is perfect, but the workmanship is a little too prominent, beautiful metal polished like a mirror. But it's a beautiful thing that's a pleasure to see, it's the only successful thing at the Salon. It's the only thing I can feel is really stronger than mine in the Salon."[16]

A new conception of art was beginning to take shape, to which he refers in a letter to its family. If he continues to conceive of a link between nature and the work, from this point on this concept plays a decisive part, one that is at the heart of the artistic process. Giovanni sent his blessing: "Nature will always be the inspiration, but the artwork, as you sense correctly, has to live a life of its own, with its own laws, independent of nature."[17] Still, Alberto's works were clearly diverging from his father's aesthetics. Yet Giovanni, ever eager for his son to find his own way, was never the least bit critical, instead encouraging him to develop his originality.

In July, he participated at the tenth Salon de l'Escalier. This exhibition, held on the premises of the Comédie des Champs-Élysées, gathered together a small group of international artists, including a Japanese classmate from the Grande Chaumière, Ebihara Kinosuke, in addition to Campigli. Giacometti showed six works, including *Composition*, a highly schematic male figure inspired by African art.[18] As implied by the catalog, which described his work

as a "futurist sculpture," Alberto had by this time introduced a distinction between several categories of works: figures, sculptures, compositions, and heads.[19] The schematic treatment of the forms in each of these categories often verges on abstraction. The painter Mario Tozzi's report on the exhibition for the newspaper *Nuova Italia* referenced his works. "Alberto Giacometti from the Ticino presents a group of sculptures inspired by either the principles of cubism or of futurism. He has chiefly exhibited abstract works, which is a pity, because when he tires of piling up intercutting planes, of overlapping spheres and cones, and decides to do real sculpture, such as a splendid head of a man, he produces works of incisive character and rare expressive power. Vaguely reminiscent of African art, they reveal great virile energy and an accuracy of perception in the understanding of the broad planes vigorously ripped from the clay!"[20]

Tozzi belonged to the "Paris Italians" gathered into the circle known as the Group of Seven, whose joint exhibitions he promoted. If before World War I several of these artists, like Gino Severini, belonged to the futurist and cubist avant-gardes, they were by then associated with a vast movement turning back to art history, whose champion was Jean Cocteau.[21] They thus subscribed to the line of De Chirico, claiming descent from antiquity or the primitives. In Italy, the development of this tendency, launched in 1918 in the review *Valori plastici*, was embodied by the Novecento group, whose defense of an aesthetic of "*italianità*" was backed by Fascism. In a letter dating from spring 1927, Alberto's father writes about a Novecento exhibition presented at the Kunsthaus in Zurich, which met with great success.[22] Giovanni praised the new Italian movement to the skies, his interest deriving particularly from the fact that its aesthetics were close to that of several Swiss artists in his circle. Campigli, who, after a brief futurist phase, was then practicing a highly sculptural figuration, was one of the artists shown. Bruno also refers to the exhibition, at which he had admired works by Modigliani, De Chirico, and Campigli.[23] In 1929 Swiss interest in Novecento was to be translated into a major exhibition in Geneva, at the Galerie Moos, in which a number of other Italian artists, such as Campigli, were again to take part. In spite of his

friendships with both Campigli and Severini, and although he was to show several times with them, Alberto did not join their movement and was never to form part of the Group of Seven. Nonetheless, periodically he felt the neoclassical influence of what Cocteau referred to as the "return to order," and traces surfaced in a few realistic portraits.[24] Such recourse to classicism in works after the model appeared only occasionally, however, and seemed most noticeable during visits with his family.

A range of artistic perspectives thus opened up to him simultaneously, but the artist decided against taking the most radical path. During the summer, which he spent in Maloja, he devoted his time to a series of modeled and carved heads, in a range of aesthetics. He was invited to show in the fall with Giovanni at the Aktuaryus gallery in Zurich, and several of the works created during the summer in Maloja were earmarked for the exhibition. He would show three busts,[25] alongside paintings by Giovanni.[26] The range of form deployed in the series of sculpture portraits of his father, created over the summer, went from traditional representation to schematization. The piece that most advanced toward abstraction was a marble head with the face completely planed down, leaving a very light relief in which human features are barely perceptible. Julius Hembus, a friend of Giovanni's, was passing through Maloja with the expressionist artist Ernst Ludwig Kirchner, and left an intriguing testimony: "With Kirchner we drove from Wildboden to Saint-Moritz and Maloja to visit Giacometti. We didn't see him, but instead met his son. Alberto Giacometti showed us his works. He showed us a stone placed on the table, of the shape and size of an ostrich egg, telling us it was a portrait of his father. Looking at it more attentively, we noticed how the features characteristic of a head had been captured using the very simplest means. He also told us about a rock on top of the mountain whose present form he had carved. To create such a monument without the least intention of benefiting from it financially is surely the highest level of gratification an artist can attain."[27]

Chapter 7

Between Cubism and Surrealism

Familiarity with the "Paris Italians" is less evident in his realistic portraits than in his more modernist works. Traces can be seen in the search for a personal vocabulary of neo-cubist inspiration and in the "compositions" in particular. It was these works he chose to show in 1928 at the Salon de l'Escalier that featured "the group of Novecento represented by members who are temporarily living in Paris."[1] He showed *The Couple* and new "compositions," including the terracotta *Dancers*. What brings Alberto closer to these artists was neither their classicizing idiom nor their claims to cultural "*italianità*," but instead an interest in pre-modern modes of representation and in alternative models of perspective. For instance, the frontality and schematization adopted by Campigli in 1928 following his discovery of Etruscan art resonated with Alberto's own researches, especially with the stele-figures. De Chirico's fondness for distorted perspectives, and Alberto Savinio's metamorphic aberrations, were to find their echo in the "compositions." One represents two intertwining busts whose schematic heads appear architectonic, and recall De Chirico's metaphysical period. The human figure remains the favorite motif, but it is now subjected to a process of geometrization that transforms each element into an enigmatic form. In the "compositions," the sign-figures adhere to a strict code: the female figure is transformed into an undulating line, while the male figure forms a rigid mecanomorphic component. Several works present figures that only those familiar with the sculptor's vocabulary could hope to identify. In other works the transformation of the motif results from the dislocation of volumes. These approach the cubist reduction deployed by Fernand Léger and Joseph Csaky, who attained abstraction by reducing forms into cubes, cones, or spheres.

By now familiar with the cosmopolitan Montparnasse art community, Alberto drifted between the aesthetics coexisting in the second half of

the 1920s. The admiration he shared with his father for Cézanne, and his reservations concerning expressionism, induced him to adopt the constructive world of cubism rather than turn to abstraction. Choosing an idiom in the lineage of neo-cubism, but keeping up the organic links with the motif, as Lipchitz and Laurens were doing, he rejected the abstract rationalizations of Piet Mondrian and Theo Van Doesburg, who were also living in Montparnasse at the time and were regulars at Le Dôme. Alberto assimilated the forms of non-Western and ancient art, but this was less to instill its raw visual impact into his work, as Picasso had done in *Les Demoiselles d'Avignon*, than to endow it with the consistency of timeless forms. Creations from Africa and the South Pacific, as well as Sumerian and ancient Egyptian art, all radiate this quality and offered source material for many compositions. After the radicalism of the early avant-gardes, the artistic keyword in the 1920s was synthesis. From the synthesis between cubism and classicism, preached by Gino Severini[2] and André Lhote, to the synthesis between modernism and applied art manifested by the International Exhibition of Modern Decorative and Industrial Arts in 1925, the era was one of a quest for harmony and a universal language. Alberto sought to make his own way between these two poles, all the while asserting his personal vocabulary. Although his father wrote to him saying he would like to come to see the "Salon of Decorative Arts,"[3] Alberto himself expressed no interest whatever in the event. Intrigued by Lipchitz and Laurens, he was, however, searching for a more original angle that would go beyond the interplay of forms. *Spoon Woman* provides a prime example, in which the sculptor attained an iconic quality matched solely by the works of Brancusi. The simplicity emerging from the work conceals a complex interweave of references. Several sources in non-Western art might be referred to, in particular Dan spoons from the Côte d'Ivoire. But its resemblance to Lipchitz's *Harlequin with Mandolin* (1925), in which the bulge of the mandolin is identified with feminine curves, is no less apparent. Preparatory studies in one of his sketchbooks show that the artist performed a process of

schematization based on the drawing of a female figure viewed from the front, from which the geometrized forms of the torso and abdomen gradually emerge. This work also resonates with the metaphysical universe of De Chirico's mannequins. Examining this sculpture in conjunction with those that follow, it is obvious that the artist deliberately orchestrated and synthesized many references, bestowing on it a rich potential for interpretation. Throughout his life, Alberto liked to maintain the mystery surrounding these works, refusing to reveal sources or hint at interpretations.

Up to this period, Alberto's sculptures had been unitary: heads, busts, trunks, or full-length figures. The "compositions" begin to play host to several figures or motifs. Interpretation takes on all the more significant role as the artist plays with the ambivalence of the forms and the multiplicity of the references. In particular, for works in a cubic volume, he adopts multiple viewpoints, each face affording a different interpretation. Transformed into visual signs, the motifs in such complex arrangements interlock. This is the case, for example, with one of the "compositions" made of disparate elements that seems completely divorced from the human figure: a central motif whose form is reminiscent of a radiator; a large, schematized hand redolent of one of the statues of Gudea in the collection of Sumerian art in the Louvre; and ornamented cubes that recall the toy-like building blocks represented in Savinio's canvases. But comparing this work to a contemporary sculpture by Zadkine, the *Accordionist*, generates an entirely different reading. Face-on, a figure with an accordion can be made out, but it recedes as one walks around the sculpture. The piece might be regarded as a tribute to Zadkine, himself an accordionist, but the reference is carefully dissimulated behind a kind of visual rebus.

His contribution to the Salon de l'Escalier exhibition attracted some attention, as did two works presented that same year at the Salon des Indépendants.[4] Lipchitz, whom he saw on several occasions, was generous in his compliments and encouraged his development. Since 1925, the

Polish sculptor had been doing "transparent" sculptures, in which the voids opened up in the composition play a constructive role. Exploiting this in his new works, Alberto paid discreet homage to Lipchitz the following year in the composition *Reclining Woman who Dreams*, which reprises the structure of the latter's *Reclining Nude with Guitar* (1928). Lipchitz, one of cubist sculpture's principal protagonists, had at this time entered a period of research. Unlike Zadkine, who, striving to wrest forms from the compact mass of material, mainly worked in wood or stone, Lipchitz exploited the qualities of bronze in linear and open sculptures. His work also was nourished by unusual sources and he shared with artists from surrealism, the most recent incarnation of the modern movement, an interest in dreams and in aberrations of perspective. In 1925, for instance, the sculptor bought two sixteenth-century anamorphoses Alberto could have seen in his studio. Recollections of these "anamorphotic pictures" appear in "compositions" reproduced in the review *Documents* in 1929.[5] Alberto also began making assemblages of elements drawn in space, which were extremely fragile in their plaster version, but intended to be cast in bronze. He deployed his imagination in a recurrent vocabulary composed of bars, grids, spoons, waves, and balls, juxtaposed or interpenetrating. The male body, for example, is reduced to a simple assemblage of rods, often topped with a "spoon head." Rather than being abandoned, references to the human body are now encrypted, to the point that these works often pass for fully fledged abstracts. As a palliative, for the first time the artist gives his creations titles, such as *Man and Woman, Reclining Woman*, or *Three Figures Outdoors*. These pieces were unaffiliated with any official movement and unsettled some of his friends. As he explained: "I can say I'm not following any particular direction, but on the contrary, I've turned off it, and I only do what I have to do, I cannot do otherwise. If despite everything it doesn't seem traditional (as this is generally understood, at least), I can't help that."[6]

One negative review criticized the "intellectuality" of his works. Alberto probably took it as a compliment. Ever since his arguments

with Bourdelle, he had been striving to go beyond mere manual virtuosity and fuse idea to form.

His work thus entered a new, experimental phase. The treatment of the motifs became freer, not only as to the forms, but also in the symbolic connotations associated with them. In the "compositions," eroticism, too, made a surreptitious entrance. He had already played on the ambivalence of schematic forms in *The Couple*: the almond shape, present on both figures, can be interpreted as an eye, mouth, or female genitalia. The single male eye is symmetrically placed with respect to the female sex, while the male organ has its counterpart in the female figure's eye. Generally speaking, eroticism in his works is not of the sensual variety, tending instead to symbolize sexual representation, often violent and nightmarish in nature. The two recurrent motifs of penetration and voyeurism are treated with a level of abstraction that often renders them invisible to uninformed viewers. Thus in *Reclining Woman who Dreams*, labeled in a notebook more suggestively as "woman in bed with somebody," two superimposed undulating surfaces are connected by parallel struts passing through one of them, beneath the "gaze" of the spoon stem. Fleetingly allusive in this work, the theme of the voyeur becomes more explicit in several others, for which the artist sometimes provides an indication of the presence of a third party in the title. Represented by the bowl of a spoon or by spheres projected into space, the eye of the beholder is the third element that intrudes into the couple from the preceding compositions. Symbolic violence is occasionally echoed by its sexual equivalent. This is the case in *Man and Woman*, where the long, tapering harpoon of the male figure points aggressively at the female receptacle. Curiously, Alberto's sketchbooks show that this work originated in a drawing of a knight holding his lance erect. By plunging back into the child's world of fantasies of war, the sculptor emerges with sexual visions that have connotations of violence. The intellectual elaboration of his works thus conceals and aesthetically transcends his manipulation of a raw material composed of drives and desires. This inclination was soon to bring him to the threshold of surrealism.

CHAPTER 8

Decisive Encounters

During winter 1928, Alberto pushed his work on the stele-figures still further, until the simplification process attained its zenith: unlike previous steles, the flat figures he called "plaques" possess no hint of relief and recall the human body only through the most rudimentary signs. In a series of "women," he returns to the principle of the inversion of volumes already used in *Spoon Woman*, hollowing out the figure's face and stomach. Tiny diagrammatic notations scratched into the surface add, in an almost naive or childlike way, anatomical details: arms, hair, legs. He showed these to his parents passing through Paris and, in January, presented one at the Salon des Indépendants. "In spite of working a lot since your departure, in two days I've only managed to finish one thing worth exhibiting, and I didn't want to show anything old. It's the kind of broad, flat figure you saw on the last day, not the one in the shape of a pyramid. Many of those who've seen it like it, in particular Müller, who declared it good."[1]

Lipchitz also appreciated these new works, advising him to have them made in more enduring materials.[2] For the time being Alberto showed mainly plaster works, but he took Lipchitz's advice and later had a number of the plaque-figures done in marble. The coming year was to be one of important encounters, with his work attracting attention from a significant circle of artists and collectors. Through Müller, who posed for a bust he had commissioned, he became acquainted with Jean Arp. In April, he also met André Masson, whose exhibition at the Galerie Simon he visited, declaring: "For me he's the strongest of the young painters, and he is very very friendly."[3] Grateful for Masson's enthusiastic response to his work, Alberto was delighted by the painter's enthusiasm in getting his sculptures better known. Masson did his utmost to arrange visits to rue Hippolyte-Maindron and hoped to be able to get him into his

gallery. "It's odd," Alberto mused, "that it's him and Arp who are most interested in me, because they happen to be the ones I'm most interested in too."[4] By then Masson was something of an outcast from surrealism. Although present at the birth of the movement with André Breton, an argument with the "pope" of surrealism had caused him to split from the group and he had grown closer to Georges Bataille, forming part of a dissident surrealist group into which he introduced his new friend. "I saw Masson at an exhibition, the same day meeting the majority of the friends I still have today, that is, Masson, Bataille, Leiris, Desnos, Queneau, and many others."[5] Adopting him immediately, this small, informal group was made up of artists and intellectuals nourished by a common interest in Nietzsche and Dostoyevsky, and who shared Bataille's fascination with transgressive eroticism.[6] Other participants included Joan Miró, whose studio was close to Masson's on rue Blomet, and who became a close friend of Alberto's.

At this time, Masson's paintings were infused with morbid and violent imagery. His principal themes show metamorphoses or animals copulating and/or devouring one another. He had recently illustrated the Marquis de Sade's *Justine*, as well as a new book by Bataille, *Story of the Eye*. Breton was not interested in this violent eroticism and its associated references, and this had been one of the main reasons behind the group's break with him. Masson also introduced Alberto to Carl Einstein,[7] a German art critic and a great specialist in African art, who had recently moved to Paris and who instantly befriended him. Masson was keen to help Alberto show his works. In spite of his mediation, though, in the end the young sculptor did not exhibit at the Galerie Simon.[8] The painter had managed to convince its owner, Daniel-Henry Kahnweiler, to go and see Giacometti's work, and the celebrated dealer of the cubists dropped by the studio, looking round in Alberto's absence and leaving a brief note asking him to contact him again once he had some new works.[9] In fact, Kahnweiler was hesitant about taking a new sculptor onto his books. Another opportunity arose, however, when Jeanne

Bucher, Lipchitz's gallerist, went to see Alberto in the studio. She had just opened an exhibition of paintings by Campigli and, intrigued by the sculptures in progress, proposed showing two works at Campigli's show. "Campigli has an exhibition there. At the opening they sold fourteen pictures and she proposed I bring two sculptures, because she has two splendid locations free. I didn't like the sound of it, but I had no choice. Lipchitz was there and told me that I should show them. Now they're there and Mme Bucher already wants another."[10]

He thus showed a figure and the most abstract of his plaques, *Gazing Head*, which he described as "the one I prefer out of all of them." Two furrows dug into the plaque inscribe what might be an eye and a nose, or else two eyes, one open, one shut, in accordance with the principle of asymmetry that recurs in many works.[11] The enigmatic appearance and originality of these sculptures attracted much attention. Overnight, Alberto's name was on everybody's lips. The Viscount and Viscountess Charles and Marie-Laure de Noailles, major collectors and patrons of the avant-garde, purchased *Gazing Head*,[12] while Mme de Alvéar, a notable Argentine collector, visited the studio, buying a slightly modified version of the same work. Jean Cocteau visited the exhibition at Bucher's gallery, accompanied by the painter Christian Bérard.[13] Intrigued by the hollows and scratches dug out of the figures and plaques, Cocteau jotted down an observation in his notebook, published the following year in *Opium:* "I know sculptures by Giacometti that are so solid and light that they look like snow retaining the footprints of a bird."[14] Cocteau sent Alberto a note telling him how he would have loved to buy one of the sculptures, while Bérard mentioned the exhibition to Pierre Loeb, then the surrealists' gallerist, who immediately contacted him. Events promptly gathered pace. "Pierre came over but was careful not to betray his interest to Mme Bucher. He immediately looked for Bérard to ask him for my address, as Mme Bucher didn't want to give it to him. Pierre hunted all over the place, returning to the gallery where he saw Brignoni's sister. He had his telephone number sent to me, asking me to call him urgently.

On Saturday evening at ten I rang Pierre, who gave me an appointment for four on Sunday. He came with his brother and that painter, Bérard. They were enthusiastic and, after the two others left, Pierre offered me a contract. I immediately telephoned Einstein, who came round at 8.30 with his wife. He advised me to accept."[15]

Heeding Einstein's advice, the artist took up the gallerist's offer. "Pierre takes all the sculptures, the drawings, and possibly the paintings. He pays for all the expenses of the work, bronze, plaster, stone, in short, everything one could need for sculpture. He does editions of five or seven numbered copies, giving me a free one each time that I can sell for myself. What's more, I can look for a studio costing up to eight thousand francs a year, of which he'll pay half, as well as giving me a retainer of one thousand five hundred francs a month."

Alberto immediately handed over sculptures to Pierre Loeb to be sold, independently of any exhibition. If this defection temporarily estranged him from Jeanne Bucher, they were soon back on speaking terms and he consigned a number of works to her. The de Noailles were to buy *Dancers* at the Galerie Pierre.[16] In the viscount's personal record book, the work appears under the title *Man on a Chair*, evidence of the difficulty of interpreting these enigmatic pieces.

Things were suddenly looking up for the young artist. Christian Zervos, the founder of *Cahiers d'art*, had also enjoyed the work at Bucher's gallery. As Alberto met more and more people, his correspondence to his parents became peppered with new names. He made the acquaintance of Max Jacob, who, he was proud to tell them, was a good friend of Picasso's. He also received a visit from Georges-Henri Rivière, deputy director of the ethnographic museum at the Trocadéro.[17] Together with Bataille and Michel Leiris, Rivière and Einstein had joined forces to set up a review, *Documents*, that was to serve as the mouthpiece of dissident surrealism. The principle behind the publication, whose debut number came out in April, was to combine art history, archaeology, and ethnography. In the fourth number published in September, Leiris devoted an article to

Alberto's oeuvre, in which, conditioned by his involvement in ethnography, the writer compares his works to "real fetishes one could idolize." The language of his description is highly poetic: "Some of these sculptures are hollow like spatulas or cored-out fruit. Others are openwork and the air passes through them, emotionally charged grills interposed between inside and out, sieves gnawed at by the wind." The words Leiris employs in trying to capture the sculptor's singular personality are individual and extremely suggestive: "There are times one can call crises and which are the only ones that count in a life.... I like Giacometti's sculpture because everything he does is like the petrification of one of these crises, the intensity of an adventure stumbled into and at once captured, it is the milestone that testifies to it."

Later, looking back on this period, the artist himself, as if to corroborate Leiris's analysis, spoke of his works as "emotive." Unerringly, Leiris's antennae had detected the interplay between psychic experience and creation in works, which, in common with his own writings, are innovative in the way they bring a fundamentally traditional personal culture to point of crisis. Such observations are also evidence of the influence of Henri Bergson, who characterized the "inner crisis" as the event that awakens the individual's awareness of life. The article is accompanied by photographs taken in the studio by Marc Vaux. The author deliberately shows in the same photograph three plaque-figures and *Man and Woman*. This set-up—which gives a suggestion of ceremony or ritual to the sculptures arranged in a semicircle around *Man and Woman*—also instills a strident, erotic note into the heart of the silence and hermeticism of the white plaques. Leiris's reading of the artist's work associates him with the spirit of the Bataille circle, who all admired de Sade and Lautréamont. In Masson's group, Alberto would meet Roland Tual, who collected African art, the poet Jacques Prévert, the American photographer Man Ray, as well as his lifelong friend Gaston-Louis Roux, an artist close to Leiris. He now formed an integral part of a recognized artistic and intellectual community, with whom he stood on the kind of friendly

and equal footing he could never enjoy with members of the generation of Zadkine and Lipchitz. He was entering a new and stimulating milieu that was to accelerate the development of his work, pushing it towards an increasingly personal expressiveness.

Making up for the lack of sales, Alberto received a number of commissions. At this time, Masson was carrying out two ornamental panels for the collector Pierre David-Weill—*Animals Devouring Each Other* and *Metamorphoses*—which were to be the two largest canvases he ever painted. Grandson of one of the founders of the Lazard bank, David-Weill had contracted several artists to decorate his apartment, including Masson, Lipchitz, and Jean Lurçat. Masson suggested to David-Weill that he might turn to Alberto to provide the finishing touch with a sculpture relief. Alberto was enthusiastic about the idea since it would allow him to bring to fruition the researches started in the "compositions" on a larger scale. His most recent creations were linear structures drawn in space, whose latent content was sexual or violent. *Apollo*, a highly schematic figure of a man apparently directly inspired by African art, also hints at a person in shackles. *Three Figures Outdoors*, a trio represented in a near abstract geometrical idiom inscribed within a grid-like structure, is heavy with aggressive, erotic connotations. This relief combines his work on the schematization of figures with Masson's favorite theme of metamorphosis, deploying over the wall a half-female, half-spider creature charged with a strange, monstrous eroticism. Georges-Henri Rivière, too, placed an order for a bronze relief for his living room. Passionate about ethnography and non-Western artistic traditions, Rivière, a close friend of Marie-Laure de Noailles, was a larger-than-life character. Leiris was to describe him as a "bird of prey with blue eyes, a thin, glabrous character from a novel by de Sade, an ascetic tempted by who knows what hell."[18] This, then, was clearly a context in which Alberto could give his imagination free rein. Erotic inspiration was thus at the heart of the large openwork relief Alberto created for Rivière, which showed two insect figures locked in an embrace. The demystifying power that Bataille discerned in the formless finds expression in these works, which directly echo the provocative writing

that was creating such a sensation in *Documents*. "To state that the universe resembles nothing and is but formless," writes Bataille, "amounts to affirming that the universe is something like a spider or a gobbet of spit."[19]

Leiris, too, became a friend, and, over the following years, the destinies of the two men were often intertwined. For *Documents*, Leiris would write not only about his artist friends, but also about American jazz and movies, showing particular enthusiasm for the African-American review by Lew Leslie's Blackbirds at the Moulin-Rouge, as well as for the sculptures of his new friend. Although he now belonged firmly to the Bataille circle, Leiris had not broken with all his surrealist friends. He was especially close to Arp, who exhibited reliefs in an exhibition at the Galerie Goemans, and which Leiris praised in the review. As Alberto had written to his parents, Masson and Arp were also exactly the artists "who interest" him. The fact that, above and beyond their friendship, he could simultaneously admire two artists whose productions and imaginary worlds were so different reveals a deep-seated ambiguity. Alberto's new works betray these paradoxical tendencies. In parallel with a sexual and violent imagination, still perceptible despite the abstraction of the forms, several works display a childlike approach, with schematic forms suggesting playful, even amusing connotations. One round-eyed character made in marble, standing squarely on tiny feet, and another in the form of a blue-painted ghost, as well as the various "compositions" combining cube or skittle motifs,[20] introduce the theme of the toy and play into his work. At the same time, Arp was creating reliefs still inspired by Dada, combining with imagination and humor features of the human body such as eyes, moustache, navel. These works appealed to Alberto, and the title he gave one of his plaque-figures, *Three Eyes, Two Arms*, would have suited a piece by Arp. Alberto had first encountered surrealism via its dissident side, but he was soon to meet the orthodox group around Breton. The movement enabled him to reconcile these two contradictory tendencies: the poetic freedom and oneirism the movement preached offered an intellectual framework for the infantile imaginings expressed in these works, whether playful or erotic.

Einstein soon became an ardent defender of his work. For *Documents*, he wrote a review of the modern sculpture exhibition organized by the Galerie Bernheim at the end of the year, in which Alberto exhibited. In a plea for a revival in sculpture, he singles out the young artist. "We've had enough of these positive Venuses, examples of a misplaced classicism now taught solely in provincial institutions for girls. Enough of these orthopedic torsos that compete with broken relics from the Dark Ages. One is not modern by hollowing out one corner while letting another bulge. People do pseudo-cubism, bobbing along in the fatal gondola of threadbare contrasts. Enough of the elegant proportions of late Rome. We miss Arp, that poet of popular song. On the other hand, we see too many of Bourdelle's jagged mantelpieces transposed into tawdry modernism. We give a sympathetic nod to Lipchitz, Laurens, Brancusi, and Giacometti. Sculptures need influential collectors, a manager who'll create a market for them. Commission sculptures!"[21]

In the exhibition, Alberto was represented by two works, a male plaque-figure in plaster and the bronze *Three Figures Outdoors*. It was on this occasion that he met Henri Laurens for the first time, and from then on was to regard him as the most interesting sculptor then working. His judgment on his onetime mentors is, if anything, more censorious than Einstein's: "Lipchitz's large composition is all wrong. I can't stand it, Despiau and Maillol even less, the Brancusi is well made but that's all, the Laurens is the best, but he always has to put in his little figures, it's a pity! Zadkine, always the same stuff, uninteresting."[22]

He now emphasized how far he had come from his former influences. Perhaps his admiration for Laurens, which was to grow into a sincere friendship, was due to the fact that Alberto's work owed relatively little to the older artist's and that his current pieces could never be mistaken for the swelling forms and sensual harmony of Laurens. Even though he had not burnt every bridge connecting him to the sculpture he had once admired, Alberto now adopted a new trajectory that brought with it still faster developments.

A New Phase

Despite his growing number of new friendships, Alberto remained strongly attached to his family circle. During autumn 1928 Diego left on a tour lasting several weeks to Italy and then to Egypt. Accustomed to having his brother by his side, Alberto expressed a mixture of joy and relief when Diego returned. In May 1929, all the siblings were delighted to meet up together in Paris. Diego, however, once again without regular employment, decided to seek work elsewhere, going first to Italy and then to Basel. In the fall Alberto's burgeoning success gave him an idea: why shouldn't his brother, who had always been so useful around the studio, act as his assistant? It was true that work was becoming more intense by the day,[1] with Alberto having to do several copies of his plaques in plain and painted plaster, terracotta, or marble, and with many bronzes on the go. After David-Weill and Rivière, the Noailles, with whom he had recently become personally acquainted, also placed an order—a sizable commission for a large sculpture in the garden at their new villa in Hyères.[2] The realization of this exterior piece, which would occupy him for more than two years, was to be the culmination of all his research on these plaque-figures. In October, a few days after being contacted by Charles de Noailles about the project, Alberto proposed that Diego return to Paris to become his assistant.

The sculptor himself was very supportive of the idea, not only for the help it would bring him, but also due to his immense affection for his brother, whose presence was a calming influence. Although the unexpected upswing in his career was exciting—and surprised Alberto as much as anyone—this new-found fame had thrown his carefully regulated life off-kilter. Meanwhile, Diego, who had not yet found his vocation, was a source of concern for the whole family. Alberto shared their worry and was equally keen to see his brother stand on his own two feet, but he also had more personal reasons for wanting Diego by his side. He felt as though he was caught between two

worlds, and, despite all his recent acquaintances, he still felt his loneliness keenly. He did not yet feel close enough to his new friends and found it hard to adjust to the social whirl now surrounding him. But he wasn't any more satisfied with his immediate environment. He opened his heart to his brother Bruno, describing all of the fashionable invitations he received, adding: "In brief, I've no time to get bored, at least in the day, but I am sometimes in the evening. I've had enough of Montparnasse, but the other districts seem even worse. I don't know what to do with myself but I can't always stay at home. I want to find a woman who suits me and after that it will be fine. At dinner tomorrow I'll be sitting next to one of the most beautiful and most elegant women in Paris, but, as she stands five foot eleven, I think it may be a lost cause, I'll just have to wait and see. In the cafés, one always sees the same faces, in the same places, all the time!"[3]

The amusing anecdote of the five-foot-eleven woman, which he also told his parents, was a bright note in a generally downbeat report. Hugely in demand as an artist and with glamorous new friends, Alberto was making his way in the world, but he was seeking a new equilibrium, necessary as much for his creativity as his psychological wellbeing. On the emotional level, nobody had yet replaced Flora Mayo, who had returned to the United States that year. During the summer in Maloja, he was joined by his cousin Bianca and they got back together. But, if the affair was now physical,[4] the passion he felt during his stay in Rome had mellowed into an affectionate friendship. He still frequented brothels, in particular Le Sphinx, which he enjoyed for its atmosphere and for the sight of women who displayed themselves with no inhibition or artifice. In the evenings he also enjoyed bar and cabarets, where he would often hang out until dawn, chatting with streetwalkers and fellow night owls. His new friends came from the upper-middle classes and aristocracy; he might share their culture, but not their lifestyle. "Saturday I went to see a marquise in a palace with enormous rooms. I would never have believed that such luxury even existed,"[5] he wrote to his mother. He also recounted his forays into high society, to the de Noailles' residence—"a palace like you've never seen"—and to the houses of other wealthy patrons.

"Sunday I went to a reception where there were many very well-known people and it amused me, and anyway I stayed in a corner drinking cocktails."[6] In his reply Giovanni gently mocks his son: "We are most impatient to hear Alberto speak to us about his new acquaintances and to tell us about his invitations to princesses and marchionesses. We too will put on white gloves to receive him."[7] In one of his articles, the Swiss writer Charles-Albert Cingria described him as a young artist on the up. "I have been struck, for a number of years, by the insistence with which chance has contrived to cross my path with a young man whose head is exactly like an Etruscan figurine. I was far from suspecting that I was in the presence of [Alberto Giacometti], an extraordinary sculptor who all Paris was talking about at the time. Somebody, whose name, which I am loath to continuously drop, is on everybody's lips [Jean Cocteau], has, it appears, just given the signal. He had, however, been preceded by someone else, I mean the surrealist poet (now, like so many others, no longer a surrealist at all), Michel Leiris."[8] The "extraordinary sculptor," whom the writer also describes in a letter as a "Swiss Etruscan," had seemingly, from one day to the next, become the talk of the town. Even the celebrated composer Igor Stravinsky showed an interest in his work and asked for an introduction.

His social circle was widening considerably and although Alberto was pleased—even proud—he found it hard to fit into his new role. "I'd been introduced to a countess and a princess. Two days later, I saw them again and, as I failed to recognize them, I hardly acknowledged them, I think I may have made a faux pas, all the more so as I think one of them has bought something from me."[9]

Long accustomed to a simple lifestyle, Alberto had learnt how to ward off his angst with little ceremonies and habits that regimented his daily life—his fixed schedule and his meager and unchanging menus, as well as his attire. Inundated with invitations, he preferred to spend as much time as possible in his studio. It was with great joy and relief, then, that in December he welcomed back Diego, who had at last decided to move back to Paris. "Coming in one day after breakfast, I was so glad to find Diego in the studio, spick

and span and in a good mood, and we spent the finest days of the season together. He lives in the studio, helping me a great deal with the large statue and also with all the rest, and we spend almost all our time together."[10]

Alberto put his new-found funds to good use by renting a room in a small hotel nearby, the Primavera. The relief for David-Weill was progressing well. The artist planned to make it in bronze and coat it in Chinese lacquer. For the same apartment he was also to make a pair of firedogs, literally in the shape of barking hounds. For this order he worked closely with the interior designer Desny,[11] who would also become a friend. Desny thought they could probably continue their collaboration, counting particularly on orders from his American customers.

Frequenting Rivière and Einstein had improved Alberto's knowledge of non-Western art. The German critic, who was to devote several articles to his work in international reviews, remained his most effective advocate. A journalist and art publisher, Einstein also taught him how to promote his work through good photographs. Alberto, already with contacts to Marc Vaux, photographer for the artists of the School of Paris, then approached others closer to the surrealist orbit, such as Man Ray, Jacques-André Boiffard, and Rogi André. He had never even held a camera, but Alberto very quickly realized the importance of possessing original photographs of his works. He was also conscious of the power he exerted over photographers: although by nature reserved, he would readily sit for them. Most photographs show him completely still, staring resolutely at the lens—the perfect incarnation of the artist concentrated on his thoughts, at once earnest and mysterious. As Man Ray recalled: "Giacometti, the sculptor, gave one the impression of a tormented soul. Always dissatisfied with his work, feeling that he had not carried it far enough, or perhaps too far, he'd abandon it in his heaped-up little studio, and start on an entirely new formula. He could talk with lucid, voluble brilliance on many subjects. I liked to sit with him in a café and watch as well as listen to him. His deeply marked face with a grayish complexion, like a medieval sculpture, was a fine subject for my photographic portraiture."[12]

CHAPTER 10

Joining Surrealism

In April 1930, Alberto exhibited for the first time at the Galerie Pierre in the company of Miró and Arp. Presenting plaque-sculptures, including a marble version of *Gazing Head*, he also unveiled a new composition that was to prove a turning-point in his oeuvre and in his career: *Suspended Ball*. Fired with enthusiasm for the piece, Salvador Dalí viewed it as a prototype for the "symbolically functioning object," a new concept he was to propose to the surrealists as a substitute for the by then slightly tired practice of automatic writing.[1] Suspended from a string in a metal cage is a ball into which a broad notch has been gouged. It hangs very close to a crescent moon fitted onto a thin platform. Even if one can detect in it a reference to the "sun and moon" clock in the family home at Stampa, the work also harbors sexual allusions and an obvious violence. Dalí describes it in the surrealist journal: "A wooden ball marked with a female slit and suspended from a thin violin string above a crescent, the edge of which brushes against the cavity. The beholder instinctively feels the urge to slide the ball over this edge, something the length of the string makes it possible to do only to an extent."[2]

To the young Catalan painter, seeking to impose his erotic and morbid imaginative world on a surrealism then in search of renewed energy, the ambiguity and latent aggressiveness of Alberto's works appeared as a welcome adjunct. André Breton himself was immediately interested and also paid a visit to the sculptor, who was much impressed by both Breton's charisma and the spirit of collective emulation among the surrealists. From autumn on, he regularly joined their meetings and participated in various group activities. A new chapter was opening, one that would prove influential for his career. Now his friends included figures such as Breton, Dalí, Tristan Tzara, Max Ernst, Yves Tanguy, Louis Aragon, and Georges Sadoul. As the spectrum of his art and acquaintance was

expanding, however, he did not wish to be seen as exclusive, and he was careful not to upset those of his friends who might have criticized his growing proximity to "official" surrealism. Entering the surrealist group, he managed to keep the friendships he had forged with the dissident family at *Documents*.

In spring 1930, he embarked on another decisive collaboration, with decorator Jean-Michel Frank. Interior designer to the Parisian intelligentsia whose style was characterized by a classical and refined modernism, Frank suggested Alberto make a number of decorative objects and light fittings.[3] Alberto found the proposal as interesting as Frank's personality. A friend of the de Noailles, whose private mansion he had refurbished, Frank, whom François Mauriac was to describe as having invented an "aesthetics of renunciation," stood at a turning-point in his career, too. Newly named art director at Chanaux & Cie, Frank now had the means to surround himself with architects such as Emilio Terry, as well as artists receptive to projects for interiors and objects. He was in particular associated with the small group of "neo-Romantics," to which Bérard belonged. Giacometti and Frank were soon friends, and began a fruitful collaboration that was to last for more than ten years. "We see each other pretty often and he's one of the people I like best,"[4] Alberto wrote to his parents in January 1931, announcing that Frank would be likely to visit them at Maloja during a stay in Switzerland. With Diego's assistance, Alberto was to design lamps, sconces, and decorative objects for the interiors of Paris society. Unlike with the two reliefs conceived for David-Weill and Rivière that remained close to his "compositions," the imagery mobilized for these decorative objects was quite different from that in his artworks, even if the sources were often related. If Alberto continued his activities in the field of decorative arts, producing art to make money was, he realized, highly suspect in the eyes of the surrealists. In any case, despite the stroke of luck he had meeting Frank, everyday life was hardly plain sailing. Times were hard and the economic crisis was starting to impact on the art market. Miró did not make a single sale

at the exhibition at the Galerie Pierre, while Dalí, who also benefited from Frank's commissions, was short of money.

One day on leaving the exhibition, Alberto felt unwell. Wracked by stomach pain, he was forced to take to his bed. He consulted Theodore Fraenkel, a doctor and part of Breton's circle, but he was unable to immediately diagnose the cause of his suffering. It was appendicitis, which would not be operated on until July, in a Swiss hospital.[5] The sculptor remained in a weakened state for some time, and working was out of the question. Helped by his parents, his friends also gathered round, looking after him and keeping him afloat financially.[6] Diego hovered at his bedside, keeping the work ticking over. It had been a close shave, but Alberto had been comforted by the network of solidarity that had supported him. Shortly before the operation, another noteworthy event had occurred in his life: the start of a new love affair. This time it was no highly educated American heiress, but a young woman who frequented the same bars as he did. A laborer's daughter who lived hand to mouth, Denise Maisonneuve was a regular of many late-night haunts. Their affair had more than its fair share of ups and downs, and arguments and reconciliations were frequent. Denise was unstable in her relationships and sought solace in drink, frequently testing Alberto's jealousy. Alberto was alternately enraged, remote, and, once they had made up, deeply passionate. This tempestuous relationship—which he did not dare inform his parents about, telling only Diego and some close friends, like Einstein and Frank—was to last several years, however. During the entire period, the artist was engulfed in a maelstrom that affected his professional as well as his private life. He opened his heart to Tristan Tzara, whom he had only recently met and who had expressed concern at how lonely the young man seemed. "That I've arranged my life really badly now on several levels is true and you sensed it more than the others, but at the same time I'm much less lonely than you think. To be alone at certain moments is a need occasioned by various things in which woman has surely a large part to play, but it's not due to a lack of women,

or a vague quest for an ideal woman. Even all the time since my return, while I've been in love with a woman in a way that hasn't happened to me for years (it's not the same one I called my girlfriend above), and this love was not just emotional, on the contrary, but I reckon it's all over since yesterday morning, on one side I'm disorientated enough, as I was yesterday evening, but this thing was bound to end like that, and I've moved on to something else."[7] Several times, as in the confiding note to Tzara above, Alberto believed he had finally severed the bond with Denise. It was, however, the nature of their relationship to be chaotic, and the liaison endured in spite of all the ups and downs. Despite all this, art remained the mainspring of his life and the prime focus of his concentration above all else.

Being part of the surrealist group and the discussions with his new friends provided a significant stimulus to his work. In the months following his meeting with Breton he tried out new forms. On October 22, 1930, he attended the private screening of Buñuel and Dalí's film *The Golden Age*, an occasion that attracted—a matter of rows apart—"orthodox" and "dissident" surrealists alike. Several artists were there: Brancusi, Picasso, Braque, Duchamp, Miró, Tanguy, and Ernst.[8] Giacometti's relationship to Miró, whom he regarded as "one of the few to do stuff that actually interests me,"[9] amounted to a form of emulation. "Miró is back from Spain with a whole series of wooden constructions, with nails and little color, very close to what I did this summer in Maloja, but his are very successful and I like them a lot."[10] Alberto experimented with various constructions in Maloja, such as a schematic figure made of planks and a totem studded with nails, both of which were immediately destroyed. Without letting them go completely, he distanced himself from the problems inherent in neo-cubist sculpture with a series of works that can be compared to surrealist objects in the lineage of the *Suspended Ball*. *Cage* reverts to the principle behind the cubic "compositions," with elements that connect when the viewer moves around them. Biomorphic forms, vegetable pods, or insect thoraxes fall prey to a razor-sharp claw

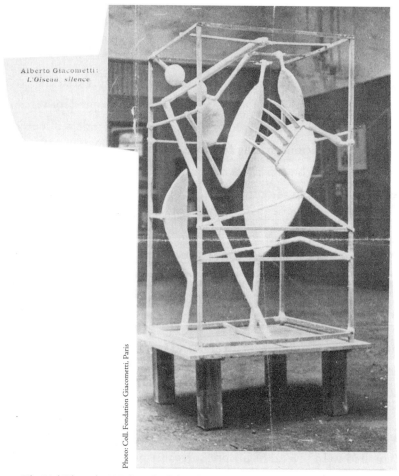

Alberto Giacometti:
L'Oiseau silence

Photo: Coll. Fondation Giacometti, Paris

The Bird Silence (c. 1931), at the Salon des Surindépendants, in *Vu*, November 1933.

beneath the goggled-eye stare of two ocular spheres. More assemblage than sculpture, the work is reminiscent of the welded-iron constructions carried out by Picasso with Julio González, as much for the compositional process as for some of the motifs. 1930 was a productive year, with the new models joined by editions of earlier pieces in diverse materials. Fulfilling the clause in his contract with Pierre Loeb, Alberto had several bronze sculptures made, including *The Couple*, *Apollo*, and *Man and*

Woman. But bronze is an expensive material, and the gallerist, hit by the economic downturn, could not absorb the entire cost of such editions as stipulated in their agreement. Due to their complex openwork structure, these bronzes demanded hours of painstaking finishing that the artist worked on in tandem with Diego. Generally, then, he opted for versions in plaster or sometimes terracotta. Deep down, and independently of the practical questions arising from the translation of the models into another material, the artist was fond of the plain white color of plaster. Prior to having them photographed, he would have the plasters given a coat of white "Ripolin" paint,[11] and even went so far as to paint certain bronzes white, such as *Reclining Woman who Dreams.*

At the beginning of 1931, Arp introduced him to another group of artists who practiced abstract geometric art. On February 15, he attended the founding meeting of the Abstraction-Création group, at Theo Van Doesburg's in Meudon. There he met Jean Hélion, who recalled the event. "There was Arp, chummy and dreamy, and Giacometti, surly looking and with unkempt hair, who refused to join us. At this time he was a surrealist, but he always remained opposed to the idea of non-figuration."[12]

Unlike Arp, who adhered simultaneously to surrealism and to abstraction, Alberto resisted the temptation of the abstract, a temptation he had succumbed to in several of his pre-surrealist pieces. It was no longer a time for formal considerations, but for symbolic objects. He employed a carpenter and metalworker to make a wooden version of *Suspended Ball* that Breton was to purchase from him. In the same way he created *Man, Woman, Child,*[13] a wooden games board on which three schematic figures in metal are arranged to represent the family triad. Whereas the triangular blade representing the man is fixed, the woman with open arms and the child, represented by a simple ball, are fitted on runners and are thus potentially mobile. Alberto devised several variations on board games in the same vein, and the new ventures delighted him. "I've made sculptures that can move! While I was sick Diego put together three and then I worked on them. With the new pieces the studio has

changed appearance, they are more joyful works and I had a lot of fun doing them, they're like games! (I'm curious to see them on show, it won't be a weighty exhibition.) I have no idea what the next one I'll make will look like, and that's a very pleasant feeling. One seems to breathe a lighter air!"[14]

As well as these objects, he also carried out more sculptural works, which suggest motion rather than actually moving. Alberto had seen works by Raymond Duchamp-Villon, and others by Umberto Boccioni, while Luigi Russolo had visited him at his studio. He associated the question of movement in sculpture with the interpenetration of space and plane, and proceeded to hybridize the symbolic register with formal analysis in works that were more ambiguous than ever, such as *Disagreeable Object to Be Thrown Away*. Although ostensibly abstract, the sculpture hints at spatial displacement: the board indicating the ground is pierced by an angular shape and stands on pointed forms the artist identified as figures. A similar work, in wood, bears a more explicit title: *Limping Figure*. Generally sparing with commentary, Alberto explained that this piece had been inspired by seeing a person limping down the street. In spite of this literal interpretation, however, the erotic connotations are clearly perceptible. The entire year was devoted to creating works of this type, strange and ambivalent. Patently erotic, often violent, these works introduce the black humor enjoyed by the surrealists into forms with a range of resonances. The highly suggestive *Disagreeable Object* is thus redolent all at once of a vegetable husk, a studded dildo, an African ritual object, a giant amulet, and the anamorphosis of a skull that emerges when the object is viewed side-on. A version in marble, smaller and smoother, is curiously entitled *Embryo*. Alberto's taste for puzzles and for images with double entendres, already expressed in previous works, was exacerbated by his adherence to surrealism. As his imagination ran riot, the conception of the image developed in such objects edged closer both to Masson's "metamorphoses" and to Dalí's "double images." Alberto, however, opted for less storytelling and more mystery, injecting narrative

and metaphorical content into forms that often flirt with abstraction. He adopted a lighter tone in ersatz games such as *Circuit* and in his arrangements of little characters, with *Desperate Little One* being the first example. This taste for the absurd recurs in the imaginative drawings that populate his sketchbooks, as in several unrealized schemes for objects, strange combinations of figures and animal outlines. These drawings of a surrealist inspiration are similar in spirit to the *"cinépoèmes"* of Jean Cocteau and Man Ray and to the humor of Jacques Prévert, who, with his wife Simone, lodged for a time in the studio on rue Hippolyte-Maindron.[15] Alberto was interested enough in Prévert's cinematographic projects for Bruno to think he might be tempted to take up film himself.[16] But although he often displayed an interest in cinema and would call on the best photographers for his works, these new art techniques never really appealed to him. His chief concern remained sculpture, even if, from this time on, he often delegated the actual manufacture. Some of his "games" were displayed at the Galerie Georges Petit, in an exhibition showcasing the young art scene.[17] He combined several of the "objects" and "games" under the heading "Mobile and Mute Objects" in a series of drawings published at the end of the year in the surrealist review.[18]

The artist had been working for a year with Diego on the monumental sculpture ordered by the de Noailles In January 1931, Alberto traveled to Burgundy to look for a suitable block of stone from which to carve it. He had considered doing a group of three figures—a triad of man, woman, and child—and sketched a life-size model for the design in Maloja, but he eventually decided on a single sculpture. He selected a two-and-a-half meter (7 ft. 10 in.) block of white-colored soft stone: "a magnificent stone."[19] In spring, they made a clay model in the studio, then the brothers both set off to Burgundy to begin work.[20] The sculpture was rough-hewn out in the quarry and then transported to Hyères. *Figure* reuses the shape of one of the figures composed in Maloja, and represents a tall figure in the form of a stele topped by an almost cubic head, animated with a sense of movement. The work undertaken since

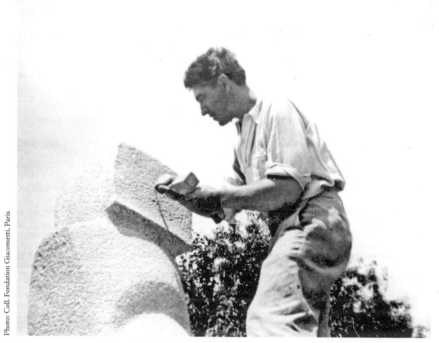

Alberto Giacometti sculpting *Figure* for Villa Noailles, Hyères, 1932.

that early sketch had led Giacometti to synthesize the features of a figure presented alternatively as female or male, depending on the position from which it is seen. The themes of hermaphrodism and androgyny, crucial to the phantasms of the surrealists, had also interested Alberto for a long time. *Crouching Figure*, of uncertain gender, and *The Couple*, whose respective attributes suggest strange interconnections, already presented instances of sexual ambivalence. The large figure for the de Noailles uses the multiple viewpoint perspective already deployed in the "compositions" to let viewers gradually discover the complexity of a deceptively simple-looking form. The realization of the piece was a lengthy and exhausting process that Diego undertook, with Alberto finishing it off. The artist was precise in selecting its orientation and location, which he was only to visit in the fall. However original in form,

the work obeys the traditional schema for a statue standing in a garden. The project did fulfill a major aspiration for the artist: to produce a work for an outside space.

At the same time, Alberto designed other projects for large-scale sculptures that were more experimental in nature. One such was the *Project for a Square*, which would not be carried out but for which he made two models, one small and one medium scale. The concept of play was convened once again for a group of elements placed about the ground. The sculptor wanted these elements, the models for which would long be stored in the studio, to be reproduced in stone on a large scale and be installed in a public space. Abstract in appearance, each form offers a symbolic connotation: a stele and a cone evoke male attributes, a hollow hemisphere could refer to breasts, a zigzag hints at a diagrammatic representation of a snake—which has led to an interpretation of the piece as a modern Garden of Eden.[21] The deliberately archaic character of these forms likewise suggests a more primitive source, bringing to mind the enigmatic standing stones of ancient civilizations. Giacometti did not provide any iconographical key with which to interpret the piece, although he did indicate that walkers would be free to sit down on the various modules, even planning for one element to be dug into the ground. In the preparatory drawings the forms are arranged like facial features, perceptible only from a bird's-eye view. The simple volumes, fluctuating between the geometric and the biomorphic, recall the composite bodies of Picasso's *Bathers* of 1928, whose sculptural character Alberto had not appreciated at the time,[22] but which he had sketched in his notebooks and which, in this case, helped him satisfy his desire for monumentality.

Around the same time, he planned another vast project that was surrealist in inspiration. *Project for a Corridor*, for which he produced a plaster model, was conceived as a work halfway between sculpture and architecture, that people could enter. Equating to a reclining female body, the overall form is a kind of three-dimensional translation of a phantasm of penetration. From now on, Alberto would give free rein

to his dreams and obsessions, expressing them in works, drawings, and notations in his sketchbooks. For *Project for a Corridor* he redeployed the model of anthropomorphic landscape fashionable in baroque garden design. Many old engravings illustrate these anthropomorphic visions, often founded on anamorphosis. The mannerist *Bizarrerie* of Giovanni Battista Bracelli is a perfect example of this, and Alberto had copied some of these plates in his notebooks. *Project for a Corridor* is connected with the architecture-figures of Bracelli's "anthropomorphized city," as is another of Alberto's large plaster works, *Landscape–Reclining Head*. With Dalí, he also dreamed of designing a total surrealist garden, probably for the de Noailles. The two artists' drafts show a garden comprised of artificial hillocks and grottoes of Dalí-like inspiration, inside and on top of which are sculptures by Alberto such as *Suspended Ball*, elements from *Project for a Square*, and *Disagreeable Object to Be Thrown Away*. These aspirations and dreams for monuments were, however, never to be fulfilled, remaining as drawings or models that were considered as works in themselves.

CHAPTER 11

Eroticism and Violence

Alberto joined the surrealist movement at a complicated juncture in its history. Conflict raged between Breton's group and the ex-surrealists gathered round Bataille. The numerous anathemas pronounced by Breton were a source of rancor, and the review *Documents* was scathing in reaction. At the end of 1929, in the last issue of the journal, Breton published his "Second Surrealist Manifesto," in which he let fly at Bataille by name, ridiculing his concept of "low materialism." A month later, his target, together with his friends, went on the counterattack with a lampoon entitled *A Corpse*. In it Bataille compared Breton to a "castrated lion," declaring surrealism to be a religion with Breton as its self-appointed prophet. Denouncing Breton's idealism, Bataille condemned the movement as cut off from social reality. As a newcomer, Alberto found himself caught up in a conflict that had been brewing for years, in a situation similar to that of Dalí. The Catalan artist, whose sensibility was essentially closer to Bataille's than to Breton's, nevertheless rejoined the surrealist movement, hoping to spark its renewal. In so doing, he turned his back on Bataille, although at the risk of being less well understood by his new companions, who had expressed doubts about his "paranoia-critical" method. Less of a strategist than Dalí and having no desire to expound theories, Alberto tried to bridge the gap and reconcile the two sides. Personally closer to the main proponents of "orthodoxy"—Miró, Éluard, Aragon, Ernst, and Tanguy—and a great admirer of Breton, who had introduced him to a whole new arena of thought, Alberto nonetheless retained ties with the "dissident" faction around *Documents*. In fact, his work is irrigated by the two contrary currents of surrealism represented by Breton and Bataille: playful and oneiric explorations, on the one side, and transgression on the other. In an attempt to overcome the opposition, he would operate a synthesis in works combining poetry and provocation, sublimation and perversion.

He was also increasingly preoccupied by political questions. The surrealists announced themselves as a "revolutionary" movement, but could not agree about the relationship they should maintain with Communism. Most members had joined the Communist Party in 1927, but dissenting voices were being raised; the party itself was hardly enamored of the activities of these bourgeois intellectuals either. Opinion was split between partisans of the "integral surrealist revolution" and supporters of the Communist cause. Alberto's leanings tended to be with Aragon, Éluard, and Crevel, who sought to bend their artistic convictions to the party line. It was a tendency that perturbed his parents. "I hope, Alberto, that you will grow tired of moving in Communist circles," Annetta pleaded.[1] Alberto in fact did not go so far as to adhere to the party, and, although he read the Communist daily *L'Humanité*, he never became a militant. He was not among the signatories of the surrealist diatribe against the Colonial Exhibition in 1931, but he did visit the "counter-exhibition" organized by Aragon, Éluard, and Tanguy. "I went to an anti-colonial exhibition organized by Aragon, it's far more interesting than the colonial one."[2] In May, Michel Leiris left for Africa for two years under the aegis of the Dakar-Djibouti ethnographic mission conducted by Marcel Griaule. In spite of his interest in ethnographic artifacts, Alberto was critical of his friend's involvement in an expedition that in his eyes was nothing more than a colonial venture. Alberto was resistant to partisan discipline, but his political opinions were incisive, and the subject of politics long preoccupied him, underpinning a number of his friendships. In later years he even contended that he was attracted to surrealist circles mainly so he could spend time with Aragon and Sadoul, who had both traveled to Moscow.

Alberto had been an admirer of Picasso ever since his earliest days in Paris, and, even if the young sculptor might admit to occasional misgivings, in his eyes Picasso remained the epitome of the modern artist. It is no surprise, then, that in December 1931 Alberto was overjoyed to at last meet his hero. "Tomorrow after lunch I'm going to Picasso's with Miró, and it delights me to be meeting him and see what he's doing."[3] Since the

"Mobile and Mute Objects," many similarities had arisen between his works and Picasso's treatment of the image in his painting. The bathers painted at Dinard, which had been analyzed by Carl Einstein in the first issue of *Documents*, and still more the works Picasso carried out in Boisgeloup, freely associated bodies comprised of an assemblage of organs reduced to simple volumes. Alberto shared with Picasso the fantasy of a female body that could be manipulated, the objectivation of a twofold desire to possess and to destroy. His imaginary world, a fusion of sexuality and violence, echoed that of the aficionado of the bullfight. As with Picasso, Giacometti's oeuvre offers a seismograph of the artist's emotional state, recording in particular the character of his ongoing love affairs. The nature of Alberto's stormy relationship with Denise thus acted as a sounding board for his surrealist works. The affair was far from calming. Denise played the role of both muse and obsession, her absence no less than her presence constituting a threat to the artist's peace and quiet. But nothing could put a stop to their checkered relationship, not even the young woman's constant appeals for money. As much as her infidelities, it was Denise's unstable and depressive character that spawned works by Alberto associating femininity and anguish, sexuality and damage. In surrealism, the artist had uncovered a vein of art that enabled him to symbolize both violence and distress, extreme emotions inspiring a series of works that were to become iconic. After *Woman, Head, Tree,* and *Cage,* which mix references to the human, animal, and vegetable in an erotic theater, *Anguished Woman in Her Room at Night* fuses sexuality with angst. A few months later, the same association reaches a paroxysm in a work of untold violence, *Woman with Her Throat Cut.* An especially traumatic episode reinforced Alberto's feeling of insecurity. In early April 1932, after an evening spent with some surrealist friends at Le Dôme, a group split off and dragged him to an apartment where they all took opium. Falling into a torpor, Alberto awoke next morning to discover with horror that one of his companions lying next to him, the young Robert Jourdan, had died of an overdose. His first impulse was to flee back to rue Hippolyte-Maindron. He received

OBJETS MOBILES

Toutes choses... près, loin, toutes celles qui sont passées et les autres, par devant,

qui bougent et mes amies — elles changent (on passe tout près, elles sont loin), d'autres approchent, montent, descendent, des canards sur l'eau, là et là, dans l'espace, montent,

descendent — je dors ici, les fleurs de la tapisserie, l'eau du robinet mal fermé, les dessins du rideau, mon pantalon sur une chaise, on parle dans une chambre plus loin ; deux ou

18

ꓕUETS

personnes, de quelle gare? Les locomotives qui sifflent, il n'y a pas de gare par ici,

était des pelures d'orange du haut de la terrasse, dans la rue très étroite et profonde — la
, les mulets braillaient désespérément, vers le matin, on les abattait — demain je sors —

approche sa tête de mon oreille — sa jambe, la grande — ils parlent, ils bougent, là et
nais tout est passé.

Alberto GIACOMETTI.

19

"Mobile and Mute Objects,"
in *Le Surréalisme au service de la révolution,* no. 3, December 1931.

a visit from the police shortly after, but no official investigation was ever undertaken. Totally unexpected, this event rekindled the sense of tragedy he had felt at the time of the death of Van Meurs. The obsessive memory of the young man's corpse was to catalyze morbid imaginings that found an outlet in his work.

In France, the effects of the economic crisis were worsening. Alberto had to give up his long-cherished plan of finding a new studio and was even unable to take rooms in a hotel. "There are not many reasons to be particularly happy, the situation seems utterly catastrophic and I really do not know how we will make do if it goes on like this. Frank still has not the least scrap of work and with the sculptures it's not easy. Pierre says he's done nothing for a year, he's sold nothing except a sculpture by Matisse."[4]

In the end, though, he put a brave face on things, and was able to see beyond his financial straits. "Still, our problems are confined to the wallet and at the same time we are working and I'll begin new things."[5] He had frequently met up with Einstein, who had turned the spotlight on Alberto's work in his recently published book, *Art of the Twentieth Century*. Like several of his artist friends, Alberto also tried his hand at writing, accompanying the drawings for "Mobile and Mute Objects" with a text redolent of automatic writing. The poems he scribbled in his notebooks were assemblages of notes on the perception of everyday reality and daydreams, while he would also jot down fragments of dialogue overheard in brothels. Frequenting the surrealists, who were followers of Freud and close to Lacan, had induced him to delve deeper into his unconscious. His writings, nourished by sexual fantasies, were based on the principle of free association. The introspective methods of the surrealist movement and the freedom of creation it professed at this stage squared perfectly with Alberto's own development, but his relationship with the group itself was far from smooth. After the quarrel that broke out in the wake of the "Second Manifesto," a new polemic festered. In truth, the "Aragon affair" was a side effect of the movement's political indecisiveness. Aragon, for example, was a card-carrying Communist, yet found himself navigating

between singing from the hymn-sheet of the party and defending the artistic freedom espoused by surrealism. Following the publication of a pro-Communist poem, "The Red Front," Aragon suddenly found himself threatened with legal action for incitement. The surrealists tried to come to his defense in a tract, but Aragon objected to its tone. Breton then issued a reaction, advocating the imperative of creative freedom, "The Misery of Poetry," which lambasts all art responding to an external necessity. Alberto basically felt closer to the surrealists who toed the party line. In early 1932, he was present, in the company of Buñuel, Ernst, and Tanguy, at the first meeting of the Association of Revolutionary Writers and Artists, and produced illustrations for political articles by Aragon. Under the pseudonym "Ferrache", he published extremely virulent, anti-Fascist, and anti-clerical satirical drawings. He even dabbled in political sculpture, with the depiction of a revolutionary brandishing a flag, but it was a vein he did not pursue. He was not set against the idea that art could be placed directly in the service of a political cause, as long as it was in parallel to its free practice. When, in March, the polemic broke out among the surrealists, Alberto took Aragon's side in a letter to Breton and condemned "The Misery of Poetry." "I for my own part have done drawings for *La Lutte*, drawings on topical subjects, and I think I'll go on with it, doing in this direction everything I can to aid in the class struggle. I do not see this as incompatible with my sculpture and my investigations."[6]

Two months later, however, in another letter, he was expressing second thoughts. He explained how he had believed that he was able to engage in political art without this damaging the integrity of his artistic research, but experience had proved that this was not a tenable position. "Instead of a solution, it was, I realized on the ground, a compromise, a compromise which for me has become impossible and which bothers me a great deal."[7] Not only had some of those close to him, like Frank, warned him of the dangers of squandering his time in political struggles, but he was also keen to keep the place he had recently gained inside the surrealist circle. From 1932 to 1935, however, he continued to contribute drawings for radical

reviews on which Aragon collaborated. In a text devoted to the artist, Aragon recalled those that remained deliberately unsigned: "It would not have been very helpful for their creator to have been identified as a then little-known sculptor, who had started making models for decorative objects and furnishings with the decorator Jean-Michel Frank, which would have caused a scandal. And the sight of a pig sporting horns like a cross, snuffling into the intestines of a man it had just gorged, with the accompanying caption in Giacometti's handwriting: *The Filthy Beast* would not have helped matters. Nor would the new-born lain out on a cradle full of nails with a cross skewered through the fontanel and a flagpole driven into its belly. These, we, I mean Georges Sadoul and myself, found too virulent and they were not printed. As for our friend Luis Buñuel, he thought we were too timid! We stuck to less outlandish subjects: caiman-headed generals wielding their flags like spears and cardinals armed with crosses terminating in hooks massacring a dozen men and women in front of a kind of 'Communards' Wall.' I also have a mock-up in blue ink in which a Japanese soldier, one foot on Japan and the other on China, a curved saber in each hand, threatens a USSR border post: it was intended to be carried at a demonstration, but nothing came of it."[8] The ferocity of Alberto's editorial cartoons found another outlet, if on a different register, in his surrealist pieces. Alberto did not follow Aragon in breaking with the movement, and did his best to safeguard his friendships and steer clear of the group's infighting. Although he refused to join forces exclusively with Breton, neither did he wish to be obliged to sever their links. On the contrary, over the following months their connection consolidated and grew into an authentic friendship.

His contract with the Galerie Pierre was only for a year, and, as it drew to a close, Alberto thought of terminating it. "Pierre is interested solely in orders, and I don't want to go on like this. I could deal with commissions on my own and I want to exhibit my sculptures in a different context."[9] For several months, he had been attracting attention from another gallerist. Pierre Colle, a dealer close to Frank's circle and a good friend of Max

Jacob's, had opened a new gallery in February 1931 and offered Alberto a solo show of his sculptures. He spent months getting ready, and the exhibition only opened in May 1932. Meanwhile, after terminating his contract with Loeb, Alberto continued to sell works through him, as well as through Bucher. Although he kept his parents abreast of these new developments in his art, he did so allusively, fearing a negative reaction. Giovanni was indeed to reveal his incomprehension of this new path, but, once again, he recognized his son's freedom was a precondition for his artistic development. Some of the surrealist works were even made in Maloja, like *No More Play*.[10] The exhibition at Colle's gallery opened on May 4, with Picasso its first visitor. "He looked and said 'very pretty,' like a child. He was very interested in the materials, but never divulged his opinion, something anyway he's well known for,"[11] Alberto recorded, a touch deflated. He was, however, delighted with the exhibition, which included fifteen works, with some older sculptures. "It is exactly what it should be, at the same time very varied and absolutely unified, the rooms really good and there's nothing on the walls."[12] Reporting on the exhibition in *L'Intransigeant*, Tériade described the works as follows: "Sculptures, objects, toys even, which show the various phases of the genuine disquiet of a young sculptor seeking ways to express himself amid the artistic chaos of his generation."[13] Waldemar-George, a defender of the neo-Romantics, waxed more critical: "Giacometti's productions present several analogies with those of Calder, they are mobiles, mechanical apparatuses, but as they don't move, the spectacle is far less amusing. Among these curious pieces there appear certain attributes of the phallic kind impressively enlarged, which M. Giacometti ventures to subject to the appreciation of lovers ... of art."[14]

Christian Zervos, meanwhile, referenced the exhibition in a gratifyingly positive article published in the *Cahiers d'art* at the end of the year. Making no secret of the fact that Alberto's most recent works were unsettling and might arouse criticism, he nevertheless placed the artist at the forefront of the younger generation, praising in particular the junction of a radical will

to renew sculpture without forgetting the timeless forms of art of the past. "Giacometti is of the opinion that, following the literal representation of the external world, the time has come for formal games to be freed from the tyranny of naturalism. But he is also of the opinion that the experience of the past too has value and that aesthetic rules must be obeyed; the benefit of this being, as he has quickly realized, unquestionable, if only in the long term."[15]

Zervos detects, in the work of Giacometti as in that of Arp, a return "to the heart, to individual emotion, to strength, at the same time as to a refined sensibility." The diversity of the artists visiting the exhibition was representative of Alberto's situation, coexisting in several different worlds. "Many people will come, companions and ex-companions, and my enemies like Lipchitz, who of course avoided being present at the opening!" And indeed, in addition to Picasso, the exhibition was attended by Laurens, Lipchitz, Bérard, Man Ray, and Einstein, as well as Aragon. This last, Alberto explained, would have liked him to also display his political drawings, and so emerge from anonymity. "But I reckoned it wasn't worth the trouble stirring up a scandal at this time."[16] The American gallerist Julien Levy, a friend of Dalí's with a fondness for surrealism, was also among the guests, and proposed holding an exhibition the following year.[17]

Over recent months Alberto had also conceived a number of new works: *Point to the Eye, Caught Hand, Hour of the Traces,* and *Despite the Hands,* which he designated no longer as sculptures, but as objects. However, unlike the surrealist "symbolically functioning objects," these works are not assemblages of found objects, but compositions of elements he made himself or had made by others. Each is freighted with considerable evocative power. Without being narrative, all are pregnant with meaning and contain a strong emotional charge. The majority, as he was to admit himself, relate to childhood memories, for which, however, he offered no further explanation. Thus, *Caught Hand,* which shows a hand trapped in belt-driven gears, probably refers to an accident that befell Diego when he was child. The story, as relayed by Alberto's friends, describes how, as a dare,

Diego deliberately put his hand into the cogs of a farming machine, which sheared off two of his fingers. All his life Diego would hide the severed stumps whose wound was more than just physical. Yet the connotations of this object go beyond such family drama; it also recalls the fascination of contemporary artists for mecanomorphic figurations generally. *Despite the Hands*, whose title was to become *Caress*, is a work similar to the landscape anamorphoses of *Landscape–Reclining Head* (whose original title was *Fall of a Body onto a Diagram*). This hesitation over the title, oscillating between the poetic and the descriptive, was one aspect of the artist's determination to conceal the main motivations behind his works. The swelling head-body is thrown back, while the hands appearing on either side probably recall the cave paintings he so admired. Alberto moreover attached importance to little love rituals, like the one described by Denise: "I kiss you three times pressing my hand against your cheek really hard (as you know!)."[18] The piece is thus a combination of intimate memories and more universal references. Zervos, having visited Alberto's studio, reported that the artist, determined to attain purity by successively suppressing anything anecdotal, planned to remove the hands engraved on the surface of the material.[19] This was not actually the case, and the sculptor was irritated by the critic's suggestion, which would have reduced his work to formalism.[20] As if to impose his point of view, Alberto was to present a version of the sculpture to Zervos as a gift, and had an identical marble version carved featuring the incised hands to donate for a benefit auction sale for the *Cahiers d'art*, then in straitened financial circumstances. *Hour of the Traces*, a cage in which hangs a heart and that is surmounted by a schematic male figure, also alludes to romantic relationships. It is though a fragile relationship, overshadowed by peril and death. Although not unlike certain contemporary constructions by Calder, the various components of the piece activate a virtual erotic dynamism. In these works, the artist mobilized his astonishing imagination, exploiting the metaphorical and symbolic potential of the simplest forms.

One of the most captivating and emblematic of these creations is *Point to the Eye*. In his photographs of these sculptures, Man Ray captured all the magic and ferocity of the work. A very long blade threatens to thrust into the eye socket of a tiny figure reduced to the state of a skeleton. Initially titling it *Disintegrating Relations*, Alberto described it as a "point threatening the eye of a skull-head."[21] At the same time, he was executing a drawing to illustrate Lautréamont's famous image, and a favorite among the surrealists: "The fortuitous meeting of a sewing machine and an umbrella on a dissection table." In fact, the wooden plank on which the point and the head are stuck is gouged out with runnels redolent of those on a dissection table. If, for an artist who placed vision at the center of the artistic process, this Oedipal object possessed very strong personal connotations, it also chimed with contemporary surrealist imaginings. In a manifestation of cruel eroticism, the eye, injured or plucked out, was a favorite theme of both artists and writers in that era. Striking variants included the eyeball leaving its orbit and floating inside the body in Bataille's *Story of the Eye*, illustrated by Masson; the eyeball sliced through with a razor in the famous image in *Un Chien Andalou* by Dalí and Buñuel; or, again, the blinded eye Victor Brauner depicts in his *Self-Portrait with Enucleated Eye*. At this period Brauner was a neighbor living on a street near the studio, on rue du Moulin-Vert, in which Tanguy also had his studio, and the three artists would often meet up. Dalí and Buñuel too, although by then at loggerheads, both remained acquaintances of Alberto.

The de Noailles, by now Alberto's frequent dinner companions, also enjoyed the exhibition at Galerie Colle. In April 1932, Alberto and Diego at last set off to install the large figure in the garden of their villa at Hyères. Two further months of work were necessary to complete the sculpture. The couple then sent him another order: a new, playful installation, to be a surprise at one of their musical evenings. Setting to work with Luis Buñuel, Alberto designed a large giraffe painted on a wooden panel. The animal's spots took the form of removable panels, which concealed poetic phrases written by Buñuel. On April 20, the two artists installed it in the villa's garden, before the arrival of the guests. "Before going into dinner," Buñuel recalled,

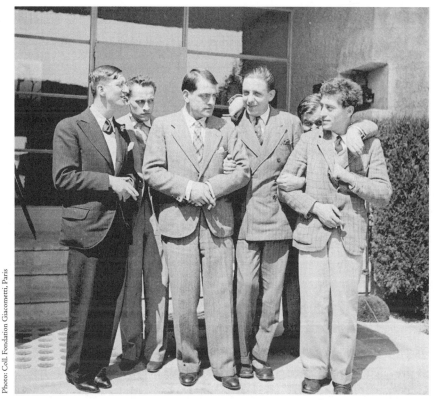

Photo: Coll. Fondation Giacometti, Paris

Henri Sauguet, Jean Desbordes, Luis Buñuel, Francis Poulenc, Christian Bérard, and Alberto Giacometti at Villa Noailles, Hyères, 1932.

"each guest was allowed to climb a ladder and read the spots. After coffee, Giacometti and I wandered back into the garden only to discover that our work of art had vanished without a trace. Had this been one scandal too many? (I still have no idea what happened to it, and, oddly enough, Charles and Marie-Laure never mentioned it to me)."[22]

It is possible that Buñuel's phrases were considered a step too far for the class of company—the filmmaker was indeed accompanied by a whiff of scandal. The two films he had made in collaboration with Dalí were simultaneously unconventional and blasphemous. The de Noailles, the patrons for the second of these films, *L'Âge d'or*, in 1930, had already suffered the

consequences of backing an iconoclastic film that was virulently attacked by conservative leagues. Dalí's fondness for profanation was compounded by Buñuel's Communist militancy. Aragon had been one of the first to welcome the filmmaker to Paris, and Buñuel was one of the most politically committed surrealists, with Georges Sadoul and Pierre Unik. Indeed, it was perhaps this last aspect that lay at the root of the trouble. The de Noailles were gradually distancing themselves from the more political fringe of the surrealists, although this had no effect on their relations with Alberto, from whom they continued to order various objets d'art, through the good offices of Frank.

Certain works that Alberto felt less successful and that he had been unwilling to show at Colle's gallery he stored in the studio. In a letter to his parents, he relates his astonishment at learning how it was precisely two works that neither he nor Diego liked that aroused the interest of his friends.[23] Zervos refers to one of them, *Anguished Woman in Her Room at Night*, in his article: "Giacometti's commitment to the technique of sculpture is prevalent in the figure of a woman that a coincidence of circumstances recently led him to carry out. It is a singular figure that performs a magic spell on the beholder. It exudes something satanic, which exerts a violent attraction on the imagination, causing an almost painful sensation on the nerves. By its expression, the figure would already have been sure to grab the attention of viewers, garnering the artist either praise or virulent criticism. But Giacometti will not give his work an air of artifice for anything. He thus opted to rework the figure entirely, continuing to improve it artistically into the most harmonious forms. He relentlessly pursues the clarification of the figure, to render its forms as perfect as possible."[24] In spite of his enthusiasm for the piece expressed here, Zervos was actually betraying the spirit of Alberto. Even in objects that conserved links with the constructive forms of cubism and flirted with abstraction, the artist was careful never to jettison the psychological dimension, constantly recalling the human body and emotions. "Never by form, neither by figure, nor by aesthetics, but, on the contrary, against, absolutely. Play yes/ erotic yes/ anxious yes/ destructive

yes," he recorded in response to the critic in a notebook.[25] The sculptor can hardly contain his irritation: "In absolute disagreement, the opposite of what he says." He instructed himself "not to let myself be influenced, by anything." Since his introduction into avant-garde milieus, Alberto had been receptive to radical attitudes, without adhering to one or other of the most extreme options, formal or anti-formalist. He met Duchamp, a great friend of Man Ray's, and proclaimed an interest in his work, without, however, opting for the conceptualism of the ready-made. Similarly, he highlighted the originality of Mondrian's oeuvre, but never crossed the line into abstraction, which he criticized for being disconnected from reality.

Over the following months, he carried out two female figures in completely different styles. The first, *Walking Woman*, already underway when Zervos's article came out,[26] is a finely executed, elongated figure, deprived of both head and arms. In its hieratism, as well as in the slightly advanced position of its left foot, it recalls ancient Egyptian sculptures. The serenity it exudes, as well as its style, makes it the polar opposite of the second female representation, *Woman with Her Throat Cut*.[27] Spread-eagled on the ground, her limbs shattered, she belongs to a long line of abused figures. A hybrid between vegetable and animal forms, disjointed and thus lacking definitive form, the morphology of this creature, with its jugular sliced through, is more insect than woman. The forms in *Cage* already presented this hybrid character, and the scene taking place within it was interpreted as a praying mantis attacking her prey. Going beyond the surrealist object, the artist thus reverts to figure, albeit by taking two diametrically diverging paths, each corresponding to a particular vision of woman. In both cases, the female depiction is the representation of an idea rather than a reality. The goddess on the one hand, and the "unruly" monster on the other, both belong to the register of symbolization. If this duality can be identified with the ambiguous relationship the young man maintained with the feminine, the woman-goddess/castrating woman binary is also a recurrent theme in surrealist imagery. Dalí thus associated his phobia of insects with the female image, while deifying the romantic icon of Gradiva, the striding woman. Ernst, Masson,

and Tanguy, as well as Picasso, whose recent works Alberto admired greatly, offer a range of interpretations of woman as threat, comparable to the praying mantis. Alberto had made preparatory drawings for *Woman with Her Throat Cut* that show how, if the work had originated with the motif of the female skeleton wracked by a spasm, subsequently the subject of the narrative had evolved. One of the drawings suggests instead a scene of masturbation, while in another the figure is impaled through the pelvis by a stake. The equivalence established between sexuality and crime was also a constant in surrealist production, accentuated notably in the works of Bataille and his friends. Among both poets and artists, the rehabilitation of the Marquis de Sade and the reading of Lautréamont were channeled into an erotic fascination with cruelty. The review *Documents* itself provided many examples of ritual cruelty in traditional societies. In a famous article on the Chinese torture of laceration, Bataille highlighted what he saw as a "paradoxical image" in the features of the torture victim, a fusion of pleasure and suffering whose intensity he compared to that of religious ecstasy. *Woman with Her Throat Cut* is an image of this type. The concepts of rape, death, and ecstasy coexist in an image that remains hard to interpret—save perhaps by using Dalí's "paranoia-critical" method. During this period in Alberto's output, the body and sexual relations are inextricably linked to feelings of terror and anguish. An example is given by a short poem scribbled into a notebook: "Woman eats son/son suckles woman/man penetrates woman/woman absorbs man/on the same Plane."[28] These feelings can be expressed in a manner to be shared with viewers, in sculptures like *Woman with Her Throat Cut*, or, on the contrary, they can be neutralized and defused by recourse to the impassive forms of the archaic, as in *Walking Woman*. In each of the two cases, Alberto chooses the symbolic mode. In the first case, he suggests rather than depicts a sex murder: the neck and head of the woman with her throat cut resemble a violin fingerboard. Likewise, the *Walking Woman* is not based on life, but represents the quintessence of the female figure.

CHAPTER 12

Interior Decoration and Objects

Alberto's meeting Frank marked the beginning of both a busy collaboration and an enduring friendship. Thanks to the decorator, Alberto was now able to combine the practice of art with the manufacture of objects and decorations, which guaranteed him financial security. His parents provided significant support in pursuing this activity; informed of the objects Alberto was creating and free of any prejudice against the applied arts, they were quick to encourage him. Sconces, standard lamps, table lamps, and vases formed the largest proportion of a production that was to extend over many years. Diego displayed his customary zeal as the studio hand, overseeing manufacture, making multiple series, and transferring Alberto's models into various materials. In accordance with Frank's signature style, these once simple and elegant decorative objects were deliberately left with a rugged quality. The inspiration of archaeology is obvious, and determined the choice of material, which was often rough-hewn in appearance. Many of the bowls or brackets, in white and colored plaster, recalled grave goods. As for the lamps and light fittings, they melded various influences, including early antiquity and African art, as well as alluding to Brancusi's "stack" motifs. Colored versions unfolded in a range close to the pastel shades Bérard had introduced into interior decoration.

Alberto took great care to separate these activities in the applied arts from his artworks and was alarmed whenever he perceived formal proximities between them. Yet, in spite of these denials and precautions, it is obvious that the decorative arts offered him a way of trying out different forms and that these were often close to his experiments in sculpture. Since *Project for a Square*, he had cherished the ambition of creating works on an architectural scale for public spaces, and he would have liked to carry out monumental versions of several works, such as

Man and Woman and *Cage*. If he did exhibit an enlarged version of the latter piece in 1933, this type of project was expensive and required a specific type of commission. He was in fact only able to satisfy this impulse once, with *Figure*, made for the de Noailles. The first person with whom he shared this interest in the links between art and architecture was Masson, responsible for his first commission, and it was a natural association from an artist such as Alberto who trained at the school of Rodin, then of Bourdelle, and who was fascinated by Egyptian and Sumerian archaeological remains. After joining forces with Frank, Alberto filled notebooks with prototypes for lamps and other objects, as well as mural decorations, with relish. Interior decoration, for which he would produce a vast number of sketches, provided an outlet in which to plan for architectural space. The prospects opened up in this field by his collaboration with interior designers, such as Desny and then Emilio Terry, led him to invent new spatial arrangements for sculpture. In the decoration proposed for the living room in François Spitzer's apartment in 1931, he scooped out the wall and distended the volumes into biomorphic compositions. Interior decoration provided him with a vehicle for exploring on a large scale both formal contrasts and the inversion of solids and hollows deployed in the plaque-figures. Many drafts exemplify his idea of bringing to life an entire wall using prismatic compositions or vegetal curves. Unfortunately, none of these sketches was realized, except for the studies carried out for Lise Deharme's living room. The culmination of a lengthy gestation, in 1934 he designed an extended wall decoration featuring applied white-on-white plaster elements that in the space resolved into a semi-abstract, semi-vegetal composition of hemispheres and vine-like tendrils. Not dissimilar to surrealist biomorphisms by Arp and Tanguy, the forms hint at an unspecified eroticism. At the beginning of the 1930s, several sketches for lamps based on swelling plant forms express the same latent sexuality as the sculptures of the same period. In fact, even if Alberto kept the two activities separate—since the surrealists condemned the applied arts, especially when destined

for a society clientele—the relationship seems to have been mutually beneficial. Thus, the strangely shaped and sexualized plaster flowers he made for Frank in 1932–33 are a direct example of the translation of the surrealist imagination into the field of the decorative artifact. This association is clearly referenced in comments jotted in a notebook at the time: "Do the flowers for Frank, but first two or three completely unfettered, irregular, uncontrollable sculptures. Finish the standard lamp tomorrow and then immediately start before leaving the fantastic flowers, sickly with vibrations, with blood and flesh, and with life and delirium."[1]

Through Frank he also sold objects that would more strictly be considered sculpture, as in *Pocket Tray*, which, in spite of its title, is a nonutilitarian object similar to the "Mobile and Mute Objects."

In early January 1932, he was commissioned by theater director Boris Kochno to design a set. Several of his friends had already collaborated in the theater, most notably Picasso, whose sets for the Ballets Russes had proved a sensation. This project was for the same company, for a new show Kochno was preparing at Monte Carlo, *Jeux d'enfants*. Alberto accepted the offer and started designing sets and costumes, but, after a series of sketches, he began to experience difficulties meeting the brief and suddenly abandoned the project. Whereas on January 14 he had written to the director: "I've done a very detailed drawing of the ballet and have now almost finished a sketch in color. Tell me what you think," by January 26 he was explaining: "Dear Boris, As I said yesterday it's impossible for me to do the ballet, everything in me is against it."[2] The director had requested significant alterations that Alberto had not been ready to accept.[3] The artist's straightforward and uncompromising character comes out in the whole exchange. He never dreamt of going back once he had made a decision, and in the end the sets were carried out by Miró. The ideas for the production, however, were not lost; echoes can be detected in a work executed the same year, *The Palace at 4 a.m.* Ideas for the costumes also resurface in several works. Characters in the ballet had been designed to look like animated pawns moving about on

a checkerboard. Alberto reused the pawn-figure template for the funny little schematic characters in *No More Play*. He also redeployed it in a small, singular, and rather atypical work, *Desperate Little One*, which shows a tiny bronze figure with outstretched arms emerging from a tilted plaster disk. In spite of Alberto's reservations, Frank obtained his permission to include this last work in a set he was designing for a play entitled *La Fleur des Pois* (Sweet Pea). After this concession to his friend, Alberto would never again agree to collaborate on a theater project, except for once, at the end of his career.

Through Frank, Alberto also worked for several fashion designers, such as Elsa Schiaparelli and Lucien Lelong, designing jewelry, buttons, and interior décor for stores and showrooms. Diego assisted by supervising the manufacture of objects delegated to craftsmen. The techniques used were increasingly diverse. Plaster and bronze remained the main materials, but some pieces were made in marble, alabaster, or terracotta. In 1932, Diego was also working as an assistant for Georges Braque. The artist, a friend of both brothers, remained an inspiration for Alberto, who respected him hugely. In March 1935, Frank and his associate, cabinetmaker Adolphe Chanaux, opened a store on the fashionable rue du Faubourg-Saint-Honoré, in which Alberto's objects would be permanently on display. Until its closure in the late 1930s, it functioned as a shop window for creations by Frank and his close colleagues, in particular Terry, Bérard, Dalí, Paul Rodocanachi, and Alberto, who had become Frank's chief collaborator. There was hardly an interior fitted out by the decorator that did not feature one of the artist's vases or light fittings. Frank was constantly in demand for new projects, and regularly turned to Alberto for ideas. A postscript to one letter reads: "P.S. All those who come here or to the studio go weak at the knees for your works—they're perhaps the only thing people like—if you make some other models, I'll be able to buy myself a suit. Don't forget me: lamps, vases. And what about furniture? Tables, seats, armchairs, beds, sofas, etc."[4]

Above, top: Plaster flowers in the studio, 1931–32.

Above, bottom: Diego Giacometti, Rodocanachi, Chanaux, Bérard, Terry, Frank, and Alberto Giacometti in Jean-Michel Frank's showroom, 1935.

Right: Faceted vase, c. 1934.

Alberto regularly supplied new models, but never ventured into furniture. Except for occasional one-off decorative elements for commissions after his surrealist period (notably the major interior design project for the Born family in Argentina in 1939), he generally kept to lights and decorative objects. He was never to neglect this aspect of his oeuvre and he returned to it after World War II, both reissuing older lines and creating new objects in a style closer than previously to his sculptures of the period. Following Alberto's death, Diego, who began developing his own furniture line in the late 1930s, continued to issue editions of decorative objects by his brother.

CHAPTER 13

The Palace at 4 a.m.

Late in 1932, Alberto created his most enigmatic work, a synthesis of all the ingredients of his surrealist objects. Containing autobiographical elements, *The Palace at 4 a.m.* combines an expression of the marvelous advocated by Breton with Bataille's inversion of Eros into Thanatos. Beneath the cool surface there bubbles a concentrate of emotions, creating a work of rare poetic power. A fragile wire model of a "palace" houses a female figure and three ghostly apparitions: a backbone, the skeleton of a bird, and a mysterious, elongated receptacle containing a ball. Alberto, for once explaining the starting point for the work in a text, offered the following interpretation: "This object gradually took form at the end of summer 1932. It only slowly dawned on me, the various parts taking on their exact shape and precise location in the whole. By autumn, it seemed so real that its execution in space took me no more than a day. It refers without any doubt to a period of my life that had come to an end a year earlier, to a six-month period spent hour after hour with a woman, who, concentrating all life within her, raised my every second to a pitch of wonderment."[1]

As in all his published writings with personal connotations, the artist transforms reality, endowing it with a surreal quality. For Giacometti, this text, like the others, is above all literary, rather than documentary in nature. Although he aspired to unleashing his thoughts or dreams in writing according to the surrealist model, in reality Alberto refined his texts in a series of rough drafts. With each successive stage, the concern was not to polish his style—his writings preserve the peculiar syntax that inflected his speech—but to transpose reality onto a symbolic narrative register. The affair to which he alludes is the one that, for better or worse, had bound him to Denise for three years. However, at no time was their liaison as idyllic as Alberto suggests in his text, not even in

the early stages he mentions. As he wrote in one of his notebooks dated 1932: "The happiest days with Denise and the most atrocious because of Denise."[2] Although the affair was tumultuous from the very beginning, every time he thought he might be on the verge of losing Denise, Alberto felt the pangs of love return. Neither was faithful: Denise had a relationship with a street hawker who sold fruit, while Alberto continued to frequent brothels. Contrary to what he claims, by the time of this text their relationship had not yet come to an end, although he now was also involved with a woman named Hildegaarde. He confided his anxiety over the situation in his notebooks, recording an emotional state that veered from a determination to break definitively with Denise to burning declarations of love and even plans for cohabitation. From the beginning of their affair, Denise had lived at rue Hippolyte-Maindron from time to time, Alberto having lent her the keys while he was in Maloja. They exchanged many letters during summer 1931, while Alberto was away in Switzerland with Frank. Denise first told him about her vacations at her parents', then, back in Paris, she would regularly drop in to check on the studio, sending him news. She complained that Frank was receiving preferential treatment, since he, not she, was thought worthy of an introduction to the Giacometti family. "Hey, watch out! Remember the museum director in the corner of the studio. I'm joking, you realize. I'm not really having a fit of jealousy."[3] It was not that Denise was truly worried that Alberto might succumb to the charms of Frank; instead, the various messages suggest that she was envious of a friendship that seemed to be taking precedence over their affair. As well as expressing bitterness at not going to Switzerland, she also mentioned how hard she was finding it to change her lifestyle and hold down a job, as the artist had encouraged her to do. On several occasions she sought to break free from their tormented relationship. One such attempt occurred in 1932, as Alberto confided in his notebooks: "Denise: July 21, 1932, it's all over." Perhaps *No More Play*, a work made in Switzerland, bears traces of their breakup? "When I made *No More Play* there was a little tomb in the middle with a little

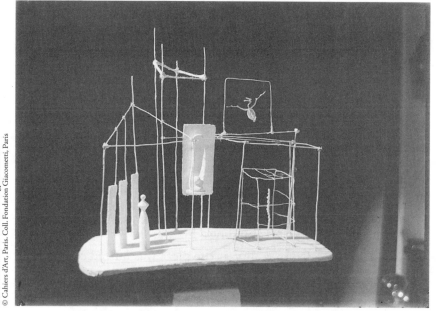

The Palace at 4 a.m., in *Cahiers d'art*, no. 8–10, 1932. Photograph by Man Ray.

skeleton inside and, separated one from the other in a kind of bowl, two figurines no longer able to move."[4] Despite the warning signs, the relationship was rekindled once again, although for both Denise and Alberto any plan for a future together was plainly unrealistic. The sculptor, who would not really have wanted to share his life with any partner, was also aware that his parents would never accept Denise as part of the family. Diego was to have the experience of living for twenty years with Nelly, whom he never felt able to take to Stampa or Maloja. Unlike several of his surrealist friends, like Man Ray and Breton, who flaunted their liaisons with prostitutes or models, Alberto's respect as a son prevented him from imposing a woman like Denise on his parents. Transfigured through the filter of literature, on the other hand, his experience in love, like his most morbid phantasms, fitted into the artistic myth. Denise was to become one of the actors in his mythmaking, the embodiment of that "mad love" that Breton invested with superior virtues.

"We built a fantastic palace in the night (days and nights had the same color, as if everything happened just before early morning; during the whole time I never saw the sun), a very fragile palace made of matchsticks: the least clumsy movement brought down an entire section of the tiny construction; we constantly had to begin it over."[5] In this highly sublimated evocation of nights with his girlfriend, Alberto also betrayed details of the true situation, in particular the fact that this relationship took place primarily at night, with day set aside for working in the studio. Similarly, the match game, which he afforded a metaphorical status, might also refer to an authentic memory, given how he liked fiddling with little objects in his surroundings. He was later to affirm that the title also corresponded to reality, as the piece was indeed conceived at four in the morning.[6] However, his description is essentially a profession of artistic faith, the aim being to demonstrate how the process of its creation conforms to surrealist precepts. The artist portrays himself as creating under dictation from an unconscious that imposes forms whose exact role he is unaware of. "I don't know why it became filled with a backbone in a cage—that backbone this woman sold me one of the very first nights I met her in the street—and why one of the bird skeletons she saw the same night preceding the morning our shared life fell apart—the birds' skeletons that flew very high above the pool of clear, green water in which swam very delicate and very white fish skeletons, in the large room discovered among exclamations of amazement at 4 o'clock in the morning."[7]

Account of a dream or coded version of an actual experience, both the description of the work and the work itself are seen from the angle of psychoanalytical interpretation. Aware of the work of Freud as well as that of Jung, to which *Documents* devoted considerable space, the artist deliberately orientated his language in that direction. "In the middle scaffolding rises around a perhaps unfinished tower; perhaps too the very top has collapsed, broken. On the other side a statue of a woman has been placed whom I discover as my mother, such as she impressed

me in my earliest memories. In its mystery, the long black dress that touched the ground disturbed me; it seemed to belong to her body, arousing within me feelings of terror and distress; escaping my attention, all the rest has been lost."[8]

In the poetic vision of *The Palace at 4 a.m.*, Alberto reconciles the contradictory emotions he felt for the women who counted in his life, whether his mother or his girlfriends. The artist harbored complex feelings towards all women, with enchantment and fear once again inextricable. Here though, for the first time, the personality of his mother, Annetta, appears in a piece. Maternal and protective, Annetta was also a figure of uncontested authority for all the Giacometti children. Feared and adored in equal measure during their childhood, she was to remain throughout their lives a crucial figure, whose judgment caused anxiety. If Alberto occasionally dared to hint at violent and even murderous impulses towards mother-figures in some of his surrealist texts, it was in a literary context only, adopting the transgressive register for which Bataille, Leiris, and Dalí had paved the way. On the other hand, and unlike the case of those artists, who unpacked their personal problems in public, the transgressive freedom Alberto adopted in his texts would have been a step too far in the easygoing relationship he had with his parents. He shared his artistic development with them, even at the price of shocking them with his surrealist objects, but he made elaborate efforts to hide everything to do with his private life and love affairs. The exaggeration characteristic of his texts was also a way of concealing behind surrealist mythmaking the prosaic truth of his emotions and sexual relations, a reality he would openly and provocatively reveal during discussions in cafés.[9]

The text devoted to *The Palace at 4 a.m.* also offers keys to the artistic process of his surrealist works. They are, he explained, the fruit of an involuntary preliminary idea, which he had only to translate into sculptural materiality. "For years I've carried out solely sculptures that come fully formed into my mind, restricting myself to reproducing them in

space without changing a thing, without wondering what they might mean (I only have to think of altering part of it or looking for another dimension, and I get completely lost and the whole object collapses)."

He names these works dictated by the unconscious "emotive" sculptures: "Once the object has been built, I tend to find within it, transformed and displaced, images, impressions, facts by which I had been deeply moved (if often unbeknownst to me), forms I sense are very close to me, although I'm often unable to identify them and this only renders them even more disturbing to me."[10]

The general appearance of *The Palace at 4 a.m.* recalls a stage set. Alberto, who had given up designing real theater productions, transposed the model into his own realm—sculpture—presenting in his mini-theater two reminiscences of his love affairs: bird skeletons, both mobile and caged. The maternal figure, highly stylized, is not unlike the queen in a chess set. The artist is also present, but in esoteric form. "I can say nothing about the object on the small red plank; it stands for me."[11] This "object on a little plank" is a sphere, in Bataille a frequent image of the expulsion of an organ outside the body. Since the "compositions" the sphere had been interpretable as an eye. The identification of the artist with the eye of the voyeur, but also of the visionary, is central to his conception of art. His explanation behind the motivation for his works at this time might also apply to the psychology governing his romantic entanglements: the "desire to find a compromise between full and calm and caustic and violent things."[12] The assimilation this work suggests, between the figure of the loved one and the spectral presence of a skeleton, expresses the morbid turmoil that, in his eyes, necessarily blighted every love affair, even those described as happy. More often than not, violence, which both attracted and repulsed him, gained the upper hand over tranquility. All Alberto's relationships seem to resemble the matchstick palace, pulled down one day only to be rebuilt the following. It is a metaphor that perfectly captures the everyday reality of his relationship with Denise. Their liaison reached a peak of intensity in 1933, and struggled on with

lengthy interruptions caused by one or the other until 1935. As with the previous affair with Flora Mayo, Alberto kept his family in the dark, or at least there is no trace in their correspondence. None of Alberto's acquaintanceships in high society ever developed into romantic or sexual attachments, in spite of the attraction of his highly original personality, as he preferred women who would neither question his freedom as an artist nor threaten to rein in his nocturnal habits. In 1932, however, he does seem to have been attracted to a Countess Madina Visconti, a wealthy Italian collector, who visited the studio several times. He sketched her portrait and did two drawings of the studio for her, which he gave to her as mementoes of that time. The countess, however, seems to have been an unsuitable match for him, and the encounter went no further. Up until now, none of the Giacometti siblings had married, but the situation was to change with Ottilia's wedding in March 1933. Two years later it was Bruno's turn, with Alberto offering the newlyweds the rather unsuitable gift of the original plaster of *Disagreeable Object to Be Thrown Away*. Alberto and Diego, both adepts of a bohemian lifestyle, now appeared as the two old bachelors of the family. Alberto was definitively separated from Denise, and the confession he had made four years previously to Tzara had lost none of its relevance: "Now I'd like to be with a woman (when I was, I only wished to be free)."[13]

CHAPTER 14

The Death of the Father

After complicated beginnings, Alberto's relationship with the surrealist group entered an almost idyllic period, dating from the reconciliation with Breton following the Aragon affair until the beginning of the year 1935.[1] "Seeing Breton every day all winter, when we spent most of our evenings together, was of huge advantage to me. He is by far the most intelligent and sensitive person I know and the only one from whom I learned so much,"[2] Giacometti wrote to his father in June 1933.

Alberto often took part in the group's meetings, which were held at the Café de la Place Blanche, in Montmartre, or at Breton's home on rue Fontaine. He was also present at the sessions of "experimental research on the irrational knowledge of the object" organized by Breton and responded to a number of surrealist "polls" on various subjects and published in the surrealist journal.[3] He also earned a place of choice in their exhibitions, in Pierre Colle's gallery and at the Salon des Surindépendants' surrealist show, both held in 1933. Among those closest to him in the ranks of the surrealists was writer René Crevel. Alberto had grown fond of the rebellious young man, appreciating both his caustic wit and his endeavors to reconcile surrealism with Communism. A friend of Dalí, Tzara, and Éluard, Crevel was one of the first to praise Alberto's work in writing, acclaiming *Suspended Ball* in *Dalí ou l'anti-obscurantisme*,[4] a vigorous defense of the Catalan painter. Crevel also belonged to Frank's entourage and, in October, Alberto was invited—with Frank, Terry, and Dalí and his wife, Gala—as one of the guests inaugurating the new interior decoration in the home of Crevel's companion, Tota Cuevas. Crevel was the only one among his friends who dared bestow a nickname on Alberto, calling him "Little Pac" and even making jokes at his expense. At the beginning of 1932, he asked Alberto to design a frontispiece for a book he was preparing, *Putting My Foot in It*. The writer was inspired and fervent, but suffered from chronic ill health, afflicted since childhood by tuberculosis.

Alberto visited Crevel several times during winter 1932 and summer 1933 while he was undergoing a cure in the sanatorium at St. Moritz, in Alberto's home region. In the course of these visits Crevel read him the early chapters of his book, which had gradually morphed into a frantic diatribe. The line engraving for the frontispiece associates two elements: the gracious form of a seahorse and the tragic outline of a man imprisoned in a polyhedral cage. Both images allude to the disease eating away at the young writer. Long after Crevel's death, Alberto would lend his name to every effort to keep the poet's memory alive.

The fifth issue of the surrealist journal includes a significant written contribution by the artist.[5] "Hier, sables mouvants" ("Yesterday, quicksand") is a poetic narrative, based on a memory from his childhood, but transformed by its simultaneously oneiric and transgressive character into a surrealist manifesto. This psychoanalytically inflected text offered a blend of vivid and authentic childhood memories and morbid fantasies of cruelty. In addition to this were two visual poems and a prose poem, as well as some particularly esoteric surrealist "investigations." The whole contribution was a combination of poetic notations, transfigured memories, and violent outbursts. At the surrealist exhibition at Pierre Colle's gallery, in June, he was to present two works. *Mannequin* is a transmuted version of *Walking Woman*, to which he added arms and a head in the shape of a violin fingerboard, morphing it into a surrealistic mannequin. *Table* is a work in plaster, halfway between decorative object and artwork. On a console fitted with different feet stands an ensemble of mysterious objects: a head of a veiled woman, a polyhedron, a mortar, a hand. Not long before, he had answered a survey by the surrealist group focusing on the fortune-teller's crystal ball,[6] and the attributes laid out on the table seem to conjure up the art of divination. The surrealist journal reproduced the piece under the title *Encounter in a Corridor*.[7] Dalí was to have written the introduction for the exhibition, but the decision was taken not to use it. Ernst and Alberto protested against its suppression, but it made no difference. Alberto's works on the other hand were hugely successful. "Everybody's talking only about my works, and from Tuesday

when I brought them in until yesterday evening, I've heard nothing but compliments and more compliments."[8] Picasso also showed at Colle's gallery; during this period his work often appeared in exhibitions with the surrealists. Apart from Breton, Picasso was one of the artists Alberto most liked to spend time with, along with Dalí, Éluard, Tzara, and Crevel.[9] He had gradually drifted away from his earlier friends, except for Laurens and Braque, whom he continued to see. "The other day," he wrote to his father, "I met up with Laurens, who really likes my stuff, as do Picasso and Braque."[10] On the recommendation of Crevel, *Table* was purchased by the de Noailles.

On June 25, 1933, the sixty-five-year-old Giovanni Giacometti, suffering from ill health and resting in a convalescent home in Glion run by one of his friends, a physician and collector, suddenly passed away of a brain hemorrhage. Only a few days previously, he had been asking for proofs of *Putting My Foot in It* and planning a joint exhibition with Alberto. Shocked to the core by this terrible news, Alberto packed his bags for Switzerland with Diego, but was so run down when he arrived that he was forced to take to his bed. He did not even feel strong enough to leave Glion to attend his father's burial and it was Bruno, the youngest of the siblings, who was left to deal with all the formalities. Alberto joined the family at Maloja and was to remain deeply affected by grief and overcome by a kind of depression he was unable to shake off for months. As he confided to Breton: "I'm more or less over my illness, if not yet my exhaustion. Too many things have happened these last weeks and I can't concentrate on anything."[11] Returning speedily to Paris, he was back in Switzerland by August, spending all summer and part of autumn there, and stopping over in Zurich, where preparations were underway for an exhibition in tribute to his father. It was a period of sadness and doubt, during which he kept up a frequent correspondence with Breton. The friendship between them had clearly become incredibly important to him. "I've been thinking a lot about you and never has it been more difficult for me to leave Paris. Every day I would have loved to drop in and see you, to stay in rue Fontaine for a moment, or go and eat somewhere together."[12] The image he used to describe his state, "well below zero," is one of a loss

of self: "I feel still just as scattered and split as I did a week ago, but now I can stay here and perhaps see where the various parts are and start to put them back together as well as I can." His mind dwelt on darkness, and the everyday routine weighed him down. "I light cigarettes, I listen to the clock, to people working in the meadows with two horses, and it's very unpleasant to walk over the stones for an errand I have to do later, I'm beside myself at having to look at, or at least to see, sky, clouds, grass, stones, etc. Going out at night is more bearable, when you're surrounded just by a black profile against the sky."[13]

He tried to work, painting, in particular, but without much success. "My projects for working and other things in Paris have lost all solidity."[14] Now she was no longer nearby, Denise was at the center of his thoughts: "It's impossible for me to draw the least line, to do the least sculpture without it relating to Denise. For two days I've been doing pictures of her, these are the only moments I feel alive."[15] Alberto also entertained romantic fantasies, evoking in his letters the fleeting and mysterious vision of a young girl, designed to arouse the curiosity of the author of *Nadja*. Although he urged him to come and join him at Maloja for a vacation, Breton was in the grip of financial and relationship problems and had to refuse the invitation. Alberto spent this stretch of spare time reading, plunging into the authors idolized by the surrealists. On Breton's recommendation he explored the tales of Achim von Arnim, which reminded him of the Romantics he read as a youth, before starting to read de Sade. "Yesterday read de Sade which really grips me and I want to go on, that's about all, besides many little things that last a few moments and drive each other out."[16]

In October Alberto returned to Paris and life took its course, but from then on his works were haunted by the specter of death. The notion of play was no longer on the agenda and was replaced by references to melancholia. *Table* already offered a modern interpretation of the traditional vanitas. One of the objects laid out next to the veiled figure was a polyhedron, a direct allusion to the enigmatic shape depicted in Dürer's print *Melencolia*. In his exchanges with Breton during 1933, Alberto

Surrealist Composition (c. 1933), ink on paper,
Fondation Giacometti, Paris.

described the figure of Melancholy as looming large in his imagery. "I thought of an article on Saturn I read the other day in a German review: little things that strike me forcibly! Stone and wood are both Saturnine materials and the polyhedron in its irregularity is a symbol for Saturn. It is this very form I wanted to represent on my plaster table, a table which for me had a lot to do with death, or rather with a kind of hopeless annihilation of all things and all movement."[17]

The works made directly after the death of his father were to mine this melancholic vein relentlessly. The extremely simplified *Head-Skull*,

for example, appears as living or dead, depending on the angle of view. This line of thought culminated in *Cube*, which Alberto initially designated by mysterious titles, *The Pavilion* and *Part of Sculpture*. The work is a large, pared-down, and irregular polygon, which looks completely abstract. It recalls the proportions of the polygon scrutinized by Dürer's melancholic figure, and sits on a base with feet similar to those of African stools. The mineral quality of this geometrical block does not exclude the undercurrent of human references, however. The illustration for *Putting My Foot in It*, as well as several sketches and engravings, had already suggested that the outline of a human figure might be imprisoned in the opaque and mute form of the polygon. Later, the artist engraved a self-portrait on one of the faces of *Cube*.

During this fraught period, Alberto continued to frequent surrealist circles and join in with their collective activities. He collaborated for instance on a collective book, *Violette Nozière*, a provocative homage to a woman who had made the news for murdering her parents. He prepared a poem, which did not actually appear, and drew an illustration.[18] He also visited Meret Oppenheim in her studio, along with Arp and Ernst. He had met the young woman, who had come from Switzerland to Paris to study art, the previous year at Le Dôme, and introduced her to Man Ray, who used her as a model for a series of nudes.[19] The three friends urged her to join their ranks, and arranged an invitation to the surrealist section of the sixth Salon des Surindépendants. In the exhibition, Giacometti showed an enlarged version of *The Cage*, under the title *The Bird Silence*. He also met Claude Cahun, another artist who was a recent recruit to surrealism and who later sent him a book of hers.[20] With Alberto, Cahun had been one of the first members of the Association of Revolutionary Writers and Artists. Alberto remained close to the association, even though he was one of the surrealists who had resigned following Breton's expulsion in July.[21] In preparation for the end-of-year issue of *Minotaure*, which would print the text written on *The Palace at 4 a.m.*, Brassaï came to see Alberto. He took photographs

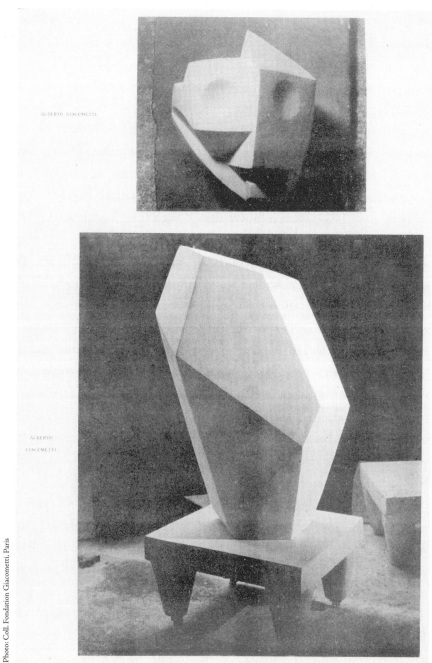

Head-Skull (1934) and *Cube* (1933–34), in *Minotaure*, no. 5, 1934.

of the studio and his works, which delighted the sculptor. By this time, arrangements at rue Hippolyte-Maindron had changed somewhat. Diego now had his own studio opposite his brother's. The production of decorative objects still continued, however, and new models were created. At the beginning of the following year, Alberto needed to free up some space in the studio and asked Max Ernst to store a few works for him, including the enlarged version of *The Cage* and the plaster of *Palace*. It was a friendly favor that unfortunately had grievous consequences, when several works, including these, were accidently destroyed.[22]

In January 1934, Alberto traveled to Zurich for a month to prepare for the exhibition of his father's works, devoting a great deal of time to an event that was very close to his heart. He also designed Giovanni's tombstone, which was installed several months after the funeral. His few letters were for Breton, to whom he wrote about the most recent surrealist activities and expressed regret about not being able to take part. Breton's replies remained affectionate. "Very dear child and friend, you well know that you are the person I miss most. When you're not here, there's no youth, no clarity, no play, no intellectual certainty, not to mention that, if it's not you we're waiting for in the evening at the café, it's perhaps because we're waiting for nobody. Quite apart from my pleasure in seeing you again, it is absolutely necessary for you to come back as quick as you can."[23]

Breton was counting on support from his friend to set up a new surrealist review, *Le Surréalisme international*, and endeavored to prevent any negative reaction on Alberto's part to the recent argument with Dalí. For, no sooner had the Aragon affair died down than a Dalí affair flared up. Breton had accused Dalí of a fascination with Hitlerism and lambasted his praise of academic painting; during a chaotic meeting, during which Dalí delighted most of the audience with his clowning, Breton expelled Dalí from the group. Breton was conscious of the fact that both Dalí and Alberto were two young recruits who were essential if he was ever to give surrealism a new lease of life, but the former's ceaseless provocations

were undermining the tenets he had defined. As he explained to Alberto, Dalí's expulsion only lasted a few days, after which the painter agreed to make amends in writing. Éluard and Tzara had already criticized the demand that Dalí retract, however, and Breton was probably afraid that Alberto would also take offence. Breton reassured him: "I won't inform you point by point of every detail of our current deliberations, which resulted yesterday in the perfect reunification of all the points of view of our comrades present in Paris, including politics, about the direction to be taken by the review."[24] He then proceeded to ask Giacometti for a contribution of his own.

Back in Paris, Alberto returned to work, and was now struggling with a new female figure. In keeping with *Walking Woman*, he had modeled a slender and stylized body, but he found the aesthetics of the head far too classical for his taste. Breton witnessed the evolution of the work and Alberto's hesitation during his visits to the studio, describing them in his book *Mad Love*: "At this time Giacometti was working on the construction of the female figure that is reproduced in this book, and this figure, although it had appeared very distinctly a few weeks before and had taken form in plaster in a few hours, underwent certain variations as it was sculpted. Whereas the gesture of the hands and the legs leaning against the small plank never caused the slightest hesitation, and the eyes, the right one figured by an intact wheel, the left one by a broken wheel, endured without change through the successive states of the figure, the length of the arms, on which the relation of the hands and breasts depended, the angles of the face were in no way settled on."[25]

One day the two friends went to the Paris flea market, and it was there that the problem was resolved. They were halted in their tracks by the sight of a metal mask that exuded all the qualities of the uncanny and mystery the surrealists sought in a found object. Its geometrical facets (Joë Bousquet later identified the mask as dating from World War I) inspired Alberto to adopt a very different visual solution for his piece. The female body, sitting on a throne-like structure with the

legs folded up, was surmounted by a head of geometric form in which Alberto incised a triangular mouth. Everything in the work conspired to maximize the enigma: the stylistic references, which range from ancient Egyptian art to African funerary sculpture; the face-mask, determined as much by the object he unearthed with Breton as by archaeological and ethnographic artifacts; the eyes, with irises in the shape of wheels; and finally the attitude of the figure, who brings her open hands together as if to hold an object. The funereal aura of the piece was reinforced by the rectangular plate placed against the legs. Finishing the model proved a lengthy process, which took until October. Breton was particularly enamored of this figure, which encapsulated in one artwork all the surrealist characteristics previously disseminated among Alberto's various pieces. For the sculptor, however, this work marked the conclusion of a period rather than heralding the promise of further pieces in the same vein. He seemed to be facing a dead end whichever path he had taken in his most recent work, whether abstract or figurative. The two masterpieces of *Hands Holding the Void*, which he would later rename *Invisible Object*, and *Cube* had led him as far as he could go in his experiments with the sculpture of the imagination. Both of these works were stamped with the hallmark of melancholia, and had diverted him from his original and long-held objective of capturing life and arousing emotional responses. His friendship with Breton was based on mutual fondness and had for a time dispelled his doubts about his creative development, which had dogged him for years. Was the surrealist road, based on producing entirely from the imagination, really the one he wished to follow? By 1932 Alberto had reintroduced the human figure into his practice. With *Walking Woman*, he abandoned the vocabulary of the surrealist object and reverted to the representation of a motif. To do so, he had recourse to the mannequin, a reference his surrealist friends were able to accept, in the process imparting to the figure timeless and dreamlike connotations. If this sculpture was only finished at the cost of countless false starts, worse was to follow. With *Hands Holding the Void*, the questions that he had been concerned with at

the academy resurfaced, enquiries relating to representation in sculpture and its specific means. He had rejected depiction after the model and had sought salvation from his conundrum through art history, notably in ancient Egyptian art. The apparent simplicity of the response to the complexity of the problem endows the resulting sculpture with the appearance of an icon. Alberto was aware of this but was still not satisfied and was now assailed by new misgivings. Perhaps, he thought, he was forcing himself to work within too rigid a set of parameters, with the attendant risk of repetition and therefore of a kind of academism. One final attempt at a female figure, begun in summer 1934, resulted in failure. "For a few days now, when the weather is not too cold, I've sat in the studio doing plasters. Perhaps it will spawn a new woman, or rather the same one who has come to me several times over the years. She has taken form, but very vaguely, disappearing again each time. Today, she is, I believe, more concrete, she starts to have eyes, a mouth, a navel especially, hands, almost. I'll take her to Paris if she lives until then."[26]

Entitled $1 + 1 = 3$, this semi-abstract figure, in the form of a standing stone, was considered by the sculptor as one last, unfruitful attempt at imaginative sculpture.[27] He shared his perplexity with those close to him and in his sketchbooks. Although he continued to take part in surrealist activities, in the privacy of the studio he would return to the practice of portraiture.

The Break-Up with Surrealism

Following his father's sudden death and the dismal period it heralded, Alberto's friendships with the surrealists seemed if anything to grow stronger. In 1934, Alberto invited Max Ernst to come with him to Maloja for the summer, where he acted as a guide to his homeland for his friend; they carved blocks of granite together and built little works out of pebbles rolled smooth by the glaciers. In August, Breton married Jacqueline Lamba, whom he had only met that spring, and Alberto and Éluard acted as witnesses at the wedding. *Le Surréalisme international* failed to see the light of day, so Breton contributed to *Minotaure*, a review launched the previous year by Skira and Tériade. Some of his fellow surrealists responded with sarcasm and denounced Breton for writing for such a lavish publication. Alberto was happy to see his works appear in the abundantly illustrated periodical and did not add his voice to the chorus of Breton's detractors. The surrealist leader had composed a sequence of poems in homage to Jacqueline, which he now asked Alberto to illustrate. The proposal came as a godsend to the artist, who was spending a morose late summer holed up in Maloja, and he immediately set to work. The series of drawings he engraved on his return to Paris were very different from his usual style: in keeping with Breton's sense of the marvelous, they seemed more dreamlike and symbolic, closer in atmosphere to illustrations for a fairy tale. Engraving had interested Alberto since he had started working in the studio of Stanley William Hayter, who was doing much to revive print techniques and whose studio was a magnet for modernist artists. At Hayter's Atelier 17, established in Montparnasse in 1932, Alberto would regularly bump into Picasso, Dalí, Miró, Calder, and Ernst. In addition to illustrations for Breton's collection, entitled *L'Air de l'eau*, Alberto also carried out several line engravings of his most recent works there. Together with geometrical

compositions, he executed a remarkable line engraving of *Invisible Object*, in which the "invisible" entity is materialized as a polygon.

On publishing "What is Surrealism?," the text of a lecture given in Brussels in June, Breton sent Alberto a copy with the following dedication: "*What is Surrealism? It is the struggle of Alberto Giacometti against the angel of the Invisible who had arranged to meet him among the blossoming apple-trees.*"[1] The sculptor was now acquiring an international reputation. In addition to exhibitions organized by the surrealists, his work was in demand for group shows abroad. In October, he sent a dozen sculptures to the Kunsthaus in Zurich for the exhibition *Abstract Painting and Sculpture*, which also featured Arp, Miró, and Ernst. At the end of the year, the Julien Levy Gallery presented his debut exhibition in New York,[2] which followed on directly from Dalí's, and, for a brief period, works by the two artists were on show simultaneously. Unlike his friend, and in spite of an invitation to go to New York, Alberto decided not to travel to the United States.[3] He dispatched a selection of eleven surrealist works, including *No More Play, Point to the Eye, Figure on a Disk* (that is *Desperate Little One*), *Hour of the Traces*, and the plaster of *Invisible Object*. He received good news concerning the reception of his work in the United States from Dalí, who wrote to Éluard: "The experience of my exhibition and that of Giacometti (whom as you know I was first to admire and whom I still admire) is conclusive."[4] Financially, on the other hand, the exhibition failed to pay, and did not result in a regular collaboration with Levy. The gallerist returned everything except for *No More Play* and the plaster version of *Invisible Object*, which the painter Roberto Matta was to purchase from him long after, in 1943.[5]

Back in Paris by the end of the year, Alberto soon returned to his routine. Discontent must have been fermenting in surrealist circles, however, because, on February 13, Breton invited him to an evening entertainment which turned into a formal rebuke. After dinner in a café with Péret, Tanguy, and Marcel Jean, the evening continued at Georges Hugnet's, where the sculptor found himself roundly criticized by the assembled company.[6]

As in the case of the Dalí affair, the accusations were political as much as aesthetic. He was reproached for producing knickknacks for well-heeled clients, for his intention to return to working after the model, and, more generally, for being insufficiently observant of surrealist discipline. Alberto was quite a different individual from Dalí, and was not one to make light of the situation or back down before his accusers. Deeply hurt by the criticism, but refusing to yield ground, he counterattacked with scant regard for his adversaries' feelings. On the following day, five surrealists signed an "exclusion order." At the top of the charge sheet was his defiance of instructions from the collective and his "fundamental hostility with regard to Dalí's recent statement." (Alberto had had a similar reaction to the Dalí affair as Tzara, who had voiced indignation at the handling of the Catalan artist's retraction.[7]) On the artistic level, the group also expressed "its utmost reservations as to his future activity." As with Dalí, he, too, was required "to admit to the error of his ways,"[8] if he wanted to be reinstated. Alberto was thunderstruck. In a letter sent to Breton the following day, he reproached himself for inadequately answering questions that did not need to have such grievous consequences, while equally expressing his disappointment at the attitude of his friend: "I find the absence of humaneness between you and me, in which the discussions took place, appalling."[9] After all, Breton, only a matter of days previously, had sent him a dedication: "For Alberto Giacometti, who to my amazement / had made leap into life / the hesitant image at the bottom of the clouded mirror / unforgettably / André Breton / January 1935." Despite all this, Alberto's letter was friendly and it acknowledged how distressed and sad he was at the prospect of losing his friend. He was to see Breton several times over the following days, but the pact with surrealism was disintegrating. The artist attempted to keep alive a friendship that had meant so much to him, but he was not ready to abandon his convictions, swallow his pride, and make amends. In any event, the artistic issues he had so frankly addressed with Breton and then with the surrealist group at large were indisputably leading him in a direction diametrically opposed to that of the movement. This is what he recalled

when he later described the episode of his expulsion, and stressed Breton's total bafflement at his desire to work once again on the live model. "A head, everyone knows what that is!"[10] the poet remarked contemptuously, simply refusing to acknowledge that the question of representation had once again become crucial to his friend's art. At the time, however, Alberto strived to save their friendship. "The only solution I don't want is a clean break,"[11] he explained, and went on to ask to contribute illustrations to the next surrealist bulletin. In spite of flickers of affection on both sides over the following months, the sculptor took no further part in the meetings of the circle, and the relationship with Breton petered out. On the artistic plane, the turning-point proved radical: the seam of surrealism had been exhausted, and now the sculptor, by confronting the model anew, was to tackle the question of representation. Even prior to his altercation with the surrealists, he had already embarked on a search for a new figurative aesthetic, which he described to his mother as being neither the naturalism of Maillol nor the academism of his onetime classmates at the Grande Chaumière. "My explorations no longer have anything in common with the abstracts, nor with the surrealists, nor of course with sculpture like Bänninger's,"[12] he had explained shortly before the exclusion episode. He turned away from the sculpture of the imagination to confront the live model once again. "Today I worked on the bust (of Diego) after the model (started years ago) and I shall finish it because I've got to thinking that the closer I stick to reality, the more progress I'll make. But to arrive at this point, I had to undertake the detour I did, everything had to be as it was."[13] His first sitter was, needless to say, his brother, who started posing for him just as he had done before the surrealist interlude. "What I'm most busy with now is finishing the bust of Diego; you see, I'm occupied with things that you'll probably think of as more normal!" he commented shortly after the rupture with Breton. "I have perhaps much to do to get to where I want to, but I'm ready to work for years."[14]

Chapter 16

A Return to the Model

Alberto had been impressed by the Balthus exhibition held at Galerie Pierre in April 1934, where the artist had exhibited a series of paintings depicting young girls, including the very erotic *Guitar Lesson*, presented in a side room, separated by a curtain. However, the works had elicited little more than jeers from the young painter's surrealist friends Breton, Éluard, and Hugnet during a visit to Balthus's studio. After Alberto's break with surrealism, he ran into Balthus again in Switzerland and developed a connection that would become a lasting friendship. He also met Antonin Artaud, who exhibited at Galerie Pierre. Subsequent encounters with artists who belonged neither to the surrealist nor to the abstract movement reinforced Alberto's desire to return to the model and to take a figurative approach to his ongoing obsession with "heads." Figuration was a popular topic of discussion at the time, as much with proponents of a "return to technique" as with artists close to the Communist Party who, at Aragon's initiative, tried to adapt the aesthetic of social realism to France. Alberto befriended Pierre Tal-Coat, a member of the Forces Nouvelles (New Forces) group, which advocated the fusion of modernity and tradition. The Association of Revolutionary Writers and Artists, who condemned avant-garde elitism, conducted a survey called "Where is painting headed?" Alberto responded with a drawing of a revolutionary with raised fist. Aragon and Crevel organized an exhibition on the same theme at the Maison de la Culture, to which Alberto contributed the work *The Two Oppressed*, now lost. In an article, "A Turning Point in Painting," published for the exhibition, Aragon stated that the sculptor "now declares that his previous oeuvre was an escape from reality and speaks disdainfully of the mysticism that had slipped into his work."[1]

As Marcel Jean remembers it, Alberto had adopted this position several months earlier. "In late 1934, we heard him say that everything he had done up to that point was masturbation, and that, for the moment, he had no

other objective than to try to represent a human head. Consequently, he began to spend days making busts of his brother Diego."[2]

Alberto, despite having returned to the model, did not support social realism, sharing neither its naturalist aesthetic, nor its visual themes. Aragon was well aware of this and dedicated his book in defense of realism to the artist, with the words "For Alberto Giacometti—his friend and poor advisor, Aragon."[3]

Several important events took place in 1935, the first being Alberto's split with Breton. The second, and painful, event was the suicide of his friend René Crevel in June. This act of desperation followed the poet's worsening illness and was carried out after a final failed attempt to reconcile surrealists and Communists, to which he had dedicated all his energy. His suicide reverberated throughout Alberto's circles and brought an end to an era and a community. In 1931, Crevel had written enthusiastically about *Suspended Ball.* "In the days of the hypnotic sleep sessions, Breton wrote: 'Words, words finally make love.' Today, to say that objects get aroused is not a bit metaphorical. And they do not get aroused on their own. They caress, suck, and swallow each other—they make love!"[4]

Four years later, disillusionment had settled in. Crevel's last words to artists in the "Address to Painters," published in June in the journal *Commune,* demonstrate how similar the poet and sculptor had become in their criticism. "Of course, the desire for novelty for novelty's sake, the fraudulence of sheer scandal, zeal for originality at any price, without ideological or emotional basis, can only end in the worst nonsense. There is excess and not a bit of discovery.... It is important to know how to reverse direction, provided this 'reverse' never becomes 'backward.'"[5]

The third important and entirely different event that year was another romantic encounter. It was a happy one, but out of it arose a period of emotional difficulty for Alberto. He met the Englishwoman Isabel Nicholas at Le Dôme; she was a student at the Grande Chaumière and a model. She had sat for the sculptor Jacob Epstein in London and, among other artists, André Derain in Paris. Alberto approached her at the café and, she wrote,

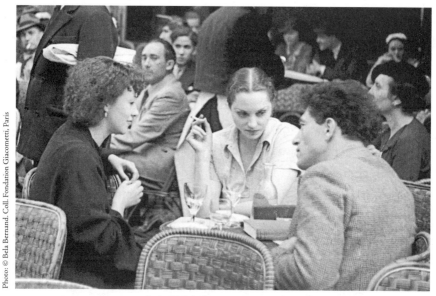

Photo: © Bela Bernand. Coll. Fondation Giacometti, Paris

Isabel Nicholas, Meret Oppenheim (?), and Alberto Giacometti
on the terrace of Le Dôme café, Paris, 1936.

"From then on, we met daily, always at 5 o'clock in the evening. It was months before he asked me to pose in his studio. I knew already that he had changed my life forever."[6]

She began sitting for him at the end of the year. The sessions produced a bust with a unique aesthetic that combined Isabel's traits with those of the famous Nefertiti bust. They shared a taste for culture and the old masters, and visited museums together, particularly the Louvre. During one of their outings, Alberto took her to his foundry, where Rodin's *The Gates of Hell* was being cast. Later, he would produce a second portrait of her in a style similar to Rodin's. With art, intelligence, and friendship to sustain it, the romance was off to a good start. But the young girl's unique and free-thinking character was hardly compatible with the artist's romantic inhibitions. Their relationship suffered from a back-and-forth of unfulfilled plans and emotional frustration. Isabel already had a lover, which she did not consider an obstacle to starting a new affair, but this

did not satisfy Alberto's desire for exclusivity. She went on to marry her partner, Sefton Delmer, in 1936, which for several years relegated her relationship with Alberto to mere friendship. Although he continued to frequent prostitutes, he also did everything in his power to maintain a romantic friendship with Isabel. For the first time in his life, he was regularly seeing a woman who shared his tastes, culture, and social circle, and the experience was so novel and enriching that it left a lasting mark.

Although he no longer identified as a surrealist, Alberto had not broken ties with his friends in the movement, and he remained particularly close with Ernst and Tanguy, as well as Miró, who had moved back to Spain, where Leiris and Masson also lived. However, Alberto distanced himself from Aragon and the politico-artistic stance he espoused, stating, "He is still too dilettante, too literary, to be in politics, and too political to write literature or poetry!"[7]

Alberto continued to be included in surrealist exhibitions and participated in one held in Tenerife in May 1935. Despite his distancing remarks ("I disagree more and more with surrealism, etc."[8]), he did not reject the works he had created in the years since 1930 and continued to exhibit them. That summer, Meret Oppenheim paid him tribute in a small surrealist sculpture, *Giacometti's Ear*. The following year, he presented several works at the *Surrealist Exhibition of Objects* organized by the Galerie Charles Ratton.[9] He even revisited *Walking Woman*, in order to improve it for the *International Surrealist Exhibition* organized in London by Roland Penrose. He also maintained ties with abstract artists Arp and Hélion, as well as with English artists like Ben and Winifred Nicholson. In fact, Winifred purchased one of his sculptures, a figure-stele from 1928, and the idea to exchange works with Ben Nicholson was proposed, but never pursued. In May 1936, he participated in the exhibition *Abstract Painters and Sculptors* organized by Pierre Loeb. He exhibited *Head-Skull*, alongside works by Hartung, Arp, Hélion, Kandinsky, and Sophie Taeuber-Arp. This was not the first exhibition to emphasize the influence abstraction had had on a selection of his work. In March, the

exhibition *Cubism and Abstraction* had opened at the Museum of Modern Art (MoMA) in New York, and included several works by Alberto in the section "Abstract Forms in Surrealist Art."[10] His *Head–Landscape*, explained the catalog, "is, from the Surrealist point of view, a successful plastic pun but it is also an interesting biomorphic abstraction and a solution of one of the problems which has recently held the attention of sculptors, namely the composition of isolated forms which Arp had suggested in his reliefs and which Giacometti carries further in his *Project for a Square*. In others of his works, constructions or 'cages,' Giacometti combines dangling and static objects, some abstract, some realistic, with great imaginative virtuosity."[11]

Despite Alberto's reluctance to be classified as an abstract artist, contemporary observations were correct. Although he intentionally distanced himself from geometric abstraction, which advocated a rejection of the subject—irreconcilable with his defense of the motif—he nevertheless often identified with biomorphic abstraction similar to that practiced by Arp and Calder. His break with surrealism also signaled his break with abstraction, which he had dabbled in with *Cube* but denied doing so, and was no longer tempted by. In August, the studio received an important visitor, Alfred Barr, MoMA's new director.[12] Enthusiastic about Alberto's work, Barr would become an ardent supporter and contribute to establishing the artist's renown in the United States. On his initiative, the New York museum purchased two major works, *The Palace at 4 a.m.*, which Barr had seen in London, and *Disagreeable Object to Be Thrown Away*. After including it in the exhibition on abstract art earlier that year, MoMA acknowledged it once again in December in an exhibition on fantastic and surrealist art.[13]

Alberto made another acquaintance who would considerably influence his career, the gallerist Pierre Matisse.[14] The son of Henri Matisse, Pierre had also studied at the Grande Chaumière, although the two had never met. Matisse had settled in New York, where he was starting out as an art dealer. Although he had attended Alberto's first exhibitions in Paris, their

real introduction took place when he visited the studio in early August. The gallerist immediately suggested a collaboration.[15] Delighted with the idea, which tempered the failure of his business relationship with Julien Levy, Alberto identified a selection of works that could be exhibited quickly. His work had taken a new direction, but he had yet to generate many finished pieces, so he offered to send Matisse his pre-surrealist and surrealist works. The gallerist purchased *Walking Woman*, which the sculptor modified one last time, to be more realistic in style. He spent most of the fall working on it, doing away with the mysterious cavity in the thorax and reshaping the back and bust. He finished his modifications late in the year, then sent the sculpture to New York, where it was to be presented in a collective exhibition at the gallery. "It is certainly the best thing I have done thus far," he wrote to his mother. "I started it in 1932 and little by little I have worked on it a lot."[16] He even considered doing a stone version.[17] However, soon after, he added, to Pierre Matisse, "But I see all the flaws clearly, everything that is lacking to make it a real sculpture, and I soon hope to go further."[18] The plaster quickly sold to Peggy Guggenheim, and Roland Penrose, who had shown the initial version at the surrealist exhibition in London, ordered an edition. Despite a unanimously positive reception, the work did not lead to other surrealist creations. Alberto was now committed to a new practice, and nothing could dissuade him from it, not even seeing the success of his previous works. During the *International Surrealist Exhibition* in 1938, in Paris, he agreed to Breton's request to present *Invisible Object*. But he did so as a "former surrealist sculptor" and expressly requested to be presented as such in the "Abridged Dictionary of Surrealism" written by Breton and Éluard for the exhibition.

Alberto was not deterred by the difficulties he encountered along his chosen path, despite spending long months searching for the most suitable way to represent his models. Besides Diego, professional model Rita Gueyfier came to sit each day. Despite dissatisfaction with the portraits he was producing, he would not be discouraged, buoyed by the

certainty that he was headed in the right direction. He worked tirelessly in the studio, without seeking to exhibit his latest works. "But I had to make up my mind not to show new things during that time and work for myself unhurried, without consideration for my audience or for success, because that was the most necessary thing to continue."[19]

Despite profoundly changing his artistic practice, Alberto remained loyal to Jean-Michel Frank, and the work he undertook for the designer provided a relatively stable income. He created new lamps and light fixtures, as well as vases, figurative reliefs, and jewelry. He also continued his collaboration with Elsa Schiaparelli, creating perfume vials for the designer. In an exhibition of the Circle group in London in 1937, he presented a purely abstract vase.[20] Later, he would use the inclusion of this object in an exhibition to critique the confusion between art and decoration produced by abstraction.[21]

The following year, at Man Ray's request, he created a relief in the form of a bird with its wings spread, and another in the form of a fish, as backdrops for a series of fashion photographs. Frank, whose activity had suffered in the economic crisis, left in search of new orders for furniture in North America. Consequently, he was charged with overseeing the entire layout of an apartment in the United States for Nelson Rockefeller and a house in Argentina for Jorge and Matilda Born. These orders, which necessitated the creation of new and sometimes unique designs by Alberto, generated intense work over the following two years. The transformation that impacted Alberto's sculpted work did not extend to the decorative art objects or reliefs he created for private interiors, which continued to draw inspiration from antiquities, particularly Egyptian, and maintain a connection with surrealism. At Aragon's request, he agreed to create press photographer Gerda Taro's headstone. Having left to cover the war in Spain with her companion, Robert Capa, Taro died in July 1937. Alberto created a simple monument composed of a bird and a birdbath, the same as he had done for his father's headstone. Diego, encouraged by his brother, began to create animal-themed decorative

objects and light fixtures with leaf motifs for the Guerlain shop and for Frank. "These are made under my name. I sign them simply 'Diego,' so there will be no confusion!"[22] Isabel, who was staying in Paris, was often in the studio. "I started going regularly to rue Hippolyte-Maindron where Alberto and his brother Diego had their studios. I arrived around 10 o'clock in the morning and I sat for about two hours, with a pause now and then while Alberto worked on the head with very small tools in a very unusual manner. We talked a lot. The atmosphere in that small room was at once hypnotic and ordinary. Across the room, on the other side of a small aisle, Diego worked as well. That was where Diego completed the practical work following Alberto's drawings, but he also created from his own drawings."[23]

Alberto's social circle shifted and new faces appeared. Picasso, whose friendship had deepened, came often to rue Hippolyte-Maindron, sometimes with his new companion, the photographer Dora Maar. Alberto knew her well because she had been a member of the Bataille circle and had photographed the studio. In expressing his obsession with death and sexuality, Alberto's surrealist works revealed a tormented nature that brought him close to Picasso. Disarticulation of the body and hybridization of the organs, as well as a fascination with the connection between Eros and Thanatos, were characteristic of the works they each created between 1931 and 1935. In 1937, Alberto visited the studio on rue des Grands-Augustins as Picasso was creating his great work, *Guernica*, which had been triggered by the war in Spain. The two artists shared the same anti-colonial, anti-Fascist, and Communist-leaning convictions. Despite a twenty-year age difference and extremely divergent personalities, they developed a warm friendship. They were both going through changes in their lives and careers, and they shared their concerns with each other. Artistically speaking, certain fundamental characteristics united them: a strong spirit of freedom and invention, and a perpetual search and continually renewed desire to redefine the limits of representation. At the same time, Alberto was also developing a relationship

with André Derain, whose works he admired, and he spent time with the young figurative painter Francis Gruber, who had recently set up a studio nearby. He met the writer Samuel Beckett, who had returned to Paris in 1937,[24] and the two men would later influence one other. In this new intellectual environment, the question of art's connection to life was of primary concern. With Beckett, Alberto shared an impossible quest for essential humanity, which from that point on he considered to be the very foundation of art. The artist, who subjected his models to exhausting hours of posing, focused on representing the head. His new works were smaller than life-size, often much so. After the ease of the surrealist period, when his vision took prior shape in his mind and guided the creative process, Alberto once again encountered the difficulties he had experienced at the Grande Chaumière—difficulties for which the cubist system of construction could no longer provide a solution. Although his choice was firmly figurative, no rule of representation could guide him in his approach, which he intended to be singular and uncompromising. How could he reproduce the truth of his perception of the model without letting himself be oppressed by the semblance of truth suggested in academic rules or the hand's ability? Alberto chose the thankless path, that of uncertainty and failure. After several works that revisited the technique of faceting volumes he had learned at the academy, he began to search for a method of representation that took neither a formalist nor psychological approach. It was neither classic, nor naturalist, nor expressionist; his explorations took a problematic and uncertain direction. Later, he would describe the difficulties he had encountered when once again he found himself confronted with a model in the studio. "Fifteen days later, I rediscovered the impossibility of 1925. I sculpted exactly as though I were at school. The more I looked at the model, the thicker the veil between her reality and mine grew. We begin by seeing the person who is posing, but little by little, all the possible sculptures intervene. The more one's real vision disappears, the more the

head becomes unfamiliar. One is no longer sure of its appearance, nor its dimension, nor anything at all."[25]

This difficulty arose from Alberto's realization that the "wild vision"[26] espoused by modern artists and glorified by Breton did not exist, and that traditional codes of representation were unsuited to the need for novelty to which modernity gave rise. "There were too many sculptures between my model and myself. And when there were no more sculptures, there was something so unfamiliar, I no longer knew who I was seeing or what I was seeing."[27] Confronted with the unknown, he found solutions in the art of ancient civilizations, characterized by what he referred to as "style." "The more real a work is, the more style it has. Which is strange, because style is not truth in appearance. And yet, the heads I find to share a likeness with the heads of anybody you would see in the street are the least realistic heads, the heads of Egyptian, Chinese, or ancient Greek sculpture. For me, the greatest invention leads to the greatest likeness."[28]

He would in this way position himself as diametrically opposed to naturalism, without actually trying to define a personal and lasting canon, or "signature." One would eventually form, but over time and almost without his conscious awareness. His recognizable style was the fruit of multiple trials that produced a very limited number of sculptures in the long period extending from his split with surrealism up until after the war. His visitors, sometimes even the closest among them, were often doubtful. Peggy Guggenheim, who visited his studio in 1938, was disconcerted by his new work—his "little Greek heads"[29]—and bought nothing for the collection she was in the process of building. She would opt, instead, for the surrealist works, which she later purchased in New York. The following year, the young sculptor François Stahly was astonished at these "extraordinarily small" heads. Alberto explained, "I try to give a head its right dimension, its true size, such as we see it when we try to grasp its total appearance at a glance."[30] Even his mother, pleased that he had given up surrealism, had trouble understanding the weeks

and months devoted to producing such a small quantity of sculptures and so small in size.

In 1937, during his summer trip to Stampa, Alberto took up painting again. Was this a result of the Cézanne retrospective presented in 1936 at the Musée de l'Orangerie? The first motif he depicted was a still life of apples. His plastic technique differed from Cézanne's and, in contrast to the explorations that he had begun in the realm of sculpture, Alberto borrowed codes from naturalism. Breaking with his father's influence, visible in the paintings he made as a young man, he instead turned his attention to Derain's creations; that same year, he had admired the artist's sober still-life paintings of fruit on black backgrounds. His color palette grew muted and he chose a small format for paintings that resisted any plastic effects. He also created several portraits in a similar style, including one of his mother in the family home. He had established the structure and would apply it to all future paintings: a simple motif, in a sparse environment. When depicting a human figure, the painting shows a single person, viewed from the front, centered on the canvas, looking at the viewer. Some of these paintings include a frame integrated into the composition, which became a constant in later works. The split with surrealism and abstraction was complete. Alberto was once again a "sculptor" and no longer forbid himself from being a "painter." The return to models also surfaced in his numerous drawings, which became a project in their own right, with no direct connection to sculpture or painting.

CHAPTER 17

The Accident, then the War

Alberto's friendship with Isabel, now Isabel Delmer, was an important new part of his life, but it did not satisfy him. The young woman, who had followed her husband to London, returned too rarely to Paris, and the times they shared together left him feeling unfulfilled. His previous romance with Denise had ended messily in 1934. Alberto's fascination with Isabel was nothing like the passionate, but doomed, love he had felt for the other woman. The Englishwoman's personality, her beauty, intelligence, liveliness, and humor, at once stimulated and intimidated Giacometti. As he would later admit to her, shyness and fear of sexual impotence kept him from declaring the full extent of his feelings. He also held back because of Isabel's freedom, which, despite the woman's many qualities, hardly corresponded to a marriage Annetta would approve of. As for Diego, he had committed a moral transgression and was living as husband and wife with a woman who had not received his family's approval. Nelly, a young woman who had a child, moved in to the uncomfortable studio and would share his life for the next twenty years. The rapid disintegration of Isabel's marriage encouraged Alberto to follow his brother's lead. Sefton Delmer was a reporter, often called to travel abroad, and Isabel was independent by nature. Their relationship rapidly waned, and the young woman began traveling regularly to Paris. On October 19, 1938, after a sitting in the studio and dinner at Le Flore, Alberto decided on a radical proposal: offer Isabel the choice between a clean break or a real romantic relationship. He accompanied her to the door of her hotel, but the words would not come out. On his way home, at the place des Pyramides, Alberto was hit by a car that had lost control. "I did not feel the slightest pain—it happened so fast. I just suddenly knew something had happened to my foot, because it pointed away from my leg as though it was no longer part of my body. I took hold of it, returned it to its normal position and it stayed in place. I thought everything was back in order."[1]

The driver was a young, drunk American woman. Alberto was taken to the hospital, then to a clinic where his fractured foot was put back in place and, after several days, set in a cast. Diego and Frank looked after him, and Isabel visited every day. One week after the accident, as he left the clinic on crutches, he realized that the event's impact on his life would reach beyond the physical consequences of his injury. His time spent in the hospital would remain a memorable experience, but, above all, he saw in the accident a sign: "For a long time now, our relationship had become so demoralizing that I had decided to break it off that evening. 'I am losing my foothold, absolutely,' I told her."[2] His accident seemed to be the materialization of his own thoughts. "Did I not foresee or sense what happened? Is it not odd that my own words could come true in that way?" And the result corresponded to his deepest desire: Isabel, whom he thought he had lost that night, instead drew closer to him. "Once more, life brought order to a situation that had become unbearable, without the slightest intervention on my part. I found a way to handle my relationship with that woman."[3]

In accordance with his tendency to mythologize certain events in his life, he turned the accident into a seminal experience. According to numerous accounts, limping did not bother him, and he even replaced his crutches with a cane, using it with a certain satisfaction. After the accident, he was very busy creating decorative reliefs for the Born family interior, and he put all his energy into the project. This premature return to work and incomplete physiotherapy prevented him from regaining complete use of his foot, but this eccentricity was to become an integral part of his persona.

Alberto's convalescence did not help to clarify his relationship with Isabel, which remained friendly. Together, they saw Derain, Tzara, and Balthus, as well as Picasso, who would paint several portraits of the young woman. The atmosphere was one of worry and foreboding; after the drama of the Spanish war, world war now loomed. Alberto had met Jean-Paul Sartre and Simone de Beauvoir, with whom he would develop a close relationship. Sartre had just published *Nausea*, and de Beauvoir, nicknamed "*le Castor*" (Beaver), also moved in literary circles. Both were fascinated by the artist

and spent intellectual evenings with him in the cafés of Saint-Germain-des-Prés and Montparnasse. Giacometti was now sculpting very small figures in Plasteline—no bigger than a pea, de Beauvoir would say—often placed on a massive base that was part of the work, which he molded in plaster and reworked with a knife. He voluntarily cultivated an air of mystery around the process of reduction: at first, he argued in favor of it using rational arguments, then by attributing it to an involuntary impulse. He defended the idea of small scale in May 1939, when an argument pitted him against his brother, Bruno. An architect, Bruno was called upon to co-create the Cloth Pavilion for the Swiss National Exposition held in Zurich and invited Alberto to participate in the project. First asked to create a relief for the pavilion, Alberto suggested affixing stucco tapestry to the façade, which turned out to be impossible. He was then commissioned to create a work to be displayed on a base in the pavilion courtyard. Alberto, who handled delivery of the work himself, unveiled his creation at the last minute: a small sculpted head, a far cry from the organizers' expectations. They considered the sculpture ridiculous and refused to accept it. Alberto was furious. "Thursday morning I installed my sculpture. I was very happy to see it in place; it had the effect I wanted and I was surprised. Egender, Bruno, and the others hesitated; I was sure that everything was fine, but the sculpture caused too much of a scandal and they will not dare leave it in place."[4]

The negative reactions hurt all the more because he was pleased with the sculpture, "absolutely the only one of its kind and very new." The critics were harsh. "It is criticized for being: too small, a joke, too serious, made to confound the bourgeois, too shabby, too pretentious, too good for an exhibition like this, too considered...."[5] In an effort to convince his brother and the organizers of his good intentions, Alberto developed a very coherent argument: the sculpture's small size altered the usual relationship to scale and made everything around it appear monumental in size to visitors, starting with the architecture. He emphasized the importance of space as a constitutive element of the work; the viewer would be all the more aware of this space if the sculpture were concentrated. "The head changed everything,"

he explained. "Tiny little flowers on the tiling became large as roses (Bruno pointed it out), the clefts between the tiles became crevasses (so Gubler said), the plants became tall trees, the garden without limits (Bänninger), and the head and the whole sculpture were very large; the head was large seen from afar, three meters even [9 ft. 8 in.], and to the eye, it acted like a telescope (an instrument that enlarges everything) on other things. It is strange that they did not give a little more consideration to this not so simple thing. In looking at my sculpture, everything around it took on a new appearance. I can make a single square meter seem huge."[6]

Despite his anger and justifications, he did not get his way and, because of his friendship with his brother, resolved to offer an existing work as a substitute—*Cube*. He was not convinced, however, but rather resigned. "Despite my efforts, this sculpture is too novel to be accepted without a revolution." Back in Paris, he continued work on the small heads, without letting the situation upset him.

In August 1939, Alberto returned to Switzerland. Two years earlier, his family had experienced a tragedy when Ottilia died giving birth to her first son, Silvio. Annetta looked after the child, which would be the family's only offspring. Following Silvio's birth, Alberto created a series of very moving drawings of the baby in his notebooks. During this summer trip to Maloja, Ottilia's memory remained painful. Silvio, beloved by all, was now two years old. Several days after arriving, Alberto left with Diego and Francis Berthoud, Ottilia's husband, for a week-long trip throughout Italy that took them all the way to Venice. "Arrived and decided not to look at a single painting or sculpture for a month, I was leaving in two days for a road trip through Italy with my brother and brother-in-law," he wrote to Isabel. "Milan, Mantova, Padova (you must see the Giottos again, they are above all the most beautiful paintings we saw during the trip), two days in Venice (especially in the P. San Marco cafés, very pleasant at the Scuola San Rocco, I walked down all the little streets while the others went to bathe at the Lido), then Vicenza, Verona, and Bergamo."[7]

On September 1, just as the two brothers returned to Switzerland, Hitler's invasion of Poland triggered World War II. Alberto and Diego appeared before the military authorities, but only Diego was fit for combat. Alberto's former classmates from the Grande Chaumière, Otto Bänninger and Germaine Richier, were vacationing in Switzerland when the war was declared and extended their stay in the country. Alberto met up with them in Zurich. Several artists took refuge in Switzerland, including Arp, Marino Marini, Fritz Wotruba, and Le Corbusier. Alberto, however, returned to Paris late in the fall, where he settled into his studio and solitude. Several of his friends had been called up or sought refuge outside of Paris. Diego joined him at Christmas, and Alberto focused on his work. Peggy Guggenheim visited him at the studio. The collector had seen the damaged plaster cast of *Anguished Woman in Her Room at Night*, which she wanted to buy. Giacometti suggested instead that she purchase a bronze edition of *Woman with Her Throat Cut*, which he asked Rudier to execute. Isabel was in Paris, and it was during the troubled weeks of spring 1940 that their relationship became a romance. "As the Germans drew closer, I spent more and more time at rue Hippolyte-Maindron. We spoke openly about the fall of France. Alberto was concerned about finding a way to protect his works. Since they were very small, heads the size of a nut or smaller, I decided the best thing to do was to make a hole in the floor and put them there. The rest he would take in his pocket. He was worried about his mother and said that he should go see her in Switzerland."[8]

Before leaving Paris for London, she promised to return to live with him as soon as the war was over. "Do not forget what has been decided, even if it takes several years (I do not think it will), that I will come live with you (to practice my new trade?)."[9] The bell had sounded and the exodus began. Isabel left, and Alberto, who until then had refused to leave his studio, agreed to leave, with the idea that he would go to his family in Geneva.[10] Frank left for Bordeaux, where he got on a ship for Brazil before heading to the United States. On June 13, Alberto, Diego, and Nelly left Paris together by bicycle. They arrived at Étampes shortly after a bomb had been dropped,

to find mutilated bodies and disembodied limbs strewn on the ground. At the end of the fourth day, they found themselves diverted from their route, having witnessed terrible scenes. Getting only as far as Moulins, and threatened by the Germans' rapid advance, they decided to return to Paris. For Alberto, this exodus, undertaken to flee the war, had been a brush with horror—incomplete and brief, but one that stayed with him.

Following the armistice and under occupation, Paris was subjected to a curfew and rationing, but Alberto did not consider leaving his studio. His friendship with Picasso deepened. In January 1941, he wrote, "Picasso wants me to make his head, and I started working a little on it."[11] And the following month, "I see Picasso nearly every evening and we dine together often; he likes nothing more than when I tell him about Stampa, its residents, etc."[12] Communication with his family was difficult and had to be sent through intermediaries or telegrams via the Swiss legation. The same was true for correspondence with Isabel, and Alberto asked Annetta to send news of him to his friend. At the end of 1941, he requested a permit to visit his mother. He left December 31 with a twenty-day permit—he would not return until September 1945. At first considered temporary, his stay was extended when he was unable to obtain authorization to return to France. Frank's exile and the war interrupted a great deal of Diego's work, so he signed up for sculpture classes at the Scandinavian academy in Paris. During the war, which he spent in Paris, he learned sculpture techniques, including casting and patina; up to that point, these had been delegated to craftsmen. It fell to him to keep watch over the studio and protect Alberto's works. Alberto had moved to Geneva, where his mother lived with Francis and Silvio in a large apartment. Intent on keeping his independence, he quickly found a room in the inexpensive Hôtel de Rive. The hotel room became a studio; he hauled in bags of plaster and continued the work he had begun in Paris. He created two kinds of sculptures: minuscule busts and small nude figures with arms held close to the body. The inclusion of the base in the sculpture itself became an important element of the work, which sometimes included several stacked bases. In this way, Alberto

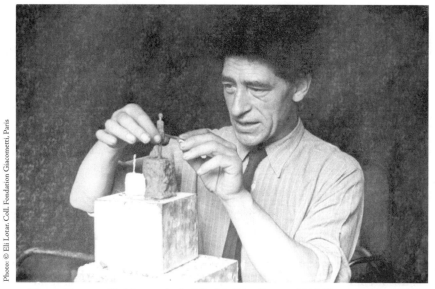

Alberto Giacometti in his room in the Hôtel de Rive, Geneva, 1944. Photograph by Eli Lotar.

introduced the concept of grandeur in his very small works. However, despite all his previous explanations defending a deliberate and reasoned reduction in size, Alberto complained about the effects of miniaturization, which from now he associated with an inability to produce larger works. A personal urge or the destructive effect of doubt pushed him to remove ever more material, until nearly destroying the work. Mastery of execution resulting from an existing vision, which presided in the surrealist objects, had given way to errors made in pursuit of a necessary, but unattainable, goal. This feeling of incompetence, which led him to destroy sculptures he was in the process of making, would soon replace the assertiveness with which he had countered his brother's criticism, and fuel a familiar lament. However, Giacometti developed a new rational explanation for the origin of his small-format works. The small female figures, in particular, reproduced an experience from 1937, when he caught sight of Isabel's silhouette from afar. "And the sculpture that I wanted to make of this woman was exactly the vision that I had had of her when I saw

her in the street, some way off. So I tended to make her the size she had seemed at this distance."[13]

The small-scale reproduction of an object seen from a distance is the accurate translation of the truth of seeing, he articulated. The presence of a base also had its explanation in this fundamental vision. "It took place on boulevard Saint-Michel, at midnight. I saw the immense blackness of the houses above her, so to convey my impression, I should have made a painting and not a sculpture. Or else I should have made a vast base so that the whole thing should correspond to my vision."

But for the time being, his discussions with Genevese friends included descriptions of failure, dissatisfaction, and lack of fulfillment. This painful reiteration, not unlike the unending grievances of Beckett's characters, would soon become an integral part of his personality. Since his accident, Alberto had voluntarily transformed his public image. The young and self-assured man in the 1923 self-portraits, the sculptor refusing the smock and working in a second-hand suit, the surrealist with firm opinions, defying Breton's authority—these manifestations of an unwavering personality gave way to another presence, less Alberto and more "Giacometti," the artist now delivered from youth. In positioning himself outside of any established movement, and in breaking with avant-garde idealism and utopias to continually invent his own path, Giacometti turned the artist's individualism into an island of resistance. The strength he demonstrated from this point on arose from an acceptance of weakness and doubt. His pride lay in purposefully renouncing honor, money, and security. To limp, use a cane, wear a threadbare suit, have bad teeth, and hair white with plaster, were no longer problems he cared about; on the contrary, they contributed to consolidating his personality as an artist. Over time, he would become the incarnation of Camus's Sisyphean hero, each day questioning the previous day's work. Remaining loyal to his artistic path became more important than anything, more important even than producing works.

In Geneva, despite his marginal position and his continued claims of failure, he found himself immediately surrounded by the city's intellectuals. As

his nephew Silvio remembers, everyone fell under the charm of Giacometti's unpredictable and fascinating personality. "Alberto was without contest more attentive to the people around him than anyone I have ever known. He listened to everyone with the same attention, whether in a café in Stampa or surrounded by a circle of philosophers. But he left no comment unanswered, and he latched on to vague or questionable statements until their unfortunate authors had explained or retracted them. He took a malicious pleasure in contradicting his interlocutors and usually came out the winner in these arguments. Sometimes he took the joke too far and ended up defending ideas so absurd that the discussion ended in a loud burst of laughter."[14]

Balthus, who was in Fribourg and met Giacometti in Geneva often, also remembered heated discussions and the spirit of contradiction that defined his friend. "He liked to say the opposite of what I was arguing. We systematically contradicted one another. We would argue all night long, and 'come to an agreement' as dawn approached, before going to bed."[15]

Insatiably curious, even about subjects far removed from his own work, adept at discussion, and skilled with humor and irony, Giacometti captured attention. Everyone heard him complain that he could not succeed in creating the sculptures he wanted to create, but, as Silvio also pointed out, this declaration of weakness was no invitation to criticism. And so his mother, who no more recognized his current explorations than she had appreciated his surrealist works, found herself rebuked when she suggested he change tack and return to a practice more in line with Giovanni's ideas. Similarly, he expressed satisfaction with his work to her many times, and never missed an opportunity to inform her when positive comments had been made about his sculptures. "But you know very well, dear Mother, the kind of long and difficult work I have undertaken; you know, having seen me, how much I apply myself and how much patience I must have. This cannot continue without difficulty and taking difficult attitudes to life in general, which displeases me, but which I cannot avoid because I must do things exactly as I do them, it is my very equilibrium and the meaning in

my life. I know that I have something to say that others do not say and if I persevere, it is because I have the deep and absolute certainty that I will achieve what I want and that these years have not been lost but gained. But you know, Mother, how impatient I am to satisfy you and to be able to give back to you, in some small measure, what you are and what you do for me, my greatest desire is to see you happy with me, and nothing could satisfy me like your confidence."[16]

Giacometti was pleased to learn of an exhibition of his works planned for February 1945 at the Art of This Century Gallery, created by Peggy Guggenheim; he considered it confirmation of his personal conviction that he must persevere. "It seems to me that you should be very satisfied that in the middle of war, and with me being so isolated, they are going to all that trouble in New York to gather together the sculptures they were able to find over there, most of them in private hands, and hold an exhibition about me." And he added proudly, "As you can see, I am far from forgotten."[17]

Giacometti had no source of income other than the small amount of money his mother provided him. A few months before leaving Paris, he had learned of the tragic death of Jean-Michel Frank, who had committed suicide in New York. Annetta's resources were subject to sales of her husband's works, which were hardly favorable in wartime. Giacometti spent this period in great poverty. But he was used to a frugal lifestyle and his living conditions in Geneva were similar to what he had known in Paris. He divided his time between his hotel room, where he slept and worked, cheap restaurants, where he took his meals, all-night cafés frequented by prostitutes, and the café popular with intellectuals in the Molard quarter, where he met with his friends. At the Café des Négociants, he regularly saw Albert Skira, who opened his office across the street in 1943. The publisher of *Minotaure* wanted to launch a new publication, *Labyrinthe*. Alberto befriended the journal's future collaborators. "Every day he came to what Roger Montandon and I referred to as the 'editorial board.'"[18] The artist quickly became an integral part of these daily meetings. "Alberto brought the good word and we listened to him. He hit the floor with

his cane to indicate if he approved or disapproved of the ideas put forth during our conversations."[19]

A young philosopher, Jean Starobinski, attended these meetings, as did Cingria and sometimes Balthus, whose work appeared in an exhibition at Galerie Moos in 1943. "When I open the *Labyrinthe* collection, I can almost hear the voices that composed some of these volumes. Alberto's harsh and slightly Italian accentuation, and his phrases that often ended in 'no?' Balthus's bright and lively timber. Skira's lighter and enthusiastic, almost cheerful, voice. Rosabianca Skira's wonderful, probing gaze. And the conversations continued from the other room, loud, lively, without pretention, giving on to the exterior."[20]

Starobinski describes the artist as someone waiting for the extraordinary to erupt into everyday life. Thus, he remembered, "a leg, with knee half bent, in the window of an orthopedic store in the passage des Lions, became a subject of surprise, for very precise reasons. Or, cut out of a journal, kept in his wallet, a photo of Mussolini and Claretta Petacci's bodies, hanging by their feet. For several days, 'Petacci's legs' came up again and again, because in it he saw an enigma, an endless source of sacred horror."

The years spent in Geneva were a time of reflection, punctuated with encounters and friendship. Besides the *Labyrinthe* contributors, Giacometti also met with the geologist Charles Ducloz, who became a friend, the artists Hugo Weber and Charles Rollier, and the actor Michel Simon. The photographer Eli Lotar, whom he had known during his surrealist period and met again in Geneva, photographed him working in his room in the Hôtel de Rive. During this period, Giacometti paid nearly daily visits to his mother and young Silvio, of whom he made small sculpted portraits. In October 1943, during a meeting in support of the Resistance at the Brasserie de l'Univers, he had an important encounter with a young Swiss woman who worked for the Red Cross, named Annette Arm. Fascinated by the artist, she went to several social gatherings at the Café du Commerce and fell quickly in love. Alberto did not know it yet, but he had just met his future wife.

Skira commissioned Alberto to write two texts for the journal—one about Laurens's sculpture, the other on Jacques Callot's etchings—which were published in 1945. In both texts, Alberto offered insight into his own work by speaking about another artist. "Laurens's sculpture," he wrote, "is for me, more than any other, a true projection of himself into space, a little like a three-dimensional shadow. His very way of breathing, touching, feeling, thinking—becomes object, becomes sculpture. And this sculpture is an enclosed zone."

Although he warned the reader—"One could imagine this to be true for all sculpture, but I do not believe so"—Alberto placed his work in the same category. Further along in the text, he addressed the questions at work in his practice at that moment: in working with clay, Laurens also worked with the space around the material, that space itself becoming volume. Laurens simultaneously created volumes of space and volumes of clay. These volumes alternated, equalized, and, together, became sculpture.

And he added, shifting to a personal level, "I get the same feeling before human beings, especially before human heads, the feeling of a space-atmosphere that immediately surrounds beings, penetrates them, is the being itself; the exact boundaries, the dimension of this being become indefinable."[21]

The text on Jacques Callot, a master of minuscule figures and war scenes, continued this reflection on size, which characterized his explorations at the time. "Callot's etchings very often depict very large spaces, vast empty landscapes seen from on high, diagonally, from an angle close to what we have before an anthill. In this space a multitude of minuscule people swarm and move."

But what captured Giacometti's attention was less the reduced size of Callot's figures as the cruelty and obscenity of the subjects depicted, which he compared to those of Goya and Géricault. In a surprising way, which indicated an additional connection that might be made between Callot's oeuvre and his own, Giacometti concluded his article by evoking the cruelty of children, establishing a connection between the artist's "frenetic desire

to destroy" and the "pleasure of destroying" unique to childhood.[22] The text was a reflection on a war with origins in a fundamental evil, present from childhood, as well as a reflection on the artistic lineage with which Giacometti identified: artists who, over time, had dedicated themselves to searching for human truth. The violence explicitly expressed in his surrealist works had not deserted him, but it had become an internal force rather than an object of representation, now acted out before representation, in the threat of destruction that loomed over the "anthill" of his creations.

Geneva was Giacometti's main residence, but he regularly traveled to Maloja, where he worked in his father's former studio, now his own. He had casts made of several small heads and figures that pleased him, but his goal was to complete a larger sculpture. In the Maloja studio, larger and more practical than his small hotel room, he began to sculpt an upright female figure, and for once, its execution did not prove problematic. Taking as a model the memory of Isabel's silhouette, he created a nude with arms held close to the body, in which the model's feminine hips differed from the slender form and pre-pubescent appearance of *Walking Woman*. Sometime earlier, he had represented the same model with a rounded pelvis, in one of the smallest sculptures he ever made. For the new one he applied a technique that he had never tried in this size, and which would become the method used in several of his future works. The silhouette was not first modeled in clay and then cast in plaster, but rather sculpted directly in plaster: he applied plaster to a core, then reworked the surface with liquid plaster and a knife. He also painted the same female figure in an identical pose on the studio's wooden wall, creating one of his first nudes. He integrated a high quadrangular base into the sculpture, which supported the figure. Even more original, he placed the entire piece on a small wooden cart with wheels, which itself became a part of the work. This was not the first time he had placed one of his pieces on a mobile base. To show *Cube*, he had built a four-footed base, similar to traditional African stools, with tiny wheels. Finally, he painted on the main facial features: large eyes, arching brows, a mouth.

This was the only large sculpture he created during the entire war. During the four years he spent in Geneva, Giacometti maintained an intense and continuous rhythm of work, but produced meager results. The desire to overcome at all cost the difficulties he had encountered in the creative process kept him in Switzerland several months after the armistice. "Bring all my sculptures back, Isabel?" he wrote in late July 1945 to his lover, who was waiting for him. "If only I am able to bring back one I am more than happy (there are some very small ones, four or five, but they are not right, and then one I am working on now to make a cast, still the same one destroyed twenty times since I arrived here—really, twenty sculptures destroyed—I will not destroy it again, but get where I can and no longer start again."[23]

He continued his struggle until September, when he returned to Paris. He described the wartime interval saying, "In part in Maloja, in large part here, in a hotel room that could have been on rue d'Alésia, I worked every night and every afternoon and time passed terribly fast. I did nothing else, neither exhibited nor sold, except a painted portrait that I began a year ago or more, and two articles in a journal."[24] Though at first glance this "suspended life"[25] seemed unproductive, the war was nevertheless a period of significant maturation. Upon his return to Paris, Giacometti resumed his work with the greatest intensity.

CHAPTER 18

Astonishing Dedication

Giacometti arrived in Paris on September 19, 1945. The little baggage he carried with him[1]—according to legend it was six matchboxes—contained small sculptures. It was an emotional return. During the war, he had often worried about Diego, receiving news of him only rarely through friends. Although communication with his brother had resumed after the Liberation of Paris, Giacometti was filled with joy at seeing him face to face once again. "I have been here eight days already, and it has been like a dream. Had a good trip—twenty-four hours—missed trains, etc. Wonderful anyway and above all amazed to be back in Paris, with Diego, my friends, the studio."[2] The shortages in Paris sharply contrasted with the situation in Geneva but they did nothing to dampen the reunion. Diego had kept the studio in order and they were able to set to work immediately. There was just one cloud on the horizon: during the war, Diego had found a companion in misery, a little fox nicknamed "Miss Rose" that a friend had brought him. The animal inadvertently escaped— the result of Alberto's carelessness?—through a door that had been left ajar; Diego was saddened by the loss. Nevertheless, work resumed as it had before. Friends returned to Paris, one after another, and things picked up. Tériade, aware of Giacometti's impending financial difficulties, lent him some money.[3] On September 28, he wrote to his mother, "I did not imagine I would be so well received by my friends, but Picasso, Gruber, and the others are not here at the moment, I hope to see them again soon. Sculpture is going well, I can hold an exhibition whenever I like and I have been invited to lunch tomorrow by a New York dealer, Matisse's son, who also orders things from me."[4]

Just after Giacometti's arrival, Pierre Loeb suggested holding an exhibition (the project never happened), and Pierre Matisse reiterated his commitment to representing the artist in New York. Isabel was back from

London and Giacometti quickly sought her out. He suggested they meet in a café. "The bar was dark and we could barely see each other. I seem to remember speaking little and that there were many silent pauses. I think that we were both exhausted. I went to the studio the next day and everything seemed as it had been. Alberto was true to form, Diego would arrive soon, Alberto continued the work begun in Switzerland."[5]

The lovers tried to resume the relationship they had had before the war interrupted it. Together, they spent time with Sartre, de Beauvoir, Leiris, and Balthus. Giacometti introduced Isabel to Bataille and his companion, Diane Kotchoubey de Beauharnais. But time had passed and things were different. At the end of the year, the couple split up, but they reconnected in 1947 and stayed good friends until Giacometti's death. Separating from Isabel was not a deciding moment in Giacometti's life. The love he felt for her had not been enough to compel a swift return to Paris; he had chosen to extend his stay in Geneva, absorbed in his creative challenges. And another woman had entered his life, one who would take on increasing importance. Young Annette, twenty-two years his junior, communicated her desire to join him in Paris. He had asked her for the money he needed to fund his return. Although he did not take the relationship seriously at first, Annette's determination in the face of her family's disapproval would eventually weaken his resolve to disregard what he considered to be an affair with someone too young, naive, and earnest.

As soon as he got back to Paris, requests and proposals of all kinds flooded in. In December, he was asked to present a proposal for a monument to the memory of the public education advocate Jean Macé, which was commissioned to replace a sculpture melted down during the war.[6] The Communist Party suggested he submit a design for a monument in honor of the Resistance fighter Gabriel Péri intended for the public square bearing his name outside the Saint-Lazare train station. He was also requested to create illustrations, including a portrait of Balzac for the cover of a book in Skira's new collection dedicated

to famous artists. He refused, however, to write any more articles. "I'm stopping, at least for the moment. I very much want to draw, but I especially want to continue with my figures."[7] Visits to the studio picked up, and he began selling works that had found no buyers before the war. "This morning, I made thirty-seven thousand francs from three of the smallest figures from '41 and drawings, and I could have made more because they wanted to buy the apple painting, but I will only sell that one for a lot of money and that dealer also said that if I did more paintings he would buy them and he is not the only one."[8]

The difficulties he encountered in his creative process during the years spent in Geneva seemed to have evaporated. Giacometti set to work producing small sculptures like those created in 1941, as well as monuments, and new busts and figures. Bases took on increasing importance, and what before the war had amounted to reusing existing bases prepared for larger sculptures[9] now became a unique and richly varied syntax, in which the motif sometimes became secondary. The size and variety of these bases, integrated into the sculptures themselves, established a key element of his artistic vocabulary: the artist, through the relationship between the motif and the mass of material supporting it, defines the relationship between space and his work. Material it was, and raw at that: the bases he modeled out of clay or carved out of blocks of plaster shared none of the smooth impersonality of typical exhibition bases. Never rectangular, they were usually slanted, with uneven edges and rough surfaces, and they underwent the same sculptural treatment as the motifs rising from them. In certain sculptures, the motif itself had so few details—barely an outline—and was so fragile compared to the base's mass, that Giacometti verged on abstraction, anticipating what would become known as "informal art." Once more, his work began to evolve along two different and parallel lines. On the one hand, he directed his explorations toward a universalist approach to human representation, eliminating any sign of personalization or story, in favor of a timeless presence; on the other, he resumed his studio

sessions with models and continued his portrait practice. His choice of
models diversified; Diego began posing again, along with Marie-Laure
de Noailles, Simone de Beauvoir, Diane Bataille, and even Picasso,
whose portrait he began but never completed. Giacometti's conver-
sations with Picasso had resumed with nearly the same frequency as
in 1941. Even though he was enjoying the height of his fame, Picasso
continued to question his creative process and sought the opinion of
his friend. "Giacometti," said de Beauvoir, "speaks of Picasso, whom he
saw the day before and who showed him some drawings; it appears
that, before each new work, he is like an adolescent just beginning to
discover the possibilities of art. He said, 'I think I am beginning to
understand something; for the first time, I made drawings that are
really drawings.'"[10]

And, she continued, he was delighted when Giacometti said, 'Yes,
progress has been made.'" Giacometti recounted the story to his mother.
"Yesterday, I spent three hours with Picasso who has made several
wonderful new drawings, and that delayed me by an hour for the lunch
with the Viscount de Noailles; they had finished, but I ate in the salon
while the others had coffee.... Picasso has shown me great friendship,
he said I can visit him whenever I like and that I am as welcome there
as in my own home."[11]

Giacometti also began drawing profusely, and he attributed to this
practice the positive progression his explorations had taken following
his return to Paris.[12] In May 1946, he took part in the exhibition to
benefit Antonin Artaud organized by Pierre Loeb. In the postwar
period, Artaud's works constituted one of the most potent demonstra-
tions of the power of drawing as an artistic concept in its own right.
Boris Taslitzky, whom Giacometti had met at the same time as Gruber,
bore witness in his poignant drawings to the horror of the concentra-
tion camps he had escaped, offering up another example of drawing's
capacity to reveal the depths of the human spirit. Drawing became a
permanent practice for Giacometti, and one which he cultivated in

every available medium. A pencil in one hand, an eraser in the other, he ensnared the model in a web of lines blurred by false starts. He also took up painting again, as Leiris recounts. "An afternoon visit to Giacometti's studio, where he is still working on the female figure he began several years ago, and for which he created models hardly larger than a pin. He also shows me a painting of a single apple on a sideboard. It is, one might say, naturalism and at the same time, beyond naturalism. As for the figurine (a woman standing, in the simplest position—at attention), she avoids naturalism through her posture (with none of the picturesque inherent in the slightest of accidental poses) and elongation."[13]

Giacometti's attempts to achieve a universal representation of the human figure, carried out for his monument projects, led him to devise increasingly simple sculptures, like graphic symbols released in space. For the Gabriel Péri monument, he created two walking figures, one female and one male. The monument was never completed, but this idea gave rise to *The Night*, a slender female figure walking on a long slab, which he described as "a skinny young girl groping around in the dark."[14] Trials for commissions—none of which was completed— provided a laboratory of ideas for new works. "Whether the statue is completed or not, I will have the sculpture,"[15] he wrote. *Walking Woman*, which he considered making in a larger, identical version, would, in the end, lose its femininity when enlarged. Henceforth, women in his work were represented as immobile and viewed from the front. Thus, his new female sculptures displayed the hieratism of *Woman with Chariot*, carried out in Maloja, which combined a portrait of Isabel with references to sculpture from early antiquity. This reference to antiquity was also clear in a series of variously sized female figures, directly evoking ancient Egyptian art both in their postures and the rough, slanted base fused to their feet. Large bases enabled Giacometti to create spindly figures rising into space by integrating metal armatures into the mass of material. Giacometti used his knife

to make the surface appear uneven, lumpy, and scarred. Sometimes, he even accentuated certain sculpted traits using a brush, as he had done in Maloja. A forest of spindly sculptures began to rise from among the bags of plaster surrounding him, while little figures and heads piled up on the studio's few furnishings. The structure of the figure in *Seated Woman* is so fine, the sculpture resembles a drawing sketched in space. Giacometti was totally absorbed in his new works, and they became an obsession. "I am incapable of explaining what I do, but I dream about it every night! And this is always useful the following day; today, I worked a bit on what I dreamed two or three nights ago, or rather several nights in a row."[16]

After returning from Geneva, Giacometti had written to his mother about how happy he was to be back in his studio. "You cannot imagine my delight at returning to everything and my studio, which pleases me more than ever!"[17] The minuscule space, which, before the war, he had dreamed of escaping in order to live and work in better conditions, now provided the environment so vital to the development of his mental landscape. In September 1947, Georges Limbour published a vivid description. "When one enters Giacometti's little studio, it is not immediately clear where to go: one is afraid to overturn the slender and fragile (or so they seem) figures rising from the floorboards, or to tumble over an enormous pile of plaster leaning against the wall and spreading under a table, rising so much it lifts it from beneath. From this perspective, Giacometti's studio more resembles a wrecking field than a building site. Wrecking what palaces, what dreams? All this plaster was once statues, but Alberto, dissatisfied with his works, destroys them, scrapes away at them, amputates them, redoes them…. It is a poignant, plaster mass-grave that speaks to Alberto Giacometti's patient and astonishing dedication."[18] Limbour exaggerated the destructive character of Giacometti's practice—his new method called for sculpting directly on plaster applied to an armature in successive layers, without prior casting—but his emphatic description of the studio was

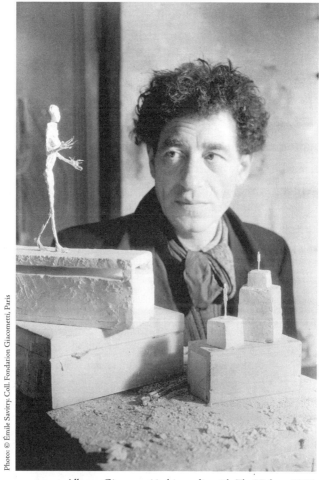

Alberto Giacometti in his studio with *The Night*, c. 1946.
Photograph by Émile Savitry.

justified: it was indeed a place of "patient and astonishing dedication."
Giacometti was engaged in a real struggle with material, working on
several pieces simultaneously, and hoping to complete them all. In two
years, the studio, which Diego had kept clean and organized during
the war, became a cave overflowing with plaster and an accumulation
of sculptures, which delighted photographers. Photographs taken by
Marc Vaux, who published a piece in *Cahiers d'art* in 1946, attest to

the diversity of forms Giacometti managed to create in such a brief period. The positive reception they garnered from his friends was encouraging, but it was also a vindication of sorts. During his time in Geneva, Giacometti had been hurt by criticism expressed by Bruno and Francis, who were afraid he might be losing his artistic way. "I am quite happy that I did not succumb to discouragement in any way regarding what I wanted to accomplish in Switzerland during the three and a half years I spent there; it was not always easy, but I have very thick skin!"[19]

CHAPTER 19

Walking Man

At Aragon's suggestion, the Communist Party commissioned a portrait of the Resistance fighter Rol-Tanguy. To this end, Giacometti created a series of heads, ranging from the highly abstract to the remarkably realist, each set on an elaborate base. The idea was similar to what he had attempted in Bern in 1939: a small head set on a massive base. In the end, the party did not take the piece, but it was presented in May 1946 at the exhibition *Art and Resistance*.[1] Upon his return to Paris, Giacometti had resumed his conversations with Sartre and de Beauvoir, which included both political and aesthetic subjects. At the end of the war, the two intellectuals founded the review *Les Temps modernes* with Leiris, Merleau-Ponty, Jean Paulhan, and Raymond Aron. Within its pages, they addressed political, ethical, philosophical, and artistic issues. With both philosophical and literary ambitions, the journal included texts by Beckett, Char, Ponge, Sarraute, and Genet, among others. In Parisian circles, Sartre's "philosophy of existence," popularized under the name "existentialism," stimulated debate. Giacometti's close relationship with Sartre and de Beauvoir, and Sartre's desire to associate the sculptor's work with his philosophy, contributed to the artist being identified with that philosophical movement. De Beauvoir wrote a critical review in the journal of Merleau-Ponty's theoretical text *Phenomenology of Perception*, which critics were quick to mine for concepts to define Giacometti's work. In the cafés of Saint-Germain-des-Prés, the artist took up with the surrealist dissidents he had known before meeting Breton—Bataille, Limbour, Queneau, and Lacan, who were also friends of Sartre and de Beauvoir. As in his prewar period, Giacometti found himself a member of several social circles, which did not necessarily overlap: old friends with whom he had remained in contact, like Leiris, Roux, Tzara, Picasso, and Tériade; painters with whom he had established similar relationships

in the prewar period, including Balthus, Gruber, Tailleux, Hélion, and Tal-Coat; and new intellectual circles he encountered in the cafés. Several of his Swiss friends had also returned to Paris, among them Skira and Montandon. A new figure materialized within this atmosphere of lively debate: the joyful Annette. He saw the young woman again while spending Easter 1946 at his mother's. During a visit to Geneva in May, de Beauvoir and Sartre met her. "We went out with Skira and Annette, a young girl Giacometti is very interested in. We liked her. I found that, in many ways, she resembled Lise;[2] she had the same brusque rationalism, audacity, eagerness; she devoured the world with her eyes: she did not want to let anything or anyone slip by; she liked violence and she laughed at everything."[3]

Although attracted by the young woman's intensity and her boundless admiration for him, Giacometti was aware that Annette's social background prevented her from being a candidate for a passing romance. Raised in a bourgeois Swiss family, she was destined for marriage, not bohemian love affairs. As for the artist, his recent attempt at a relationship more serious than his previous affairs had failed. Nothing prevented him from marrying, but he could not have children as a result of orchitis brought on by a case of mumps in adolescence. He had also resumed his old habits at Le Sphinx and in bars, the last stop on his nighttime circuit. Could this be reconciled with a relationship with a woman unaccustomed to the sexual freedom permitted by Isabel and adopted by de Beauvoir and Sartre? Giacometti's reluctance to consider a long-term relationship did not shake Annette's conviction that she had met the love of her life. On July 5, the die was cast: she packed her bags and joined him on rue Hippolyte-Maindron. They lived together out of wedlock for over two years before marrying.

Artistic activity in the studio was intense: Diego was preparing bases, plaster casts, and, soon after, bronze casts, for Pierre Matisse's visit had sparked a project for a large exhibition in New York. Planned for 1947, it took place early the following year. Thrilled, Giacometti threw himself

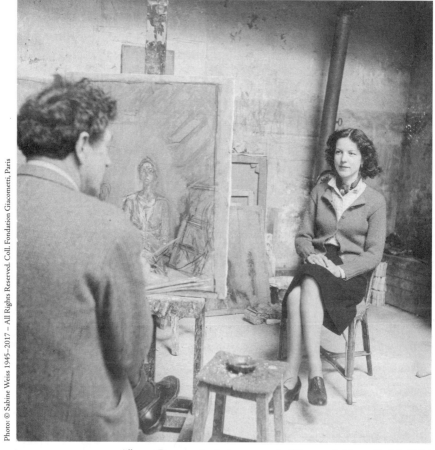

Alberto Giacometti painting a portrait of Annette in his studio, July 1954.
Photograph by Sabine Weiss.

into his work. For two years, he selected pieces he wished to exhibit from among his earlier works—neo-cubist, surrealist, and small figures—and created new models. He would show both plaster and bronze pieces, and Matisse would finance the casting. Giacometti prepared several large-format sculptures for the exhibition. "Recently, I've been making a life-sized human figure each night, and Diego often tells me to drop it and just cast it in bronze, and so the bronzes I have were done in that way."[4]

After narrowing the figures, he now elongated them. They never grew taller than life-size, but they were slender as shadows, with irregular surfaces that caught the light in fragments. In addition to female figures, which he divided henceforth into three categories—small, medium, and life-size—he created male figures that appeared to be in movement, contrasting with the static, hieratic style of the female models. *Walking Man*, a life-size creation that he completed in 1947, is so thin, it is practically invisible when viewed from the front. The whittling down to the essential that characterized these figures also applied to the "heads," which remained a favored motif. "I made and remade the same heads for months, every day, in every size, eliminating little by little everything that would not work, until I arrived at a single head, the key to all the others, and I worked on the figures in the same way."[5]

This brings to mind remarks he made about ancient Egyptian art when he was young, and fascinated with its economy of form. "They cut away what was necessary from the entire figure, there is not even a hole to place a hand, and yet there is an extraordinary impression of movement and form."[6] Patricia Matta, who worked with Pierre Matisse, came to the studio to photograph the sculptures in preparation for the exhibition. She found the artist caught up in overwhelming activity and exhausted by the work underway, which often kept him up into the early hours of the morning. "My studio has become impossible, there are mountains of plaster everywhere with little paths between them, and I have no time to see anyone anymore."[7] Giacometti fought to moderate the destructive impulse that compelled him to destroy anything he was not totally satisfied with. He desperately attempted to create a sufficient number of new sculptures, working himself to exhaustion. With cracked and chapped hands, and weakened by overwork, which kept him bed-ridden the final ten days, he still managed to deliver his pieces for the exhibition at the very last minute.

For the catalog, Giacometti retraced the works he created between 1925 and 1936 in an illustrated list of small sketches. This "catalog

attempt" was accompanied by a letter to Matisse, in which Giacometti explained the different stages in his training and creative process. The text, a brief biography written to enlighten visitors to the exhibition about his artistic career, provided an opportunity to identify key moments using anecdotes that would later shape his personal mythology.[8] In his preliminary typescript, he shortened, for example, the original mention, "In 1919, I spent barely a year at the art school in Geneva," to this more striking formulation, "In 1919, I spent three days at the art school in Geneva." He used vivid descriptions to connect very precise moments and signs to the realizations that provoked changes in his practice; the result would fuel most future commentary. The crisis in Rome, he explained, culminating with the willful destruction of the bust of Bianca, was followed by the crisis that took place at the academy before a live model: "Impossible to grasp the whole face.... The distance between one nostril and another is akin to the Sahara, no limits, nothing to hold on to, everything slips away." Then, following the surrealist objects he created from memory, came a sculpture from which, he explained, "I could not break free." Finally, after a difficult return to the model, his sculptures "became so minuscule that often with a last touch of the knife they crumbled into dust." The legend he crafted from lived experiences is not heroic; rather, it emphasized failures and incompetence, described as revealing moments and stimuli. The same was true when he took an introspective approach. Starting with his surrealist texts, Giacometti had chosen a style that exposed himself and his creative difficulties without concession, and sometimes in extreme ways. The example provided by Dalí, who cultivated shocking details about his incompetence and fantasies, along with Leiris's confessional writings, provided Giacometti with the precedent for brazen sincerity coupled with a semi-fictional reinvention of the real.

Among the sculptures listed as early works, twelve were presented at the New York exhibition, along with seventeen "new style" sculptures. The recent works included hieratic female figures, two large masculine

figures, *Walking Man* and *Man Pointing*, as well as two paintings. It was Giacometti's first large exhibition, and a retrospective one at that. Once again, he chose not to travel to install his pieces, instead sending indications for the hanging. "The sculptures must be placed far from one another, with a great deal of surrounding space."[9] Then, in a later letter, he added: "There must be three groups: I—early things, *Suspended Ball* and the *Woman With Her Throat Cut* being the main pieces, II—the bronzes not too far from each other, III—the heads and the second woman and the thin man."

In the end, unsure of his choices, he deferred to Roberto and Patricia Matta, both involved in preparing the exhibition. He asked Sartre to write the introduction. Entitled "The Quest for the Absolute," the text, which also appeared in *Les Temps modernes*, was a kind of manifesto. Sartre described the artist as belonging to time immemorial, a time unique to art itself, which made his work appear as naturally contemporary to pre-historic cave paintings as to that of his modern peers. Using Giacometti's example, the philosopher outlined a concept of existential art. "After three thousand years the task of Giacometti and contemporary sculptors is not to add new works to the galleries but to prove that sculpture is possible. To prove it by sculpting the way Diogenes, by walking, proved there was movement.... Giacometti has been able to give this matter the only truly human unity—the unity of action."[10]

The exhibition was a public and commercial success. "The bronzes have all been sold, except for one, but one was sold in two editions and another in three."[11] The paintings also found buyers. Teeny Matisse, the gallery owner's wife, came by the studio bearing good news. "I have been asked to produce ten new bronzes (ten new casts of exhibited works, in other words, a lot) and I have already made one million two-hundred thousand francs or more with my share. I was not expecting that much! Now anything is possible. Of course, I will not be paid in one install-ment, but that is of less importance. I can even pay off my debts to you! The strangest thing is that I am still swimming against the current. Two

years ago, and even just last year, others were selling and I was making and destroying, and today almost nothing is selling anywhere and I am making money! And I have just begun working. The day after tomorrow, I will invite Diego and Annette to dinner (and I can keep smoking the cigarettes I like!).”[12]

A little money was welcome, for the artist was living in greater poverty than he had been before the war. In the couple's bedroom, water froze in winter and pots were arranged on the floor to catch leaks. Trained as a secretary, Annette began working. Giacometti had remained in contact with Georges Sadoul, who now offered her a job. “I admire his very young wife for accepting this life,” remarked Simone de Beauvoir, who gave her old dresses to the young woman. “After a day at work as a secretary, she returns to that sad house, she has no winter coat and her shoes are worn out.”[13] Despite the difficult living conditions, Annette brightened rue Hippolyte-Maindron with her good humor, and the couple was happy. “Giacometti's wife measures around one meter sixty-five [5 ft. 5 in.] and resembles a delicate girl of fourteen. When addressing Giacometti, she always uses the polite ‘*vous*.’ She smiles often or laughs a young girl's laugh. Her youth and a certain poetic disposition contrast with Giacometti's introspection and brooding. He teases her sometimes, and she bursts into laughter, her face radiant as a child's. Then the creases, the two deep furrows on Giacometti's face, grow deeper still, and he beams like a simple peasant laughing at a good joke.”[14]

Harper's Bazaar dedicated its cover and four inside pages to Giacometti, and *Vogue* published an interview. *Artnews* cited the exhibition as one of the year's five best, and his work was especially well received by abstract expressionist artists. The daily papers were more perplexed by his work, which they nevertheless presented as the most current coming out of France. “The exhibition is very popular and is generating a great deal of discussion, according to what I have been told. Artists in general like it very much, the public is less sure of itself and does not quite know what to think yet. Critics have been idiotic, troubled by Sartre's introduction

or, to be more precise, by your connection to Sartre. That was the risk. But really, it does no harm,"[15] Matisse reported.

The artist was not concerned by the tepid reception in the press. "Despite everything, I do not regret asking Sartre to write the preface, in which he said many good things; one day we will win over the critics as well."[16] He was no more offended by the negative reactions from certain sculptors, like Lipchitz and Maria Martins, which he chalked up to jealousy. In fact, he took a rather philosophical stance. "The only response to these colleagues and other people is to make things that are more accomplished; that is what I will do and then we shall see."[17] Regardless, although he was pleased with the exhibition's incredible impact, he remained dissatisfied with the sculptures, and was more concerned with those he was in the process of making. "For me, those things were just trials and not finished things like I want them to be; the ones I am making now are already much better."[18] He was pleased to see his work recognized, but, most of all, he was absorbed in creating. He had several bronze commissions to complete, new works underway, and he continued to create decorative art objects with Diego, particularly for the Compagnie des Arts Français directed by Jacques Adnet. He also created chandeliers for the Thésée gallery, and Pierre Matisse commissioned lamps and light fixtures for New York interiors. His collaboration with Diego had never been so productive. Diego cast decorative objects, prepared bases and armature for sculptures, oversaw molds and metalwork, and modeled for his brother. After sending his pieces to the New York exhibition, Giacometti spent the winter of 1947–48 in Stampa recovering from fatigue. He returned rejuvenated, with new sculptures in mind. "Since my return, I have finished with destruction, you do not have to worry about that anymore,"[19] he wrote to Matisse. Ten years of artistic hardship had come to an end, at least for the time being.

CHAPTER 20

The Death of T.

During the war, several surrealists fled to New York, including André Breton, who did not return to Paris until October 1946. Giacometti was informed of his return, and, although he showed Breton his latest works, he was not interested in reconnecting with his former friend. Despite distancing himself from Breton and the movement he was trying to revive, surrealism once again made inroads into Giacometti's work. In 1946, the artist published an important text, a contribution to the journal *Labyrinthe*, which grew out of a discussion with Montandon. Rejecting his friend's suggestion to write in the form of a diary, Giacometti agreed to provide a text with autobiographical overtones. "The Dream, the Sphinx, and the Death of T.," in the style of his surrealist texts, combined his recent dreams with memories.[1] His renewed contact with Bataille may have had something to do with this shift. Shortly after his return, Giacometti made a series of engravings for Bataille's book *A Story of Rats*, and a sculpted portrait of Diane. Bataille's surrealism is present in the text, which revolves around three events: a morbid and erotic dream in which he grappled with a spider; his memory of Le Sphinx, since closed, and a venereal disease; and the shock he felt when T., a neighbor on rue Hippolyte-Maindron, died. The death was a very recent event, and Annette had also witnessed it. Since her arrival, Giacometti had rented a room next to the studio, which served as their bedroom and happened to be adjacent to the dying man's room. The proximity of the corpse kindled the terror that had gripped Giacometti twice before. He used intense imagery to describe the lifeless body, "the emaciated limbs, tossed aside, detached, abandoned far from the body, an enormous swollen belly, the head thrown back, the mouth open." As he himself indicated, this part of the story is a reference to Van Meurs's death, which he also described. "The nose became more and more prominent, the cheeks grew hollow, the almost motionless mouth

barely breathed." Caught up in the literary exercise, Giacometti once again employed provocative images and personal revelations, some of them erotic in nature. He explained this to his mother, whom he knew would be shocked. "*Labyrinthe* is out and I will send you a copy. But whatever you do, do not take things word for word (and read to the end before passing judgment) because it should not be read so, and things like the disease are imagined and transformed, but absolutely necessary to my story."[2]

As he was working on the text, Giacometti created sculptures in the same vein. These works, similar in character to certain of his surrealist objects, nevertheless took a different form, one in line with his new figurative exploration. *Head on a Rod*, which depicts a head thrown back, the mouth open; *The Hand*, an arm detached from a body; and, several months later, *The Nose*, seem to be directly inspired by the story. Preparations for the exhibition at Matisse's gallery had spurred a renewed interest in the artist for his surrealist works. For the exhibition, he made a new plaster version of *Suspended Ball*, which reintroduced the notion of incorporating the motif into a cage. Grotesque and theatrical, *The Nose* is a head-skull hanging in a cage, with an extraordinarily long nose that protrudes through the bars. He created several versions in plaster with small color accents that emphasize by turns the work's tragic and comical natures.

Despite a renewal in style following the war, the mysterious figures Giacometti had been creating since 1946 could very well have been understood as contemporary extensions of his surrealist universe. Breton, who discovered the artist's new works upon returning to Paris, immediately voiced his approval. "When he finished his new explorations, I confirmed with enthusiasm that in sculpture, Giacometti had succeeded in a synthesis of his previous concerns, which I have always said is essential to the creation of style in our time."[3] Giacometti shared this news with his mother, which, to him, felt a like a vindication. "The other day Breton wrote in a widely read article that he was enthusiastic about the progress I have made and that according to him I am essential to the style of our time!"[4] The intersection of memories from different periods in "The Dream, the Sphinx,

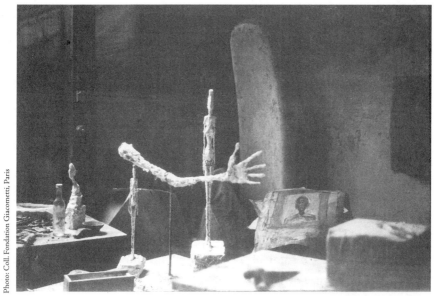

The Hand in Alberto Giacometti's studio, c. 1947.

The Nose (1947), plaster, in Alberto Giacometti's studio, 1956.

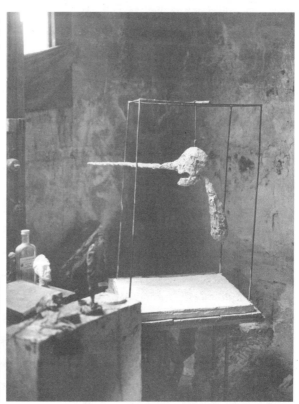

and the Death of T.," which he clarified in a diagram, corresponded to a circular conception of time which Breton could not help but find appealing. But Giacometti was not interested in turning his attention to the past. In 1947, he refused to send new works to the exhibition of surrealism held at the Galerie Maeght, instead lending only older works, and requesting to be presented as an ex-surrealist. In 1948, he sent Breton the Matisse Gallery catalog prefaced by Sartre's essay, with this vengeful inscription: "Do not forget, I do not compromise."[5]

Giacometti's ideas were being enriched with new, more stimulating inspirations more in line with his new creations. Although he would later minimize Sartre's influence on his work, it was nevertheless significant, and he identified with some of the philosopher's comments on the turns his work was taking. Sartre was able to give philosophical meaning to the problems the artist encountered—particularly his difficulty in reducing parts to a whole—as well as to his practice of establishing distance with the model. "This woman walking has the unity of an idea or a feeling; she does not have parts, because she offers herself up all at once. Giacometti resorts to elongation to give sensitive expression to pure presence, self-sacrifice, and this sudden emergence. The original movement of creation, that timeless, indivisible movement, so beautifully figured in the long, gracile limbs, runs through these Greco-like bodies, and lifts them heavenward. I recognize in them, more clearly than in an athlete of Praxiteles, the figure of Man, the real beginning and absolute source of gesture."[6]

Sartre also clarified a note of ambiguity introduced by the historical context in which the figures were created: do these emaciated, solitary figures represent men and women who escaped the camps? "Something happened to these bodies: have they come out of a concave mirror, a fountain of youth, or a concentration camp? At first glance, we seem to be up against the fleshless martyrs of Buchenwald. But a moment later, we have quite a different conception: these fine and slender natures rise up to heaven. We seem to have come across a group of Ascensions, Assumptions, they dance, they are dance, they are made of the same rarefied matter as those glorious

bodies we have been promised. And while we are still contemplating this mystical pulse, the emaciated bodies bloom, and all that we are left with are earth-bound flowers."[7] As Sartre says, Giacometti was seeking a truth that exists outside of history's grasp. The artist's political ideas had not changed, despite refusing, unlike Picasso, to demonstrate affinity with the Communist Party. He would continue to read *L'Humanité* and was not afraid of being associated with artists like Gruber and Taslitzky, who had adopted political realism. However, unlike in the 1930s, he made a point of differentiating his artistic activity from current events and political issues. In the same way he had withdrawn during the war to preserve his artistic creation, he now refused to claim an art that played the role of witness or condemnation. His works speak to his time while remaining timeless. But they no longer achieved this by eschewing the real, as his surrealist objects had; nevertheless, he remained loyal to Bataille, whom he went to hear at the Conference on Surrealism in February 1948. Neither did they follow the method of other artists who chose to pursue the act of witness through extreme realism. With works like *The Night*, *The Hand*, and *The Nose*, Giacometti entered a mental landscape closer to that of Beckett, striving for essential truth but unconcerned with realism. The sculptures are exaggerated and theatrical, some grotesque even, reminiscent of the philosophy of the absurd developed by the author of *Molloy*. Giacometti would develop these qualities further in a series of works connected to theater; the first, created in 1949, was once again called *The Cage*.

After the 1947 life-size *Walking Man*, whose arrested movement retained an ancient Egyptian appearance, Giacometti began to depict small, frail masculine figures taking large strides. He avoided archaic models, instead depicting visions of the everyday: human figures seen in the street, in a public square, or in a downpour are the subjects of sculptures in which the base, especially the space it defines, plays an important role. The slender slab in *The Night*, which he used again in *Man Walking across a Square*, and the square terrace on which *Three Men Walking* bustle about, are essential elements to their respective sculptures. These works

display the character he attributed to Laurens in his text for *Labyrinthe:* through sculptural techniques and inscribed within their own unique, virtual space, they define an "enclosed zone" that isolates the motif from the surrounding environment. Since returning to Paris, Giacometti had overcome the conflict between planarity, associated with the frontal nature of vision, and volume, which characterizes the real world; this difficulty had confounded him twenty years earlier, and again when he returned to the model. To describe this breakthrough, he would once again employ a revelatory anecdote. "The real revelation, the real shock that shook my entire conception of space and that set me definitively on the path I am now traveling, I experienced in 1945, in a movie theater. I was watching the news. Suddenly, instead of seeing figures, people moving in a three-dimensional space, I saw smears on a flat canvas. I couldn't believe it. I looked at the person next to me. It was fantastic. He took on enormous depth. I was suddenly aware of the depth in which we are all steeped and of which we are all unaware because we are used to it. I left. I discovered an unknown, dreamlike boulevard Montparnasse. Everything was different. The depth transformed people, trees, and objects."[8]

Giacometti rejected the photographic vision that "supposed objectivity" suggested would usurp painting, in favor of a return to the "depth" that is inseparable from experienced reality. This experience, never considered definitive and refreshed daily, did not, however, prevent him from applying a set of permanent characteristics to his various subjects. Nude, motionless women, with arms pressed to their bodies and head often crowned with towering locks of hair, evoke archaic representations; carried out from memory, they are usually described as deities. The male figures, depicted in movement, are reduced to a simple expression of the body's structure and embody human fragility and weakness. Similarly, the relationship between man and woman—which he would explore in 1950 in new works on the theme of city squares, grouping male figures in movement and a motionless woman together on the same base—conformed to recurring symbolic and psychoanalytical codes.

CHAPTER 21

A Time of Change

Friendships continued to play an important role in Giacometti's daily life. He regularly spent time with de Beauvoir and Sartre, whom he accompanied to the opening night of the play *Dirty Hands*. Balthus was a frequent visitor, and Tériade sat for a portrait; Giacometti also drew Loeb and Stravinsky. In March 1948, he was the witness at Montandon's wedding. But a series of deaths plunged the friends into mourning; Antonin Artaud's passing in particular shook the entire artistic community. "Last week, I went to Artaud's funeral, a few months ago he wrote a lovely little book on Van Gogh which I told you about," Giacometti wrote to his mother.[1] An even closer friend, Gruber, was seriously ill with tuberculosis and he deteriorated quickly. "Gruber, our good friend, is back from the countryside, and he and Diego are cooking together," he wrote in June.[2] Then, late November, he wrote to Matisse, "Diego just returned from the hospital where he visited our friend Francis Gruber. He is doing very poorly, I cannot tell you how upset we are; he is one of the people I love most in this world and who I've seen almost every day for years."[3]

The young painter passed away several days later. But all was not grim. Annette's arrival had brought an element of stability and happiness to Giacometti's personal life. She got on well with Diego, which made living together easy. Meals were now shared with Annette, as were discussions in the cafés. The two spent many evenings with Picasso and his new companion, Françoise Gilot, as well as mutual friends Michel and Louise (known as Zette) Leiris. Annette also became Giacometti's new model, particularly for painting, which became an activity in itself. In February 1949, he informed his mother of his intention to marry. "I must tell you, dear Mother, do not worry yourself about my plans! But I prefer to speak to you about the subject than to write! Diego has taken

a liking to Annette and gets on very well with her and he thinks I am right. I have known her almost six years now, we get along better than ever, she is the only woman I can live with and who makes it possible for me to focus completely on my work." And he added, "When you meet Annette, you will see that I am right."[4] Shortly before that, he had told her how he was going to restaurants less often and felt less of a need to see people than he had before.[5] The time for marriage had come. "It had to happen anyhow."[6] Annetta, overcoming her initial worries, warmly welcomed the idea. "I truly look forward to meeting this second Annette (she is practically my twin) who has the courage to marry so mature a companion! But God willing, this is a good decision for the two of you and that you may always be happy together, and bless this event, which is such an important one. In any case, my best, most ardent wishes are with you."[7]

The marriage was held on July 19; Diego and the concierge on rue Hippolyte-Maindron were witnesses. Later that summer, the newlyweds left for Stampa, where they received a warm welcome. "I am happy to see that even Annette was sorry to leave our country; that must mean she was at ease, and that she will be happy to return," remarked Annetta after the couple had departed.[8] Annette was immediately made to feel part of the family and would look forward fondly to future visits to Stampa and Maloja. The couple returned to Paris after a trip to Venice. Annetta advised her daughter-in-law, "According to what Alberto writes, he finds your den a little crude after the palaces of Venice, and he says linoleum etc. agrees with him. Do not give him time to change his mind."[9] The young woman, however, showed herself to be very adaptable. She adjusted well to the radical change in lifestyle and tolerated the spartan conditions on rue Hippolyte-Maindron. Yet, the level of comfort in the room never improved: exterior communal toilets, no bathroom, a simple portable stove that did not allow for cooking, an old coal stove for heat. The pipes froze in winter and the leaks in the roof grew so large that Pierre Matisse had to send them tar paper from New York to seal the

gaps.[10] Diego warned her while she was in Stampa with his brother, "For Annette! It is very cold, -5 [23° F] in the studio and the toilet is frozen. At my place on rue d'Alésia, the toilets have been frozen for several days and the concierge has turned off the water; we are far from the comfort of Maloja and even that of Stampa."[11]

This way of life did not bother Giacometti, and he never gave it up, even when his financial situation improved. But for the time being, financial comfort was but a distant hope, and he worried endlessly about money. Though he was selling regularly in New York, his works were priced low and he spent large amounts of money producing them. Moreover, conditions in the United States in the context of the Cold War were not encouraging, and Matisse was often slow to pay him. Annette had quit her job. Sitting for Giacometti and assisting his daily routine took up more and more of her time, until it became a job in its own right. Times were tough, but artistic creation took precedence over everything else, and it was a good period for Giacometti. In 1949, the photographer Denise Colomb, Pierre Loeb's sister, shot a reportage in the studio, followed by Alexander Liberman in 1951; both captured moments of joyful complicity between the couple, which contrast sharply with the usual portraits of the artist, typically portrayed alone, somber, and pensive.

The prospect of an exhibition in New York encouraged Giacometti and motivated his sculptural practice; he also made an enthusiastic return to painting, which even took precedence for a time, once works for the exhibition had been sent off to the United States. The paintings are characterized by dark colors, primarily grays, browns, and ochers. The restful time he spent in Stampa in early 1948 brought about a return to the model, which he also resumed in his sculptural practice. "I worked a great deal here and it is going to serve me well in the sculptures (I think I am entirely finished with destroying things) and I also see things more clearly for the paintings and drawings. For that, I needed once more to work from nature, and my mother, despite her seventy-six years, sat for me every morning, every afternoon, and often even on Sunday."[12]

189

On rue Hippolyte-Maindron, Diego and Annette sat nearly every day for Giacometti. He created nearly fifty paintings in the years 1948–49, which all share a similar pictorial grammar: the motif, centered, is positioned in a brushwork frame; the facial features are drawn in a mesh of lines; and the background and body are rendered in rough strokes and structured with a few lines. The nearly monochromatic palette is minimal, but vibrant. His themes were diverse and included still lifes with apples, male and female busts, representations of his studio and his sculptures, and then female nudes, which Annette always posed for. Thus, he carried out what he described as his first nude painted from life since his student days. He asked Annette to hold the same pose as his sculpted figures: straight and immobile, arms held close to her body. The representation included an unusual detail, which would appear in all the painted nudes to follow, and which had been present in the nude painted on the wall in Maloja from a sculpture: the feet are not flat on the ground, but pointed, rendering the body weightless. Is this intended to create an "enclosed zone" specific to the pictorial space? Freeing the motif from gravity is central to the works Giacometti created in this period and can be observed in both his sculpture and painting. Elevated by a high base, or isolated on slabs, the figures wrest themselves from matter and achieve autonomy. Similarly, in his paintings, the figure appears to surge from the neutral, disjointed background surrounding it. Giacometti was still grappling with the question of space. "Any sculpture that takes space to be real is false. There is only the illusion of space," he wrote in a notebook,[13] adding, "Space does not exist. It must be created, but it does not exist, no."

After the exhibition in New York, Giacometti sent a number of paintings to Matisse, along with sculptures and drawings, intended for American collectors. But he also wanted to hold an exhibition in Paris, and spoke to his dealer about the idea. Louise Leiris suggested a possible opening in Kahnweiler's gallery, Galerie Simon, which she directed.[14] Matisse, who was only active in America, supported the

idea of Giacometti working with a gallery dedicated to French clients. However, things did not unfold without incident. Several other gallerists had visited the studio, and Giacometti used this to put pressure on his American dealer. During a trip to Paris in summer 1948, Matisse encountered unfamiliar inflexibility in the artist. "After studying your proposal to buy, and pay upfront, half of all the ordered bronzes, I wish to inform you that I am not opposed in principle, though it would be a heavy burden for me considering the advances I have provided for the casts," he wrote upon returning to New York.[15]

Though he did not want to alienate Giacometti, Matisse could not hide his resentment. "My dear friend, I regret to end this letter on a bitter note, but I cannot conceal the fact that I was a little saddened by your attitude, after all the effort I have made to show your work in New York. Whatever faults you may reproach me for, it seems you might have considered and recognized in these efforts a natural and generous contribution on my part, for I, too, ran the risk of selling nothing after incurring such costs, lost time, and all kinds of trouble."

Once again, Giacometti, embarrassed by his actions but caught up in the urge to have his rights recognized, had behaved too harshly. In a letter he sent before even receiving Matisse's response, he tried to restore their personal and professional connection, without, however, retracting his demand. "If you do not agree," he wrote, at the end of a polite letter, "then I will be obliged to sell where I can, to whomever wishes to buy and pay upfront; this is the only way I would be able to survive, and it would be possible; three people have asked to buy the portrait I am doing of Diego once it is finished, or even as it is. In the fall, I will show my things here to prepare for an exhibition. (Maeght would also show, if I want, according to what the director told me.) Pierre, who came by, wanted sculptures and paintings too, Janis came to the studio twice, he is very interested and wanted to buy three sculptures, two compositions and the large figure and hold an exhibition of paintings and drawings.

He wanted *Three Men* for his private collection as well, I told him I could do nothing for America without you and that I would write him."[16]

Matisse, aware of the danger, did everything he could to avoid a split and accepted Giacometti's conditions. The friendship rapidly resumed. Giacometti was even confidant to the intimate concerns of Patricia Matta who, separated from her husband, was having an affair with Matisse. A year later, she would inform him of their marriage. "Dear friend! On Friday, we followed your bad example: a marriage with a ring, but no contract. We had the Tanguys for witnesses and my father came later with the wine. A great success. I remember little, but I know it is done, what a whirlwind!"[17]

The threat of seeing Giacometti leave the gallery had been avoided, but Matisse knew that, sooner or later, he would have to come to terms with the presence of another gallery.

Chapter 22

Falling Man

As soon as the New York exhibition had finished, Matisse asked Giacometti to take part in a group exhibition, followed by another solo exhibition. Giacometti, although not completely recovered from the fatigue of preparing his works the previous year, had grown used to being exhausted, and looked forward to the prospect with pleasure. He had experienced the stimulation of preparing for an exhibition, and it helped him to overcome the difficulties he encountered in his creative process. After a period focused on painting, he returned to sculpture and created several new models. Following *Three Men Walking,* he worked on a sculpture of four hieratic female figures aligned in a row, for which he created a very tall base on a stand. This interest in integrating tall bases into works led to his creating fine pedestals supporting small busts, evocative of Roman sculpture. As in his pre-surrealist period, his works can be broken down into a few specific categories: figures, busts, and compositions. The base, which he purposefully removed from the surrealist objects, is here present in infinite variations. "The sculptures are now behaving a different way in the space than before," he explained.[1] MoMA purchased *The Square* and, shortly after, *Woman with Her Throat Cut,* which Giacometti and Pierre Matisse had recast. Matisse commissioned sculptures, but also insisted the artist create lamps for his New York clients. Giacometti had new bronze casts made of his prewar lamps, and also created new models, which borrowed motifs from his sculptures, such as a walking man or a female figure with raised arms. "I have completed another project, which Diego is executing, and I have ideas for other objects, and for vases which could be very nice. I am able to make objects only because Diego does very good work and takes care of everything for the bronze casting, etc., but I find the objects almost as interesting as sculpture and the two touch in some way."[2] The more

he played with new forms, the more progress he felt he was making. "I have made enormous progress over the last several weeks, in painting as much as in sculpture, and now I know what I am capable of doing and where I might go; there are no longer, I believe, any limits."[3]

Yet, he was still subject to fits of doubt. One struck him in July 1949, while he attempted to create a new, medium-sized version of *Walking Man* moving forward on a slab-like base. "I think it was in good shape at several stages; I stopped several times, decided not to make any more changes, but ten minutes later, I was back at it. Monday evening, tired, irritated, no longer seeing clearly, I absolutely had to stop, but I do not really know in what state I left my sculpture. I no longer had any opinion, but at the same time, I was completely incapable of saying, 'Do not cast it, drop everything until I return,' and I let it be cast. Once more, as usual, I think having done all this work has paid off; by the middle of the afternoon, the sculpture was better than anything I have done up to now. I also know what to hold on to in walking men (I could write ten pages on it), but as for the results of this actual sculpture, I have my doubts. I think it is catastrophic and I do not know what drove me to let it be cast and I may not even see the result and that is what irritates me."[4]

After some consideration, he had the bronze cast made and sent it to New York. Given the number of variations created on the same subject, the gallery asked him to provide titles. Despite his efforts, Giacometti struggled to name his sculptures. "I do not know what to call the walking man I sent (he will not leave me alone). *Walking Man III? September 15 Man?* Or a proper name! Raoul, Jean or Paul? 'Dubious Man' is too literary, I think, or 'Inhibited Man,' which he is, rather. You can find something that works."[5]

Matisse was no more inspired than Giacometti, and this *Walking Man*, which Patricia Matisse called "Paul," went by the name "Catastrophic Man" for a time. "When will we come up with titles that make sense!" lamented the gallerist.[6] Giacometti also created a new male figure, *Falling Man*. Of medium height, the frail silhouette caught in mid-fall is the most

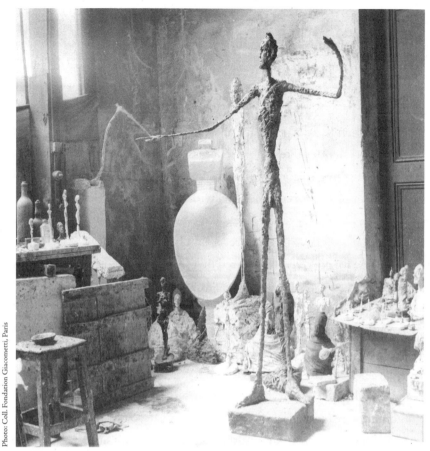

Photo: Coll. Fondation Giacometti, Paris

Man Pointing (1947), in the studio with *Spoon Woman* (1927) and female figures, c. 1954.

fragile and poetic of his male figures. "The falling man is very beautiful. A complete surprise. And so poignant. The movement is so unexpected and so expressive," Matisse wrote with enthusiasm.[7] The works met with success. Matisse had already sold three editions of *Man Pointing,*[8] one to the Baltimore Museum of Art and another to the Tate Gallery. "Should a French museum like the modern museum desire an edition, I would give up a bronze, but only in the case of a direct sale between you and the museum," suggested Matisse as he ordered the three remaining editions cast.[9] But the French museum never materialized, and the

editions were quickly sold in the United States. Giacometti continued to produce variations based on his previous motifs: a new version of *The Square* with nine figures; another with seven figures and a head; a female figure walking between two houses. He also created new works on the city square theme, which he preferred to call "compositions," comprising three, and then five, larger, static figures. The figures, set on a base, are not long and slender like their predecessors, but rather share the form he was then giving to some of his autonomous female figures: tall, thin blades, frontal, anchored in a base, with a craggy and almost abstract appearance. He also developed new, large-format female models, notably a female figure with arms outspread, perched on two large wheels: *The Chariot*. The work is clearly inspired by the art of ancient Egypt, evident both in the figure and the two wheels, which evoke the chariots used in processions. "There is a figure with large wheels! which I believe will have quite the appearance," he wrote to Matisse, also declaring, "There is also a small cavalry (six horses) forming in my studio."[10] For the first time, he set aside the human figure to focus on animal representations. Long and slender in a style recalling prehistoric painting, the horses would not be ready in time for the exhibition. Two of them would later be executed in large format, but they were never cast in bronze, and the plaster models, poorly stored, were destroyed. Giacometti borrowed the structure from *The Nose* to create *The Cage*, this time combining two characters. The reference to a theater stage is intentional, and the imbalance between the figures—a woman standing, clinging to the bars, and a man's bust emerging from the base—lent an intriguing character. Matisse identified the female figure as "a young virgin" and requested a title; Giacometti responded, with caustic humor, "The 'virgin' left only the man's head, but it is difficult to call it Judith and Holofernes, no, the room!"[11] Sketches indicate that the original idea for the work had been a cabaret act or strip tease, in which a woman bares herself as she opens a set of curtains. In that same period, Giacometti depicted prostitutes at Le Sphinx and rue de l'Échaudé in a few drawings and paintings, for

the first time making an overt reference to the unique attraction those female bodies held for him, so unknowable, yet on show and available.

Matisse's repeated request for titles provoked interesting responses from Giacometti, who tried to connect his works with his past experiences. As in his surrealist period, he associated memories with the creative process, even if those visions and emotions did not result in literal interpretations, or if he claimed they arose from his subconscious. He described the four small female figures lined up that appear in two works as "several nude women seen at Le Sphinx from my seat at the back of the room. The distance that separated us (the glistening parquet) and that seemed insurmountable despite my desire to cross it, impressed me as much as the women."[12]

The square with seven figures makes reference to a childhood memory. "The seven-figures-head composition reminds me of a corner of the forest seen over many years during my childhood, where the trees, with bare and slender trunks (bereft of branches all the way to the top) always seemed to resemble people frozen in mid-step and speaking to one another."

Similarly, the square with nine figures "seems to create the impression felt in the fall just before seeing a clearing (it was more like a wildish field, with trees and bushes, at the forest edge) that strongly appealed to me. I would have liked to paint it, to make something of it, and I left regretting that I had lost it."[13] Thus, these two works were titled *The Forest* and *The Glade*. These after-the-fact interpretations grew out of deliberate reformulation and are not to be taken literally. When he associated *The Chariot* with a memory from the hospital—"1938 in Bichat hospital, I was spellbound by the flashy pharmacy cart they pushed around the rooms"[14]—Giacometti himself added that this memory, which could in no way be a source of iconographic inspiration for his chariot driver, "was not the only motif that prompted me to make this sculpture." He thought better of his fragmented explanations in one of his letters. "Those titles I gave you yesterday will not do at all. If, for example, when the nine-figure

square is complete and in it I see a meadow that I very much wanted to paint last spring, that does not explain why I made the sculpture. These nine trials for figures ended up together by accident and formed a composition, a composition which was a vague attempt to rid myself of the rigor of the other three-figures-head square."[15]

Since his surrealist period, Giacometti had been wary of the interpretative reduction titles may produce. Several times, he had disputed and mocked those of his friends who thought they could identify the "invisible object" held by his mysterious female figure, which he referred to in his own lists simply as "sitting woman." This resistance endured. Despite Giacometti's efforts for this particular exhibition, Matisse continued to struggle to persuade him to assign titles to his works and to resist changing them over time.

The exhibition was planned for March 1950 but had to be postponed until the end of the year, because the finishes on the works were not complete. The first bronzes sent to New York in 1947–48 had been coated in a simple varnish, without patina, and were a golden color. Giacometti's opinion regarding finishes changed over time. Matisse and his American collectors had a clear preference for light bronze, practically without patina, which the sculptor often used himself. However, since commissioning the Rudier foundry for the bronzes, he had requested a dark patina, sometimes greenish in color, to be applied on site. Matisse criticized the quality of these finishes and requested that Diego carry them out himself, or at least oversee their application.[16] For the craggy figures in the city square works, Matisse recommended "dark rusty brown" patinas that would evoke the worn surface of archaeological objects. Giacometti, who had tested patinas on editions of these works, and finding none to his satisfaction, came up with an entirely different solution: to paint his bronzes. He had regularly worked this way on plaster, ever since Woman with Chariot in Maloja. He shared his idea with Matisse. "Difficulty with some of the patinas up until yesterday morning, especially for the two constructions. None of them satisfy me, not untreated,

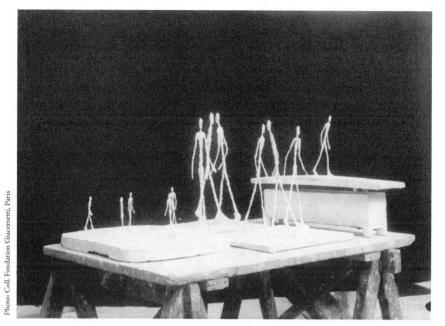

A group of sculptures at the Rudier foundry, c. 1948.

nor stripped, nor green, nor black, nor anything. They were never what I wanted them to be. Did some tests on old sculptures in the studio, but of what I have always wanted to do, which is paint them. It was so obviously what needed to be done that this morning I painted the two constructions, they were immediately finished, complete just as I had imagined them before starting, much better than what they had been in plaster, no comparison."[17]

He was encouraged by the approval expressed by Diego and Balthus, as well as Picasso, who stopped by unexpectedly to see the sculptures. Giacometti was delighted. "The patina question dropped or resolved for good, done, no question. You are in for a surprise, for the first time, sculptures as I intended them."[18] Matisse welcomed the idea with interest and expressed his approval when the works arrived in New York. "The color is quite to my liking; after the initial surprise, it seems quite natural."[19] However, problems with conservation arose immediately. One

of the figures broke in transport, and restoring it proved complicated. "It had to be soldered with a welding torch and you can imagine what that did to the paint! It melted. Even the platform had to be repainted. I will not deny, the colors you chose are difficult to reproduce and the sculpture's overall character has suffered. Repair was done by an artist who understands and likes your work, but how, even with the best intentions, could someone replace you and reproduce that essential light that illuminates your sculptures. It is a new problem to contend with."[20]

Matisse expressed interest in the painted sculptures that so pleased Giacometti, but he did not hesitate to convey his reservations about works he deemed less successful. "The only two pieces I do not like are the four white figurines on four golden feet—and the two houses. In both pieces, I find the painted figures over-painted; in other words, the paint gives the figures a character that seems to me to overstep your intentions."[21]

Giacometti did not take this criticism badly and immediately offered to rework the paintings, with which, he admitted, he was not himself satisfied. In fact, his enthusiasm for painted bronze, which had seemed to achieve the connection he sought to create between painting and sculpture, quickly gave way to a more tempered outlook. Matisse grew reluctant, as collectors were not enthusiastic about the technique either. Though Giacometti did paint some later bronzes, he did not generalize the practice, and most of the works were given the patina Matisse preferred: a "light matte gold."

CHAPTER 23

Relentless Work

The preceding years had been some of the most productive in Giacometti's artistic career. Gallerists contacted him regularly, and he informed Matisse of these exchanges. Kahnweiler had never followed through on the idea of Giacometti joining Galerie Simon because Picasso, secretly consulted, had advised him not to. Giacometti was angered by what he felt was Picasso's disloyalty, and, although he did not end their relationship, he held a grudge for years afterward. Loeb offered to represent him to sell his paintings, but Giacometti held back, waiting for a more interesting offer. The last few months, Louis Clayeux, the director of Galerie Maeght, had paid him regular visits, eventually earning his trust. Despite Matisse's reluctance—he would have preferred to negotiate for Galerie Louis Carré—Giacometti chose to join the new, fashionable gallery that had promised to cast as many bronze editions as he liked. In November 1949, he wrote, "Something else has come up, Maeght would like to hold an exhibition in spring (March), Clayeux came to see me about that. As far as spaces are concerned, I definitely prefer it and we could achieve something better here than anywhere else. I said that it could only happen with your agreement, and right here with Pierre, who bought paintings, drawings, and also sculpture (one!) and who would like to continue. Tell me what you think of it all."[1]

In January 1950, despite a heated meeting between the two dealers, an agreement was reached. The editions were divided into two groups, and the New York gallery retained exclusive rights to sales in the United States. Thus, Giacometti joined several of his friends already represented by the Parisian gallery, including Miró and Braque, to whom he paid a visit in August in Varengeville accompanied by Aimé Maeght.

Exhibition plans flourished. In June, two childhood friends from school at Schiers suggested organizing a joint exhibition with André

Masson at the Kunsthalle in Basel. With twenty-five sculptures and paintings and as many drawings, it was the first truly ambitious exhibition of Giacometti's work to be presented by a museum. He went to the opening and was particularly happy with the installation. The museum bought three works. After the inauguration, he went directly to Venice, where the contemporary art Biennale was being held. He had been approached the year before to be an advisor to and participant in an exhibition on major modern sculptors. The exhibition was originally to include an homage to Laurens and works by Lipchitz, Arp, Calder, Pevsner, Zadkine, and Giacometti. The previous year, he had traveled there with Annette to prepare his contribution. However, upset over a disagreement with the Biennale organizers, who had reduced Laurens's portion in the exhibition, and dissatisfied with the works he planned on showing, Giacometti withdrew from the event at the last minute. His pace had remained brisk ever since the intense preparations for the first exhibition at Matisse's gallery, but, despite his remarkable productivity, demand remained too high for him to fulfill every request. His schedule was irregular; he was in the habit of working at night and now grappled with nearly constant fatigue. It was a difficult time for Annette as well. Giacometti's mother was worried. "Alberto, I advise you to look after your health, and you, Diego, to take care of your brother: that means drinking less (I mean less than in Maloja, I do not know what you do in Paris); and Annettina should go to bed at 8:30 p.m. instead of 10:30 p.m. when she feels the need to rest."[2]

Giacometti withdrew from the Venice exhibition, but not because he hadn't worked. As Annette explained in a letter to Diego, during their stay in Maloja he had created several works for the exhibition, including "a woman in a cage."[3] "He needs to rest here a few more days because up until now, he has spent all his time working on his sculptures for Venice." The "woman in a cage" was never finished and was later abandoned.[4] He was "tired and anxious,"[5] he confessed to Matisse. Torn between the demands of his two dealers, both eager to show new works quickly,

Giacometti had difficulty coping with other requests and found himself increasingly beset by doubt.

This doubt, however, which tormented him daily, did not apply to the fundamental choice he had made in choosing figuration. Abstraction had triumphed in the postwar period, going on to become the dominant movement. Of the two opposing camps—the realists and the abstractionists—the latter were clearly seen as the heirs to modernity. Figurative art was relegated to the ranks of social art, a French adaption of social realism, or a conventional art popular with the masses, epitomized by Bernard Buffet and Bernard Lorjou.[6] Although still practiced by several avant-garde masters including Picasso, Matisse, and Chagall, representation no longer seemed to describe the current state of art, much less its future. The leaflet published by art critic Charles Estienne *L'art abstrait, est-il un académisme?* (Is Abtract Art Academic?) was not an indictment of abstraction's primacy, but simply an appeal in favor of lyrical abstraction as opposed to the geometric influence he had defended up to that point. Debates in the art world revolved around the question of hot versus cold abstraction. In a lecture given to an audience of critics and artists in December 1949, Pierre Loeb defended figuration and advocated "the end of abstraction," but this did nothing to weaken consensus. Giacometti attended the lecture along with his friends Balthus and Tériade, and agreed to create a lithographic print for the publication that was to be made of it the following year. He hesitated between a portrait of Loeb and a view of the studio, finally settling on the latter. Lithography had become an important practice for Giacometti, and he was happy to take on illustration projects. Since the beginning of the year, he had created etchings of the poet Iliazd and of Tzara for frontispieces in poetry collections. He created aqua fortis etchings and, at Maeght's suggestion, deepened his mastery of lithographic techniques. The gallery was developing a significant editorial element; it published its own review, *Derrière le miroir*, as well as independent prints.

The first Giacometti exhibition at Galerie Maeght took place in 1951. For the preface, Giacometti turned to Michel Leiris, an old companion who became one of his closest friends after the war; it was called "Pierres pour un Alberto Giacometti." The artist presented nearly fifty works, most of them new creations. Once again, he was hard-pressed to finish in time. "I understand that you would be happy if the exhibition were delayed a couple of weeks," wrote Annetta to her sons. "But Alberto will very probably work with plaster and colors up until the morning of the opening."[7] It was the first time Giacometti had developed a specific configuration for presenting his works. Instead of bases, he conceived furniture-like modules, some of them coated with a layer of plaster. The bronze and plaster works were presented on narrow steles, high tables, and slabs, all of them white. The highly irregular appearance of the base-tables drew on the slabs present in the most recent variations on *The Square*. Besides the female and male figures conceived after 1946, he exhibited recently created animal sculptures, including *The Horses* and the two sculptures *The Cat* and *The Dog* that followed. Borrowing from an old idea, he combined a bronze of *Man Pointing*—which he told Matisse he considered to be a "half-sculpture"—with a hieratic male figure in plaster. He also created a *Walking Man* from a new, medium-sized model on a slab base, which no doubt displeased him, because he later destroyed it, along with the figure *Man Pointing*. Included among the paintings were two particularly elaborate portraits, one of Annetta and one of Annette seated in the same spot in the family living room. Once more, Giacometti mustered all his energy to pull together the exhibition. It meant even more to him because it would be his first in Paris since his only solo exhibition at Galerie Pierre Colle in 1932. In preparing for the exhibition he worked himself into a creative frenzy, which affected his health as well as his morale. His mother was worried. "I hope, Alberto, that you are not once again working on a hundred things at once, which leave you no peace day or night!"[8] she wrote following the exhibition. In fact, as soon as the exhibition opened, he went right back to work. That

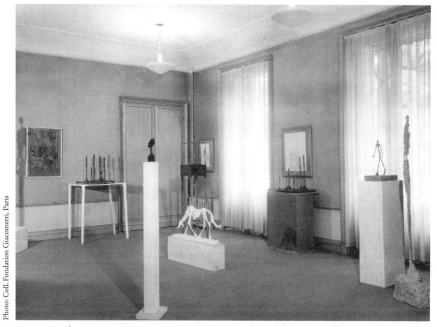

The *Alberto Giacometti* exhibition at Galerie Maeght, Paris, 1951.

summer, he worked on new "cages" and redoubled his efforts at painting. "I think the painting has been much better these last few days and there is something new."[9] He also agreed to create drawings for a book about his graphic work to be published by Tériade. After his summer trip to Maloja, he met up with Tériade in Cap-Ferrat in November. "I too think that Alberto has sat down to draw and he is ready to finish the book. He wrote me from Cap-Ferrat that after three days of interruptions he can no longer resist the urge to draw. What a character! He is only at peace with pencil or pen in hand. Sometimes, he is so anxious and impatient that he makes others anxious, especially women. Luckily, Annette is good-natured and always calm and content."[10]

During the trip, Giacometti met Henri Matisse for the first time and visited Picasso. His restlessness persisted, and several months later, his mother made a similar remark. "Odette said that during her last trip to Paris you were, Alberto, tired and very anxious, not yourself. In any

case, do not do more than you can. Annette ought to play Xanthippe and force you to take things easy. On the contrary she is patient (a lovely quality) and everything Alberto does she finds well done."[11]

Several weeks after receiving this letter, Giacometti traveled to Stampa. Charmed by the beautiful spring landscapes, he began a series of paintings, but he quickly encountered failure. "I first saw this landscape this morning, shining in the sun, the trees covered in flowers, and in the background, far off, mountains covered in snow. That is what I wanted to paint but since then the sky has darkened, it rains often, I have not seen the mountains in two weeks, the flowers have wilted, the white ones and the lilacs, and I continue with my landscapes until nightfall."[12]

The euphoria of sensation gave way to the usual struggle with representation. "All hope of rendering the vision of the first day is gone, but I am not so much bothered by it." Giacometti was no longer an impressionist painter, and nor had he been for a long time. The truth he was trying to render did not boil down to simply capturing a fleeting reality. In the evenings, he browsed his father's art history books and studied landscape paintings from different periods: Dutch and Flemish masters, impressionists, modern masters, and ancient Egyptian and Chinese paintings. Nothing he found surpassed the last two. The series of landscapes he finally painted was antithetical to his original idea: scenes of nature, painted indoors, were rendered in shades of gray accented with strong black and white lines, all placed within an inner frame that compressed the painting's square format. They combine the angular structure of ancient Egyptian reliefs with the curves of Chinese ink painting. He continued in this vein upon returning to Paris and tried his hand at street scenes, but he found himself confronting the same difficulties; he was dissatisfied with the result, and the motif seemed to evade him. After witnessing Giacometti destroy one of these landscapes, Matisse was compelled for the first time to write a long letter of admonishment and advice.

These difficulties aside, the world was in a disturbing state. The Cold War had dampened everyone's spirits and, almost two years into the Korean War, fears of nuclear war were running high. "All I can think of this evening is the overall situation, it seems rather dire, what will come of it? I would be happy to make a fuss, but I could not dare to think or speak more of our exhibition this evening without feeling ridiculously egotistical."[13]

Organization in the studio also underwent a radical change. In July 1952, both brothers felt the tragic shock of Eugène Rudier's death, which led to the foundry closing. As a result, Diego was obliged to find a makeshift foundry to meet demand, which was high. Absorbed in his work and troubled by issues in his creative process and concerns about exhibition organization, Giacometti gradually abandoned the cafés and the lively discussions that took place there. In the years directly following his return to Paris, seeing friends daily had played a large role in his life. A member of Sartre and de Beauvoir's inner circle, Giacometti had rubbed shoulders with many intellectuals, including Camus, Ponge, and Leiris. Although the connection remained, his evenings were now dedicated to work, and dinners were out of the question—such pleasures were also not available to Sartre, now famous and overwhelmed with work himself. Giacometti's friendship with Picasso had intensified when they were first reunited, but they were no longer close. First, there was the Kahnweiler incident, which had ignited a rivalry between them and left Giacometti bitter. Nor did he appreciate the way in which Picasso came to be the official illustrator for the Communist Party, and he mocked the "dove of peace" that appeared on every wall. "It looks dopey," he told Matisse.[14] In 1951, Giacometti paid a visit to Picasso in Vallauris and used his afghan greyhound as the model for *The Dog*, but the following year he spoke harshly about his friend. "Picasso in *Les Lettres françaises* an interview lower than anything, I hope to see him soon to tell him (regarding V. Hugo and Rodin), piece of s... !"[15] Giacometti was often subject to fits of anger, but friendship usually won out; however, the

time of the complicity between the two artists seemed to be over. Picasso had settled in the South of France and he was going through a difficult period in his personal life, which left him little time for others. His separation from Françoise Gilot in 1953 was the end of an era marked by Giacometti's presence. Regular visitors to rue Hippolyte-Maindron now included Balthus, who would soon leave for the countryside, Tailleux, Tériade, and Clayeux. In November 1952, while in Stampa, Giacometti received more sad news—Paul Éluard had died. Tzara asked Giacometti to create a series of works to be published in a tribute to the poet. He drew several portraits from memory, as well as a series of bouquets of flowers; their austere style lent them a funereal character not unlike the atmosphere that prevailed in his most recent works.

Doubt Returns

"I regret leaving you with such a negative impression on my second to last visit, when you destroyed your street landscape. It is very difficult, when one senses the confusion of someone searching for direction, to proffer opinions, particularly when one finds oneself impacted by the same bumps and blunders that person is experiencing. The only thing to do is to remain confident, even if there is nothing to be said. It is quite obvious that you are going through a very difficult period. Anything I could say, you already know. Perhaps you do not wish to confess or admit it. All I can say is that when you claim to use red in place of black to go faster before nightfall seems to me entirely confused. There can be no more question of light or color, at most of line. That was Picasso's stance. 'When I don't have blue, I use red, it is the same thing.' That may be true for Picasso, but certainly not for someone like you who paints in an entirely different way. All I can say is that you can do much more. I think, and perhaps I am mistaken, that you are distracting yourself in undertaking five paintings on the same subject, same pose, same character. If you cannot find what you are looking for in the first, there is no reason you will find it in the second, the third, the fourth, etc. Proof is in the fact that, for me in any case, when you go into a painting in depth, like the portrait of your mother and the still life with the apple, both painted in Switzerland during the war, you drew back the curtain and reached another plane, imagined, reconstructed, a plane where there is no longer any background or foreground that is not coherent with the rest, etc. It seems to me that after doing what you have done these last few years you now feel it necessary to start again in order to open a new door and go further. The two sculptures that you had started, the two women under their canopy, are not quite there yet. It is because they are too connected to what you did before that you cannot be done with

them. The issue of the cage and its development relative to the previous versions is not taken far enough, I would almost say that the first ones were better, purer, simpler. These seem complicated and forced, by desire, also a little by desperation, but without the same tension. You need to find solitude, peace of mind, without being hounded by anyone. If it seemed like I was pushing you, it is because I believed that this could have no negative effect on you and that you would remain independent, as you should. Why not stay on in Switzerland longer than you usually do, where you could let things get back to normal. It seems to me that the more you overdo sculpture, figures, heads, busts, painting, interiors, figures, still life, landscape, the less likely you will be to sort things out— and you will not do so in Paris—there is too much distraction in Paris, too many opportunities to justify recent errors, like that red instead of black. (I cannot get over it.) I will stop there. None of this reflects a lack of confidence, because I know very well what you are capable of, and that the hesitation you find yourself facing is undoubtedly necessary, but you must be done with it. There you have it, I never say anything, and now I hope I have not said too much, it is your turn."[1]

This long letter from Pierre Matisse was a response to Giacometti's increasing procrastination, which delayed completion of new works from week to week; it also reveals to what extent Giacometti was progressively sinking into doubt. After the self-assured period of 1947–51, when each new work seemed to be an improvement on the last, he was again assailed by uncertainty that compelled him to destroy works before he had completed them. For several months, Matisse had been urging him to finish a piece intended for an exhibition organized by MoMA, but none of Giacometti's attempts was successful. "For me, it is no longer so much about an exhibition but to see if I can still put together a sculpture and a painting. I am terribly stuck, I have done everything to end up here, but now I must be done with it, I doubt each grain of plaster, I cannot fall any further, at least that is settled!"[2]

The previous year, he had refused a proposal to represent Switzerland at the next Venice Biennale, because, he explained, he had no new works to show. Exhibitions had been a powerful motivator for his work and for generating new ideas. In four years, he had undertaken and sold more than sixty bronzes to Matisse. Despite engaging in a number of parallel explorations, he felt once again that he could only achieve truth in representation by working from models. Setting aside archetypal figures for a time, he resumed long sittings with Diego and Annette. For the first time, he allowed anecdote to enter his sculpted portraits: the bust of Diego in a sweater,[3] then one of him in a windbreaker are more descriptive than his previous works. The base was abandoned in favor of a new idea: the shoulders and torso would form the sculpture's massive, stable foundation, crowned with a head that was often much smaller. But the work progressed in fits and starts, and Giacometti often felt as if he had hit an impasse. Even projects that were ordinarily simple became very difficult to complete. He spent several months on a chandelier commissioned by Aimé and Marguerite Maeght for their home but remained dissatisfied. "And the chandelier, is it finished?" asked his mother, who urged him to complete it as quickly as possible. "It looks like the Tower of Babel, but if it is finished to everyone's satisfaction and if it is the most beautiful chandelier in Paris, I am very happy with it, too."[4]

Diego urged him on as well, aware of the impending deadlines. "I hope, Alberto, that you are working on the sculptures again," he wrote from Stampa.[5] Giacometti was caught between the voice of reason and a desire for perfection that led him endlessly to delay works or to destroy them. Exhaustion made him anxious and irritable. Although he usually appreciated Matisse's opinion, even when it was critical, the gallerist bore the brunt of Giacometti's complaints and hypersensitivity. Annetta warned him against these outbursts. "I was happy to see in your letter, dear Diego, that Matisse holds nothing against you, Alberto. You see once again you were wrong to get angry and so upset and write such harsh letters. But, as they say: the leopard cannot change its spots." She

also told him to avoid demanding too much from his models. "I hope you will make progress on the portrait of the Englishman and that you will not make that awful face I know so well. It is true, I am too old and too grumpy to be your model. Regardless, you can be sure that I will be the first to celebrate if you succeed with the others, you have the dedication and passion to get where you want to be. It so often seemed to me that you were searching for the impossible and it pained me. But I understand that I do not understand anything, and that reassures me in this case."[6]

Giacometti was as demanding with his models as he was with himself, requiring them to sit motionless for long hours and endure the fear that he might at any moment decide to destroy what he had accomplished.

The year 1953 brought a period of transition and a series of ups and downs for the artist. In the spring, he resumed sculpture with enthusiasm. He made several resolutions, including to work during the day rather than at night.[7] Diego remained vigilant. "I hope, Alberto, that you are still working on the sculptures, whatever you do, do not break them."[8] Giacometti had started new busts as well as female nudes bearing the same hieratic pose as the previous figures but displaying the more assertive femininity of Annette's body. He also sculpted a more realistic bust of Annette with a prominent bosom. The couple traveled to southwest France where they joined Fraenkel for a visit to the Lascaux caves, which had made a significant impression on Bataille the previous year. By autumn, Annetta had noticed an improvement in Giacometti's mood and attitude regarding work. But it would be another few months before the crisis was definitively over. In December, the Maeght family lost Bernard, Aimé and Marguerite's youngest son. Giacometti, who was a close friend of the family, agreed to create the funerary monument, which prompted several trips to Saint-Paul-de-Vence. In 1954, he felt as though he were progressing once again, especially in painting. He began using more colors and resumed painting his sculptures.[9] A new exhibition at Galerie Maeght, which included few sculptures, established him as a painter and draughtsman. Sartre wrote the foreword to the catalog, *Les*

Annette and Alberto Giacometti, Jean Genet, and Abdallah Ben Taga
in the artist's studio, October 14, 1956.

Peintures de Giacometti (The Paintings of Giacometti). Commissioned
to design a medallion with a head of Henri Matisse, he traveled to the
Midi region twice that summer. His drawings of the bed-ridden art-
ist were a touching tribute to Matisse, who passed away the following
November. The two painters he considered to form the pinnacle of
modern art, Bonnard and Matisse, had died within a few years of each
other. Sartre introduced him to the writer Jean Genet, the subject of
his recent book *Saint Genet: Actor and Martyr*. The two strong-minded
men took to each other immediately, and Genet became a familiar face
at rue Hippolyte-Maindron. Giacometti would capture Genet's intensity
in several painted and drawn portraits. The writer documented their
exchanges during sittings and wrote a remarkable account of the artist
and his studio. In the 1958 book *L'Atelier d'Alberto Giacometti* (Alberto
Giacometti's Studio), his vividly crafted portrait reveals the man in all
his complexity. "He smiles. And the wrinkles on his face began to laugh.

In a funny way. His eyes laugh, of course, but so does his forehead (he is the same gray as his studio). Perhaps he has taken on the color of dust out of affection. His teeth laugh—also spaced and gray—the wind blows through them. He looks at one of his statues. HIM: It is a little crooked, no? He says this word often. He is also rather crooked. He scratches his gray, disheveled head. Annette cuts his hair for him. He rolls up a gray trouser leg that had fallen down to his shoes. He was laughing six seconds ago, but he has just touched a newly begun statue: for half a minute, he will be completely absorbed in moving his fingers over the mass of clay. He is not at all interested in me."[10]

Genet, like Bataille and Beckett, conceived of the world and art in a way that resonated intensely with Giacometti's work. For the artist, the world was a source of constant wonder—felt in every detail, tree, and face—but also of private terror and hostility. Around the same time, Giacometti jotted down in his notebooks a physical and psychological portrait (no doubt of Sartre) which could have been his own. "Sharply faceted, concentrated, violent crystal, but above all head obstinately and violently straining forward with features of pain, sadness (regret) at the corners of the mouth, disillusioned as if with regret that life is nothing more than an abyss, as if denying the facts about the idea or feeling he had about life and what he imagined it could be, bitterly denied the belief he had in life but arising from within and not at all provoked by what people or facts could have inflicted upon him, or rather than bitterness, a disillusioned acceptance of the abyss that is life or the universe, with at the same time immense gentleness and kindness and understanding toward beings and things."[11]

He no longer engaged in political struggles as he had during his support of Aragon. The struggle had gone within, reaching the deepest, most impenetrable areas. Genet aptly describes the tormented humanity that connected them. "This visible world is what it is, and our action on it cannot make it otherwise. So we think nostalgically about a universe in which man, instead of acting so furiously on visible appearances, would

be employed in ridding himself of them, not just by refusing to act upon them, but by stripping himself enough to discover that secret place in ourselves from which an entirely different human adventure might possibly begin. More precisely, a moral one, no doubt. But, after all, it is perhaps to that inhuman condition, to that ineluctable arrangement, that we owe our nostalgia for a civilization that would try to venture somewhere beyond the measurable. It is Giacometti's body of work that makes our universe even more unbearable to me, so much does it seem that this artist knew how to remove whatever impeded his gaze so he could discover what remains of man when the pretense is removed. But perhaps Giacometti also needed the inhuman condition that is imposed on us so that his nostalgia could become so great that it would give him the strength to succeed in his search."[12]

The Santa Barbara Museum of Art had just held a solo exhibition, Giacometti's first in an American museum, and two major retrospectives were planned for 1955: one at the Guggenheim in New York, organized by the new director, James Sweeney, and another at the Arts Council in London, organized by the art critic David Sylvester; a third exhibition would travel to three German museums. Although Giacometti had lived in Paris for thirty years, recognition came first from abroad, particularly the United States, home to the greatest collectors of his work. Among them, an American industrialist, George David Thompson, went to great lengths to build the largest collection of Giacometti's works, starting with his pre-surrealist and surrealist pieces. There was growing interest in Giacometti's prewar period, and the artist agreed to issue his remaining plasters in bronze upon Matisse's request. He had settled on a new foundry and now had his bronzes cast at Susse. With orders arriving from two galleries, Giacometti's financial situation had greatly improved. Annetta advised him to attend to his family. "Now that you have money coming in from all over, I suggest that you open a savings account for Annette and buy her a nice ring before all that money disappears again."[13] However, Giacometti was opposed to any change in

his lifestyle and firmly rejected Annette's hope that he would add a little comfort to the couple's living quarters. But neither was he frugal. He was not generous with his works, but he could spend lavishly during his nighttime jaunts and responded favorably to numerous requests. It is easy to imagine Giacometti as a solitary figure, but in fact he had a large and diverse network. The few people allowed in the studio were very close friends and models: Genet, the English collectors Robert Sainsbury and Peter Watson, as well as Thompson, whenever he passed through Paris. But Giacometti remained a faithful friend, despite the distance that now characterized many of these relationships. Laurens, Miró, Ernst, Tzara, Balthus, and Braque remained dear friends, as did Derain, whom he visited regularly in Chambourcy and at the hospital in the months preceding his death in September 1954. After a Derain exhibition the following year at the Musée National d'Art Moderne, he produced two etchings titled *Homage to Derain*, after two portraits painted by his friend. Fraenkel was among the friends from the surrealist period with whom Giacometti was regularly in touch, and who remained his doctor and continued to treat him. He maintained ties with Sartre and de Beauvoir, even though they had fewer opportunities to meet. Although he associated with established authors like Beckett, Ponge, and Char, he also helped young poets by illustrating their books. Annette and he in this way developed long-term friendships with Olivier Larronde, André du Bouchet, and Léna Leclercq. He also had friends among the regular customers of the working-class restaurants and cafés of Montparnasse, as well as the area's cabarets and bars. He spent entire nights alone in his studio, face-to-face with his works, but this was not a sign that he was withdrawing from the world. Quite the contrary, Giacometti was gregarious and enjoyed serendipitous meetings and discussions. The poet Jacques Dupin, who wrote the first biography of the artist, confirms this. "When I talk about Giacometti and the anxiety of communication, by that I mean the impossibility of absolute communication, and not the difficulty of being and living with others. From the very beginning,

Giacometti enjoyed seduction, domination, fascination, and his gifts, his intelligence, his charm, and his physical attributes, his cunning and his obstinacy, the strength of his singular personality, sympathizing with everyone, enabled him, in effect, to seduce, dominate, and fascinate in every circumstance."[14]

The film director François Weyergans met Giacometti when he was just starting out and recounts an anecdote that captures the artist's contradictory and charming personality. "One day, I had a meeting with him and I arrived a little ahead of time, and the studio was open. So, I enter, I wait, I look around a bit, I wait. I wait an hour there and then suddenly he walks in, he looks at me and says, 'Did you steal anything?' I say, no, of course not, and he replies, 'Shame, because if you had, you would have something of mine, because I have a hard time giving things away, and I do not think I will give you anything, but if you had stolen it, I would have been happy knowing you had something of mine.'"[15] He also described Giacometti's nighttime walks in the streets of Paris, which he prolonged in order to put off being alone in the studio. Giacometti enjoyed these strolls and the nightlife. The improvement in his mood and thoughts of new opportunities for exhibitions made him forget his new resolutions. Despite exhaustion, he chose to work in the interval between sunset and the early morning hours when he felt most free. He began to work more deliberately at night, starting with his models in the studio in the afternoon, then, after his late outings, turned his attention to his oeuvre, working in silence and darkness until morning.

Success Arrives

Giacometti was now constantly beset by doubt, yet his pictorial work had flourished over the last two years. The effusion of new sculpted creations, however, gave way to a period of exploration and a return to the model, in which he struggled to produce results. Although he finished even fewer works than before, the long sittings with Diego and Annette produced a few successful pieces. Since completing *Bust of Man with a Sweater*, created in 1953, Giacometti's reflections on representation had taken a new direction. He insisted there was a difference between works inspired by "visions" and works created after models, which he claimed to favor, but he created a series of sculptures synthesizing the two approaches. The busts *Amenophis, Bust (Sharp Head)*, and *Tall Thin Head* combine realistic portraits of Diego with clear references to ancient Egyptian sculpture, evoking Giacometti's first bust of Isabel, which united two levels of representation. But he also introduced a new, more radical stylistic element. The heads of these busts, rising from substantial bases, look surprisingly like their models when viewed from the side, but fade to a fine vertical blade when viewed from the front. The informal title given to one, *Sharp Head*, aptly describes the extreme flattening Giacometti employed to achieve this. Once again, the artist combined the spatial element of his sculpture with a visual perspective that impact the work in a way that only becomes apparent as the viewer moves around it; but it was the first time he had united two directly opposed notions of the image in order to do so. The paradoxical emergence of form at the heart of the formless approaches the absurd, and gives these works a very particular suggestive power. Despite the serene and funereal aspect introduced by the reference to ancient Egyptian art, there is still a suggestion of violence, which can be felt in the extreme compression of material and the surface covered in jagged knife

strokes. The portrait is a faithful representation of Diego, but it is tormented, and more expressive of the artist's own anxiety than his brother's even-temperedness. The nude portraits of Annette sculpted during the same period convey a similarly violent approach to representation. "Sculpture in which I sense a kind of contained violence moves me the most. Violence moves me in sculpture," he explained.[1] His interest in archaeological objects incited him to include in the final sculpture accidents incurred during creation. When the arms broke on his standing figures because they were too thin, he kept the stumps of shoulders and hands resting on hips. Since 1953, Giacometti had been creating figures that he referred to as "monsters," which accentuated Annette's features to the point of caricature. With hollow eye-sockets, enlarged breasts and buttocks, and a generally ungraceful appearance, these figures stand in direct contrast to the slender feminine forms inspired by Greek korai and Egyptian figures that bespeak mythical and magical inspiration. He did not continue in this vein, but certain features of this heightened realism would infiltrate the stylized appearance of later female representations. He also introduced a form of pictorial realism in his plaster models, highlighting feminine volumes and facial features with black brush strokes or deep cuts made with a knife.

The exhibitions in London and New York were successful. Inaugurated just days apart, both received significant press coverage. Giacometti did not attend the installation, but he did travel to London with Annette and Clayeux following the opening. He was delighted with the exhibition, as well as the welcome he received. Having traveled so little, he was excited to discover the city. He shared his impressions with Diego, who had traveled to Switzerland to be with Annetta. "The exhibition is very, very beautiful, more than any of the others I think, and the space is beyond anything I could have expected. A very beautiful house, big with an incredible courtyard, better than a real palace. Everything is very well organized, including the catalog, which I will send. Huge success, lots of visitors, and a long raving article in the *Times*, the main English

paper. I found everything good here, basically, any better would have been impossible."[2]

As usual, this feeling of satisfaction did not prevent Giacometti from experiencing the self-criticism he perpetually subjected himself to. "Yesterday, I once again saw everything that is wrong with the sculptures and the paintings, which changes nothing about the exhibition."[3] His mother and Diego ended up teasing him about it. "Both of us, in reading your next-to-last letter, agreed that you are quite a character, in short, a whiner, constantly talking about your doubts and vowing to do better."[4]

Giacometti harbored a profound inner duality: a firm conviction that he was among the best and following the right path, and chronic dissatisfaction fueled by a feeling of being capable of more. Praise, however, was unanimous. The exhibition at the Guggenheim Museum was also positively received. Giacometti was celebrated as the leading European sculptor of his generation, having broken away from modern formalism to embody the spirit of his time. "As for Giacometti, he is just entirely expressionist. He is the heir to Rodin and Bourdelle. His elongated figures, his clay figures, as though petrified in a nervous outburst too long contained, most certainly express the Romantic state of mind that so clearly characterizes postwar painting and which seems to most reflect years of anxiety and disillusion, the Cold War years."[5]

He refused another invitation to New York, too anxious to return to the studio. "This morning I received a very nice letter from the director of the New York museum where my exhibition is being held and to my great surprise he tells me that the exhibition is a great success, with many visitors, and he invites me on behalf of the museum committee to visit New York, which I was not expecting. The exhibition is running until July 17, but I will not for a second consider going."[6]

In New York, critical success led to commercial success. Matisse, short on pieces to offer collectors, bought several works from Galerie Maeght through an intermediary, and had Diego apply a new patina

that was more in line with American tastes. The galleries were not on good terms. Matisse regularly reproached Giacometti for the favors he accorded Galerie Maeght, which had more direct access to the artist's works and had begun encroaching on Matisse's exclusive rights in America. Giacometti, despite declarations of loyalty and friendship, was not always scrupulous in his dealings with the galleries and intended to remain independent no matter what. He was a famous artist now, and he knew that nothing he could do would seriously impact his relationships with the two dealers. He delighted in commercial success because it was a sign of recognition, but it also created problems, even with those closest to him. "In your last letter, Alberto, I read that it is raining millions. Well, Annette and Diego, beware of promises!" lectured his mother.[7] But even as sales multiplied and money poured in, Giacometti was never interested in comfort. He crammed banknotes into a box under the bed and felt no need to improve his lifestyle. He had eaten the same meal for years: hard-boiled eggs, ham, bread, wine, and coffee—and it would never change. The furnishings in his studio grew more dilapidated and eventually dwindled to just two chairs, his and one for his model. At most, he agreed to a few changes in the bedroom. Genet, who had been a regular visitor to rue Hippolyte-Maindron for nearly four years, reports, "The room, the one he shares with Annette, is adorned with pretty red tile. The floor used to be packed earth. It was raining in their room, which also serves as their living quarters. It is with a heavy heart that he resigned himself to tile. The prettiest, but the humblest possible. He tells me he will never live anywhere but this studio and this room. If it were possible, he would have them be even simpler."[8]

The studio continued to attract many photographers. Since returning to Paris after the war, the most famous among them had come to call, including Cartier-Bresson, Brassaï, Irving Penn, and Gordon Parks. Giacometti had also met Ernst Scheidegger in Switzerland during the war and they had become friends. In 1948, the photographer settled in Paris, and he visited the studio nearly every day for two years. The two

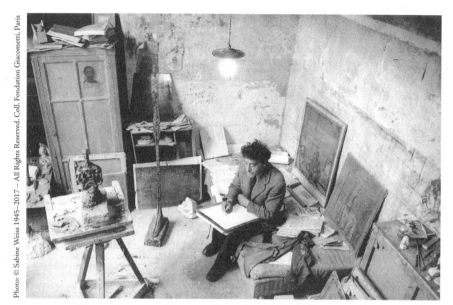

Alberto Giacometti drawing in his studio, July 1954. Photograph by Sabine Weiss.

remained close and Scheidegger took more than three thousand photographs of the studio over the years. In 1954, Sabine Weiss, a young Swiss photographer who had known Annette in Geneva, came to do a piece for the magazine *L'Œil*. She got on well with Giacometti and would return several times to photograph his works in the following years. The images she took of the studio show canvases piled in corners, evidence of painting's growing importance in the artist's practice—he now considered himself a painter as well as a sculptor. But the confidence that incited him to accept several portrait commissions was only temporary, and another troubled phase began. He had started several paintings simultaneously but was unable to complete any of them. Painting may have seemed to him a more stable practice and one spared the struggle with material that plagued his sculpture, but it, too, slipped from his grasp. Matisse's request that he write a preface for an upcoming Balthus exhibition provided him the opportunity to put into words his own personal inquiry. "Because of my work, which takes up all my time, it

seems more than ever that I have no idea where exactly I am with it. Everything is new at nearly every instant and what happened half an hour ago is forever obsolete, this generates a constantly new vision of things (of what I paint and therefore of everything) and not only of nature but also of painting (I do not see a painting by Rembrandt today the same way I saw it yesterday, nor any other), which all means I have no fixed idea about any painting, that I do not know what I think of it and it seems totally impossible to me to say anything about Balthus's painting, just as it would be impossible for me to say anything about Miró or Picasso or Buffet or Dubuffet or Mondrian or Riopelle or any of the others. I do stumble over the paintings of Matisse (I saw the marvelous exhibition again) or Derain or Bonnard but I could not write prefaces for their exhibitions without succumbing to a thousand contradictions."[9]

Giacometti visited Balthus in Chassy with Matisse in November. Despite his friendship with the painter, Giacometti considered his style to be different than that of Balthus, who was a disciple of modern classicism. Both men shared an interest in art history that spanned different time periods, but, according to an analysis by Balthus's brother Pierre Klossowski, the painter used culture to introduce "moral confusion" in his work.[10] Giacometti, who in 1952 had firmly reproached Ponge for describing him as an artist uninterested in culture, used it in another way. He rejected the anachronism of Balthus's compositions, as well as their theatrical character. For the most part, the peculiar eroticism of Balthus's work derives from the pose, which is openly presented in a series of contrived attitudes occasionally verging on contortion. There is nothing like this in the portraits of Annette. Although the young woman remains immobile, the subject, rather than her pose or attitude, is the object of Giacometti's pursuit. This is why, he explained, he always returned to the same models and the same positions. Art of the past infused his paintings—albeit less than his sculpture—yet it was not used as an element of confusion, but rather as a guide to accessing the essence of representation. He traveled a solitary path that took him away

from painters of the time; he described himself as an artist fumbling around in the fog. This uncertainty led to despondency, embarrassment, complaints, and a renewed enthusiasm in his work. "At the moment (for the last four weeks) I am living more like an exile than ever before, and every day I get the impression I am chasing a great adventure across unseen countries, where the world continually opens and closes on new lands with infinite horizons and even if it does not leave any traces."[11]

Giacometti shared Derain's fascination with ancient cultures. As an art collector, Derain had put together an imaginary museum of Greek, Roman, Etruscan, Coptic, and African art, which provided a source of inspiration for a series of clay sculptures created in the early 1950s. After his death, Giacometti restored a number of these works.[12] He also advised the artist's widow, Alice Derain, to have bronze editions made of the objects, especially the masks and medallions, to prevent them from being lost. He assisted with selecting the pieces to be cast and suggested a Swiss foundry to carry out the work. He also wrote an article for *Derrière le miroir* on the occasion of a posthumous Derain exhibition. In it, he expressed his admiration for the painter whom he considered to have defied classification. This was not the first time he had defended an artist he considered to be unfairly forgotten or insufficiently recognized. In 1949, he had agreed to participate in selecting artists for an exhibition on modern sculpture at the Venice Biennale, and strongly defended Laurens, whose contribution, he felt, had not been sufficiently represented. In 1956, besides advising Alice Derain, he agreed to serve on the selection committee for a sculpture exhibition organized for the Milan Triennale. He was heavily involved and took the initiative of having a new edition made of Raymond Duchamp-Villon's work *Large Horse*, so that the artist, who had figured among his avant-garde discoveries, might have an emblematic piece in the exhibition. Similarly, he agreed to create texts and etchings for tributes to his artist and poet friends— during their lifetime in the case of Laurens, Braque, and Picasso, and posthumously for Crevel, Éluard, and Reverdy.

CHAPTER 26

Yanaihara

In November 1955, Giacometti met someone who would play an important role in the years to come. A young Japanese philosopher, Isaku Yanaihara, was staying in Paris and asked to meet him. In his usual friendly way, Giacometti welcomed him warmly, and soon the young philosopher enjoyed the rare privilege of experiencing the intimacy of the artist's daily life. From his first visit, Yanaihara noticed the artist's tormented personality and poor health. "At 1:30pm I went to see Giacometti. He had just gotten up; bloodshot eyes, pale skin, coughing a lot."[1] Yanaihara observed the artist with enquiring eyes. "Large head and large hands," he noted. "He has very large fingers, fast fingers, always moving, and which continue to draw in the air while he speaks to me."[2] They quickly became friends and talked about art and the artist. Giacometti brought up the obstacles he had faced in painting and sculpture. "I do not understand anything," he repeated, "nothing, nothing, nothing."[3] He was going through his most difficult period yet. He had even resumed creating small sculpted figures, like those he had made during the war. But he was driven by necessity to create new works, for, after the exhibitions in London and New York, requests came pouring in. In December 1955, he agreed to represent France in sculpture at the next Venice Biennale, alongside Jacques Villon, who would represent painting; consequently, he turned down the same proposal to represent Switzerland that arrived several weeks later. He also agreed to present a retrospective exhibition at the Kuntsmuseum in Bern. His preparations for the two events included a series of female figures in the same vein as the large and medium-sized hieratic figures he had created from memory after the war. The figures were characterized by small heads that contrasted with large bodies, employing a similar approach to proportions present in recent busts of Diego. "Tomorrow," he explained to Matisse, "I must deliver the final

things for Venice, a head that I would like to finish tonight and small figures in the suitcase. And then I have to see to the Bern things. For this reason, I got out the large female figure from '47 that I am putting in order and another old one, too. I made thirteen medium-sized figures a bit like the one from '47 that I sent you. It helped quite a bit: I think each is an improvement on the last, up to the most recent one which Diego is in the process of casting."[4]

Of these thirteen figures, seven would be exhibited at the Biennale, where Giacometti installed them himself. These hieratic female forms, with arms held close to the body, synthesized the figures inspired by antiquity created from memory in 1947, and the nudes he was creating with Annette as his model. They combined the timeless and generic "style" of ancient Egyptian figures and Greek korai, with the embodiment unique to portraits painted from nature. Once again, Giacometti applied unnatural proportions—one meter twenty (3 ft. 11 in.) in height—in his quest to convey the experience of seeing something from a distance. Although the figures in *Women of Venice* appear very similar when seen from afar, their individual differences become apparent upon closer inspection. As Françoise Gilot reported, Giacometti was obsessed with capturing the moment and the distance at which the anonymous form suddenly becomes a familiar figure, but before the features come into focus.[5] Nine of these plaster models, including the seven presented in Venice, were subsequently issued in bronze. In 1956, Giacometti also created new works for the retrospective at the Kunstmuseum in Bern. He would have liked to turn his attention to painting, but he was obliged to continue producing sculptures for the exhibitions; for once, these clearly pleased him more than his paintings. He also received a rather unique request: Edgar J. Kaufmann, a wealthy American collector who commissioned Frank Lloyd Wright to build him a house—the well-known Fallingwater—asked him to create the door to the mausoleum he intended to have constructed on the property for himself. For the reliefs on the structure's double doors, Giacometti developed a new

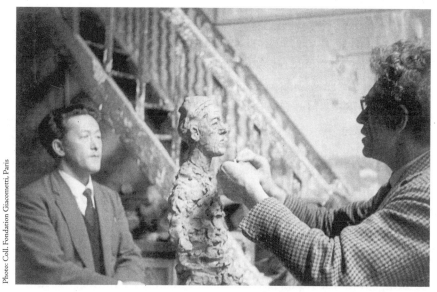

Yanaihara posing in the studio, Paris, 1960.

theme, which had surfaced in several drawings: an individual facing a tree. The work was completed in a single session during which he traced the motif by hand on a flat clay surface, transposing the quick gesture of drawing into the malleable material. Enlivened with a subtle relief, the two leaves present a mirror image of figures in nature, one masculine and one feminine, which can be interpreted as a romantic vision or a new take on the theme of Adam and Eve.

For months, Yanaihara, whom Giacometti would later ask to pose in the studio, watched the artist struggle mentally and physically with creating. From his very first visit, Yanaihara witnessed this struggle, particularly with sculpture. While speaking to his guest, Giacometti mechanically returned to his sculpting stand and massaged the clay of a small bust. "It was a bust fifty centimeters [18 in.] high, topped, as one might guess, with a very small head. The face was veined with the same minuscule web of lines as the paintings. The torso, however, formed a mass of clay swollen like lava."[6] On Yanaihara's next visit, Giacometti was

working on a female figure. His fingers traveled up and down the length of the armature, the figure no long possessed of arms or legs, only the beginning of the shoulders, which towered over the slender, powerfully sculpted body. The same struggle was taking place in his painting, and Giacometti found himself asking many questions, which he discussed with his visitor. "The age of painting is over," he declared. "Painting has no future." Then he tempered his opinion, limiting himself to his own conception of painting, which he insisted he was the only one to defend. "But I am the only one today who paints the way I do, only I want to paint the person himself.... From this perspective, I paint the old-fashioned way. For today's painters, whether figurative or abstract, the goal is not what they paint, but how they paint. The goal is not the subject but the painting. Whereas for me, it is not about making a painting, but rather creating exactly what I see. The painting is but a method for reaching this goal, which is to paint Genet's head or this woman's head, touch this reality that is reflected in my gaze."[7]

Giacometti constantly bemoaned his solitude, which found him swimming against the current so to speak, even in relation to his closest friends.

Yanaihara showed himself to be a tremendous intellectual companion. Many Japanese artists at the time were exploring how to overcome the dichotomy between tradition and modernity, and this became a recurring subject of discussion for the two men. "Do you think that your art is connected to arts of the past? asked the philosopher. —Intimately connected, yes. —And what do you like in particular about arts of the past? —That is difficult to say, because tastes change, do they not, with time. When I began my travels through Italy, I had a passion for Tintoretto. When later I discovered Byzantine mosaics, I thought I had reached the pinnacle of art. With Rembrandt, too, I thought I had reached the pinnacle. But Egyptian art remains the highest of all.... That will never change, and then there is the art of Mesopotamia."[8]

They discussed the great problems perplexing artists. Is art universal? Giacometti, who had always been extremely curious about all forms of

traditional art, was particularly enchanted by the existence of stylistic constants that transcend differences in civilizations. "Curiously, there are similarities, for example, between Mexican and pre-Columbian art. And in all kinds of ethnic arts, which share commonalities when you go back far enough, no?"[9] Can we be moved by the art of a foreign culture? "We look at Egyptian or Mesopotamian art and we feel real emotion. And we are quite right to do so. Myself, in these moments, I understand the very spirit that moved people to create these works. That is art's strength, it grabs hold of us.... It even has the power to change the world around us. We see Corot in the museum, and upon leaving, every landscape seems to have been painted by Corot.... That is real. Because it is not about grasping painting, it is painting that seizes us. Otherwise, why would we, Europeans, feel moved before Hokusai, eh?"[10] And he reminded Yanaihara that, as a young man, he had many times copied one of his father's Japanese prints.

Giacometti participated in these discussions with fervor. He had tackled these subjects in the past and his arguments had clarified over time. He presented Yanaihara with his idea that it is necessary to differentiate between work and object, one that had originally been presented to him by the critic Zervos regarding his pre-surrealist sculptures, and which he now applied to contemporary art. In the simple forms of the Cyclades, explained Zervos, each fragment, even broken, remained a work, because it was "full to bursting with plasticity,"[11] which he felt Giacometti's sculptures had not quite achieved. Giacometti returned to this criticism later, at a time when he was in need of redefining his practice, reflecting on the very nature of the work of art. The memory of having exhibited a vase in an exhibition of abstract artists[12] in 1937 strengthened his desire to establish a clear distinction between sculpture and object, and to position himself firmly within sculpture.

"Basically, if I compare them to pre-historic works," he explained to Yvon Taillandier in 1951, "it seems to me that modern sculpture (abstract—or that tending toward the abstract) is not 'descended' from

the first sculpture to represent a woman, but from pre-historic axes. This being so, they shift from one category to another and become objects. But to me, an object ceases to be a sculpture. To me, a sculpture must be the representation of something other than itself. And when I paint, I do so with the same intention."[13] He explained this idea to Yanaihara, who did not hesitate to play the role of critic. "Where, then, is the line between the work that is merely object and the work of art?" he retorted. Giacometti replied, "It is impossible to draw a line between the two, and yet, there is a clear difference, and I would even say a radical opposition. Take Mondrian, radically different from Cézanne or Rembrandt. Look at Brancusi and Greek statuary.... Mondrian's paintings are pleasing, it is true, and yet—and for this very reason—the slightest stain, the slightest hole made in a Mondrian painting strips it of all value. This is not true of a Rembrandt: even covered in dust, even stained, its value remains constant."[14]

Giacometti based the singular nature of his work on this reasoning and used it to differentiate himself, including from his artist friends. Thus, he classified both Miró and Picasso as creators of objects, along with Mondrian and Brancusi.

Yanaihara's discerning questions fueled discussion and went beyond the realm of the fine arts. Giacometti revealed himself to be a learned and well-read man, who held poetry in high regard, but also remained attentive to world events. He was anxious to hear about Sartre's travels in China, and curious about the progress of de-Stalinization in the Eastern Bloc countries, disgusted as he was by Soviet repression of the Hungarian Uprising and concerned about the position his Communist friends would take on the matter. Each morning, he bought newspapers and magazines, which he read from cover to cover in the little corner café where Annette and he ate. Then he would retreat to the studio where the noise of the world fell away, leaving him to his musings. Yanaihara was astounded by the simplicity and dilapidated state of rue Hippolyte-Maindron, which appeared to be a hovel at first sight. "We crossed the

threshold, opened the first small dirty door located on the side of a small courtyard and we went in, there, the studio I recognized from photos. A poorly lit studio, the windows too small. In the middle of the room, under a sad naked bulb, a delicate clay female statue, thirty centimeters [12 in.] tall, rose from a wooden stool. Near the entrance, a large table was pushed against the wall, piled with a collection of dusty bottles and old brushes. In the shadow of this extravagant heap, a little table and, what could only be described as the remains of human existence once freed of all that is superfluous, like phantoms and yet incredibly gracious, audacious, with boundless humility, a row of plaster figurines that seemed frozen in place. They were present in every size, from as big as a pinky to life-size; some, damaged, revealed their iron armature."

On the other side, the little space under the mezzanine was just as cluttered. "Against the back wall, there was a little bed covered with a jumble of newspapers, catalogs, and some other books. Then, in the middle of all that, a painting clearly in the process of being painted, a portrait of a woman whose face measured five centimeters [2 in.], leaning against the wall."[15]

At the time, Giacometti was working mostly with clay; accumulations of plaster had given way to a chaos of sculptures and paintings, both finished and unfinished. One year after meeting Yanaihara, Giacometti suggested that he pose for a painted portrait. Yanaihara was about to discover the studio and the artist from the model's point of view. He revealed himself to be an invaluable model, capable of holding the same pose for hours without moving. "He sits as immobile as a statue," marveled Giacometti.[16] The distance between his chair and Yanaihara's was precisely defined on the ground with a red mark, and the model was expected to remain strictly in place. Giacometti was alone with Yanaihara; only Annette passed now and again to stoke the coal stove. Visitors arrived unexpected, but they were all turned away—except for one, Jean Genet, who was always welcome, even if he interrupted the work. Giacometti remained focused on his model for two months.

An extraordinary affection developed between the two men. Yanaihara understood the difficulties Giacometti encountered in the creative process, accepted the agony of never-ending poses, tolerated and understood the endless lamentations, the angry outbursts, the dissatisfaction that could ruin an entire day's work in a single movement. Discussions gave way to silent, tense, tiring days for both artist and model. Statements of admiration poured forth—"marvelous," "how handsome you are"—referring less to the particularity of Yanaihara's face than the artist's own wonder in the face of nature. "Absorbed in his work, he emitted now and then a curious 'aie, aah,' a sort of barking. I thought they were cries of surprise at a mistake, an unexpected difficulty, but they were cries of joy at discovering something new in my face. The work was going well, one could almost say Giacometti was prevailing. 'It's working, this is the first time it has worked so well.'"

But enthusiasm quickly gave way to discontent. "His good mood is gone, I realize that I witnessed a gradual sinking. 'It's getting difficult, that's normal, a face is much more complicated and much more demanding than a bottle.'" Destruction was not far off. "Your face has disappeared from the painting, but it had to be done, do not be discouraged."[17] Giacometti was not discouraged. In Yanaihara's opinion, he was stimulated by failure and fought a constant battle with it. Desperation—"Catastrophic!" "It's not working!" "Shit!"—alternated with signs of progress. "It's starting!" For the first time, he had found a model, other than Diego and Annette, who understood and accepted his endless deferrals. Genet, after three painted portraits, declared defeat in 1957, no longer capable of withstanding the torture of sitting. "My buttocks still bear the straw imprint from the kitchen chair he made me sit on for some forty-odd days to paint my portrait," he would recall, twenty-five years later.[18] Yanaihara was committed to his role as model. This enabled Giacometti, if not to resolve his chronic crises, then at least to continue moving forward with this work. "Do not worry about the Japanese man," he wrote to Matisse, who was concerned that this new model would distract him further,

"to the contrary, if his portrait goes well, and I think it will (a little at least!), then there will be Annettes and Diegos and trees and apples and anything else you like and a little better in sculpture, too."[19] Despite the initial difficulties Giacometti encountered with his new model, his presence had the beneficial effect of rekindling in the artist a creative energy. Exhibitions, which had played this role when they were still a novelty, had since become a source of stress and fatigue—not to mention grumblings from his two dealers. Yanaihara's presence reestablished the suspension of time Giacometti needed to move forward, and their conversations enriched his reflections, which he now sought to distance from his postwar intellectual debates, regardless of the friendships he still maintained from that period.

CHAPTER 27

A Unique Friendship

Yanaihara first posed for Giacometti in September 1956, nearly a year after they first met. After two years in Paris, he was approaching the end of his stay and his departure was scheduled for early October. In the end, though, he would push his departure back several times in order to meet the sculptor's incessant demands. He became a part of Giacometti's life and the couple's routine. The three ate their meals together, went to performances, and spent hours talking in cafés. During this time spent together, Giacometti talked about his artistic conceptions and his lifestyle. The importance of travel was one of the first subjects to arise. Unlike Yanaihara, who felt compelled to see the world, Giacometti had never traveled because his obsession with work kept him tied to his studio. But he had also never felt the need to travel. He did not share the conviction that spending a limited time in a culture led to a better understanding of it, and mocked the idea that Sartre now better understood China for having been there. Yanaihara contradicted him by citing Goethe and Stendhal. "Yes, travel is good for writers. But Stendhal's notes on his travels are interesting because he was not a tourist, and at the same time he traveled within, there is no point in traveling if it does not entail self-exploration!"[1]

He was convinced that artists in general do not travel. "Neither Cézanne nor any of the others traveled." The idea was very important to him. "After a long while, I was surprised to hear him murmur, 'We are talking about writers in general, but poets are a bit different, neither Baudelaire nor Mallarmé were travelers.'—He was still thinking about it! He had a kind of obsession, to keep mulling something over while you had already stopped thinking about it." The friendship between the two men grew so close precisely because Giacometti could return endlessly to questions that excited or preoccupied him. When speaking

with the ever-alert philosopher, he sought both to convince him and to clarify his own ideas. They also spoke of Giacometti's distain for modern technology; particularly anything having to do with modern domestic comfort, which he now had the means to acquire for rue Hippolyte-Maindron. Yanaihara argued in its favor. "Mechanized civilization is nonetheless an advance for humankind. Is that which facilitates life not welcome? (Changing the subject slightly, I addressed Annette.) For you, too, it would be more comfortable to have a washing machine, a gas water heater, central heating.... Oh, no! Giacometti jumped in, no central heating, there is nothing more tiresome, and it is so much better to burn coal in a stove, no? Rather than having hot water at the ready, I prefer a thousand times over when Annette goes to the faucet to fill a pot, and sets it to boil on the fire. —You must admit, without electricity you would be hard up? —For that, even if the old gas lamps are nicer, it is true that we see better by electricity. But since water temperature is the same whether boiled on the stove or by a machine, why not choose the more pleasant? —Except it does not require the same amount of time, and by saving time and trouble, one is free to take up more useful things. —More useful? Like what?"

Giacometti was firmly opposed to modern mechanization. "Machines serve only to kill the spirit." He lamented, for example, the arrival of running water in Stampa, which had eliminated the old tradition of socializing around the communal well. He rejected the acceleration that accompanied progress; he rejected comfort not out of asceticism, but rather a profound appreciation for a life he loved and whose discomforts did not bother him, accustomed as he was to the harsh climate and life in the mountains, which he still missed. His belief in preserving local traditions was quite compatible with his interest in foreign cultures and customs. He was enchanted at the idea of dining in the only Japanese restaurant in Paris, unlike Genet, who was wary but eventually gave in to his friends' urging. Annette and he delighted in their "Japanese" outings with Yanaihara, remarking at length about a kabuki performance,

then questioning their friend about the art, lifestyle, and importance of religion in Japan.

Yanaihara came to sit each day in the early afternoon and stayed until evening. Then Annette joined them and they all went to a café. After dinner, the friends parted ways and Giacometti would go off alone on his nighttime stroll. Yanaihara sometimes accompanied him or joined him in his usual hangouts. "He was often at Chez Adrien, a bar located on a little street across from La Coupole, with white writing paper spread before him, motionless and immersed in his thoughts. Sometimes he was surrounded by prostitutes, chatting amiably. Relaxing in a bar after dinner was his only opportunity to rest. Then, he returned to work in the studio."[2] Yanaihara discovered with some surprise the unique couple that was Giacometti and his young wife. One evening, after attending a play by Camus inspired by one of Faulkner's novels, the conversation turned to one of the play's themes, prostitution. Giacometti freely stated his attraction to prostitutes, without appearing to shock Annette. "No creature is more free and more absurd than a cocotte. I am practically on my knees before them. If I were a woman, I would be a cocotte," he declared, which reminded him of his first memory of a prostitute, in Italy. "When I saw her in the street, she was an ordinary woman. Naked, she was an inaccessible goddess, a thousand times more marvelous than all the Renaissance sculpture that I discovered in Rome." His wife interjected. "So, you did not make love? –Of course we did. And I was happy to find that it was something purely mechanical, without the slightest sentimentality one usually imagines when talking about love."

Annette and Alberto were not an emancipated couple, united by a pact, like de Beauvoir and Sartre. They had a far more traditional relationship, and Annette's combined role of wife, assistant, and model instilled an ever-present familiarity between them. Diego and Nelly had since moved into a separate studio Giacometti rented in an adjacent street, which they used as living quarters, and the domestic circle had tightened even more around the couple.[3] But Annette respected her husband's need for

freedom, as well as his dealings with prostitutes. When she met him in Geneva, his friends had all been aware of his penchant for the nightlife. Yanaihara's nearly constant presence, however, introduced a new element. Over time, the relationship between the three friends grew closer and closer. From this point on, Annette, who usually engaged in her own activities and dined by herself when Alberto stayed too long at the studio, attuned her rhythm to that of the artist and his model. "We were like three points, each spinning with its own centripetal force and converging little by little towards the center. And at the center, of course, there was Giacometti's work," Yanaihara would later recall.[4] One evening when Giacometti was out, Annette and Yanaihara went to a concert together. That same evening, they became lovers. Annette did not hide the affair; on the contrary, she immediately told her husband about it. Yanaihara was surprised by Giacometti's reaction when he saw him the next day. "You are not angry with me? —Me, angry with you? And as though the idea seemed absurd to him: Whatever you might do, I could never be angry with you. Quite the contrary, it seems perfectly natural to me that she should be with you. She did well to do so, and I am happy for her."[5]

The jealousy that had tainted his first romantic relationships was gone. Giacometti valued his freedom above all else and would never oblige Annette to respect rules he himself had no intention of following. He did, however, make a distinction between sexuality and love, and one might imagine him worrying about these developments in Annette's feelings, since she had loved him exclusively up to that point. But he demonstrated no such fears, clearly confident in the strength of their marriage and in his friendship with Yanaihara. If anything, the affair, which Giacometti accepted, contributed to strengthening the "circle" of friendship between the three of them. "I would not know how to describe exactly what influence my relationship with Annette may have had on Giacometti, on his mood, on his work. But to say that it pleased him, that is no lie. He said it himself. 'According to conventional common sense, I should be laughed at like a pitiful cuckold, or a husband

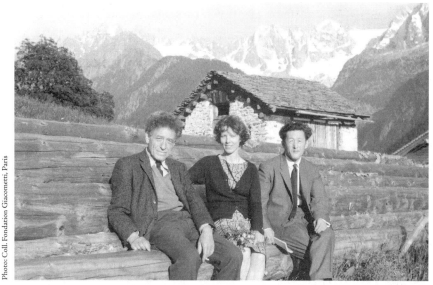

Alberto and Annette Giacometti and Yanaihara near Stampa, 1961.

devoured by jealousy, but it is common sense that is laughable. Nothing is more foreign to me than jealousy. This feeling that turns a husband, a wife, a lover into a belonging, that wants to possess beings as though they were things, that wants to dominate and chain them.... There is no greater threat to freedom.'"

And he added, "To respect Annette's freedom is to love her, no? Especially in the present case, if she chose you, I can only be pleased myself. Look at how happy she has been recently, thanks to you.... I love Annette, am I not right to delight in her happiness?"

These words may have been invented for the circumstance, but even if that were so, Giacometti intended to maintain their exceptional relationship, which united work and friendship. "The relationship between the three of us has surpassed anything imaginable. This adventure surpasses every other adventure, in the same way our work is an adventure that surpasses all the others," he would later write.[6] In December, Yanaihara was called back to Japan; he could delay no further. His departure was

wrenching for Alberto and Annette, who accompanied him to the airport. The very next day, Giacometti wrote to him, "I am at La Coupole, facing our spot, Annette has gone to bed (we dined with Diego at Tamaris) and I was anxious to write to you. You do not know, my dear Yanaihara, everything you have done for me. Our wonderful adventure, and to know that since the day before yesterday, we are free to see each other again whenever we like. But it is as though you were still here and I can write no more this evening, next time, yes. Your Alberto Giacometti."[7]

The next day, he wrote again. "We returned home before midnight. Annette went to bed straight away, I went to the studio, I looked at our work and I began your portrait on a small canvas in the size I find more natural, the head much smaller than the one further away, I saw you as though you were there. I will make this portrait for Annette, and one for you, in the same size."[8]

They exchanged letters regularly over the years and Yanaihara returned to Paris several times, invited by Giacometti, who paid his way, thrilled to see his model and friend once more. But the friendship had made its most significant contribution to Giacometti's career during the first period in 1956. Without leading to a major stylistic shift, it nevertheless constituted an exceptionally intense experience and helped him broaden his investigations. Yanaihara's alterity plunged him into greater perplexity than his previous relationships and models had, but the occasional disruption was beneficial. After Yanaihara's departure, Giacometti approached his work with renewed confidence.[9] He wrote to his friend from Stampa, several months after his departure. "I redid all the work we did together, traversing every adventure except desperation, and it was as if you were still there although I could not particularly do your head, I thought of all the heads I had done all at once, Annette, Diego, and the others, and here I've been looking at Annette, my mother, the servant, the men in the bistro, everything, through, and in relationship to, what we achieved together."[10]

The following month he added, "My work has changed since our work together. I began six sculptures, it has been ten years since I've worked with such interest or enthusiasm, anxious to continue tomorrow, and anxious to paint as well."[11]

Two years later, he would recall with feeling that decisive moment. "But now it is as if we were in the studio in '56, the day when nothing was working anymore, when for the first time in my life I found myself seated before my canvas unable to draw the slightest line, incapable of doing anything at all. It is thanks to you that I reached this point that I absolutely had to reach. This was only possible after two or more months of uninterrupted work with you. That day everything started over for me. It was no longer about painting your portrait, but about understanding why I was incapable of doing it."[12]

Giacometti maintained his friendship with the Japanese philosopher for the rest of his life, and kept several portraits that he made of his friend.[13] Over a five-year period, he would make twenty-two in all, as well as numerous drawings and two finely sculpted busts. As for Yanaihara, he contributed a precious record of the artist's life through his writing, and contributed to making Giacometti's work known in Japan.

CHAPTER 28

Giacometti the Painter

"It is curious how most people think photography is better than paint-
ing when it comes to accurately representing reality. Even a surrealist
or abstract painter will show you photographs of his children, but what
does that matter! There are many who think that painting portraits serves
no purpose considering the progress made in photography. And so, as
a result, painted portraits are rarely found any more in exhibitions. But
I, myself, think that a sculpted Egyptian head or a Byzantine mosaic
more closely resembles the reality of real faces than any photograph."[1]

Giacometti, who had long avoided encroaching on his father's artistic
territory, now considered himself a painter in his own right. When he
resumed this practice, he assumed that it would cede more easily than
sculpture to his desire to accurately represent what he saw. Despite his
claims in favor of observing the real, he continued to produce sculptures
created without models and inspired by art's historical past. His painting,
however, remained rooted in a direct confrontation with the subject. His
originality as a painter did not result from a rich imagination, but rather
his insistence on translating his perception of the real, unfettered by any
preconceived ideas. "Nearly all painters today wish only to exercise their
subjectivity instead of abandoning it in order to accurately copy nature.
The result? You saw it today at the gallery: current painting seems to have
a thousand facets and strangely it all looks the same. They want to be
individual and instead they disindividualize. In seeking to do something
new, they repeat the old. This is particularly true of abstract painting.
Most young abstract painters find copying nature common, they prefer
to be subjective and individual rather than common. But in reality, they
become so through this very choice. The situation is completely reversed.
Cézanne did not at all seek to be an individual, he wanted to copy nature

accurately by removing subjectivity. Which means nothing could be more individual than Cezanne's painting."[2]

Giacometti walked the fine line of trying to render what he saw without succumbing to photography's supposed objectivity, nor surrendering to subjectivity's fictional freedom. Abstraction and expression were the dominant trends of the day. Giacometti knew, and even regularly spent time with, some of the painters who represented these new movements. He met and befriended Jean-Paul Riopelle—an artist represented by Galerie Maeght—Hans Hartung, and artists in the CoBrA movement. His studio neighbor, the Norwegian sculptor Sonja Ferlov, had joined the group along with her husband, the painter Ernest Mancoba. Ferlov and Giacometti had neighborly relations—rumor had it she even gave birth to her son in his studio. Among the French members of CoBrA, he met Alechinsky and was interested by the way in which he drew inspiration from Eastern calligraphy. In the field of painting, as in sculpture, ancient and foreign influences fed his conception of the reality of representation. "A landscape of a street corner in Paris like this one more closely resembles Japanese or Chinese painting than European painting, no? The 'Orientals' knew how to render the vastness and depth of a place using shades of India ink or subtle monochromatic nuances, knowing nature as deeply as they did. I do not understand why European painters only use loud colors."[3]

Besides his rejection of personal expressiveness, his revulsion for strident colors placed him outside of the dominant movements. His choice of color was closer to that of the cubists than to any other artistic movement. At the Picasso retrospective held at the Musée des Arts Décoratifs in Paris in 1955, this period in particular enthralled him. The restricted colors that define his paintings were in keeping with his working conditions. His studio was dark, he objected to using electric light and continued to work after darkness had fallen. Although he used a variety of colors, they served only to highlight this or that detail among the many shades of gray and ocher that dominate his paintings.

He worked over fine-lined figures with a turpentine-soaked brush, isolating them and reinforcing the overall gray tone. Yanaihara described the result of this particular brushwork technique after a long day of sitting. "The portrait that so resembled me no longer existed, the eyes and the mouth appeared swaddled in a thick fog and had melted in among the shades of gray. 'It looks like a painting by Eugène Carrière,' remarked Giacometti. 'What I am trying to do obviously has nothing to do with Carrière's work, in which objects dissolve into a lyrical shadow. Yet, these nuances lingering on alone resemble it, do they not? I liked him most of all when I had just arrived in Paris. At the time I painted in a style a bit like cubism, but really I wanted to paint like Carrière in monochromatic nuances. It seemed more real to me. Except there were ideas going around that prevented me from doing it. Thirty years later, today, I am finally in a position to try.'"[4]

The artist may have been expressing his fondness for paradox and provocation in making reference to Eugène Carrière. The painter's camaïeu technique was in fact the complete opposite of Giacometti's first reference in painting, his father, who painted colorful outdoor scenes. Although Giacometti had never previously cited Carrière, he had nevertheless paid close attention before the war to the work of Gustave Moreau, whose studio-museum he visited. The painter's choice of subjects fascinated the surrealists, and Giacometti picked up on his use of infinite shades and the way he made the figure stand out from a dim background by superimposing a precise drawing.

The artist paid attention to everything that went on in the artistic world and was generous in encouraging younger artists—he bought Taslitzky's drawings, wrote a letter of congratulations to the young painter Eugène Leroy whose work he had seen at Galerie Pierre, provided financial help to the Lettrist Isidore Isou, and lent encouragement to Gérard Fromanger—but he only compared his own work to past artists. He felt that none of his friends—Picasso, Miró, Masson, or even Balthus—shared his pictorial approach. During his discussions with Yanaihara, he

preferred to compare himself with the amateur painters in the place du Tertre, who, through their naiveté, offered an uncorrupted relationship to the real. He was no more forgiving with contemporary realist artists than with abstract artists, and he felt no more affinity with them. Bernard Buffet, the new favorite of Paris society, and André Fougeron, leader of a "social art" supported by the Communist Party, were no more credible in his opinion. He had been tempted to believe that social realist art was possible, but, he explained, the works it produced destroyed any illusions he had had. Realism's aesthetic was not the solution to the search for the real; it was not even a possible option for a purely political aim. "For a while I supported those who were exploring the path of 'socialist real-ism'; I thought they could at least do social good, even if that lies outside the realm of artistic creation. I had to retract my support when I saw that, in socialist countries, this painting's nineteenth-century academic foundation compromised not only its artistic value but also any possible good it might do in terms of immediate and passionate agitation around important questions of revolution. For me, all things considered, and within certain limits, I might take more interest in poor popular painting (for example, the decoration in certain restaurants in Paris)."[5]

What Giacometti disapproved of in the work of most figurative painters was a dependency on existing pictorial methods that intro-duced a filter between the artist and the real. "Painting can only be the representation of something other than painting itself," he insisted. Shortcomings in modern culture that devalued or rendered personal experience impossible corresponded to the loss of reality in the realm of painting. Giacometti was referring to this constantly renewed experi-ence when he claimed to paint what he saw, exactly as he saw it and not according to conventions, whatever they may be. He intended to paint straightforward copies of nature, as ambiguous a goal as that may have been. He was aware of the pitfalls, which he tried to get around with rational argument. "Regarding reality, I must clarify that, in my opinion, the distinction between interior reality and exterior reality is purely

rhetorical, for reality is a fabric of relationships at every level." Similarly, he anticipated the critics by addressing his own difficulty in conveying his position in his paintings and thus articulating discourse and experience. "Furthermore, my position is full of strange misunderstandings. Most of my acquaintances are abstract painters, they say that I am a modern artist, and when I tell them that I am copying a head, they do not believe me; we are talking at cross purposes, strictly speaking. My interlocutor already knows what reality it, he thinks it is opaque, even mundane, and he likes me because he thinks I am not mundane. For me, on the other hand, my painting and my sculpture are beneath reality. To them reality is wretched, for me, it is my painting that is wretched. I prefer Manet to an official painter of the Second Empire, not because a nude by Manet is more imaginative, but because it is more real. If I were able to represent a head as I really see it, perhaps the others would say that it is mundane."[6]

Giacometti's models all attested to the artist's demand for truth in the face of reality, that it was not a posture he took to stand out, but a real struggle he undertook with himself every step of the way. "We have these pleasant discussions, but the calm does not last long. Suddenly, a storm picked up. 'It is not going well, I am almost there, and I do not have the courage to take this small step further, shit!' He clenched his teeth, forcing himself to paint and from his mouth poured forth the darkest words, cries of desperation and curses. And sometimes even, to cap it all, an aaah! shouted at the top of his lungs. The little rue Hippolyte-Maindron where the studio was located was often deserted, but anyone who happened to pass by on an evening in November 1956 would most certainly have been frightened by the strange exclamations that emanated from the walls of this rickety shack. They sounded like the ravings of a madman."[7]

Giacometti cursed, swore, demolished, started over, each day stimulated by the previous day's failure. He established a fanatical protocol, for both himself and his model: an exact distance between the easel

and the model, a specific height for the canvas, an insistence on being positioned correctly. In his left hand, he held his palette, a handful of ultrafine paintbrushes, and a brush. A table next to him was strewn with used paintbrushes and bottles of turpentine. He smoked endlessly, scattering his ashes and letting cigarette butts burn the easel or sculptures. Sometimes, he continued painting from memory after his model had left, then went back to it when the person returned. But he never painted a portrait entirely without a model, not even of Annette or Diego, whose features he knew by heart. When his pictorial production began to flourish again in 1958, following the Yanaihara period, his conflictual relationship with representation remained the same, and his shifting feelings of satisfaction and discouragement stayed the norm. Although his style crystalized and he showed himself to be at his best in a series of nudes of Annette, he would never again have a peaceful relationship with creation.

Unlike most of his contemporaries, Giacometti kept his motifs as well as his colors to a minimum. In his portraits, the positioning almost never changed, and the model took precedence over surrounding details, which he eliminated in favor of a wash or canvas left white. The model's face, particularly the eyes, held all his attention, at the expense of the rest of the body. Concentrating on the essential seemed to him a necessary condition to achieving truth in painting. He defended this principal to his artist friends, including Jean Hélion, who, after a lively discussion on the topic, replied, "I think that you have chosen to always look at things by staring first at the figure that you have placed among them, and then, in the painting that you make, you try not to let these things take up any more space than what the figure leaves them if you do not take your eyes off of it. Is that it? So be it. It is perfect. But it is not the only nor mandatory position. I have the right to look at the figure in my portrait straight on, as you do; or I can look at it and include the nearest objects: the hand, the book it is carrying, the chair, and, another time, more of what surrounds it."[8]

Giacometti could not accept this reasoning, removed as it was from his own ideas. He refused the idea of composition and remained attached to motifs without anecdote or arrangement. Similarly, the idea of ambiance was foreign to him; he created a face-to-face relationship between the viewer and the model through the intervention of his particular vision. The unfinished appearance that characterized most of his paintings from the mid-1950s onwards contributed to this focus on vision. The image, emerging from shadowy depths, crystalized in the center and at the surface of the canvas. The dim, neutral zone that he created around the subject played the same role as the frame integrated into the canvas, which enabled him to contain the viewer's gaze. He drew on Cézanne, but also Picasso's *Paul as Harlequin*, left partially unfinished, and Derain's *Pears* on a black background that had so impressed him in 1936. Inspiration also came from further afield. A series of small gray heads bearing expressions of concentration conveyed through an exceptional density of material call to mind Fayum portraits, a reproduction of which Giacometti had tacked up in the studio.

In the last several years, landscape had taken on particular importance in his work. Those paintings done from his window in Stampa in 1952 were followed by urban landscapes and numerous drawings of natural elements carried out in Paris and Switzerland, including fruit, flowers, trees, and mountains. Nature was a recurring theme and became the main source of many analogies. To the artist, the figures in the city square works had evoked trees and the faces in the busts of Diego towered over a mountainous mass, and now even painting fell under the influence of this association of ideas. "Painting a face is like painting a landscape of tangled mountains and valleys, the nose is a gigantic mountain made up of countless boulders."[9] As Giacometti often said, his portraits were not psychological portraits. He explained to Yanaihara how he started them at the nose, which he compared to a pyramid, as though he were dealing with an aerial view of a mineral landscape. In fact, he appreciated this mineral quality in Yanaihara's face, the eyes that narrowed to two

notches and its ability to remain perfectly still; long periods of sitting and fatigue blurred the facial and corporeal expressions of Annette and Diego. In 1951, Giacometti began drawing a series of maps in which the topography of the sites corresponded to the topography of the body. Volume was represented not in the play of shadows but rather by a web of curving lines shifting from black to white. Structural lines underpinned volumes, similar to a technical drawing. Giacometti often cried out in wonder before the natural perfection of facial structure. Once again, the skeletal structure was visible beneath facial features. Nearly all of his models are represented frontally; in profile, the topography of the face gives way to anecdote. Giacometti blurred features that were too pronounced and tried to restore symmetry. The faces he painted were ageless and the adolescent Aika, who sat in 1959, seems no younger than Annette in her portrait. Why, then, did he feel such a need for models? To immerse himself in vision, as he would in a landscape, to experience resistance, tension, hostility even, bodies reduced to silence. He was not obsessed with similarity in appearance but rather in capturing the humanity that resides in beings beyond any particular features. "I would be entirely incapable of drawing you from memory. Picasso has the talent of being able to see the characteristics of each head; me, not at all, I recognize you by what, I don't know, but after five minutes of sitting for me, you become entirely unknown, you are no longer the person I thought I knew, you no longer have any specific characteristics, because from an individual you tend to become a common head, anybody's head," he explained.[10]

The artist achieved this "common head" only after a series of steps that alternated between creation and destruction as the day went on. When the layer of paint became too thick, he scraped it back to the canvas and started over again. "The painting advanced in the same way conversation usually did with Giacometti," Sylvester remarked. "He pushed an argument to one extreme and then another, opposing, one followed, which he also pushed to the extreme; every claim had to be countered by its antithesis; reality wasn't this or that, but this and that."[11]

His reflections on art were steeped in paradox. The essential, he claimed, lay not in success, but in the truth of exploration, which prompted him to express admiration for Derain's successes and failures in the text he wrote on the artist. "All of Derain's paintings, without exception, caught my attention, forced me to look for a long time, to search for what lay beneath, the best and the least accomplished," he explained. He went on to clarify: "When I say the best and the least accomplished I must add that this differentiation is almost meaningless to me; I only like a painter's work when I like the most awful, the worst of his paintings, I think the best paintings retain traces of the worst, and the worst traces of the best."[12]

He often said he no longer cared if a work was successful or not. In both instances, he had made progress. The following statements, though made in reference to Derain, seem to describe himself. "Derain's qualities only exist beyond possible failure, defeat, ruin, and I think, it seems to me, only in these qualities, at least in modern art—I mean, (maybe) since Giotto. Derain was in a spot, in a place that constantly escaped him, terrified by the impossible and every work was for him a failure even before beginning it. Every foundation, every valid certainty for most painters today, if not for all of them, even for abstract painters, even the Tachists, had no sense for him; so, where are the means to express oneself to be found? A red is not red—a line is not a line—a volume is not a volume, and everything is contradictory, an abyss without end we lose ourselves in. And yet perhaps he only wanted to capture a little of the appearance of things, the marvelous appearance, attractive and unknown, of everything that surrounded him." These words evoke the feeling he often described, as his friends attested, of admiration or even astonishment, that he felt before a simple glass, a tree, a face. In choosing simple subjects—the human figure, landscapes, studio scenes, bouquets—and opting for literal representation, with no concern for arrangement, Giacometti tried to share with his viewers the astonishment he felt for the real.

CHAPTER 29

Caroline

Yanaihara's appearance in Giacometti's life left an enduring mark. Both for Alberto and for Annette, the time they all spent together in the studio, in cafés, at shows made for happy memories. When the artist and his model got too cold, they would take refuge with her in the bedsit. And while Alberto was producing drawing after drawing of his model, Annette would share her daily life, and in particular her love of music—for, as Yanaihara described in the narrative he devoted to his Parisian experience, the gramophone played a significant role in the Giacomettis' private world. Annette was a huge fan of opera, while the artist had a fondness for Gregorian chant and Handel, as well as jazz. It was a harmonious but vibrant period, during which they would chat, joke, and go out together. With Yanaihara's departure, all this came to a sudden halt and their normal routine took over. The artist dived back into his work, and Diego and Annette struck their poses once again. They rented a new small room in the courtyard at rue Hippolyte-Maindron, and had a telephone line installed. Their daily existence was enlivened by a group of close friends, in particular Olivier Larronde and his companion Jean-Pierre Lacloche, a particular favorite of Annette, as well as Léna Leclercq, whenever she visited Paris. Jean Genet came back to sit for Alberto, though not for long, as he found holding a pose unbearable.

Then a dramatic event intervened: on May 30, 1957, Michel Leiris attempted suicide. During the lengthy period of convalescence that followed, Giacometti went to see him frequently. Over the course of these visits the artist built up a sequence of illustrations for Leiris's poetry collection *Vivantes Cendres, innommées* (Living Ashes, Unnamed). Giacometti engraved around fifty etchings in all, including portraits of his bedridden friend and a group of drawings of the convalescent's surroundings as seen from the bed. Leiris was offended by his tomb-like

appearance in some of the prints, and rejected those he thought made him look like a corpse. The book was initially issued in an extremely limited edition and illustrated with just a few of the plates. Giacometti's compassion for his friend was diluted by his incomprehension for an act sparked by a disappointed love affair. The possibility of suicide and its methods was a question Giacometti enjoyed debating with his friends, but such discussions expressed more an attraction for morbid subjects than any intensely personal dilemma. "I think about it every day.... But it's not because I find life intolerable, not at all, it's rather because I tend to think that death must be a fascinating experience and I'm curious about it."[1] His work was far too important for him to consider ending it, and his moments of angst had a tendency to spur him on his battle against time, inspiring him to redouble his efforts. His new-found success left him with little freedom and he found his time taken up by his many obligations. And then, more often than he would have liked, he had to leave the studio to go to Stampa, Venice, Bern.

In the summer, Yanaihara returned to pose once again every day. The artist put all his other activities on hold, and their sessions picked up seamlessly where they had left off. Once again, working with his favorite model proved especially fruitful. "I hope the trip went well, but I think you were tired after our last days here, and you've been able to sleep. On my side what happened was the very opposite of what I'd expected! After you left (we watched as the plane started off, we were in the same place as where we left you, did you see us?), we returned home, me straight to the studio, I started working on the canvases I'd begun on Thursday, I didn't stop until 10 in the evening, just drinking a coffee at 7.30, and since I've continued in the same manner up to 11 this evening, without stopping or taking 'breaks,' working as much if not more as when you were here, and I'm already impatient to get back to it. For a little while I had to do all the work from memory and look back on all I'd seen while we were working together. I've made much more progress than last year and am really keen to continue (but I've already said that!). I cannot even begin to put into words everything you've done for me."[2]

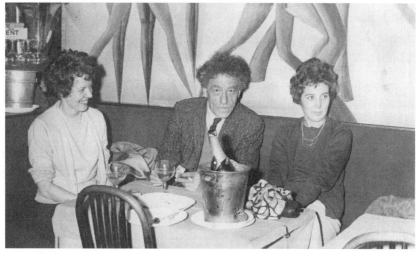

Annette, Alberto, and Caroline at La Villa, rue Bréa, Paris, c. 1962.

The following year the philosopher was busy with his personal projects and was unable to leave Japan, but they kept in contact and he returned in 1959. The model once again took his pose, but the situation had changed. The artist and Annette were as delighted as ever to see him, but Yanaihara could immediately sense that some new factor had upset the couple's life together. Giacometti in fact had met someone else. One night in late 1958, in one of his favorite bars, Chez Adrien, his attention had been drawn to a very young woman. Pretty, vivacious, and forward, Caroline lived off men and other expedients. Their relationship would, however, be different from what he had been used to with prostitutes. Giacometti found her first entertaining, then bewitching. The precedent of Yanaihara even encouraged him after a few months to allow her access to the studio, where she started sitting for him in 1960. But it was obviously different from the earlier three-sided relationship that "exceeded any other adventure in the world." At the beginning Annette tacitly accepted the arrangement, but with Caroline regularly and noisily bursting into the confines of rue Hippolyte-Maindron, she found the situation increasingly repellent. Diego, too, had no time for the young woman and, worried that she might exert

Photo: Coll. Fondation Giacometti, Paris

a bad influence on his brother, began to find things uncomfortable and disturbing. Caroline (as she chose to call herself) moved among pimps and petty crooks. Very much one for the easy life, she often turned up asking for money. Giacometti had little notion of finances and was generous not only to his mistress but also to her friends, who were not above extorting money from him. Caroline's taste for luxury—which the artist personally disliked—raised a smile rather than shocking him. Caroline was some forty years his junior and brought a dash of youthfulness into his life. He enjoyed listening to detailed accounts of her pranks and the shady dealings she would get mixed up in, and, when she became a regular model, the bond between them if anything tightened. In the studio, the artist alternated sessions with Annette, who would pose in the afternoon, and with Caroline, who sat in the evening. In spite of her rebellious nature, the young woman nonetheless complied with the constraints of sitting motionless for hours. But she would also sometimes vanish without notice, leaving the artist to pace back and forth, worried he might never see her again. Paradoxically, it was Caroline who could be jealous; Giacometti seemed to have got over his feelings of possessiveness. "It is absurd, Caroline, to be jealous of me, no one can be jealous on my account. You know, Caroline, that for me love is very different from the usual idea of love, therefore no one should be unhappy because of it."[3]

Occasionally, Caroline got in trouble with the law, and Giacometti would come to help her out of her predicament.[4] At other times the relationship could hit rock bottom. "I don't understand you anymore, you're just too weird. I don't know what to think. I'm really sad despite it all. You're too complicated. I don't know what you want. You're just a dirty brute. Caroline."[5]

Yet the relationship would always stagger back on track. It was similar to the one the artist had had years before with Denise: animated, if chaotic. Still, it had no real impact on the artist's work and daily life.

Shortly after meeting Caroline, Giacometti had an encounter with a very different dazzling female. In 1959 he was introduced to Marlene Dietrich

and they immediately began an affectionate flirtation. Although they felt a mutual fascination, the film star moved in radically different circles from the artist, who would never have let anything distract him from his work. Giacometti was plainly aware of this, and the little sculpture he gave the actress before she left France was a goodbye gift. Although they were to meet again, it was to be as no more than acquaintances.[6] Living a life split between very distant and often incompatible worlds, the artist had had to adapt his everyday existence to the paradoxes of his personality: there were no tempestuous affairs and heartbreaking separations like Picasso; no botched suicides occasioned by fleeting passion, like his friend Leiris. Nothing would ever really undermine the foundations of his equilibrium: rue Hippolyte-Maindron, the domain of Diego and Annette—the "two good assistants," as his mother called them[7]—the dives where he would meet up with his prostitute friends, such as Ginette and Danny whom he had known for years, and finally his regular sojourns back in Stampa. The relationship with Caroline was less threatening to this delicate balance than a love affair in a more intellectual milieu or an encounter among his art patrons might have been. Even when he lavished gifts on the young woman (a fancy car, an apartment), things stayed within limits, and the affair never really threatened his daily routine.

Giacometti could count on unquestioning devotion from his brother and Annette. Even if Annette—after all the happiness she had felt during her early years in Paris and afterward thanks to the period with Yanaihara—sometimes found life difficult, she stood wholeheartedly behind the artist and his work. Annette had adapted to her husband's way of life, and, in spite of her middle-class upbringing, she had grown to like the little cafés and bars in the modest suburb that was then the district around rue Hippolyte-Maindron. Yet, at the same time, going with him to see his intellectual friends, like Picasso, Gilot, Leiris, de Beauvoir, and Genet, did not intimidate her. Diego, who tended to steer clear of his brother's more highbrow and fashionable circles, always put Alberto's needs above his personal life and art. Once a rather lost figure, the junior brother had

become the mainstay of Giacometti's life. He was indispensable as the one who kept the everyday art-making schedule ticking over and who ensured that deadlines were respected. He did not approve of Caroline's repeated intrusions into his brother's orbit, but he kept his counsel and carried on as if nothing had happened. Annette, on the other hand, would make clear her annoyance, sadness, and even anger. Yet even this made no real difference and did not prevent her, for instance, from taking photographs to document the daily progress of a painting depicting her rival.[8] In spite of its ups and downs, Annette's relationship with Giacometti proved resilient, understanding, and affectionate—unlike the experience of so many of their friends' wives. Come what may, she remained steadfastly committed to her husband's art, realizing long before that Giacometti's abiding concern was that nothing disturb his everyday existence. As Jean Clay noted, "this apostle of precariousness is also a fanatic for the immutable. The same friends, same district, same habits that nothing will ever change."[9] Hence the artist's determination to cordon off his relationship with Caroline from the rest of his life: "Never did he take me off to Lipp's or to Le Dôme," Caroline recalled; "never to lunch with Sartre or Jean Genet. They were confabs between intelligent people. He must have thought I wasn't bright enough.... And then, after all, I didn't give a damn, these gentlemen had nothing to do with me, that was more the life he had with Annette.[10]

Giacometti though was changing. His lifestyle caused him to age before his time, and youth had become still more alluring in his eyes. Plagued by appalling coughing fits, he felt tired, physically weakened by a lack of sleep, by a starveling diet, by alcohol, and especially by the disquiet that still ceaselessly gnawed away at him. His art had to come first, before any other consideration, and his urge to create became more overwhelming than ever, forcing him to sacrifice his personal life. He himself complained continuously of being exhausted and liked to tease his friends by portraying himself as having one foot in the grave, even aping the tics of old age. "I'm an old man. Don't you think I've aged terribly? I just can't work. I'm a little old man,"[11] he quipped to Yanaihara.

Chapter 30

Chase Manhattan Plaza

In May 1958, Giacometti's work was shown at the Matisse Gallery in New York. The exhibition had been postponed countless times at the artist's behest and was the result of many months' labor, containing several new sculptures. The artist once again tried his hand at larger dimensions. "One of the sculptures I did this evening is taller than the tallest in 1948," he wrote in April.[1] This large figure, however, was not completed in time for the exhibition. Giacometti also carried out some new models: heads characterized by "large eyes" and a focus on the essential features of the face, "heads on steles," and a "seated Annette with her hands on her knees." In the final weeks preceding the exhibition work reached fever pitch. "For two weeks now but especially since last week, Alberto has worked so much," Annette informed Yanaihara. "You'd scarcely recognize the studio, there are three great plaster sculptures, three tall standing women about two meters high [6 ft. 6 in.], there's another smaller woman, a large head, and also a large sculpture representing a leg, Alberto says it's his leg, I cannot really explain it, the studio's full of plaster, you can follow Alberto's footprints all the way to rue d'Alésia."[2]

The most astonishing piece is indeed the hugely oversized "leg" stuck on a high base, which harks back to the sculptures of body parts he did in 1947.[3] Production on new pieces had restarted, to the satisfaction of his two dealers, who even managed to reach a temporary truce. "Miró has been here for two weeks, closely followed by Maeght and Clayeux, who came to see his exhibition at the museum before it closed," wrote Matisse. "I've got a good one for you! He [Maeght] has done a U-turn and me too, and now we get on like a house on fire! We shower each other with compliments, bouquets of flowers for the ladies rain in from all sides, we're over the moon! One can only pray it lasts, as you might say."[4]

In November, the artist received a proposal that filled him with enthusiasm: an invitation to tender for an open-air sculpture to be erected at the foot of the Chase Manhattan Bank in New York. The prospect of such a significant commission could not have come at a better time, since he was enjoying an especially productive period and under no particular pressure. He set to work immediately, dedicating the whole of 1959 and part of the following year primarily to trials for this project. The basic principle did not take him long to devise. As with one of his city square works, the artist planned to set up a dialogue between three sculptures of diverse natures: a very tall standing woman, a walking man, and a monumental head. In May 1959, he wrote to Matisse: "I work almost every day on my project, and I can't wait to get back to it tomorrow. In any case, whether it works or not for the architect, it's enormously useful to me for all my work and I'm delighted to be doing it."[5]

He worked hard but was soon encountering obstacles and grew increasingly concerned about the question of proportions. Giacometti never went to New York and so never physically experienced the enormity of American skyscrapers for himself. He derived its proportions from passers-by, rather than trying to adapt to the scale of the city. "He's doing three big sculptures in plaster," Annette informed Yanaihara in June, "a large motionless standing woman two meters seventy-five [9 ft.] high, a man walking (two meters twenty [7 ft. 3 in.], I guess) and a large head (as large as he can), the three sculptures arranged in respect of one another."[6]

Diego and Annette meanwhile took turns in Stampa with Annetta, who was recovering from a minor heart attack. The artist was detained by his work, and would leave Paris only on July 15. He did not answer Pierre and Patricia Matisse's invitation to join them on the Côte d'Azur, so Annette went alone. Instead, he cut short his stay by his mother's side and set off for Bern, where the Kornfeld gallery presented an exhibition of drawings and sculptures. He returned to Paris at the beginning of August, when he was again joined by Yanaihara. During this time he

carried out three portraits and continued to work on the head once the model had left for Japan. He was able to return to his sculptures very quickly, but the New York project was not evolving as he would have liked. In October, he decided to change technique: "He's given up plaster and has started the head and the tall woman again in clay. I think he's pleased enough with the walking man now."[7] The workshop had never been so cluttered with works and heaps of materials. "I've removed all the plaster from the studio," Annette explained. "I filled five bags, the studio is crammed full, in addition to the plaster sculptures there are the new ones in clay."[8] But the difficulties persisted, and none of the sculptures satisfied him fully. "He has redone it all in clay and for the moment the sculptures are becoming smaller and smaller, the head especially, you know, the large head, now it's become very much smaller."[9] He then returned to the plaster. The project caused problems he had never had to confront before. His tiny studio wasn't suited to large-scale sculpture, and Giacometti himself was not accustomed to the task. For the "tall women" he was obliged to clamber up a ladder. Cutting into the material directly, he would sprinkle the surface with liquid plaster, spattering the surrounding works. To view the sculptures better and test their scale, he dragged them out into the courtyard or the street.

That autumn, his work was again celebrated in New York. He was one of the artists best represented at the *New Images of Man* exhibition, organized at MoMA by Peter Selz, which showcased an international range of "effigies of the disquiet man"—a collection of the most striking images of the postwar era. Giacometti was represented by eight works, including three large female figures, one of which was selected to illustrate the cover of the exhibition catalog. He was presented as one of the most famous artists in the exhibition, with his works described as follows: "His emaciated figures, though they first appeared at the end of the Second World War, are not starved survivors of the concentration camps: they are simply human beings, alone, inaccessible, and therefore inviolate.... Sartre in *No Exit* prevents his characters from ever closing their eyes ...

Giacometti's Tall Figures—erect, distant, and immutable—can stand or pace, but never rest."[10]

Selz had urged him to write an essay for the catalog; the artist accepted only after much heart-searching, expressing both his vision and his doubts: "You ask me about my artistic intentions concerning the human image. I do not know how to answer your question very well.

"Sculpture, painting, and drawing have always been for me the means by which I render to myself an account of my vision of the outer world and particularly of the face and of the human being in its entirety or, more simply, of my fellow creatures, and particularly those who, for one reason or another, are closest to me. Reality for me has never been a pretext to make art objects but art a necessary means to render myself a better account of what I see. Hence the position I take with regard to my conception of art is entirely traditional.

"Yet I know that it is utterly impossible for me to model, paint, or draw a head, for instance, as I see it, and, still, this is the only thing I am attempting to do. All that I will be able to make will only be a pale image of what I see and my success will be always less than my failure, or perhaps the success will be equal to my failure. I do not know whether I work in order to make something or in order to know why I cannot make what I would like to make. It may be that all this is nothing but an obsession, the causes of which I do not know or a compensation for a deficiency somewhere. In any case, I realize now that your question is much too vast or too general for me to answer it in a precise manner. In fact, by this simple question, you have put everything in question, so how to answer it?"

His expressions of doubt had become so natural that he had no qualms about airing them in public, but the quandary that faced him with the figures for the Chase Manhattan commission worried him more than usual and heralded an acute phase of confusion. After an initial burst of exhilaration, a sense of failure seeped into everything. In August, however, after a few weeks away in Stampa, he felt happier with his progress, as

he wrote to his mother: "Today I'm at the studio working away on my sculptures for New York that are almost finished."[11] A month later, he wrote to Gordon Bunshaft, the architect who had commissioned the piece: "I was very happy with what you thought of my sculptures during your visit here, but since then things have not quite turned out as I had envisaged. I thought I could complete the sculptures in two weeks, but in fact I've had to destroy and redo them several times. I had to begin a new head, a new woman, and a new walking man."[12]

Unfortunately, these works no more lived up to his expectations than their predecessors. At the beginning of the following year, after a further visit from Bunshaft to Paris, Giacometti's mood brightened. Waiting for the architect to arrive, the artist stayed on in the studio while Annette left for Stampa to tend to Annetta who remained unwell. In plaster, Giacometti made two models of *Walking Man*, one *Tall Woman*, and one *Large Head*. Whereas the woman is perfectly hieratic, with her long arms stuck close to the body, the movement of *Walking Man* was more dynamic than that of 1947, which was closer to the pose of an ancient Egyptian figure than to true walking. As for the large head: it reprised the principle of the head on the ground that appeared in *The Cage*, but betrayed a specific model. "It's almost the memory of some bits of a Roman sculpture," Giacometti explained. "It's probably the memory of a head seen in a square in Rome in 1920 that had impressed me hugely."[13] This work, characterized by a giant upright neck like the barrel of a column, combines a reference to the Colossus of Constantine seen in Rome some forty years earlier, with the features of Diego, which transpire almost involuntarily in all his male figures. "Dropping in the other day the architect seems content with everything and I could send in the sculptures such as they are, but for me they still need working over for two more days and that'll be that."[14] Giacometti had pledged to dispatch the sculptures to New York to be presented to the selection committee, but the sculptures would not be finished as quickly as he had hoped—far from it. Expressing his disappointment to Matisse, he

explained how hard it was to execute a project for a public space without ever seeing where the figures were meant to be installed. He even started doubting the intrinsic quality of the works. Contrary to what Bunshaft had believed when he contacted the artist, for Giacometti, the question of monumentality could not be resolved by simply enlarging an existing piece. "I'm utterly against the current practice of making small sculptures and having them mechanically enlarged. Either I can make something as big as I want it, or I cannot.... And I was interested to discover the maximum height I could reach by hand. Well, that maximum height is exactly that of the large women. They are already almost beyond what's possible and, beyond that, they'd have to be entirely imaginary."[15]

The concerns that arose from the Chase Manhattan commission rendered him unresponsive to all other requests. "This is the time Switzerland chooses to officially offer its entire pavilion for me alone in Venice for the Biennale this spring. They couldn't have timed it better! Laborious refusal letter posted this morning. Written by me, but, through modesty and due to a vicious circle of complications, I seemed both insanely proud and to be making fun of them; redrafted by Diego, who found the right tone, corrected by Annette, rewritten by me after all, I reckon it ended up just about acceptable. I'd have loved to have seen their faces on receiving my first draft uncorrected! It more or less retold my whole life story!"[16]

Once again, a proposal from the Swiss government had come at the wrong time. Alberto could not even find the time to visit his mother, as Annette described to Yanaihara: "I have been to Stampa for a week, I went to take over from Alberto who is again working on the large plaster sculptures you saw this summer. After you left, Alberto, if he had not destroyed, had all the same damaged all the work he'd done in summer. Especially 'Walking Man' and the large head. Discouraged, he'd given up plaster (temporarily) and had tried to make the large sculptures out of clay. That didn't work either, that is to say, they became increasingly small! In a single day he also started on a head as large or almost as the

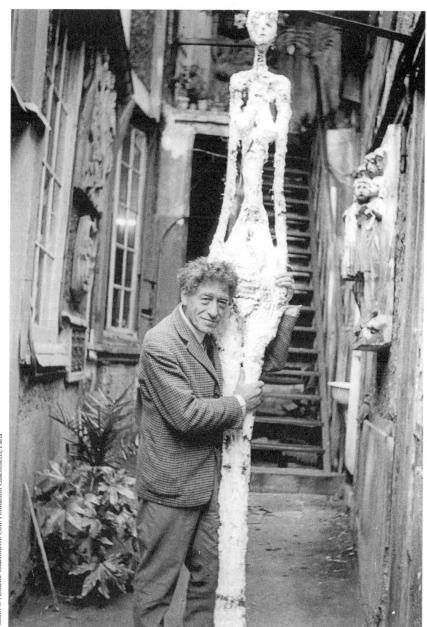

Alberto Giacometti with *Tall Woman IV* in the studio courtyard, August 1960.

one in plaster (that you know) and by the end of the day the head was only five centimeters [2 in.] high, really tiny on a great clay base. Alberto has become more and more passionate in his work, little by little he's completely dropped the monument for New York, continuing instead on a small head and on a small figure of a woman. And all the time he worked during the night until the morning (8 in the morning). The New York architect (the one for the monument) came to see Alberto (once more) to ask him to finish the large sculptures and have them cast in bronze if possible. Alberto, after all these months working in clay, had again the courage to attack the large plaster sculptures and it was at that moment I left Paris to go to his mother so she wouldn't become too impatient waiting for Alberto to arrive. Yesterday evening I spoke for almost an hour on the telephone with Alberto! He's very pleased, he says that this time it's OK and that he'll finish everything this week and then he'll be able finally to come for a little to rest in Stampa. I hope that this time it really does come off and that all these large sculptures will go off to the foundry and then on to New York."[17]

By April Alberto had indeed finished, and he went to Rome with Annette. "On April 7 Alberto has to go to Rome for a few days, only four days because he's on the jury for a sculpture prize. He's also on the jury for the Prix de Rome in Paris. I reckon he's becoming an official personage!"[18] The artist was delighted to return to the city where he had stayed forty years previously, but, once back in Paris, he was disappointed when he saw the works he had so recently sent to the foundry. His conclusion brook no argument: it all had to be done *again*. Completely out of the blue, he decided not to send the works he had promised the jury in the United States. "You're going to be disappointed and probably annoyed perhaps and Bunshaft too," he wrote to Matisse. "The sculptures have been cast. I looked at them at the foundry, had them burnished, looked at them on the pavement, in the street in front of the foundry, had them transported to Susse's garden at Garches, bronzes and plasters, everything, cast or not. Perhaps all have something good but they're

all at odds with what I wanted (or what I thought I wanted), so much at odds, so bad that there's no way I can send them, I'd prefer never to do any sculpture ever again, to drop dead even, rather than send these bronzes to New York now. I've worked a whole year and more on this and done nothing else, dropped everything for it and the exhibition this spring, I've never worked so much, until the eve of my departure for Stampa when I had them cast, four instead of three, I couldn't have had more done. I can see they're failures or rather not realized, they've all missed the mark, it would be hard to do worse. It could not have been otherwise, I don't regret my work for a moment, on the contrary, but it's absolutely impossible for me to present it as a valid project for a sculpture on a plaza. I saw things too vaguely, too many memories of sculptures seen long ago (in Rome, especially), the dimensions totally mixed up, wanting to make big things out of things I'd seen small, and many other complications and too much for one year. Apart from the fact that one cannot do anything for a given space without seeing it first, my sculptures are all three utter failures in themselves. I won't drop them, I'll redo the large woman and the head as fast as I can and I want to obtain a result as quickly as possible. The walking man is more complicated, I don't know yet if it's possible for me to do it, I'll give it one more go in any case. But for the moment I am where I am. Whatever your reaction and that of Bunshaft, I cannot do what I cannot do and one can only reproach me for my ineptitude, but that's all, it's impossible for me to add anything more this evening, give this letter to Bunshaft to read. The only thing that hurts me is that I may have hurt you and disappointed you, but nothing else."[19]

The artist tried out some new figures before completely abandoning all hope. In summer, he made a new *Tall Woman* in plaster that was never to be cast in bronze. He renounced the commission and informed Bunshaft, who had already been resigned to the fact. All in all, Giacometti had had made editions of three giant female figures—the largest measuring three meters high [9 ft. 8 in.]—two slightly larger than life-size *Walking Men*,

and two *Large Heads*, which were to be exhibited individually in his next exhibitions. Paradoxically, these sculptures that in his disenchantment he had thought of as "failures in themselves" were soon regarded as iconic works. Along with the pieces of 1947, they were to remain the only examples of large-size sculpture in his whole career. After giving up the American project, Giacometti returned to more modest dimensions that corresponded better to the very physical process he used in making his sculptures and indeed to his general conception of art. "They have been given a completely exaggerated importance compared to the rest of my output, simply because they are large, that is for such an utterly idiotic and elementary reason," he was to note later, going on to describe the taste for the gigantic as childish. "People make big objects because they think that by making big objects they'll become bigger themselves."[20] He admitted nonetheless to having other motivations: if he accepted the New York project, it was also because he still cherished the desire to make a work for a public space, but, since his researches around *Project for a Square* in 1931, none of the opportunities that had arisen had led to its realization.

The Venice Biennale

Even if it came to nothing, the project for Chase Manhattan Plaza had given a considerable boost to the artist's creativity, and he embarked on new ventures. "Today, I'm again thinking of starting it all over, like twenty or twenty-five years ago,"[1] he wrote to his mother in late 1959. During summer 1960, Yanaihara came to Paris for almost two months. Giacometti worked away on his model relentlessly, carrying out several painted portraits and beginning a sculpture bust he was to complete from memory. Yanaihara, remaining close to Annette, also served as her confidant. "You have often written to me that, in spite of the difficulties of your situation, you are OK, and that you steadfastly put up with worries that of course it cannot be easy to bear. You've often written that you're no longer jealous and that you've found a good system—that is, to understand Alberto. I think you're completely right, because, for an untroubled life, willpower is not enough. What one needs is the intelligence to understand and I'm sure that you get along fine with Alberto. As for Caroline, whom I don't know very well, it seems to me that it's not worth bothering to understand her, at least for me, and also for you. But I do understand that she is something that escapes us (that is, moreover, what attracts Alberto) and that she can change nothing in your relationship with Alberto, so, to you, she's nothing. Anything she may do or say takes place outside your own relationship with Alberto. And if you're sad or demoralized, it's because I miss you, because it was so wonderful when we were together, and not because of Caroline."[2]

Nonetheless, a long shadow had been cast over Annette's life. The affair with Yanaihara, at the same time happy and painful, had awoken within her the desire for a child, which she had to repress. And then Caroline appeared. Judging by her letters over the following months, however, Annette soon seemed to recover her serenity. Making the best

of the situation, she grew accustomed to the presence of Caroline, who, as Yanaihara had noted, did not constitute a threat to the couple. She saw her friends regularly, in particular Paola Carola, a new acquaintance she had met when Paola came to commission her portrait from the artist, and who often invited Annette to her house in the country. Finally, Giacometti acceded to his wife's desire to have a little apartment of her own, offering comforts their very basic interior sorely lacked. From the end of 1961, after several months spent decorating, Annette could divide her time between two living spaces, the room in rue Hippolyte-Maindron, where she spent the day, and a new apartment near the boulevard de Montparnasse that she refurbished as her own personal domain. Diego's everyday surroundings were also improving. In June 1961, he moved into a house bought by his brother, located two doors down from his previous lodgings on rue du Moulin-Vert. He had never been so busy, and his new address gave him the larger studio he needed. Diego supervised the realization and transport of an immense number of works, new and old, cast every year for exhibitions and sales. He was also creating more and more works on his own account, with his furniture now distributed in the United States by Pierre Matisse.

Apart from exhibitions, orders for books were a further incentive to work, and Giacometti responded readily. In 1959, he had embarked on a very ambitious project initiated by his friend Tériade: a series of lithographs centering on his walks through the French capital for a book entitled *Paris sans fin* (Paris without End), for which he was also to write the text. This long sequence of drawings, which he continued to work on until his death, constituted a kind of diary recounting his daily life: his walks in the neighborhood around the studio, car journeys through Paris with Caroline (he never learnt to drive), the restaurants where Annette, Diego, and he would take their meals, the cafés of Saint-Germain-des-Prés where he would meet up with friends, the night bars, the studio with its works in progress, the printer's, Mourlot, Annette's apartment, a visit to the natural history museum, the scenery

viewed from the highway after taking Yanaihara to the airport.... For a number of years he was also involved in another publishing project. Originating with two Italian friends, the critic Luigi Carluccio and the sculptor Mario Negri, it concerned a book featuring a wide selection of the copies of works from the past he carried out throughout his career. Giacometti was intrigued by the idea, and the initiators also asked him to supply a text. Copying was a practice close to his heart, and he regularly said how important it was for the germination of his ideas. In May, the premiere of Beckett's play *Waiting for Godot* revealed another and unprecedented type of collaboration. Following repeated pleas on the part of the playwright himself, Giacometti eventually agreed to work on the theater set. Beckett's concept was precise: the set was to be reduced to just two objects, a tree and the moon. After much debate, the sculptor finally limited his contribution to a white plaster tree the height of a person. "All one night we tried to make that plaster tree larger or smaller, its branches more slender. It never seemed right and each of us said to the other: maybe."[3] The end result, though, lived up to the writer's expectations: "Superb. The only good part of what has been up to now a gloomy exhumation."[4]

In June 1961, Giacometti received an invitation to present a retrospective exhibition in the international pavilion at the Venice Biennale. It was a proposal he accepted with the proviso that he would be allowed to choose and hang the works himself, with assistance from Clayeux. A few days later, the Galerie Maeght inaugurated an exhibition of his recent work, on which, as always, he worked until the very last second.[5] The exhibition was divided equally between paintings and sculptures, and presented the majority of the pieces created in the context of the Chase Manhattan project. The show also featured approximately twenty painted portraits, including six of Yanaihara and five seated women, all depictions of Caroline, which together demonstrated the enduring vitality of his pictorial practice. Giacometti then left for Stampa with Annette, where he was joined by Henri and Nicole Cartier-Bresson, the

photographer taking a series of photos of the village and studio. By late July the couple had been joined in Stampa by Yanaihara. Annette put an end to their love affair, which gradually morphed into a long-lasting friendship.[6] At the end of July, Pierre and Patricia Matisse were invited to the family home for the first time. There the gallerist discovered works from Giacometti's youth, as well as *Woman with Chariot*, realized during the war and left behind. The dealer had never seen these works, which made a singular impression on him, and he proposed casting them in bronze. Giacometti painted portraits of Annette and Dr. Corbetta, who treated his mother and had become a friend of the family. Engaged, as usual, on several works at a time, he also painted some bunches of flowers. For some time, his color range had been widening, in particular towards red. He made, however, only drawings of Yanaihara, who left for France on August 2. On August 5, the entire family gathered round to celebrate Annetta's ninetieth birthday. Returning to Paris two days later, the artist had Yanaihara sit for a bust and a painting, in daily sessions lasting more than seven hours at a time. "Straightaway Giacometti went back to my portrait and everything went on just as in the previous year: afternoons he would sculpt until the evening, and then in the evening he would paint until midnight. The only difference was that now he was using forty centimeter [15 ¾ in.] canvases (the size above) and the hour's rest whittled down to nothing, while his enthusiasm for work was even more all-consuming than the year before."[7]

The two men spent the majority of their evenings together, at Le Dôme or La Coupole, then at Chez Adrien or striptease joints, sometimes joined by Annette or Caroline. The latter had a surprise in store for him, however: she was now married.[8] The marriage soon fell apart and did not anyway seem unduly to bother the artist, who had long tolerated his mistress's "customers." He was only really perturbed by Caroline's regular vanishing acts. He soon set out again briefly for Geneva with Annette, to attend Silvio's wedding. They felt deep affection for this nephew, the Giacometti clan's only offspring, and in his early years the family made

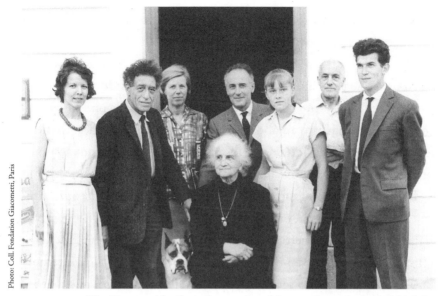

Photo: Coll. Fondation Giacometti, Paris

The Giacometti family on the occasion of Annetta Stampa's ninetieth birthday (Annette, Alberto, Odette, Annetta, Bruno, Françoise, Diego, and Silvio), August 5, 1961.

him the center of attention. In October the artist traveled to Turin and Venice, where he visited the pavilion where he would exhibit. From the vast rooms set aside for him, it was clear that preparations for a major exhibition were underway. Once more, projects were coming in thick and fast: immediately after the Biennale he was invited to be the subject of a significant retrospective at the Kunsthaus in Zurich. He returned to Stampa to join Annette, where he was met by a further piece of good news that sealed his reputation in the United States: he had been awarded the Carnegie Prize. "You can imagine the pleasure this prize occasioned my mother especially! and all the others too! That's for me the greatest joy."[9]

An exhibition at Pierre Matisse's in late 1961 reprised the works shown at Maeght's, together with some new paintings. As with each project, he was especially keen on exhibiting new works. "It's really regrettable that you didn't say the exhibition had been put back a week, I'd have had the time to do enough work on a large canvas of a nude to be able to send it, or perhaps two, and perhaps a sculpture as well. I had

worked as much as I could until the last moment and was unhappy at having to suddenly grind to a halt."[10]

The exhibition was duly noted by a new generation of American artists. At the time a practicing art critic, Donald Judd, described it as follows: "The empty space appears to push inwards on the figures, compressing them into an obdurate shaft. The dual definition is one of nothingness and meaning. Protuberances in a figure are not so much projections as they are residual points left by lines cutting inward."[11]

But the most significant project, the one that monopolized his time and his thinking, was the exhibition in Venice. It had taken on an unusual significance for Giacometti, since he was aiming for the Grand Prix as the ultimate recognition of the special place he occupied on the contemporary scene. He chose to send a mix of surrealist sculptures and a broad selection of postwar work, as well as new pieces especially created for the occasion. Matisse assisted him in compiling the list of older works. They decided to exhibit about fifty sculptures and the same number of paintings and drawings. The time seemed ripe for his oeuvre to be presented to a truly international public. In Rome, he met Palma Bucarelli, the director of the museum of modern art, who was preparing a book on his work and was to write the introductory text for the Biennale catalog. Giacometti himself drew up a basic plan of the exhibition and set it up on site with assistance from Diego and Clayeux. He was to spend more than three weeks in Venice, where he was eventually joined by Annette and by the Matisses and Leirises. In the end, he produced few new sculptures; the recent work concentrated on drawings and paintings, including twelve painted in 1962. At the last moment, while the exhibition was being hung, he painted a few of his sculptures— without though asking for authorization from their owners. "Alberto was always walking through the rooms devoted to his work, moving about small and large sculptures, rearranging those marvelous squares with the figurines crossing them, yet always dissatisfied: he would have liked to redo it all, because everything, or almost, was not yet quite as

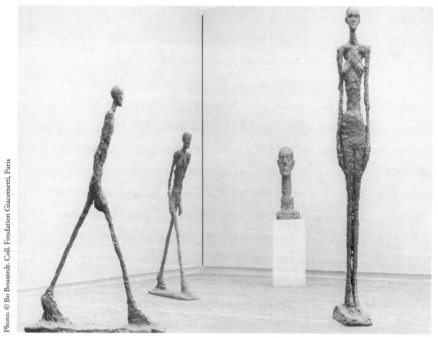

Photo: © Bo Boustedt. Coll. Fondation Giacometti, Paris

View of the exhibition *Alberto Giacometti* at the Venice Biennale, 1962.

it should be. One particular night, he grabbed his brushes and started painting the sculptures."[12]

Among the forty-five sculptures presented, from *Spoon Woman* of 1926–27 to the recent busts, a significant place was set aside for works created for the Chase Manhattan project. Rather than being laid out chronologically, Giacometti arranged the show to create striking juxtapositions between different works. The exhibition proved a runaway success, and he was duly awarded the first prize for sculpture. A touch disappointed—he had even protested that he would not accept the prize if it was not combined with that for painting—he was nevertheless glad of such a distinguished mark of appreciation. Shortly afterwards he left to set up the exhibition in Zurich, whose retrospective vision was more all-encompassing. "Much larger than the one in Venice. A room seventy meters by twenty [230 ft. x 65 ft.]! We assembled it very quickly, much

more quickly than in Venice, Clayeux, Diego, Dr. Wehrli (the director), and me. In broad outline, I set it up alone on Tuesday afternoon, the others arrived on Wednesday, I hung the whole thing more or less as I wanted."[13]

He threw himself body and soul into these two projects and was particularly pleased with them. As he was to tell Matisse not long before the works were dispatched for Zurich, preparations had not run all that smoothly, however. Exhilaration sometimes reinforced his unease. "I work from midday on, Diego sits for me, with Annette in the afternoon, since this evening Caroline too and other stuff in addition, everything is much more difficult than ever, I'll see tomorrow where I'm going, I'm almost afraid of setting to work."[14] In the same letter, however, he had a more amusing anecdote to tell: "Four hours the other evening with Marlene D., very very pretty; for four hours at the same table, she had a coffee, me, an aperitif, nothing more." Admired by "very very pretty" women, celebrated for his oeuvre, acclaimed by collectors, a friend of towering intellectuals, nonetheless, dissatisfaction continuously preyed on Giacometti, who was haunted by a sense of unfulfillment and by the idea of the progress he might still make. All the same, the year 1962 had been exceptionally profitable, yielding two of the most prestigious international prizes in art and two landmark retrospective exhibitions. It was also a period of intense pictorial activity, marked in particular by the splendid series of the seated Caroline. Giacometti was in demand from every quarter, and his exhibition projects were becoming ever more ambitious. In autumn, the Tate Gallery offered him a retrospective and he traveled to London to discuss terms. During the trip, which for once took place with Caroline, he met up with Isabel, with whom he had kept in contact. She was a personality on the London art scene and a friend and model of Francis Bacon's, so she organized a dinner for the two artists to meet. Giacometti was won over by the Irish-born painter's larger-than-life persona, and their esteem proved mutual. In spite of the fears he had expressed during the postwar period, figurative painting had

not been swept aside by the trend for abstraction, and, like him, Bacon was one of the prime examples of the revitalized potential of what had long been a disparaged genre. He was also to see Lucian Freud, whom he had met in 1946 in Paris and who had occasionally sat for him in 1952. Giacometti did not win the painting prize at the Venice Biennale, which was awarded to the abstract painter Alfred Manessier, whose work was much lampooned in the press for its triteness. This distinction seemed if anything like a desperate last stand, because the global art scene was entering a new phase of aesthetic upheaval. Only the most outstanding individuals from the prewar period were destined to survive in this new, shifting artistic landscape. Among them—and certainly the most original—was Giacometti. In years to come, his oeuvre, far from being consigned to history—and unlike that of the greater part of abstract painters from the second School of Paris—was to be widely celebrated in iconic international museums.

CHAPTER 32

The Shadow of Death

Whereas the year 1962 had concluded on a high note, the following began with a bolt from the blue. Giacometti was suddenly stricken with excruciating stomach pains, and it soon transpired he would have to have an operation. The diagnosis was a worrying one: cancer necessitating the almost total removal of the stomach. The artist was placed by his friend Fraenkel into the hands of Dr. Leibovici, who had already treated his foot fracture, and the operation took place on February 6. The two doctors decided to keep the artist in the dark about his condition—against Annette's better judgment. In a notebook he kept at the hospital, Giacometti noted: "Everything to be begun again from the bottom, such as I see people and things, especially people and their heads, the eyes on the horizon, the curve of the eyes, the watershed. I no longer understand anything about life about death about anything."[1] The operation went well, and shortly afterward he left to recuperate in Stampa. There, a discussion with his friend Dr. Corbetta revealed the truth about his illness. Giacometti was furious: how could such an important piece of information have been kept from him? More than just an affront, he saw it as treason, and he reproached Fraenkel bitterly, refusing to talk to him ever again. In spite of his friend's apologies and explanations, the relationship was at an end, with the artist's resentment running too deep for him to ever reconsider his decision.[2] Fraenkel died just two years later, without the two men ever having seen each other again. On this occasion, the ambiguous relationship Giacometti had always maintained with the idea of death was confronted with the personal experience of imminent danger. The artist's grievance with the physician related to his refusal to be cheated of the consciousness of death. "At that time, at the private clinic, what worried me was a kind of morbid exaltation: 'Ah! So you reckoned you had time in front of you.... Well, there you go! Cut down.

Already. Pack your bags.' It thrilled me. It was like a challenge. One to take up. Yet, very quickly, after the operation, it was the opposite: after just two days I walked down three floors. Nobody could believe it. A week afterwards I was hailing a taxi: I went to the studio. Today, I'd be quite content to live three more years. One year, in any case.... And yet, if I were told now that I had two months to go, that would interest me: to live for two months knowing one is going to die, that's surely worth twenty years of unconsciousness."[3] In Stampa, rest, a strict teetotal diet, and the mountain air soon put him back on his feet, as he recounted to Matisse: "After the operation (I don't remember if I told you on the telephone that I know very well what it was!), I started recovering very quickly from the first day, truly amazed to find myself so well, and here in Stampa things improve a little every day. I'm never tired and I want to start working again, I've already drawn a little and we go for walks. The day before yesterday and yesterday, a rather long trip, each time nearly five hours there and back by car in snow and fog to meet with Anne who'd asked me for sets for Alban Berg's *Wozzeck* at the Opera! I refused, it's impossible to commit to that with all these complications, I've too many other things to do."[4]

Returning to Paris on April 18, he went to stay in a hotel near Montparnasse, L'Aiglon, which provided superior comforts. His schedule, as he described it to Matisse, was "to start all over again from zero."[5] The very next month, after the United States ambassador bestowed upon him honorary membership of the American Academy of Arts and Letters, he set out again for Switzerland. Passing through Geneva, where he had an exhibition at the Krugier gallery, he continued on to Basel, where he had a meeting with the gallerist Ernst Beyeler, "who has more than sixty things of mine and who will exhibit them at the end of the month."[6] The Swiss dealer had in fact purchased all the artist's works formerly belonging to George David Thompson, a wealthy American collector, who had put his collection up for sale after abandoning his idea of establishing a private museum. "I was glad to see so many things again

I hadn't laid eyes on for fifteen years and more! They all did me good and I was pleased with them, but I'm thinking more about what I'm doing now."[7] Giacometti then retreated to the family home. During the many weeks he had spent in Switzerland recovering from the operation, he had come to realize how fragile Annetta's own health was. He devoted a great number of lithographs and drawings to intimate portraits of his mother and to the familiar surroundings of his childhood home. Finally returning to Paris, everyday life took its course. "I have taken up my life exactly as it was before and this seems right for me at the moment," he told Matisse, before going on to underline that he drank "neither aperitifs nor whisky anymore."[8] He then told his mother: "Annette has almost finished with her apartment, but for the moment she busies herself with it all day. I let her do everything and I'm sure I'll be surprised by the result."[9] In addition to preparing a space for herself, Annette also did spring cleaning in the studio, where the artist was again focusing on his work. Overjoyed to return to his artistic activities, he was nonetheless much concerned about his mother, and he would write and telephone on a regular basis. "I hated leaving because, even if I stayed six weeks more, it seemed too short, time passed too quickly, and I want to come back soon. But I was impatient to get back here, to my studio and to my own surroundings, as I had been here since January, and I'm very content with the result. It's so beautiful and so full of things all over the place. Thanks to my stay at Stampa, I'm feeling better than I have for years. But for now I especially think of you, my dear mama, and of dinner and the evening the other day when you recounted all your memories of when you were a child, with such powers of recall and such vivacity, as if the things that happened then more than eighty years ago were still all very close, as if time didn't really exist and as if being six, twenty, sixty, or ninety is almost the same thing, as if everything that occurred then was here at the same time, a fact reinforced by our being in the same house, amid exactly the same furniture, in the very same place as half a century ago and more."[10]

Now, more than ever, he felt the need for the sense of permanence, and the things that he loved so much, in the unchanging scenery of Stampa. In Paris, Annette and Diego's new arrangements meant he could keep rue Hippolyte-Maindron in a state almost identical to when he first moved in. Annette never felt at home in her new apartment and quickly sold it. She purchased another on rue Mazarine and continued to keep an eye on the studio and to pose every day. It was a routine that had been consolidated over the course of time and designed to stave off the artist's angst. An observation noted down shortly after returning to the studio after the war continued to reflect his state of mind: "At this moment I've got my studio in my head, as if there was really in my skull a miniature studio with its space and its light, all the objects inside exactly in their places, and the dust and little scraps of plaster on the floor, which I think about with such intense pleasure, as if they were smiling at me, and with the same intense pleasure I feel the space, the emptiness of the studio limited by the walls, not as solid as they might be, perhaps owing to their color or blend of colors, and the fragile, fragile glass canopy, and in the void stand objects with their latent life, and yet they are dead and unconscious."[11]

Twenty years had passed, but nothing had changed; the studio still constituted that familiar space, living its "latent" and immutable life that he was able to visualize in his mind's eye in its every detail.

On August 31, Georges Braque died. Hurrying to the painter's deathbed, Giacometti made a series of poignant drawings of his deceased friend. In November, the documentary-maker Jean-Marie Drot, directing a series of films on the School of Paris for French television, shot the first full-length interview with Giacometti.[12] The film opens with these words: "I work all the time. It's not an act of will, it's because I can't turn myself off. My brother sits from midday to half past one, then I putter about, then I spend an hour next door for a bite to eat, and then my wife poses from four to nightfall, then I start again on the same things, I'll go drink a coffee, and then at nine I begin again till midnight. I don't go

out on the town at all. Then I'll go out for dinner, I'm half dead, I've no appetite, I hang about a bit, I down a few whiskies and go home. I have to get to bed by three in the morning to be more or less up the next day. It's like being in a chain gang."[13]

In effect, Giacometti had lost no time in taking up life where he left off, life in the "chain gang," utterly dedicated to work. The sense of urgency was dictated by his realization that now time was at a premium, compelling him to stay in the studio, toiling away on an oeuvre he always thought of as incomplete. "At the same time I know it can only ever be a failure. But actually it's solely through failure that one can approach it a little. The fact of succeeding or failing no longer has any meaning. At root, I work only for myself, striving to know what I'm seeing."

The journalist asked him about what motivated him: "Your work's a bit like a game of Patience." Alberto answered: "No, not at all, it's more a mania. It's maniacal rather than patience. It's not voluntary, more in spite of my best intentions, and I wonder whether, under pretext of working, it's not just a mania for fiddling with clay, without it giving much of a result anyway, or the result is almost secondary."

The word "mania" to describe the creative impulse is one he had started using some time earlier, but he went on to tone down its negative con-notations: "It is a mania, but, at the same time, there's that will to get something done in order to get rid of it. If I do sculpture it's to get it over and done, to get sculpture done as quickly as possible." If Giacometti belonged to the generation that prophesied the death of art, at least in its conventional form, he was an artist who endeavored to renew the dialogue with tradition, mobilizing all the powers of creativity residing within him in the search for a complete understanding of the artistic act. No artist of the twentieth century was so deliberately to pare down his subjects to essentials, to probe ceaselessly the same question day after day. Head, female figure, male figure: he devoted the majority of his life's work to three elementary motifs, three subjects that can be summed up in one expression—the depiction of the human. "Since the start, it has

been the human figure that has interested me more than anything else. So much so that I recall, as a young man or in Paris, that I sometimes happened to stare at people I didn't know so hard it unnerved them. As if I couldn't see what I wanted to see. Like when everything's so blurry you can't tell what you're looking at."

Giacometti assigned to art one principal objective: understanding. Throughout his life he complained he did not understand. "I started doing sculpture because it was precisely the area I understood least," he explained. "In fact, I should just have got over it and done something else better suited to me; but I just couldn't put up with a domain escaping me so completely. I hoped to understand it rather quickly, quickly enough to go on and do something else. In fact, I didn't understand anything. So I've been forced to pursue it. There's been no choice."

To his mind, understanding what one sees and understanding what art is amounted to the same thing.

All Giacometti's creative energies focused on this project of comprehending the world, something he endeavored to address in many interviews, in an attempt to dispel the various misunderstandings that clouded his work. No, his art is not the expression of loneliness, as so many have believed. "For sure there's no intention on my part to be an artist of solitude, there are no concessions in that direction. On the contrary, I must add that, as an intellectual, as a citizen, I think that life is quite the opposite of solitude, since it is a web of relationships with others. The society in which we live, here in the West, allows me the opportunity of undertaking explorations that are, from a certain standpoint, solitary. It has been hard for me to spend long years doing work that is of no use, work on the margins of society (but not, I hope, on the margins of humanity); the condition of solitary research does not, however, necessarily equate to a poetics of solitude."[14]

If his art is anchored in a poetics, it is a poetics of life, of a life that might be taken away at any moment, a life for which art is an attempt to impart permanence. "I have always had the feeling, the impression of

the fragility of living things, as if, at every moment, under the constant threat of collapse, it takes enormous energy for them to remain standing each and every instant. Every time I work after the model I feel it."[15]

For several years, as he said himself, he was more fascinated by any real face than by the greatest masterpiece in the Louvre. "It has become a kind of exhilarating delirium. I delve into the face, every day a little deeper. I advance. I know perfectly well that the core, that the secret of life progressively retreats and that I'll never attain it. But the adventure, the great adventure is to see something unknown emerge each day, in the same face. It's worth more than any journey, anywhere in the world."[16]

Driven by a tireless pursuit of life, he was focusing his attention more than ever on fundamentals. In the two portraits of his new friend Giorgio Soavi done at the end of the year, as in the portraits of Caroline, he left the canvas bare around the motif. He zeroed in on the eyes, complex constructions of superimposed circles and lines. Several drawings even show just eyes, floating on a blank sheet. "Eyes, that's what interest me at the moment. The aim is to do an eye. I've never managed to get anywhere near it. There's always a conflict between the eye and the rest. In the end, the eyes are the human being itself. It is the other; it's me reflecting myself."[17]

CHAPTER 33

Consecration

The year 1964 started with a bereavement that affected him deeply. On January 24, Annetta Giacometti passed away, surrounded by her children. Recently, as Diego and Annette took turns going to Annetta's aid, the artist had become more anxious about his mother than about himself. He later described his experience of her final moments: "During the last week, the house contracted around her. In the end, it was no bigger than the bedroom in which she lay, then the room itself shrunk to the size of her bed—and finally to just where she was lying, becoming a still more smaller place. When she finally left us I couldn't make sense of it, and over the following days I'd find myself saying: 'I must go to my mother's room to see how she is.' Whenever I'd go out, coming back I'd first look up at her bedroom window to check if the light was still on, until it would dawn on me, that's odd—I'd forgotten my mother is dead."[1]

In the previous few years, these regular sojourns in Stampa provided an anchor to family life that offered emotional stability and were the only interludes of rest and healthy living Giacometti permitted himself. To Annette and Diego's concern, no sooner had he emerged from his convalescence than he reverted to his disorderly lifestyle. The cancer had been halted and he had recovered perfectly from his operation, but he remained in a state of permanent physical and nervous exhaustion. He was now entering an era of consecration, and was increasingly sought after. Several years previously, Aimé and Marguerite Maeght had asked him to take part in preparations for the foundation they were planning to set up in Saint-Paul-de-Vence. The project had mobilized their family and many of their close friends, and Giacometti had become deeply involved in it. The building was on the verge of completion and he was working with the architect, Josep Lluís Sert, on designs for a suitable setting for his works. At the end of 1962, he decided to have casts taken for an

exceptional edition of bronzes that would not be available for purchase but would be donated to the foundation. He chose to be represented by the ensemble of figures he had created when he had been working on the Chase Manhattan Plaza project, by a group of nine *Women of Venice*, and by eight individual works from the surrealist period and the 1950s. He was not fond of traveling but he made the trip to Saint-Paul-de-Vence several times, following the project's progress and installing his sculptures. Two sizable spaces were devoted to his oeuvre: a courtyard integrated into the central range of the museum—the site of the permanent installation of the large figures—and a vast room fitted out by Giacometti himself. The sculptures were accompanied by an ensemble of paintings and draw-ings. The collection constituted the first group of his works to appear in a French museum. In July 1964, he was, with Miró, one of the stars at the inauguration during which André Malraux delivered a vibrant tribute to a private initiative then exceptional in France. Following this moment of concord, however, a serious argument broke out with Aimé Maeght, who, at the inauguration, had neglected to mention Clayeux's efforts in estab-lishing the foundation. The ensuing discussion proved so tempestuous that Clayeux, after due reflection, felt obliged to tender his resignation as director of the gallery. Giacometti, outraged at what had flared up into an acrimonious quarrel, came down firmly on the side of his friend: if Clayeux were to leave, then he too would sever all links with the Galerie Maeght. After making his position clear to Aimé by way of Dupin,[2] neither the latter's attempts at mediation nor Marguerite's friendly entreaties—in spite of the artist's fondness for her—could make him change his mind. Once Clayeux had left, the contract between Giacometti and the gallery was at an end. This decision, taken in the heat of the moment, did nothing to undermine his solidarity with the foundation's basic project, however. Informing Matisse of his break with the Paris gallery, he nonetheless justified his decision two years earlier to have cast the very large group of bronzes now in the hands of the foundation, in spite of the reservations his American dealer expressed at that time.[3] His friendly relations with

Dupin finally paved the way for amicable negotiations with the gallery, and, although the agreement on the bronzes was rescinded, it continued to publish the artist's lithographs.[4]

Giacometti had a habit of breaking with people after a fit of anger. His repudiation of Fraenkel was still fresh, and only two years previously he had also had an altercation with Jean-Paul Sartre. In his autobiographical narrative *The Words*, the writer had enraged Giacometti with a description of the 1938 accident that had left him with a limp. In addition to factual inaccuracies, Sartre had permitted himself a liberty the artist judged totally unacceptable, by alleging that Giacometti, trying to make sense of the accident, had drawn the following conclusion: "So, he said himself, I wasn't made to sculpt, not even to live; I was made for nothing." The artist ruminated on his resentment for a long time, talking about it with all his friends. "How stupid to maintain I was made for nothing!"[5] For his part, he had forged his own legend about the accident, casting it in a redemptive and regenerating light. To his mind, Sartre had proposed a diametrically opposed interpretation, which betrayed their understanding as friends and amounted to the worst kind of treason. In spite of the writer's astonishment and regret at this unforeseen reaction, the artist never forgave him. Giacometti was steadfast in friendship and was no less resolute when things went awry. Touchy but incapable of hypocrisy, to his dying day emotions played a major role in all of Giacometti's relationships, including professional ones. The only people to remain immune were members of his immediate family. Despite their regular quarrels, Annette was spared, as was Caroline, whom he always forgave no matter what she did. Matisse, who was never estranged, despite the many misadventures inherent in the artist-gallerist relationship, also benefited from Giacometti's unfailing benevolence. The artist still enjoyed a wide circle of friends, but it had considerably evolved over time. His ability to forge new attachments remained intact, and he became close to his more recent models and to the young poets to whom he would supply prints. He had also acquired a circle of friends in Milan, and would frequently stop off in the city on his

way to Stampa. The artist was now at the pinnacle of his fame, but he had lost none of his simplicity and accessibility. Giorgio Soavi described how people immediately warmed to him: "Free of any self-regard. And yet, who is exempt from that? Café waiters, matadors, poets; artists like Chagall and Picasso: all brimful of self-regard. Even when tired, Alberto radiates immense kindness and trustworthiness. He has the way of walking of a man who might stagger over at any moment and yet who stands firm, head turned towards the person addressing him; once alone, his head drops."[6]

As he started work on the Tate Gallery exhibition envisaged for the following year, Giacometti received an invitation from MoMA in New York for around the same period. "How can it be done?" he wrote to Matisse. "I've no idea. For the sculptures, it seems to me that there's no problem since at least it looks like there are enough copies for two exhibitions. For the drawings too. But the paintings?"[7]

Once again, he turned to his gallerist. "If I can continue working as I do now it should be possible, it's the only thing that interests me, plus the exhibitions. The past doesn't interest me much and it seems it's been seen quite enough before," he added, underlining how the priority was to unveil new works. He was exhausted, though, and conscious that he needed to push himself less: "I've seldom worked as much as over the last ten days, but I do have to slow down a little, not much." In the end, both exhibitions were retrospectives, with just a few recent pieces. Among these, many were created from a new model. For several months his friend Lotar, short of funds, had been coming to the studio. Giacometti took him on as an assistant and then asked him to sit for sculptures. His portraits of the photographer recall the delicacy and refinement reflected in the two busts of Yanaihara. Since his work with the Japanese philosopher, the style of his sculptures had been characterized by increased fidelity to the sitter. If the ten busts of Annette from 1961–64, for instance, are among the most realistically modeled since the war, the degree of exactitude in the faces of Yanaihara and Lotar is unique. Giacometti complained ceaselessly of how difficult he found capturing a likeness, but he came closest to attaining one

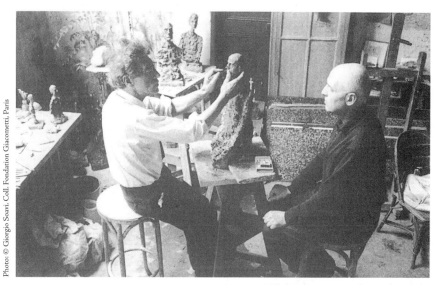

Photo: © Giorgio Soavi. Coll. Fondation Giacometti, Paris

Eli Lotar posing in the studio, 1965.

with less familiar sitters. As if to confirm the fact, the last busts of Diego, intended for the exhibition at MoMA, are far from realistic. Perhaps it was a foretaste of a new inflection he never had time to develop. The features grimace, tortured by blows from a penknife, in contrast to the serene heads of Lotar. Two parallel, but entirely distinct aesthetic paths: this was a dichotomy which Giacometti was never to depart from, up to his final works. It was this phenomenon among others that makes his output impossible to categorize in any one style or tendency. He also continued to paint portraits, of Caroline in particular. In 1964–65 he produced a remarkable series of large pictures of the young woman seated with her hands clasped. In these works, as in the painted portrait *Annette in a Coat*, he used a more colorful palette than usual. He also executed a portrait after a new model, James Lord. This eccentric American, whom he had known since the 1950s, a friend of many artists and of Picasso in particular, was to note down some of the remarks they exchanged during the eighteen days the sitting lasted. He turned this eyewitness account into a remarkable

book published the following year, recording the artist's changing moods and creative processes. After Giacometti's death, Lord was also to author an exhaustive if less inspired biography, an inextricable mix of attested facts and romanticized interpretations.

The beginning of 1965 saw the fulfillment of a project very close to Giacometti's heart. The previous year he had received a thrilling piece of news: at the instigation of Ernst Beyeler, several Swiss collectors and patrons had joined forces to purchase the Thompson collection and create a foundation dedicated entirely to his oeuvre. The project, headed by Hans C. Bechtler, was to be based in Zurich. Giacometti replied to the letter outlining the plan with enthusiasm and gratitude. "I am very moved and most touched by what you have managed to do. I'm overwhelmed and, at this moment, I can only express to you my profoundest gratitude. As I told you yesterday evening, in the future I shall do everything in my power to enhance the collection; with older stuff, but especially with more recent things, as well as with whatever I will do, as I hope, in the future. All this has had the strangest effect on me and forgive me if I can write nothing more this evening."[8]

Having recently honored him with several important exhibitions, Switzerland thus acquired an entire collection worthy of the name. There were hitches before it was finally established, however: the citizens of Zurich voted against the city's participation in purchasing the collection, which infuriated Giacometti. The backers of the project persevered, however, and eventually overcame every obstacle, setting up the foundation formally in December 1965. The holdings were split between the Kunsthaus, Zurich, showcasing the works, while the museums at Winterthur and Basel—home cities of two of the chief patrons—were allocated various deposits. To complete the outstanding collection Thompson had amassed, Giacometti donated several recent works. No other museum possesses such a wide and coherent ensemble of his works. At the same date, France had only a handful of works in public collections, and no monographic exhibition had yet been devoted to the artist.[9]

CHAPTER 34

The Final Months

Despite his visceral dislike of traveling, Giacometti's deeply personal involvement in his last exhibitions persuaded him to go abroad, notably, to London to supervise the hanging at the Tate Gallery in spring 1965. Since several older works, such as *Suspended Ball*, were unavailable for loan, he decided to make new versions. To complete the exhibition, he even made a few works on site, in the gallery's basement. Once again he was accompanied by his closest associates: Diego and Clayeux assisted in the preparations, and he was joined by Annette and Leiris before the opening. Even Caroline made a brief appearance. He collaborated closely with the curator of the show, David Sylvester, a critic whose portrait he had painted in 1960. Together they chose, among other pieces, a selection of surrealist works in both versions, plaster and bronze, to be shown in juxtaposition. The exhibition would be the first to bring out the unique place plaster held in his oeuvre, considered on a par with bronze as a material for sculpture. Giacometti was delighted with the results and agreed to sell a group of works to the gallery for a price he set much lower than the market value. The exhibition at MoMA was held practically simultaneously. Because he had not participated in the hanging nor been present at the opening, the artist decided to go to New York for the first time in his life, before the exhibition closed, embarking on October 1 on the *Queen Elizabeth* for the week-long crossing with Annette and the Matisses. For him, the whole trip, the first of such length, was like being on a different, enchanting, planet. Giacometti was acclaimed with all honors at a reception in New York that was attended by many important artists, including Rothko, De Kooning, Motherwell, and Rauschenberg. After visiting the exhibition, he asked to be taken to the famous site at the Chase Manhattan Plaza that had occupied his mind for so long. He returned to see it on several occasions, once again seized by the excitement of the project. On October 14, Giacometti and Annette set sail back to Europe.

As he had on the outward journey, he endeavored to finish the text he had promised for his book on his copies of works from the past, a project that had since expanded into a lavishly illustrated volume. "I'm on the liner on the way back from New York, tomorrow we'll arrive in Le Havre and Paris. Impossible to concentrate on anything. The sea takes over everything, for me it's without name, though today it's called the Atlantic. For millions of years it had no name and one day it will again have no name, endless, unseeing, as unchained as it is for me today."[1]

In addition to the actual crossing, what struck him most on the trip was the Chase Manhattan site, which fueled his new desire to execute a female figure on a gigantic scale. At times joyous and at others disturbing, the whole experience offered a pause in the practice of an art that otherwise left him alone with himself. "I now know that I undertook this trip mainly for the two ocean crossings. I've hardly glanced at the sea for two days since I saw the extreme tip of New York dissolve, vanish on the horizon, slender, fragile, and transitory, and it's as if I were living through the beginning and the end of the world, there's a knot of anguish in my chest, I feel the sea surrounding me, but there's also the dome, the immense vault of a human head."[2]

He was barely back on dry land when he left again for Denmark to fulfill his promise to attend the retrospective devoted to his work at the Louisiana Museum. As Diego informed Matisse: "So, Alberto has left for Copenhagen, in a dreadful mood, he didn't want to be on the road again, he wanted to get back quickly quickly, still he thought the exhibition was really good, the owner of the Louisiana very nice, Copenhagen very pretty, and, since he knows neither Hamburg nor the valley of the Rhine, he'll do those in stages, so as not to travel at night he'll stop off in Hamburg and in Cologne, and I think they (he's accompanied by Annette) will arrive back on Thursday."[3]

Even though he enjoyed all these trips, the artist was exhausted by the fast pace, complaining that they kept him out of the studio for too long. He had produced little work since the beginning of the year, etchings mainly. After a series of eight prints for a book by Robert Lebel, including six portraits of Annette and two views of the studio, he agreed to illustrate some poems by

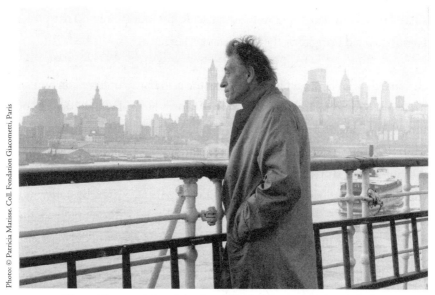

Photo: © Patricia Matisse. Coll. Fondation Giacometti, Paris

Alberto Giacometti aboard the *Queen Elizabeth* arriving in New York, October 1965.

Édith Boissonnas, although they were not personally acquainted. As he had done for the book by André du Bouchet ten years previously, he proposed etchings on the theme of the studio, together with seven portraits of the poet herself. Back in the studio, he immediately got back to work, producing sculpture busts of Lotar and paintings of Caroline and Annette. For the last two years, another project had been encroaching into his daily routine. His friend Ernst Scheidegger, in collaboration with Dupin, wanted to shoot a documentary film about his work. After recording his comings and goings in both Montparnasse and Stampa, in autumn 1965 the crew set up in the studio. The artist was annoyed at the equipment and the cables straddling the little room, but he entered into the spirit of the exercise remarkably well, allowing the cameras to roll while he was painting a portrait of Dupin and sculpting without a model. The film, in color, shows the unvarnished reality of the studio: walls that had never been repainted, covered in his drawings; the plant sprouting through a crack in the wall that he had let grow into a

small bush; completed and unfinished sculptures cluttering up the place; paintings piled up against the walls; papers spread across the bed.

In mid-November France awarded him a national Grand Prix for the arts, and shortly after he set off to Bern where the university conferred on him an honorary doctorate. He returned to Paris worn out and with a bad case of bronchitis. Even before he had left for New York, his friends were expressing worries about his declining physical state and his incessant coughing, which did nothing to stop him from chain smoking. "I found Giacometti much thinner, bowed, floating about in his clothes, the face riven by suffering," Brassaï recalled after a visit to him in March. "However, the light that shone in his eyes red with sleeplessness was as intense as ever and his magnetic voice just as warm."[4] On December 5, he set out for Chur, to undergo further medical examinations. The cancer seemed not to have returned, but his general health was very poor. However, he received treatment that was immediately beneficial, as Annette wrote to Patricia Matisse, assuaging her concern: "I've waited for precise information before writing to you. Here it is: it was the bronchitis that kicked it all off. The main thing is that there's no recurrence of the cancer. I saw the doctor again yesterday evening and now that's sure. The liver's completely OK, the blood too. The heart's on the mend, it's been overworked by a ghastly chronic bronchitis they're now dealing with. Alberto showed up at the hospital on Monday December 6 utterly exhausted, because, though I tell him to look after himself, to treat the bronchitis (I've been going on about this incessantly for two years!), he pays not a blind bit of notice … and he'd got up to eighty cigarettes a day! (Perhaps only sixty.) Now he appears much improved, he's breathing normally, he sleeps, he eats, but the bronchitis is not over and Alberto absolutely has to look after himself, give up smoking (for the moment he's not smoking) and relax as well as he can for a month or two until he's entirely cured. Perhaps it's not possible to heal it completely because the bronchi and the lungs are not exactly new (obviously!), but surely we can do far better. The doctor seems all right to me. For the moment I go back and forth to Chur, I was

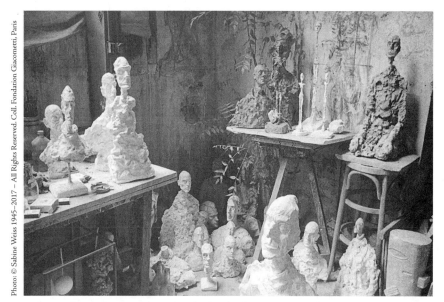

Alberto Giacometti's studio after his death, June 1966. Photograph by Sabine Weiss.

here the first week and went back yesterday—when Alberto leaves hospital (not before a week in any case) I'll go to Stampa until the end of January."[5]

Initial signs of recovery were encouraging, as the artist reassured all his loved ones by telephone. Many of them came to visit him: Bruno and his wife Odette, Diego, who quickly returned to Paris to look after the studio. Leaving hospital for the holidays was however no longer on the agenda. Having lost a lot of weight, Giacometti was extremely run down; as his state worsened, Bruno and Diego hurried to his bedside. Warned that his friend did not have long to live, Pierre Matisse jumped on a plane for Zurich. In spite of her reservations, Annette also permitted Caroline to join them. All those who meant most to the artist gathered round for his last hours, except for Matisse, who arrived shortly after his death. Alberto Giacometti died at the age of sixty-five at 10 a.m. on January 11, 1966. "I saw Alberto die," Diego remembered. "I was seated at his bedside, I held his hand. Alberto looked at me or rather scrutinized the contours of my face, drew me with his eyes as he used to draw eyes, transposing into drawing all he could see."[6]

On the following day, Diego returned to Paris to salvage the sculpture in progress, a half-length bust of Lotar, which he proceeded to mold. The funeral took place on January 15, in Alberto's native village, in the presence of his family, his closest friends, some villagers, and a few officials. Later Diego had erected over the tomb a bronze edition of the sculpture he had saved from destruction. From Giacometti's earliest work when he left the academy to this very last sculpture, his career had lasted forty tireless years. He created more than five hundred and fifty original sculpture models, and as many paintings, in addition to etchings, thousands of drawings, and around fifty models for decorative objects. Managing finally to complete the text, he left the project he had been working on for years, *Paris without End*, almost finished. In this rather jumbled account he recalls the pleasure he always found in strolling about Paris, "which suddenly became something immense and unknown, to run through, to discover," but also the times of discouragement and the impossibility of ever truly accomplishing anything.

He concludes with a meditation occasioned by nocturnal solitude, at that hour in the early morning when, befuddled, for him the night is just beginning: "Silence, I'm here alone, outside it's nighttime, nothing moves and sleep gains me again. I know neither who I am, neither what I'm doing, nor what I want, I don't know if I'm old or young, I have perhaps a few hundreds of thousands of years to live before my death, my past slides into a gray pit, I was a snake and I see myself as a crocodile, with wide-open mouth; it was me, the crawling crocodile with its mouth agape. Shout and howl until the air trembles; and the matches dotted about the ground, like warships on a gray sea."[7]

Notes

Introduction

1 "Fragmente aus Tagebüchern," conversation between Alberto Giacometti and Gotthard Jedlicka, March 30, April 1, April 3, 1953, *Neue Zürcher Zeitung*, April 4, 1964, reprinted in Alberto Giacometti, *Écrits* (Paris: Hermann/Fondation Giacometti, 2008), 197–98.

2 Letter from Samuel Beckett to Georges Duthuit, September 10, 1951, in Samuel Beckett, *Les Années Godot: Lettres, 1941-1956* (Paris: Gallimard, 2015), 322.

3 Alberto Giacometti, note in French in a notebook, c. 1932, reproduced in Alberto Giacometti, *Écrits*, 464.

4 Alberto Giacometti, "Notes sur les copies," in Alberto Giacometti, *Les Copies du passé* (Paris: Éditions Fage, 2012), 47.

5 Jean Genet, *The Studio of Giacometti*, trans. P. King (London: Grey Tiger, 2014), 51.

6 Alberto Giacometti, "En dehors de tout contrôle…," handwritten sheet, in French, c. 1930, reproduced in Alberto Giacometti, *Écrits*, 353.

7 Interview with Alberto Giacometti in *Du*, no. 205 (March 1958): 34–36

Chapter 1: Childhood

1 "What attracted me especially to the Giacomettis was the joyous and welcoming harmony that always reigned in the family," Renato Stampa, in "Per il centenario della nascita di Giovanni Giacometti," *Quaderni grigionitaliani*, XXXVII, no. 2 (1968): 47.

2 Ibid.

3 Alberto Giacometti, "Hier, sables mouvants. Souvenirs d'enfance d'Alberto Giacometti," *Le Surréalisme au service de la révolution*, no. 3 (December 1931), reprinted in Alberto Giacometti, *Écrits*, 36.

4 Alberto Giacometti, note in a notebook, in French, c. 1916–19, reprinted in Alberto Giacometti, *Écrits*, 397.

5 I learned this detail from Christian Klemm, who was told it by Bruno Giacometti.

6 Fritz Burger, *Cézanne und Hodler: Einführung in die Probleme der Malerei der Gegenwart* (Munich: Delphin Verlag, 1919).

7 Letter from Giovanni Giacometti to Cuno Amiet, 1912, Cuno Amiet archives, Oschwand.

8 Diego Giacometti, radio interview, in Paule Chavasse, "Alberto Giacometti, une quête sans fin," ORTF, October 17, 1969.

9 "Pourquoi je suis sculpteur," conversation between Alberto Giacometti and André Parinaud, *Arts*, no. 873 (June 13, 1962): 1–5.

10 Letter from Giovanni Giacometti to Cuno Amiet, April 26, 1916, Cuno Amiet archives, Oschwand.

11 Auguste de Niederhäusern, known as Rodo, Swiss sculptor and friend of Giovanni Giacometti.

12 "Fragmente aus Tagebüchern," reprinted in Alberto Giacometti, *Écrits*, 197–98.

13 Bruno Giacometti, "Souvenirs fraternels," in *Alberto Giacometti* (Martigny: Fondation Pierre Gianadda, 1986), 37.

14 Ibid.

15 Alberto Giacometti to Jean Clay, in "Le dialogue avec la mort d'un très grand sculpteur de notre temps," *Réalités*, no. 215 (December 1963).

16 Ibid.

17 Alberto Giacometti, "Notes sur les copies," *L'Éphémère*, no. 1 (1966): 104.

18 Alberto Giacometti, "Lettre à Peter F. Althaus," *Du*, no. 205 (March 1958): 34.

19 Ibid., 34–36.

20 "Alberto always had a foible for *idées fixes*. He could be incredibly pedantic, in the way, for example, of arranging his clothes or socks. If I altered something in the careful rows of objects, just to annoy him, he could fly off into a rage. For him, things were living beings," Bruno Giacometti, in *La mamma a Stampa* (Kunsthaus Zurich, 1990), 26.

21 Unpublished note written in French on a loose leaf in 1946 or 1947, Fondation Giacometti archives, Paris.

22 i.e. *The Jewish Bride*.

23 Alberto Giacometti, handwritten text in French in one of his notebooks, 1947, published in Alberto Giacometti, *Écrits*, 531.

24 Alberto Giacometti, "Hier, sables mouvants," reprinted in Alberto Giacometti, *Écrits*, 38.

25 Christoph Bernoulli, "Jugenderinnerungen an die Familie Giacometti," *Du*, no. 252 (February 1962): 16.

26 Letter from Alberto Giacometti to his parents, Schiers, March 9, 1917, Alberto Giacometti-Stiftung archives, Zurich.

27 Letter from Alberto Giacometti to Lucas Lichtenhan, around May 20, 1918, Alberto Giacometti-Stiftung archives, Zurich.

28 Ibid.

Chapter 2: **Becoming an Artist**

1 "Fragmente aus Tagebüchern," reprinted in Alberto Giacometti, *Écrits*, 197–98.

2 Letter from Annetta Giacometti to Alberto Giacometti, Stampa, November 26, 1919, Fondation Giacometti archives, Paris, 20160608 FAAG.

3 Letter from James Vibert to Giovanni Giacometti, September 26, 1919, Alberto Giacometti-Stiftung archives, Zurich.

4 Pierre Courthion, "Alberto Giacometti," *Art documents*, nos. 10–11 (July 1951): 5.

5 Letter from Giovanni Giacometti to Cuno Amiet, 1920, Cuno Amiet archives, Oschwand.

6 Letter from Alberto Giacometti to Pierre Matisse, letter-cum-text for the catalog of the 1948 exhibition, Pierre Matisse Gallery, New York. Pierre Matisse Gallery Archives, The Morgan Library & Museum, New York. All letters to Matisse are written in French.

7 Letter from Giovanni Giacometti to Cuno Amiet, May 1920, Cuno Amiet archives, Oschwand.

8 Alberto Giacometti, "Mai 1920," *Verve*, vol. III, no. 27–28 (December 1952): 33 and 34.

9 Ibid.

10 Letter from Giovanni Giacometti to Cuno Amiet, May 1920, Cuno Amiet archives, Oschwand.

11 Letter from Alberto Giacometti to his parents, December 8, 1920, Alberto Giacometti-Stiftung archives, Zurich.

12 Letter of January 29, 1921, quoted in Reinhard Hohl, *Alberto Giacometti* (London: Thames and Hudson, 1972), 245.

13 Letter from Alberto Giacometti to his parents, December 31, 1920, Rome, Alberto Giacometti-Stiftung archives, Zurich, A1920XII31.

14 Alberto Giacometti, *Écrits*, 38.

15 Letter from Giovanni Giacometti to Alberto Giacometti, January 23, 1921, Fondation Giacometti archives, Paris.

16 Ibid.

17 Letter from Alberto Giacometti to his parents, April 18, 1921, Alberto Giacometti-Stiftung archives, Zurich.

Chapter 3: **Death Up Close**

1 Letter from Alberto Giacometti to his family, SIK-ISEA archives, Zurich, 274.A.2.1.23.

2 Letter from Alberto Giacometti to his family, SIK-ISEA archives, Zurich, 274.A.2.1.24.

3 Letter from Alberto Giacometti to his family, SIK-ISEA archives, Zurich, 274.A.2.1.25.

4 Jean Clay, *Visages de l'art moderne* (Lausanne: Éditions Rencontre, 1969), 151.

5 In the review *Labyrinthe*.

6 Alberto Giacometti, "Le Rêve, le Sphinx et la Mort de T.," *Labyrinthe*, no. 22–23 (December 1946): 12 and 13; published in English in Véronique Wiesinger and José Lebrero Stals, *Alberto Giacometti: A Retrospective* (Málaga: Museo Picasso, 2012).

7 Alberto Giacometti, quoted by Reinhard Hohl, *Alberto Giacometti*, 301n41. He read the letter in Guy de Maupassant, *Étude sur Gustave Flaubert*.

Chapter 4: **Settling Down in Paris**

1 Diego had been born on November 15, 1902.

2 *Diego Standing in the Living Room in Stampa* (*Diego debout dans le salon à Stampa*), oil on canvas.

3 Letter from Annetta Giacometti to Alberto Giacometti, December 16, 1922, Fondation Giacometti archives, Paris.

4 Daniel Marquis-Sébie, *Le Message de Bourdelle* (Paris: L'Artisan du Livre, 1931).

5 Letter from Alberto Giacometti to his parents, December 16, 1922, Alberto Giacometti-Stiftung archives, Zurich, A1922 XII 16.

6 Letter from Alberto Giacometti to his family, January 14, 1924,

SIK-ISEA archives,
Zurich, 274.A.2.1.39.

7 Alberto Giacometti interviewed
by Jean-Marie Drot, "Alberto
Giacometti," TV film, 35 mm, Paris,
ORTF, series *Les heures chaudes de
Montparnasse,* November 1963.

8 Ibid.

9 Bror Hjorth, in *Alberto Giacometti,
Bror Hjorth* (Stockholm:
Liljevalchs Konsthall, 2006), 7.

10 Ibid.

11 Letter from Ottilia Giacometti
to Alberto Giacometti,
March 1923, Fondation
Giacometti archives, Paris.

12 Letter from Alberto Giacometti to
his parents, December 16, 1922,
Alberto Giacometti-Stiftung
archives, Zurich, A1922XII16.

13 Ibid.

14 An optical phenomenon, mirage.

15 Letter from Giovanni Giacometti
to Alberto Giacometti,
March 15, 1923, Fondation
Giacometti archives, Paris.

16 Letter from Annetta Giacometti to
Alberto Giacometti, December 7,
1923, and letter from Giovanni
Giacometti to Alberto Giacometti,
December 9, 1923, Fondation
Giacometti archives, Paris.

17 Alberto Giacometti interviewed
by Georges Charbonnier,
RTF, Paris, March 3, 1951.

18 Letter from Giovanni Giacometti
to Alberto Giacometti,
December 9, 1923, Fondation
Giacometti archives, Paris.

19 Letter from Alberto Giacometti
to his parents, December 29,
1923, Alberto Giacometti-
Stiftung archives, Zurich.

20 Letter from Giovanni Giacometti
to Alberto Giacometti,
January 6, 1924, Fondation
Giacometti archives, Paris.

Chapter 5: An Artist's Life

1 Letter from Giovanni Giacometti
to Alberto Giacometti,
January 6, 1924, Fondation
Giacometti archives, Paris.

2 Letter from Alberto Giacometti
to his parents, February 18,
1924, SIK-ISEA archives,
Zurich, 274.A.2.1.41.

3 Letter from Alberto Giacometti
to his parents, March 1,
1924, SIK-ISEA archives,
Zurich, 274.A.2.1.42.

4 Letter from Alberto Giacometti
to his family, February 8,
1924, Alberto Giacometti-
Stiftung archives, Zurich.

5 Ibid.

6 Letter from Alberto Giacometti
to his parents, January 22,
1924, Alberto Giacometti-
Stiftung archives, Zurich.

7 Ibid. The Japanese student was
probably Sato Chozan (although
it might also be Takashi Shimizu,
at the academy in 1924).

8 Letter from Annetta Giacometti
to Alberto Giacometti,
May 29, 1924, Fondation
Giacometti archives, Paris.

9 Ibid.

10 Letter from Annetta Giacometti
to Alberto Giacometti,
January 4, 1925, Fondation
Giacometti archives, Paris.

11 Letter from Alberto Giacometti to his parents, January 31, 1925, SIK-ISEA archives, Zurich, 274.A.2.1.46.

12 *Ossip Zadkine*, Galerie Barbazanges, January 1925 (70 sculptures); letter from Alberto Giacometti to his parents, January 31, 1925, SIK-ISEA archives, Zurich, 274.A.2.1.46.

13 Ibid.

14 Ibid.

15 Letter from Annetta Giacometti to Alberto Giacometti, March 1, 1925; letters from Alberto Giacometti to his parents, March 2, 1925 and January 4, 1926, SIK-ISEA archives, Zurich, 274.A.2.1.47 and 274.A.2.1.54.

16 Letter from Alberto Giacometti to his parents, March 2, 1925, SIK-ISEA archives, Zurich, 274.A.2.1.47.

17 Unidentified.

18 Letter from Diego and Alberto Giacometti to their family, February 8, 1925, SIK-ISEA archives, Zurich, 274.A.2.3.4.

19 Letter from Diego and Alberto Giacometti to their family, February 17, 1925, SIK-ISEA archives, Zurich, 274.A.2.3.5.

20 Letter from Alberto Giacometti to his family, January 31, 1925, SIK-ISEA archives, Zurich, 274.A.2.1.46.

21 Otto Bänninger, Massimo Campigli, and Milo Milunović.

22 Letter from Giovanni and Annetta Giacometti to Alberto and Diego Giacometti, April 9, 1925, Fondation Giacometti archives, Paris, 2003-5256.

23 Salon des Tuileries, May 16– June 1925; in the salon catalog: "Giacometti, Alberto – Swiss – 37, rue Froidevaux – 14e: 648. *Torso* (plaster), 649. *Head* (plaster)."

24 Reinhard Hohl, *Alberto Giacometti*, 245.

25 Alberto Giacometti, in Alain Jouffroy, "Portrait d'un artiste. (VIII.) Giacometti," *Arts*, no. 545 (December 7–13, 1955): 9.

26 Letter from Alberto Giacometti to Diego Giacometti, August 24, 1925, Fondation Giacometti archives, Paris.

27 Letter from Alberto Giacometti to his family (writes about the grant he hopes to be awarded), January 28, 1926, SIK-ISEA archives, Zurich, 274.A.2.1.52.

28 Only two examples are known, one of which has disappeared.

29 Lost work, known from a drawing in a sketchbook (known as the "Carnet Gallia"), Fondation Giacometti archives, Paris, 2000-0037.

30 Brancusi does not feature. He marks: "Bourdelle 9½/10, Maillol 8/10, Despiau 9/10, Laurens 10/10, Lipchitz 10/10, Zadkine 8/10," Fondation Giacometti collection, Paris.

31 Letter from Alberto Giacometti to his family, February 18, 1926, SIK-ISEA archives, Zurich, 274.A.2.1.57.

32 Ibid.

33 Quoted in Jean Clay, *Visages de l'art moderne* (Lausanne: Éditions Rencontre, 1969).

34 Letter from Flora Mayo to James Lord, undated, Beinecke Library, Yale University.

35 Quoted in Jean Clay, *Visages de l'art moderne*.

36 "I told him my name and he immediately said that it was then me who was showing two statues close to his in the Tuileries, that he had seen them and that he thought they were good and interesting," letter from Alberto Giacometti to his family, June 19, 1926, SIK-ISEA archives, Zurich, 274.A.2.1.58.

37 Ibid.

38 Letter from Flora Mayo to James Lord, 1971, Beinecke Library, Yale University.

39 In the catalog to the Salon des Tuileries, 1926: "Giacometti, Alberto – Suisse – 37, rue Froidevaux, Paris: Sculpture, s.; Bust, s." See also the "Carnet Gallia" sketchbook, c. 1934, corrected in 1953, Fondation Giacometti collection, Paris.

40 Véronique Wiesinger, "Alberto Giacometti: From the Grande Chaumière to the Big Apple," in *Alberto Giacometti, Bror Hjorth*, 19–76.

41 Letter from Diego Giacometti to Alberto Giacometti, October 4, 1926, SIK-ISEA archives, Zurich, 274.A.2.2.26.

42 Cf. note inscribed in one of Alberto Giacometti's notebooks: "Hjorth, 46 rue Hippolyte Maindron." On a 1925 picture by Hjorth one reads "girl, 46 rue Hippolyte Maindron"; this address also appears in 1924 in the Salon des Tuileries catalog.

Chapter 6: **Rue Hippolyte-Maindron**

1 Letter from Alberto Giacometti to his parents, December 30, 1926, SIK-ISEA archives, Zurich, 274.A.2.1.60.

2 Letter from Diego Giacometti to his family, August 17, 1926, SIK-ISEA archives, Zurich, 274.A.2.2.24.

3 Letter from Alberto Giacometti to his parents, March 2, 1927, SIK-ISEA archives, Zurich, 274.A.2.1.66.

4 Letter from Alberto Giacometti to his parents, December 30, 1926, SIK-ISEA archives, Zurich, 274.A.2.1.60.

5 Ibid.

6 Ibid.

7 Emmanuel Auriscote, "Alberto Giacometti," *Les Lettres françaises*, no. 115 (January 20, 1966): 2.

8 Letter from Alberto Giacometti to his family, January 1927, SIK-ISEA archives, Zurich, 274.A.2.1.53.

9 With the letter from Alberto Giacometti to his family, February 26, 1927, SIK-ISEA archives, Zurich, 274.A.2.1.65.

10 Ibid.

11 Letter from Giovanni Giacometti to Alberto Giacometti, February 28, 1927, Fondation Giacometti archives, Paris.

12 Letter from Alberto Giacometti to his family, March 2, 1927, SIK-ISEA archives, Zurich, 274.A.2.1.66.

13 Letter from Alberto and Diego Giacometti to their family, March 13, 1927, SIK-ISEA archives, Zurich, 274.A.3.1.288.

14 In the catalog to the Salon des
 Tuileries, 1927: "Giacometti,
 Alberto, 46 bis, rue Hippolyte-
 Maindron (14e), 1001. Sculpture, s.;
 1002. Sculpture, s." As Alberto's
 descriptions refer to just one
 work, he probably thought better
 of presenting the second, or it
 might not have been accepted.

15 Letter from Alberto Giacometti
 to his family, April 28,
 1927, Alberto Giacometti-
 Stiftung archives, Zurich.

16 Ibid.

17 Letter from Giovanni Giacometti
 to Alberto Giacometti,
 April 1927, Fondation
 Giacometti archives, Paris.

18 Letter from Bruno Giacometti to his
 brothers, August 7, 1927, Fondation
 Giacometti archives, Paris.

19 F. Fosca, "Introduction," brochure
 guide to the tenth exhibition of the
 Salon de l'Escalier (July 1927).

20 Mario Tozzi, Nuova Italia
 (July 21, 1927).

21 Jean Cocteau, Le Rappel à
 l'ordre, discipline et liberté
 (Paris: Stock, 1926).

22 Letter from Giovanni Giacometti
 to Alberto Giacometti,
 April 11, 1927, Fondation
 Giacometti archives, Paris.

23 Letter from Bruno Giacometti to his
 brothers, May 12, 1927, Fondation
 Giacometti archives, Paris.

24 Jean Cocteau, Le Rappel à l'ordre.

25 Busts of his father, of Diego, and of
 a young woman; letter from Annetta
 Giacometti to her son, Diego,
 September 10, 1927, Fondation
 Giacometti archives, Paris.

26 Ibid.

27 Julius Hembus, quoted in
 the Frankfurter Allgemeine
 Zeitung (May 26, 1970).

Chapter 7: **Between Cubism and Surrealism**

1 Waldemar-George, "Les artistes
 italiens de Paris," in Entracte
 VI, brochure guide to the
 exhibition (February 1928).

2 Gino Severini, Du cubisme au
 classicisme (Paris: Povolozky, 1921).

3 Letter from Giovanni Giacometti
 to Alberto Giacometti,
 April 1, 1925, Fondation
 Giacometti archives, Paris.

4 Letter from Alberto Giacometti
 to his family, February 6,
 1928, SIK-ISEA archives,
 Zurich, 274.A.2.1.73.

5 Quoted by Jurgis Baltrušaitis, Les
 Perspectives dépravées: Anamorphoses
 (Paris: Flammarion, 1996). The
 author notes that Lipchitz had
 purchased these two anamorphoses
 at a sale at the Hôtel Drouot auction
 house on April 3, 1925, and that
 they were on view in his studio.
 They were an anamorphic portrait
 of Charles V (1533), with his nose
 pointed like a spearhead, and an
 "anamorphotic picture" representing
 St. Antony of Padua (c. 1535).

6 Letter from Alberto Giacometti to
 his family, July 2, 1928, SIK-ISEA
 archives, Zurich, 274.A.2.1.75.

Chapter 8: **Decisive Encounters**

1 Letter from Alberto Giacometti to his family, January 16–21, 1929, SIK-ISEA archives, Zurich, 274.A.2.1.84.

2 Letter from Alberto Giacometti to his family, March 2, 1929, SIK-ISEA archives, Zurich, 274.A.2.1.90.

3 Letter from Alberto Giacometti to his family, April 16, 1929, SIK-ISEA archives, Zurich, 274.A. 2.1.91.

4 Ibid.

5 Alberto Giacometti interviewed by Jean-Marie Drot, November 1963.

6 The group is usually known as the "groupe de la rue Blomet," after the address of Masson's previous studio where they would initially meet up. By the time Giacometti and Masson had become friends, the painter had changed studios and the gatherings would take place in avenue de Ségur.

7 Letter from Alberto Giacometti to his family, May 6, 1929, Alberto Giacometti-Stiftung archives, Zurich. By this date he already knew Carl Einstein and was waiting for another visit ("The other evening we met up with Einstein and all the leaders, and they were really, really friendly to Alberto, you could see they were very interested in him." Letter from Ottilia Giacometti to her parents, May 3, 1929, SIK-ISEA archives, Zurich, 274.A.3.2.23).

8 Kahnweiler, the cubists' legendary dealer, owned the gallery, which was run by Louise Leiris. André Masson had been exhibiting there since 1922.

9 Letter from Alberto Giacometti to his family, May 26, 1929, Alberto Giacometti-Stiftung archives, Zurich, and letter to Michel Leiris, published by Agnès de La Beaumelle in *Donation Louise et Michel Leiris: Collection Kahnweiler-Leiris* (Paris: Centre Georges-Pompidou, 1984), 48.

10 Letter from Alberto Giacometti to his family, May 26, 1929, Alberto Giacometti-Stiftung archives, Zurich.

11 Ibid.

12 Ibid.

13 Visitors' book at the Galerie Bucher. Letter from Alberto Giacometti to his family, June [3], 1929, Alberto Giacometti-Stiftung archives, Zurich.

14 Jean Cocteau, *Opium* [1930], trans. M. Crosland (London: Peter Owen, 1990), 126.

15 Letter from Alberto Giacometti to his family, June [3], 1929, Alberto Giacometti-Stiftung archives, Zurich.

16 Acquisition made in November 1929, cf. letter from Albert Loeb to Charles de Noailles, Albert Loeb archives.

17 Letter from Alberto Giacometti to his family, June 19, 1929, SIK-ISEA archives, Zurich, 274.A.2.3.22.

18 Michel Leiris, *Journal* (Paris: Gallimard, 1992).

19 Georges Bataille, "Informe," *Documents*, no. 7 (December 1929): 382.

20 These "compositions," probably since destroyed, are known from undated photographs in the Fondation Giacometti archives, Paris.

21 Carl Einstein, *Documents*, no. 7 (December 1929): 391.

22 Letter from Alberto Giacometti to his family, December 5, 1929, SIK-ISEA archives, Zurich, 274.A.2.1.97

Chapter 9: A New Phase

1 Letter from Alberto Giacometti to Diego Giacometti, October 28, 1929, Fondation Giacometti archives, Paris, 2003-5189.

2 Letter from Alberto Giacometti to his family, October 8, 1929, SIK-ISEA archives, Zurich, 274.A.2.1.98.

3 Letter from Alberto Giacometti to Bruno Giacometti, November 27, 1929, SIK-ISEA archives, Zurich, 274.A.2.1.102.

4 Letters from Bianca to Alberto Giacometti, Fondation Giacometti archives, Paris.

5 Letter from Alberto Giacometti to his parents, December 5, 1929, SIK-ISEA archives, Zurich, 274.A.2.1.97.

6 Letter from Alberto Giacometti to Bruno Giacometti, November 27, 1929, SIK-ISEA archives, Zurich, 274.A.2.1.102.

7 Letter from Giovanni Giacometti to Alberto and Diego Giacometti, December 11, 1929, Fondation Giacometti archives, Paris.

8 Charles-Albert Cingria, "Falconetti sculpteur," *Aujourd'hui*, no. 6 (January 9, 1930): 5 and no. 8 (January 23, 1930): 5, reprinted in *Les Musées de Genève*, no. 65 (May 1966), 15–16. The article had been published under the incorrect name of "Antonio Falconetti," and Cingria demanded an erratum from the journal.

9 Letter from Alberto Giacometti to his parents, November 27, 1929, SIK-ISEA archives, Zurich, 274.A.2.1.103.

10 Letter from Alberto Giacometti to his parents, before December 22, 1929, SIK-ISEA archives, Zurich, 274.A.2.1.83.

11 Given name, Clément Nauny.

12 Man Ray, *Self-Portrait* (London: Penguin, 2012), 250.

Chapter 10: Joining Surrealism

1 Alberto Giacometti, in Jean Clay, *Visages de l'art moderne*, 159.

2 Salvador Dalí, "Objets à fonctionnement symbolique," *Le Surréalisme au service de la révolution*, no. 3 (1931). Dalí is describing the wooden model, constructed in early 1931.

3 He collaborated with Desny until spring 1930, when he began working with Jean-Michel Frank.

4 Letter from Alberto Giacometti to his parents, undated [January 1931], Paris, SIK-ISEA archives, Zurich, 274.A.2.1.106.

5 Letter from Annetta Giacometti to Alberto Giacometti, July 3, 1930, Fondation Giacometti archives, Paris.

6 Letter from Alberto Giacometti to his family, May 7, 1930, Alberto Giacometti-Stiftung archives, Zurich.

7 Letter from Alberto Giacometti to Tristan Tzara, in French,

November 3, 1930, Bibliothèque Jacques-Doucet archives, Paris.

8 Román Gubern and Paul Hammond, *Luis Buñuel: The Red Years* (Madison: University of Wisconsin Press, 2012), 46.

9 Letter from Alberto Giacometti to his family, February 2, 1931, SIK-ISEA archives, Zurich, 274.A.2.1.116.

10 Ibid.

11 Letter from Denise Maisonneuve to Alberto Giacometti, April 2, 1931, Fondation Giacometti archives, Paris. The artist entrusted Denise with the *"ripolinage"* of the pieces.

12 Jean Hélion, "À perte de vue," in *Récits et commentaires* (Paris: ENSBA, 2004), 185.

13 Letter from Alberto Giacometti to his family, January 7, 1931, SIK-ISEA archives, Zurich, 274.A.2.1.108.

14 Letter from Alberto Giacometti to his family, December 4, 1930, SIK-ISEA archives, Zurich, 274.A.2.1.107.

15 In 1929, according to a letter to his family of October 8, 1929, SIK-ISEA archives, Zurich. "He did a script for the cinema that seemed promising, I hope for him in any case. It pleased me all the more in that I did not expect it for the studio. [The Préverts had cleaned up the studio.] In addition, he has a funny effect on all these people and they find him very nice."

16 In a letter of November 23, 1931 to Alberto and Diego, Ottilia asks for news of Prévert, writing: "Bruno wrote to us that Alberto is dabbling in the cinema, can this be true?"

17 Letter from Alberto and Diego Giacometti to their parents, October 5–6, 1931, Alberto Giacometti-Stiftung archives, Zurich. "This month a major gallery will hold an exhibition of modern art the sculptors in which will be Laurens, Lipchitz, and me." Exhibition *Jeunes artistes d'aujourd'hui*, October–November 1931.

18 *Le Surréalisme au service de la révolution*, no. 3 (December 1931): 18 and 19.

19 Letter from Alberto Giacometti to his parents, SIK-ISEA archives, Zurich, 274.A.2.1.106 and 274.A.2.2.59.

20 Letter from Alberto Giacometti to his parents, March 1, 1931, SIK-ISEA archives, Zurich, 274.A.2.1.111.

21 Reinhard Hohl, *Alberto Giacometti*, 236.

22 Letter from Alberto Giacometti to his parents, October 25, 1929, SIK-ISEA archives, Zurich, 274.A.2.1.99.

Chapter 11: Eroticism and Violence

1 Letter from Annetta and Ottilia Giacometti to Alberto and Diego Giacometti, October 30, 1931, Fondation Giacometti archives, Paris, FAAG 154 CL.

2 Letter from Alberto Giacometti to his parents, September 30, 1931, SIK-ISEA archives, Zurich, 274.2.3.32.

3 Letter from Alberto Giacometti to his parents, December 15,

1931, SIK-ISEA archives, Zurich, 274.A.2.3.35.

4 Letter from Alberto Giacometti to his parents, October 5–6, 1931, Alberto Giacometti-Stiftung archives, Zurich.

5 Ibid.

6 Letter from Alberto Giacometti to André Breton, March 9, 1932, Breton archives, Bibliothèque Jacques-Doucet, Paris.

7 Letter from Alberto Giacometti to André Breton, May 16, 1932, Breton archives, Bibliothèque Jacques-Doucet, Paris.

8 Louis Aragon, "Grandeur nature," *Les Lettres françaises* (January 20, 1966), reprinted in Louis Aragon, *Écrits sur l'art moderne* (Paris: Flammarion, 1981), 217–18.

9 Letter from Alberto Giacometti to his family, December [21], 1930, SIK-ISEA archives, Zurich, 274.A.2.1.107.

10 "I'm in the process of making in marble that thing A. did at Maloja, full of holes, let's hope that the exhibition at Colle's is successful, I think the splendid new things will make an impact," Diego in a letter from Alberto and Diego Giacometti to their family, late 1931–early 1932, SIK-ISEA archives, Zurich, 274.A.2.3.36.

11 Letter from Alberto Giacometti to his family, May 6, 1932, Alberto Giacometti-Stiftung archives, Zurich.

12 Ibid.

13 Tériade, "Giacometti (galerie Pierre Colle)," *L'Intransigeant* (May 10, 1932): 6.

14 Waldemar-George, "L'actualité artistique," *Formes*, no. 25 (May 1932): 280.

15 Christian Zervos, "Quelques notes sur les sculptures de Giacometti," *Cahiers d'art*, no. 8–10 (1932): 339.

16 Letter from Alberto Giacometti to his family, May 6, 1932, Alberto Giacometti-Stiftung archives, Zurich.

17 Letter from Alberto Giacometti to his family, May 13, 1932, SIK-ISEA archives, Zurich, 274.A.2.1.119.

18 Letter from Denise Maisonneuve to Alberto Giacometti, September 1, 1933, Fondation Giacometti archives, Paris.

19 Christian Zervos, "Quelques notes sur les sculptures de Giacometti."

20 "Monday, Zervos, talk to him about the article/a corrective article," Giacometti writes in French in a notebook, 1932, Fondation Giacometti archives, Paris, 2000-0051.

21 Alberto Giacometti to Pierre Matisse, letter-cum-text for the catalog for the 1948 exhibition, Pierre Matisse Gallery, New York. Pierre Matisse Gallery Archives, The Morgan Library & Museum, New York.

22 Luis Buñuel, *My Last Breath*, trans. Abigail Israel (London: Fontana, 1985), 122.

23 Letter from Alberto Giacometti to his parents, May 22, 1932, Alberto Giacometti-Stiftung archives, Zurich.

24 Christian Zervos, "Quelques notes sur les sculptures de Giacometti," 342.

25 Remark in a notebook, in French, 1932–33, Fondation Giacometti archives, Paris, 2000-0051, published in Alberto Giacometti, *Écrits*, 465.

26 Letter from Alberto Giacometti to his family, autumn 1932, Alberto Giacometti-Stiftung archives, Zurich.

27 Made in late 1932, after the publication of Zervos's article. Michael Brenson, *The Early Work of Alberto Giacometti: 1925–1935* (Baltimore: The Johns Hopkins University Press, 1974), 163n191.

28 Notes in a notebook, in Italian, 1932–33, printed in Alberto Giacometti, *Écrits*, 463.

Chapter 12: Interior Decoration and Objects

1 Remarks in a notebook, 1932–33, in French, Fondation Giacometti archives, Paris, 2000-0051, published in Alberto Giacometti, *Écrits*, 465.

2 Letter from Alberto Giacometti to Boris Kochno, in French, January 14, 1932, and January 26, 1932, Fondation Giacometti archives, Paris.

3 "I'm finally not doing the 'ballet,' considering Monte Carlo and all the work it would have entailed (having to change heaps of things), it would easily have taken me three months without even managing to do what I wanted, so I preferred to drop it; in any event, the project is much liked by all who have seen it, it's there, and it'll be of use one day or another,"

letter from Alberto Giacometti to his family, February 1, 1932, SIK-ISEA archives, Zurich, 274.A.2.3.38.

4 Jean-Michel Frank to Alberto Giacometti, October 24, 1934, Fondation Giacometti archives, Paris, 2000-0021.

Chapter 13: *The Palace at 4 a.m.*

1 Alberto Giacometti, "Notes sur la sculpture," *Minotaure*, nos. 3–4 (December 12, 1933): 46, reprinted in Alberto Giacometti, *Écrits*, 49.

2 Alberto Giacometti, private note in French, notebook, Fondation Giacometti archives, Paris, 2000-0053 (3738-82).

3 Letter from Denise Maisonneuve to Alberto Giacometti, August 13, 1931, Fondation Giacometti archives, Paris.

4 Letter from Alberto Giacometti to David Sylvester, in *Giacometti* (Marseille: André Dimanche Éditeur, 2001), 195.

5 Alberto Giacometti, "Notes sur la sculpture."

6 Letter from Alberto Giacometti to David Sylvester, in *Giacometti*, 195.

7 Alberto Giacometti, "Notes sur la sculpture."

8 Ibid.

9 Robert Wernick, *Souvenirs sur les Giacometti* (Paris: L'Arbre à Lettres, 2008).

10 Alberto Giacometti, "Notes sur la sculpture."

11 Ibid.

12 Letter from Alberto Giacometti to Pierre Matisse, 1947, Pierre Matisse

Gallery Archives, The Morgan
Library & Museum, New York.

13 Letter from Alberto Giacometti
to Tristan Tzara, November 3,
1930, Bibliothèque Jacques-Doucet
archives, Paris, Tzr.C.1757.

Chapter 14: The Death of the Father

1 "I see a great deal of Breton,"
letter from Alberto Giacometti
to his family, undated [autumn
1932], Alberto Giacometti-
Stiftung archives, Zurich.
2 Letter from Alberto Giacometti to
his father, June 8, 1933, SIK-ISEA
archives, Zurich, 274.A.2.3.44.
3 *Le Surréalisme au service de la
révolution*, no. 6 (May 1933): 11–17.
4 Paris: Éditions surréalistes, 1931.
5 Alberto Giacometti, "Hier,
sables mouvants," "Poème en 7
espaces," "Le rideau brun," and
"Charbon d'herbe," *Le Surréalisme
au service de la révolution*, no. 5
(May 15, 1933): 15 and 44–45.
6 Alberto Giacometti, response to
"Sur la connaissance irrationnelle de
l'objet, boule de cristal des voyantes,"
February 5, 1933, published in the
article "Recherches expérimentales,"
*Le Surréalisme au service de la
révolution*, no. 6 (May 15, 1933): 11.
7 *Le Surréalisme au service de la
révolution*, no. 5 (May 15, 1933): 41.
8 Letter from Alberto Giacometti to
his father, June 8, 1933, SIK-ISEA
archives, Zurich, 274.A.2.3.44.
9 As shown by remarks in the
artist's notebooks, Fondation
Giacometti archives, Paris.

10 Letter from Alberto Giacometti to
his father, June 17, 1933, SIK-ISEA
archives, Zurich, 274.A.2.3.43.
11 Letter from Alberto Giacometti to
André Breton, July 3, 1933, Breton
archives, Bibliothèque Jacques-
Doucet, Paris, BRT.C.830.
12 Letter from Alberto Giacometti
to André Breton, August 8, 1933,
Breton archives, Bibliothèque
Jacques-Doucet, Paris, BRT.C.832.
13 Letter from Alberto Giacometti
to André Breton, August 3, 1933,
Breton archives, Bibliothèque
Jacques-Doucet, Paris, BRT.C.831.
14 Letter from Alberto Giacometti to
André Breton, August 11, 1933,
Breton archives, Bibliothèque
Jacques-Doucet, Paris, BRT.C.833.
15 Letter from Alberto Giacometti to
André Breton, August 23, 1933,
Breton archives, Bibliothèque
Jacques-Doucet, Paris, BRT.C.834.
16 Letter from Alberto Giacometti
to André Breton, August 29,
1933, Fondation Giacometti
archives, Paris, 2003-1155.
17 Letter from Alberto Giacometti
to André Breton, August 8, 1933,
Breton archives, Bibliothèque
Jacques-Doucet, Paris, BRT.C.832.
18 *Violette Nozière* (Brussels:
Nicolas Flamel, 1933).
19 According to Neil Baldwin, in
Man Ray: An American Artist
(New York: Da Capo, 2000), 150.
Giacometti had met Oppenheim
in late spring 1932 at Le Dôme,
later introducing her to Man Ray.
20 Claude Cahun, *Les Paris sont ouverts*
(May 1934), copy dedicated to
Alberto Giacometti, Fondation
Giacometti archives, Paris.

21 July 4, 1933. Román Gubern and Paul Hammond, *Luis Buñuel: The Red Years*, 151.

22 As recalled by Pierre Bruguière in *Alberto Giacometti, retour à la figuration* (Geneva: Musée Rath, 1986), 8.

23 Letter from André Breton to Alberto Giacometti, February 2, 1934, Fondation Giacometti archives, Paris, 2003-4502.

24 Letter from André Breton to Alberto Giacometti, February 2, 1934, Fondation Giacometti archives, Paris, 2003-4502.

25 André Breton, *Mad Love*, trans. M. A. Caws (Lincoln NE: University of Nebraska Press, 1987), 26–28. *L'Amour fou* was written between 1934 and 1936 and published in 1937; the text in question appeared in June 1934 as part of "Équation de l'objet trouvé," in the review *Documents*, no. 34.

26 Letter from Alberto Giacometti to André Breton, September 10, 1934, Breton archives, Bibliothèque Jacques-Doucet, Paris, BRT.C.839.

27 Alberto Giacometti, Pierre Matisse, letter-cum-text for the catalog to the 1948 exhibition, Pierre Matisse Gallery, New York. Pierre Matisse Gallery Archives, The Morgan Library & Museum, New York. Long stored in the studio at Stampa, the work was subsequently destroyed.

Chapter 15: The Break-Up with Surrealism

1 Private collection, Switzerland.

2 *Abstract Sculpture by Alberto Giacometti*, December 1, 1934–January 1, 1935.

3 Letter from Annetta Giacometti to Alberto and Diego Giacometti, undated [March 28, 1934], Fondation Giacometti archives, Paris.

4 Letter from Salvador Dalí to Paul Éluard, undated, fonds Éluard, Musée d'Art et d'Histoire, Saint-Denis, Na 3940-1, Na 3940-2.

5 Miranda Lash, "Imagining the Unseen in Roberto Matta's Cube Constructions," *RES*, no. 55–56 (2009).

6 "Paris, le 14 février 1935," handwritten text, act of exclusion signed and dated by Benjamin Péret, Georges Hugnet, Marcel Jean, André Breton, and Yves Tanguy. Breton archives, Bibliothèque Jacques-Doucet, Paris.

7 Letter from André Breton to Alberto Giacometti, February 2, 1934: "As he returned and agreed to sign a very precisely worded text that was satisfactory to us, this exclusion was naturally reversed, but Éluard and Tzara let me know from Nice that clearly they disapprove of the condemnation." Fondation Giacometti archives, Paris.

8 See note 6 above.

9 Letter from Alberto Giacometti to André Breton, February 16, 1935, Breton archives, Bibliothèque Jacques-Doucet, Paris, BRT.C.841.

10 As recorded by Simone de Beauvoir in *The Prime of Life*, trans. P. Green (New York: World Publishing Company, 1962), 386–87.

11 Pneumatic card from Alberto Giacometti to André Breton, February 19, 1935, Breton archives, Bibliothèque Jacques-Doucet, Paris, BRT.C.842.

12 Letter from Alberto Giacometti to his mother, January 7, 1935, SIK-ISEA archives, Zurich, 274.A.2.1.129.

13 Letter from Alberto Giacometti to his mother, 1935, SIK-ISEA archives, Zurich, 274.A.2.1.271.

14 Letter from Alberto Giacometti to his mother, February 14, 1935, SIK-ISEA archives, Zurich, 274.A.2.1.131.

Chapter 16: A Return to the Model

1 Louis Aragon, "La peinture au tournant," *Commune*, no. 22 (June 1935): 1188.

2 Marcel Jean, *Histoire de la peinture surréaliste* (Paris: Seuil, 1959), 228.

3 Louis Aragon, *Pour un réalisme socialiste* (Paris: Denoël et Steele, 1935), private collection, Switzerland.

4 René Crevel, *Dalí ou l'anti-obscurantisme* (Paris: Éditions Surréalistes, 1931).

5 René Crevel, "Discours aux peintres," 1137–38.

6 Isabel, quoted by Véronique Wiesinger in *Alberto Giacometti, Isabel Nicholas: Correspondances* (Paris: Éditions Fage, 2007), 30.

7 Letter from Alberto Giacometti to his family, February 23, 1936, Alberto Giacometti-Stiftung archives, Zurich.

8 Ibid.

9 May 22–29, 1936.

10 *Cubism and Abstraction*, March–April 1936.

11 *Cubism and Abstraction* (New York: Museum of Modern Art, 1936), exhibition catalog, 197.

12 Letter from Alberto Giacometti to Annetta and Diego Giacometti, Paris, August 1936, Alberto Giacometti-Stiftung archives, Zurich.

13 *Fantastic Art, Dada and Surrealism*, December 1936–January 1937.

14 Letter from Alberto Giacometti to his mother, August 1936, Alberto Giacometti-Stiftung archives, Zurich.

15 Pierre Matisse interviewed by Paule Chavasse, "J'ai rencontré Alberto Giacometti en 1936," ORTF, 1969.

16 Letter from Alberto Giacometti to his mother, October 27, 1936, Alberto Giacometti-Stiftung archives, Zurich.

17 Letter from Alberto Giacometti to Pierre Matisse, October 23, 1936, Pierre Matisse Gallery Archives, The Morgan Library & Museum, New York, box 11, folder 5.

18 Letter from Alberto Giacometti to Pierre Matisse, November 2, 1936, Pierre Matisse Gallery Archives, The Morgan Library & Museum, New York, box 11, folder 5.

19 Letter from Alberto Giacometti to his mother, July 19, 1936, SIK-ISEA archives, Zurich, 274A2.1.138.

20 *Circle: International Survey of Constructive Art.* The exhibition was accompanied by the publication of a constructivist manifesto of the same name, written by Nicholson and Gabo (London: Faber & Faber, 1937).

21 Alberto Giacometti, interview by André Parinaud, "Pourquoi je suis sculpteur," *Arts*, no. 873 (June 13, 1962): 1 and 5.

22 Letter from Diego Giacometti to his mother, April 9, 1938, SIK-ISEA archives, Zurich, 274.A.2.2.76. The fixtures were reproduced in *Vogue* in 1939.

23 Isabel, quoted by Véronique Wiesinger in *Alberto Giacometti, Isabel Nicholas: Correspondances*, 35.

24 The exact date of their encounter is unknown.

25 Alberto Giacometti, interview by André Parinaud, "Pourquoi je suis sculpteur."

26 "The eye exists in a wild state," wrote Breton in *Le Surréalisme et la peinture* (Paris: NRF, 1928).

27 Alberto Giacometti, interview by André Parinaud, "Pourquoi je suis sculpteur."

28 Ibid.

29 Peggy Guggenheim, quoted in Yves Bonnefoy, *Giacometti: A Biography of His Work* (Paris: Flammarion, 1991; new edition 2012), 272.

30 Ibid., 273–74.

Chapter 17: The Accident, then the War

1 "Fragmente aus Tagebüchern," reprinted in Alberto Giacometti, *Écrits*, 346.

2 Alberto Giacometti quoted in Yves Bonnefoy, *Giacometti: A Biography of His Work*, rev. ed. (1991; Paris: Flammarion, 2012), 272.

3 "Fragmente aus Tagebüchern," reprinted in Alberto Giacometti, *Écrits*, 336.

4 Letter from Alberto Giacometti to his mother, April 29, 1939, in French, Alberto Giacometti-Stiftung archives, Zurich.

5 Ibid.

6 Ibid.

7 Letter from Alberto Giacometti to Isabel, August 1939, Tate Gallery, London, 9612.1.2.7, reprinted in Véronique Wiesinger, *Alberto Giacometti, Isabel Nicholas: Correspondances*, 62–63.

8 Isabel, quoted by Véronique Wiesinger in *Alberto Giacometti, Isabel Nicholas: Correspondances*, 40.

9 Letter from Isabel to Alberto Giacometti, early June 1940, Fondation Giacometti archives, Paris, 2003–1886, reprinted in Véronique Wiesinger, *Alberto Giacometti, Isabel Nicholas: Correspondances*, 77.

10 Letter from Alberto Giacometti to his mother, July 8, 1940, SIK-ISEA archives, Zurich, 274 A 2.1.193.

11 Letter from Alberto Giacometti to his mother, January 21, 1941, SIK-ISEA archives, Zurich, 274.A.2.3.52.

12 Letter from Alberto Giacometti to Annetta and Francis

Berthoud, undated [likely March 1941], SIK-ISEA archives, Zurich, 274A2.1.158.

13 Alberto Giacometti interviewed by Pierre Dumayet, *Le Nouveau Candide*, no. 110 (June 6–13 1963): 9, reprinted in Alberto Giacometti, *Écrits*, 302.

14 Silvio Berthoud, "Some Personal Memories," in *Alberto Giacometti: 1901–1966* (Washington: Hirshhorn Museum, 1988).

15 Balthus about Giacometti, in *Alberto Giacometti* (Andros: Museum of Contemporary Art, Fondation Goulandris, 1992).

16 Letter from Alberto Giacometti to his mother, January 1, 1945, Alberto Giacometti-Stiftung archives, Zurich.

17 Letter from Alberto Giacometti to his mother, 1943, SIK-ISEA archives, Zurich, 274.A.2.1.213.

18 Albert Skira, *La Tribune de Lausanne* (January 16, 1966).

19 Ibid.

20 Jean Starobinski, *Balthus et Giacometti à la place du Molard*, reprinted in *Giacometti, Balthus, Skira* (Geneva: Musée Rath, 2009).

21 Alberto Giacometti, "Henri Laurens," *Labyrinthe*, no. 4 (January 15, 1945), 3, reprinted in Alberto Giacometti, *Écrits*, 60.

22 Alberto Giacometti, "A propos de Jacques Callot," *Labyrinthe*, no. 7 (April 15, 1945): 3, reprinted in Alberto Giacometti, *Écrits*, 64.

23 Letter from Alberto Giacometti to Isabel, July 30, 1945, Tate Gallery, London, reprinted in Véronique Wiesinger, *Alberto Giacometti, Isabel Nicholas: Correspondances*, 83–84.

24 Letter from Alberto Giacometti to Isabel, May 14, 1945, Tate Gallery, London, reprinted in Véronique Wiesinger, *Alberto Giacometti, Isabel Nicholas: Correspondances*, 81–82.

25 Letter from Alberto Giacometti to Isabel, July 30, 1945, op. cit.

Chapter 18: **Astonishing Dedication**

1 Christian Klemm, *Alberto Giacometti* (New York: MoMA, 2001).

2 Letter from Alberto Giacometti to Francis Berthoud, September 27, 1945, SIK-ISEA archives, Zurich, 274.A.2.1.218.

3 Letter from Alberto Giacometti to his mother, September 28, 1945, SIK-ISEA archives, Zurich, 274.A.2.1.219.

4 Ibid.

5 Isabel, quoted by Véronique Wiesinger in *Alberto Giacometti, Isabel Nicholas: Correspondances*, 44.

6 Letter from Alberto Giacometti to his family, December 31, 1945, SIK-ISEA archives, Zurich, 274.A.2.1.221.

7 Letter from Alberto Giacometti to his family, December 26, 1945, SIK-ISEA archives, Zurich, 274.A.2.1.220.

8 Ibid.

9 Diego Giacometti in David Sylvester, *Looking at Giacometti* (London: Chatto & Windus, 1994), 143.

10 Simone de Beauvoir, May 17, 1946, in *La Force des choses* (Paris: Gallimard, 1963), 124.

11 Letter from Alberto Giacometti to his mother, summer 1946,

Alberto Giacometti-Stiftung archives, Zurich.

12 Letter from Alberto Giacometti to Pierre Matisse, September 1947, Pierre Matisse Gallery Archives, The Morgan Library & Museum, New York, box 11, folder 7, item 10.

13 Michel Leiris, November 4, 1945, in *Journal* (Paris: Gallimard, 1992), 423.

14 Letter from Alberto Giacometti to Pierre Matisse, 1947, Pierre Matisse Gallery Archives, The Morgan Library & Museum, New York, box 11, folder 7, item 11.

15 Letter from Alberto Giacometti to his family, January 8, 1946, SIK-ISEA archives, Zurich, 274.A.2.1.222.

16 Letter from Alberto Giacometti to his mother, October 8, 1946, Alberto Giacometti-Stiftung archives, Zurich.

17 Letter from Alberto Giacometti to his mother, September 28, 1945, Alberto Giacometti-Stiftung archives, Zurich.

18 Georges Limbour, "Le charnier de plâtre d'Alberto Giacometti," *Action* (September 24, 1947), reprinted in *Dans le secret des ateliers* (Paris: L'Élocoquent, 1986), 39.

19 Letter from Alberto Giacometti to his family, December 31, 1945, SIK-ISEA archives, Zurich, 274.A.2.1.221.

Chapter 19: *Walking Man*

1 Musée National d'Art Moderne, Paris, May 18–June 2, 1946.

2 Nathalie Sorokine, called Lise Oblanoff in de Beauvoir's *Memoirs*.

3 Simone de Beauvoir, *La Force des choses* (Paris: Gallimard, 1963), 132.

4 Letter from Alberto Giacometti to his mother, fall 1947, Alberto Giacometti-Stiftung archives, Zurich.

5 Letter from Alberto Giacometti to his mother, summer 1947, Alberto Giacometti-Stiftung archives, Zurich.

6 Letter from Alberto Giacometti to his parents, December 8, 1920, Alberto Giacometti-Stiftung archives, Zurich.

7 Letter from Alberto Giacometti to Pierre Matisse, mid-October 1947, Pierre Matisse Gallery Archives, The Morgan Library & Museum, New York, box 11, folder 7, item 15.

8 Letter from Alberto Giacometti to Pierre Matisse, November 6, 1947, Pierre Matisse Gallery Archives, The Morgan Library & Museum, New York, box 11, folder 7, item 16. Preliminary typescript, Fondation Giacometti archives, Paris.

9 Letter from Alberto Giacometti to Pierre Matisse, October 13, 1947, Pierre Matisse Gallery Archives, The Morgan Library & Musuem, New York, box 11, folder 7, item 14.

10 Jean-Paul Sartre, *We Have Only This Life to Live: The Selected Essays of Jean-Paul Sartre*, ed. Rondal Aronson and Adrien van den Hoven (New York: New York Review of Books, 2013).

11 Letter from Alberto Giacometti to his mother, March 13, 1948, Alberto Giacometti-Stiftung archives, Zurich.

12 Letter from Alberto Giacometti to his mother, undated [possibly February 1948], Alberto Giacometti-Stiftung archives, Zurich.

13 Simone de Beauvoir to Nelson Algren, quoted in Claude Delay, *Giacometti, Alberto et Diego: L'histoire cachée* (Paris: Fayard, 2007), 166.

14 Alexander Liberman, reprinted in Reinhard Hohl, *Alberto Giacometti*, 275.

15 Letter from Pierre Matisse to Alberto Giacometti, late January 1948, Fondation Giacometti archives, 2003-4982.

16 Letter from Alberto Giacometti to Pierre Matisse, March 12, 1948, Pierre Matisse Gallery Archives, The Morgan Library & Museum, New York, box 11, folder 8, item 31.

17 Ibid.

18 Letter from Alberto Giacometti to his mother, March 12, 1948, Alberto Giacometti-Stiftung archives, Zurich.

19 Letter from Alberto Giacometti to Pierre Matisse, May 17, 1948, Pierre Matisse Gallery Archives, The Morgan Library & Museum, New York, box 11, folder 8, item 32.

Chapter 20: The Death of T.

1 Alberto Giacometti, "Le Rêve, le Sphinx et la Mort de T," *Labyrinthe*, nos. 22–23 (December 1946).

2 Letter from Alberto Giacometti to his mother, December 1946, Alberto Giacometti-Stiftung archives, Zurich.

3 André Breton, *Le Figaro littéraire* (October 5, 1946).

4 Letter from Alberto Giacometti to his mother, October 8, 1946, Alberto Giacometti-Stiftung archives, Zurich.

5 Fondation Giacometti documentation, Paris.

6 Jean-Paul Sartre, *We Have Only This Life to Live*.

7 Jean-Paul Sartre, "La recherche de l'absolu," *Les Temps modernes* (January 1, 1948), and *Alberto Giacometti* (New York: Pierre Matisse Gallery, January 19, 1948).

8 Alberto Giacometti interviewed by Jean Clay, 1963, reprinted in Alberto Giacometti, *Écrits*, 318.

Chapter 21: A Time of Change

1 Letter from Alberto Giacometti to his mother, March 13, 1948, Alberto Giacometti-Stiftung archives, Zurich.

2 Letter from Alberto Giacometti to his mother, Paris, undated [early June 1948], Alberto Giacometti-Stiftung archives, Zurich.

3 Letter from Alberto Giacometti to Pierre Matisse, November 29, 1948, Pierre Matisse Gallery Archives, The Morgan Library & Museum, New York, box 11, folder 8, item 44.

4 Letter from Alberto Giacometti to his mother, undated [June 1949], SIK-ISEA archives, Zurich, 274.A.2.1.223.

5 Letter from Alberto Giacometti to his mother, April 26, 1949, SIK-ISEA archives, Zurich, 274.A.2.1.225.

6 Letter from Alberto Giacometti to his mother, undated [June 1949], SIK-ISEA archives, Zurich, 274.A.2.1.223.

7 Letter from Annetta Giacometti to Alberto Giacometti, June 15, 1949, Fondation Giacometti archives, Paris.

8 Letter from Annetta Giacometti to Alberto and Annette Giacometti, November 9, 1949, Fondation Giacometti archives, Paris.

9 Letter from Annetta Giacometti to Annette Giacometti, late 1949, Fondation Giacometti archives, Paris.

10 Letter from Annetta Giacometti to Alberto Giacometti, late February 1947, Alberto Giacometti-Stiftung archives, Zurich, and letter from Pierre Matisse to Alberto Giacometti, October 31, 1947, Pierre Matisse Gallery Archives, The Morgan Library & Museum, New York, box 11, folder 7.

11 Letter from Diego Giacometti to Alberto, Annette, and Annetta Giacometti, December 29, 1950, private collection, Geneva.

12 Letter from Alberto Giacometti to Pierre Matisse, February 16, 1948, Pierre Matisse Gallery Archives, The Morgan Library & Museum, New York, box 11, folder 8, item 29.

13 Alberto Giacometti, personal notebook, around 1949–50, in French, reprinted in Alberto Giacometti, *Écrits*.

14 Letter from Alberto Giacometti to Pierre Matisse, March 12, 1948, Pierre Matisse Gallery Archives, The Morgan Library & Museum, New York, box 11, folder 8, item 31.

15 Letter from Pierre Matisse to Alberto Giacometti, August 8, 1948, Pierre Matisse Gallery Archives, The Morgan Library & Museum, New York, box 11, folder 8. It appears the artist never received this letter.

16 Letter from Alberto Giacometti to Pierre Matisse, August 18, 1948, Pierre Matisse Gallery Archives, The Morgan Library & Museum, New York, box 11, folder 8, item 36.

17 Letter from Patricia Matisse to Alberto Giacometti, November 1949, Fondation Giacometti archives, Paris, 2000-0103-2.

Chapter 22: *Falling Man*

1 Letter from Alberto Giacometti to Pierre Matisse, September 11, 1948, Pierre Matisse Gallery Archives, The Morgan Library & Museum, New York, box 11, folder 8, item 40.

2 Letter from Alberto Giacometti to Pierre Matisse, November 3, 1948, Pierre Matisse Gallery Archives, The Morgan Library & Museum, New York, box 11, folder 8, item 43.

3 Ibid.

4 Letter from Alberto Giacometti to Pierre Matisse, July 23, 1949, Pierre Matisse Gallery Archives, The Morgan Library & Museum, New York, box 11, folder 9, item 52.

5 Letter from Alberto Giacometti to Pierre Matisse, October 18, 1949, Pierre Matisse Gallery Archives, The Morgan Library & Museum, New York, box 11, folder 9, item 54.

6 Letter from Pierre Matisse to Alberto Giacometti, November 21, 1949, Pierre Matisse Gallery Archives,

The Morgan Library & Museum, New York, box 11, folder 9.

7 Letter from Pierre Matisse to Alberto Giacometti, December 12, 1950, Fondation Giacometti archives, Paris, 2003-4998.

8 Original title of *Pointing Man*.

9 Letter from Pierre Matisse to Alberto Giacometti, September 29, 1949, Pierre Matisse Gallery Archives, The Morgan Library & Museum, New York, box 11, folder 9.

10 Letter from Alberto Giacometti to Pierre Matisse, October 15, 1950?, Pierre Matisse Gallery Archives, The Morgan Library & Museum, New York, box 11, folder 17, item 70.

11 Letter from Alberto Giacometti to Pierre Matisse, December 27, 1950, Pierre Matisse Gallery Archives, The Morgan Library & Museum, New York, box 11, folder 17, item 76.

12 "Titres, croquis et explications des oeuvres," letter from Alberto Giacometti to Pierre Matisse, early September 1951, private collection.

13 Ibid.

14 Ibid.

15 Letter from Alberto Giacometti to Pierre Matisse, December 28, 1950, Pierre Matisse Gallery Archives, The Morgan Library & Museum, New York, box 11, folder 17, item 77.

16 Letter from Pierre Matisse to Alberto Giacometti, September 23, 1949, Pierre Matisse Gallery Archives, The Morgan Library & Museum, New York, box 11, folder 9.

17 Letter from Alberto Giacometti to Pierre Matisse, October 15, 1950?, Pierre Matisse Gallery Archives, The Morgan Library & Museum, New York, box 11, folder 17, item 70.

18 Letter from Alberto Giacometti to Pierre Matisse, dated October 26, 1950, but before October 24, 1950?, Pierre Matisse Gallery Archives, The Morgan Library & Museum, New York, box 11, folder 17, item 71.

19 Letter from Pierre Matisse to Alberto Giacometti, Christmas 1950, Fondation Giacometti archives, Paris, 2003-4999.

20 Letter from Pierre Matisse to Alberto Giacometti, December 12, 1950, Fondation Giacometti archives, Paris, 2003-4998.

21 Letter from Pierre Matisse to Alberto Giacometti, Christmas 1950, Fondation Giacometti archives, Paris, 2003-4999.

Chapter 23: **Relentless Work**

1 Letter from Alberto Giacometti to Pierre Matisse, November 27, 1949, Pierre Matisse Gallery Archives, The Morgan Library & Museum, New York, box 11, folder 9, item 56.

2 Letter from Annetta Giacometti to Alberto, Diego, and Annette Giacometti, February 26, 1950, Fondation Giacometti archives, Paris.

3 Letter from Annette Giacometti to Diego Giacometti, June 1, 1950, Fondation Giacometti archives, Paris.

4 The plaster work (a woman's head in a tall cage) can be seen in a 1950 photograph that includes the plaster for *The Forest*.

5 Letter from Alberto Giacometti
 to Pierre Matisse, undated, Pierre
 Matisse Gallery Archives, The
 Morgan Library & Museum, New
 York, box 11, folder 17, item 65.
6 In 1948, Bernard Lorjou, along
 with Bernard Buffet, Paul
 Rebeyrolle, Yvonne Mottet, and
 Jean Carzou, formed the anti-
 abstract group *L'Homme témoin
 de son temps* (Witness-Man).
7 Letter from Annetta
 Giacometti to Alberto, Diego,
 and Annette Giacometti,
 April 29, 1951, Fondation
 Giacometti archives, Paris.
8 Letter from Annetta Giacometti
 to Alberto Giacometti,
 August 11, 1951, Fondation
 Giacometti archives, Paris.
9 Letter from Annetta, Alberto,
 and Annette Giacometti
 to Diego Giacometti,
 November 12, 1951, Fondation
 Giacometti archives, Paris.
10 Letter from Annetta Giacometti
 to Diego Giacometti, December 4,
 1951, Fondation Giacometti
 archives, Paris, 384.
11 Letter from Annetta Giacometti
 to Alberto and Diego Giacometti,
 April 24, 1952, Fondation
 Giacometti archives, Paris
12 Alberto Giacometti, handwritten
 note, Fondation Giacometti
 archives, Paris, reprinted in
 Alberto Giacometti, *Écrits*, 202.
13 Letter from Alberto Giacometti
 to Pierre Matisse, early
 November 1950, Pierre Matisse
 Gallery Archives, The Morgan
 Library & Museum, New York,
 box 11, folder 17, item 65.

14 Letter from Alberto Giacometti
 to Pierre Matisse, April 19, 1949,
 Pierre Matisse Gallery Archives, The
 Morgan Library & Museum, New
 York, box 11, folder 9, item 51.
15 Letter from Alberto Giacometti to
 Pierre Matisse, March 21, 1952,
 Pierre Matisse Gallery Archives, The
 Morgan Library & Museum, New
 York, box 11, folder 19, item 96.

Chapter 24: **Doubt Returns**

1 Letter from Pierre Matisse to
 Alberto Giacometti, September 22,
 1952, Fondation Giacometti
 archives, Paris, 2003-5014.
2 Letter from Alberto Giacometti
 to Pierre Matisse, late April 1952,
 Pierre Matisse Gallery Archives,
 The Morgan Library & Museum,
 New York, box 11, folder 19, item 99.
3 "There is a woman who likes the
 'bust in a sweater,'" letter from
 Annetta, Alberto, and Annette
 Giacometti to Diego Giacometti,
 November 12, 1951, Fondation
 Giacometti archives, Paris.
4 Letter from Annetta Giacometti
 to Diego, Annette, and Alberto
 Giacometti, July 14, 1952, Fondation
 Giacometti archives, Paris.
5 Letter from Annetta and
 Diego Giacometti to Annette
 and Alberto Giacometti,
 September 9, 1952, Fondation
 Giacometti archives, Paris.
6 Letter from Annetta
 Giacometti to Diego, Annette,
 and Alberto Giacometti,
 January 22, 1953, Fondation
 Giacometti archives, Paris.

7 Annetta Giacometti to Diego, Annette, and Alberto Giacometti, February 24, 1953, Fondation Giacometti archives, Paris.

8 Diego Giacometti to Alberto and Annette Giacometti, April 11, 1953, Fondation Giacometti archives, Paris.

9 Alberto Giacometti to Pierre Matisse, May 1, 1954, Pierre Matisse Gallery Archives, The Morgan Library & Museum, New York, box 11, folder 20, item 111.

10 Jean Genet, *L'Atelier d'Alberto Giacometti* (Décines: L'Arbalète, 1958), 15.

11 Alberto Giacometti, handwritten text in a sketchbook, around 1950. The first letter, which identifies the person painted, is S or G. Reprinted in Alberto Giacometti, in French, *Écrits*, 547.

12 Jean Genet, *Fragments of the Artwork*, trans. Charlotte Mandell (Stanford: Stanford University Press, 2003), 10.

13 Letter from Annetta Giacometti to Diego, Annette, and Alberto Giacometti, February 14, 1954, Fondation Giacometti archives, Paris.

14 Jacques Dupin, *Alberto Giacometti* (Paris: Éditions Maeght, 1963), 64. In 1955, Dupin joined Galerie Maeght as a bookseller, then went on to oversee the gallery's publications.

15 François Weyergans, transcription of the TV program "Weyergans, du pitre au fakir," RTBF, series *En toutes lettres*, October 27, 1993.

Chapter 25: Success Arrives

1 Alberto Giacometti interviewed by Georges Charbonnier, RTF, Paris, March 3, 1951.

2 Letter from Alberto Giacometti to Diego Giacometti, June 12, 1955, Alberto Giacometti-Stiftung archives, Zurich.

3 Ibid.

4 Letter from Annetta Giacometti to Alberto Giacometti, October 9, 1954, Fondation Giacometti archives, Paris.

5 Russell Warren Howe, "Alberto Giacometti," "Les arts," *France-Amérique*, July 3, 1955.

6 Letter from Alberto Giacometti to his mother, June 17, 1955, Alberto Giacometti-Stiftung archives, Zurich.

7 Letter from Annetta Giacometti to Alberto, Diego, and Annette Giacometti, February 28, 1955, Fondation Giacometti archives, Paris.

8 Jean Genet, *L'Atelier d'Alberto Giacometti*, 36.

9 Letter from Alberto Giacometti to Pierre Matisse, November 6, 1956, Pierre Matisse Gallery Archives, The Morgan Library & Museum, New York, box 11, folder 22, item 131.

10 Pierre Klossowski, "Du tableau vivant dans la peinture de Balthus," 1957, reprinted in *Balthus* (Paris: Centre Georges-Pompidou, 1983).

11 Letter from Alberto Giacometti to Pierre Matisse, November 6, 1956, Pierre Matisse Gallery Archives, The Morgan Library & Museum, New York, box 11, folder 22, item 131.

12 Cf. Lydia Harambourg, *Derain, sculpteur & photographe* (Paris: Expressions contemporaines, 2007).

Chapter 26: **Yanaihara**

1 Isaku Yanaihara, *Dialogues avec Giacometti* (Paris: Allia, 2015), 65.
2 Ibid.
3 Ibid.
4 Letter from Alberto Giacometti to Pierre Matisse, [June 1956], Pierre Matisse Gallery Archives, The Morgan Library & Museum, New York, box 11, folder 22, item 127.
5 Françoise Gilot, discussion with the author, 2016.
6 Isaku Yanaihara, *Dialogues avec Giacometti*, 66.
7 Ibid, 30.
8 Ibid.
9 Ibid.
10 Ibid.
11 Christian Zervos, *Cahiers d'art*, 1932.
12 *Circle: International Survey of Constructive Art* (London: Faber & Faber, July 1937).
13 Alberto Giacometti to Yvon Taillandier, 1951, reprinted in Alberto Giacometti, *Écrits*, 175.
14 Isaku Yanaihara, *Dialogues avec Giacometti*, 30.
15 Ibid., 25.
16 Letter from Alberto Giacometti to Pierre Matisse, October 15, 1956, Pierre Matisse Gallery Archives, The Morgan Library & Museum, New York, box 11, folder 22, item 129.
17 Isaku Yanaihara, *Dialogues avec Giacometti*, 33.

18 Letter from Jean Genet, interview with Antoine Bourseiller, documentary film, 50 minutes, 1981, transcribed in *L'Ennemi déclaré* (Paris: Gallimard, 1991).
19 Letter from Alberto Giacometti to Pierre Matisse, October 1956, Pierre Matisse Gallery Archives, The Morgan Library & Museum, New York, box 11, folder 22.

Chapter 27: **A Unique Friendship**

1 Isaku Yanaihara, *Avec Giacometti* (Paris: Allia, 2014), 17–18.
2 Ibid., 171.
3 Alberto Giacometti began renting the studio at 51 bis rue du Moulin-Vert in 1956.
4 Isaku Yanaihara, *Avec Giacometti*, 149.
5 Ibid., 154.
6 Letter from Alberto Giacometti to Isaku Yanaihara, December 17, 1956, Yanaihara archives.
7 Ibid.
8 Letter from Alberto Giacometti to Isaku Yanaihara, December 18, 1956, Yanaihara archives.
9 Correspondence between Annette and Alberto Giacometti and Isaku Yanaihara, 1957, Yanaihara archives.
10 Letter from Alberto Giacometti to Isaku Yanaihara, February 24, 1957, Yanaihara archives.
11 Letter from Alberto Giacometti to Isaku Yanaihara, March 31, 1957, Yanaihara archives.
12 Letter from Alberto Giacometti to Isaku Yanaihara, January 12, 1959, Yanaihara archives.

13 Letter from Pierre Matisse
to Alberto Giacometti,
May 15, 1957, Fondation
Giacometti archives, Paris.

Chapter 28: Giacometti the Painter

1 Isaku Yanaihara, *Avec Giacometti*, 67.
2 Ibid., 82.
3 Ibid., 24.
4 Ibid., 47.
5 Alberto Giacometti interviewed
by Antonio Del Guercio, in
Alberto Giacometti, *Écrits*, 260.
6 Ibid.
7 Isaku Yanaihara, *Avec Giacometti*, 141.
8 Letter from Jean Hélion to Alberto
Giacometti, June 1953 (written
after Giacometti's visit to Hélion's
studio with Tériade), Fondation
Giacometti archives, Paris.
9 Isaku Yanaihara, *Avec Giacometti*, 66.
10 Alberto Giacometti interviewed by
Jean-Marie Drot, November 1963.
11 David Sylvester, *Giacometti*
(Marseille: André Dimanche
Éditeur, 2001), 119.
12 Alberto Giacometti, "Derain,"
Derrière le miroir, no. 94–95
(February 1957).

Chapter 29: Caroline

1 Alberto Giacometti in James Lord,
Un portrait par Giacometti (1965;
Paris: Gallimard, repr., 1991), 26.
2 Letter from Alberto Giacometti
to Isaku Yanaihara, September 23,
1957, Yanaihara archives.
3 Letter from Alberto Giacometti
to Caroline (Yvonne-Marguerite

Poiraudeau), May 6, 1960, photocopy,
Fondation Giacometti archives, Paris.
4 Caroline (Yvonne-Marguerite
Poiraudeau) to Franck
Maubert, in *Le Dernier Modèle*
(Paris: Pluriel, 2014), 95.
5 Letter from Caroline (Yvonne-
Marguerite Poiraudeau) to Alberto
Giacometti, 1960, Beinecke Library,
James Lord Papers, Yale University.
6 Letter from Alberto Giacometti to
Pierre Matisse, October 19, 1962,
Pierre Matisse Gallery Archives, The
Morgan Library & Museum, New
York, box 11, folder 39, item 182.
7 Letter from Annetta Giacometti
to Alberto, Diego, and Annette
Giacometti, April 11, 1951,
Fondation Giacometti archives, Paris.
8 *Portrait of Caroline*, 1962, Fondation
Giacometti collection, Paris.
9 Alberto Giacometti, in Jean Clay,
Visages de l'art moderne, 153.
10 Caroline to Franck Maubert,
in *Le Dernier Modèle*, 102.
11 Isaku Yanaihara, private diary,
year 1961, Yanaihara archives.

Chapter 30: Chase Manhattan Plaza

1 Letter from Alberto
Giacometti to Pierre Matisse,
undated, not sent, Fondation
Giacometti archives, Paris.
2 Letter from Annette Giacometti
to Isaku Yanaihara, April 14,
1958, Yanaihara archives.
3 Letter from Pierre Matisse
to Alberto Giacometti,
May 10, 1958, Fondation
Giacometti archives, Paris.

4 Letter from Pierre Matisse to Alberto Giacometti, February 10, 1959, Fondation Giacometti archives, Paris.

5 Letter from Alberto Giacometti to Pierre Matisse, May 17, 1959, Pierre Matisse Gallery Archives, The Morgan Library & Museum, New York, box 11, folder 25, item 163.

6 Letter from Annette Giacometti to Isaku Yanaihara, June 5, 1959, Yanaihara archives.

7 Letter from Annette Giacometti to Isaku Yanaihara, October 27, 1959, Yanaihara archives.

8 Ibid.

9 Letter from Annette Giacometti to Isaku Yanaihara, November 30, 1959, Yanaihara archives.

10 *New Images of Man* (New York: MoMA), 72–73.

11 Letter from Alberto Giacometti to his mother, August 8, 1959, SIK-ISEA archives, Zurich, 274.A.2.1.237.

12 Letter from Alberto Giacometti to Gordon Bunshaft, September 13, 1959, photocopy, Fondation Giacometti archives, Paris.

13 David Sylvester, *Giacometti*, 186.

14 Letter from Alberto Giacometti to his mother, 1959, SIK-ISEA archives, Zurich, 274.A.2.1.235.

15 Alberto Giacometti to David Sylvester, in David Sylvester, *Giacometti*, 187.

16 Letter from Alberto Giacometti to Pierre Matisse, February 2, 1960, unsent, Fondation Giacometti archives, Paris.

17 Letter from Annette Giacometti to Isaku Yanaihara, February 9, 1960, Yanaihara archives.

18 Letter from Annette Giacometti to Isaku Yanaihara, March 11, 1960, Yanaihara archives.

19 Letter from Alberto Giacometti to Pierre Matisse, April 29, 1960, Pierre Matisse Gallery Archives, The Morgan Library & Museum, New York, box 11, folder 37, item 169.

20 Alberto Giacometti to David Sylvester, in David Sylvester, *Giacometti*, 187.

Chapter 31: The Venice Biennale

1 Letter from Alberto Giacometti to his mother, 1959, SIK-ISEA archives, Zurich, 274.A.2.1.235.

2 Letter from Isaku Yanaihara to Annette Giacometti, November 27, 1960, Fondation Giacometti archives, Paris.

3 James Lord, *Giacometti. A Biography* (New York: Farrar, Straus & Giroux, 1985), 429.

4 Letter from Samuel Beckett to Barbara Bray, April 21, 1961, quoted in Samuel Beckett, *Lettres III* (Paris: Gallimard, 2016), 485n3.

5 Letter from Alberto Giacometti to his mother, unfinished, not sent, June 4, 1961, Fondation Giacometti archives, Paris.

6 Transcription from Yanaihara's private diary, year 1961, unpublished, Yanaihara archives.

7 Isaku Yanaihara, *Avec Giacometti*, 208.

8 James Lord, *Giacometti. A Biography*, 436.

9 Letter from Alberto Giacometti to Pierre Matisse, October 28, 1961, Pierre Matisse Gallery Archives,

The Morgan Library & Museum, New York, box 11, folder 38, item 172.

10 Letter from Alberto Giacometti to Pierre Matisse, December 9, 1961, Pierre Matisse Gallery Archives, The Morgan Library & Museum, New York, box 11, folder 38.

11 "In the Galleries," in Donald Judd, *Complete Writings 1959–1975* (New York: Distributed Art Publishers, 2016), 44.

12 Giorgio Soavi's testimony in *Mon Giacometti* (Venice: Basilissa, 2001), 20.

13 Letter from Alberto Giacometti to Pierre Matisse, December 6, 1962, Pierre Matisse Gallery Archives, The Morgan Library & Museum, New York, box 11, folder 39, item 183.

14 Letter from Alberto Giacometti to Pierre Matisse, October 19, 1962, Pierre Matisse Gallery Archives, The Morgan Library & Museum, New York, box 11, folder 39, item 182.

Chapter 32: The Shadow of Death

1 Alberto Giacometti in a notebook, in French, February 1963, Fondation Giacometti collection, Paris, 2000-0123.

2 Letter from Théodore Fraenkel to Alberto Giacometti, April 22, 1963, Fondation Giacometti archives, Paris, 2003-7110.

3 Alberto Giacometti interviewed by Jean Clay, 1963, reprinted in Alberto Giacometti, *Écrits*, 323.

4 Letter from Alberto Giacometti to Pierre Matisse, March 22, 1963, Pierre Matisse Gallery Archives,

The Morgan Library & Museum, New York, box 11, folder 40, item 184.

5 Letter from Alberto Giacometti to Pierre Matisse, May 19, 1963, Pierre Matisse Gallery Archives, The Morgan Library & Museum, New York, box 11, folder 40, item 185.

6 Letter from Alberto Giacometti to his mother, June 12, 1963, SIK-ISEA archives, Zurich, 274.A.2.1.246.

7 Ibid.

8 Letter from Alberto Giacometti to Pierre Matisse, [May 19, 1963], Pierre Matisse Gallery Archive, The Morgan Library & Museum, New York, box 11, folder 40, item 185.

9 Letter from Alberto Giacometti to his mother, June 12, 1963, SIK-ISEA archives, Zurich, 274.A.2.1.246.

10 Ibid.

11 Alberto Giacometti, note on a loose leaf, in French, undated, Fondation Giacometti archives, Paris.

12 Jean-Marie Drot, "Alberto Giacometti," TV film, 35 mm, Paris, ORTF, series *Les heures chaudes de Montparnasse*, November 1963.

13 Ibid. The following quotations are all taken from the same film.

14 Alberto Giacometti, "Entretien avec Antonio Del Guercio," *Rinascita*, June 23, 1962, 32.

15 Alberto Giacometti to Jean-Marie Drot, *Alberto Giacometti*.

16 Alberto Giacometti, interview with Jean Clay, *Réalités*, no. 215 (December 1963), reprinted in Alberto Giacometti, *Écrits*, 321.

17 Ibid.

Chapter 33: **Consecration**

1 "Fragmente aus Tagebüchern,"
reprinted in Alberto
Giacometti, Écrits, 333.

2 Letter from Alberto Giacometti
to Jacques Dupin, October 11,
1964, Fondation Giacometti
archives, Paris, 2003-4830.

3 Letter from Alberto Giacometti to
Pierre Matisse, October 26, 1964,
Pierre Matisse Gallery Archives, The
Morgan Library & Museum, New
York, box 11, folder 41, item 192.

4 Letter from Alberto Giacometti
to Jacques Dupin, October 10,
1964, Fondation Giacometti
archives, Paris, 2003-4831.

5 "Fragmente aus Tagebüchern,"
reprinted in Alberto
Giacometti, Écrits, 336–37.

6 Giorgio Soavi, Mon Giacometti, 18.

7 Letter from Alberto Giacometti
to Pierre Matisse, April 22, 1964,
Pierre Matisse Gallery Archives, The
Morgan Library & Museum, New
York, box 11, folder 41, item 188.

8 Letter from Alberto Giacometti to
Hans C. Bechtler, 1964, Fondation
Giacometti archives, Paris.

9 Tall Woman II was acquired
by the French State in 1964.

Chapter 34: **The Final Months**

1 Alberto Giacometti, Les Copies du
passé (Turin: Botero, 1967; new
ed. Paris: Éditions Fage, 2012).

2 Alberto Giacometti, "Notes sur
les copies," 1965, reprinted in
Alberto Giacometti, Écrits, 163.

3 Letter from Diego Giacometti to
Pierre Matisse, October 26, 1965,
Pierre Matisse Gallery Archives, The
Morgan Library & Museum, New
York, box 11, folder 41, item 192.

4 Brassaï, "Ma dernière visite,"
March 22, 1965, in Les Artistes de
ma vie (Paris: Denoël, 1982), 54.

5 Letter from Annette
Giacometti to Patricia Matisse,
December 18, 1965, Pierre
Matisse Gallery Archives, The
Morgan Library & Museum,
New York, box 11, folder 42.

6 Diego Giacometti, quoted in
Claude Delay, Giacometti, Alberto
et Diego: L'histoire cachée, 249.

7 Alberto Giacometti, Paris sans
fin, 1964, reprinted in Alberto
Giacometti, Écrits, 157–60.

List of Works Cited

Page numbers in **bold** refer to illustrations.

1 + 1 = 3 / 1 + 1 = 3, 133

Amenophis / Aménophis, 219
*Anguished Woman in Her Room at Night /
Femme angoissée dans une
chambre la nuit*, 95, 106, 155
*Annette in a Coat / Annette
au manteau*, 293
Apollo / Apollon, 74, 85

Bird Silence, The / L'Oiseau silence, **85**, 128
*Bust of Man with a Sweater /
Buste au chandail*, 219
*Bust (Sharp Head) / Buste
(tête tranchante)*, 219

Cage / Cage, 84, 95, 107, 110
Cage, The / La Cage, 128,
130, 185, 196, 265
*Caress (or Despite the Hands) / Caresse
(or Malgré les mains)*, 102, 103
Cat, The / Chat, 204
Caught Hand / Main prise au doigt, 102
Chariot, The / Le Chariot, 196, 197
Circuit / Circuit, 88
Composition / Composition, 60
Couple, The / Le Couple, 53, 63, 67, 85, 89
*Crouching Figure / Personnage
accroupi*, 54, 89
*Cube (or The Pavilion or Part of
Sculpture) / Cube (or Le Pavillon
or Partie de sculpture)*, 128,
129, 132, 143, 154, 163

Dancers / Danseurs, 63, 72
*Desperate Little One (or Figure on a
Disk) / Le Petit désespéré (or Figure
sur un disque)*, 88, 112, 136

Disagreeable Object / Objet désagréable, 87
*Disagreeable Object to Be Thrown Away /
Objet désagréable à jeter*, 87, 91, 121, 143
Dog, The / Chien, 204, 207
*"Dream, the Sphinx, and the Death
of T., The" / "Le Rêve, le Sphinx et
la mort de T.,"* 34, 181, 182, 184

Embryo / Embryon, 87
*Encounter in a Corridor / Rencontre
dans un couloir*, 124

*Falling Man / L'Homme qui
chavire*, 194, 195
Figure / Figure, 88, **89**, 110
Forest, The / La Forêt, 197

Gazing Head / Tête qui regarde, 9, 71, 81
Glade, The / La Clairière, 197

Hand, The / La Main, 182, **183**, 185
Head of Diego / Tête de Diego, 49
Head on a Rod / Tête sur tige, 182
Head-Skull / Tête-crâne, 127, **129**, 142
*Homage to Derain / Hommage
à Derain*, 216
Horses, The / Chevaux, 204
*Hour of the Traces / Heure des
traces*, 102, 103, 136

*Invisible Object (or Hands Holding the
Void) / L'Objet invisible (or Mains
tenant le vide)*, 132, 136, 144

*Landscape–Reclining Head (or Fall of
a Body onto a Diagram) / Paysage-
tête couchée (or Chute d'un corps
sur un graphique)*, 91, 103

Large Head / *Grande tête*, 261, 262, 263, 265, 266, 270

Leg, The / *La Jambe*, 261

Limping Figure / *Figure boiteuse en marche*, 87

Living Ashes, Unnamed / *Vivantes cendres, innommées*, 255

Man / *Petit homme*, **59**

Man and Woman / *Homme et Femme*, 66, 67, 73, 85, 86, 110

Man Pointing / *L'Homme qui pointe*, 178, 195, **195**, 204

Man Walking across a Square / *Homme qui marche sur un plateau*, 185

Man, Woman, Child / *Homme, femme, enfant*, 86

Mannequin / *Mannequin*, 124

"Mobile and Mute Objects" / "Objets mobiles et muets," 88, 95, **96–97**, 98, 111

Night, The / *La Nuit*, 169, **171**, 185

No More Play / *On ne joue plus*, 101, 112, 116, 136

Nose, The / *Le Nez*, 182, **183**, 185, 196

Palace at 4 a.m., The / *Le Palais à 4 heures du matin*, 111, 115, **117**, 119, 120, 128, 143

Paris without End / *Paris sans fin*, 272, 300

Pocket Tray / *Vide-poche*, 111

Point to the Eye (or *Disintegrating Relations*) / *Pointe à l'œil* (or *Relations désagréeantes*), 102, 104, 136

Project for a Corridor / *Projet pour un passage*, 90, 91

Project for a Square / *Projet pour une place*, 90, 91, 109, 143, 270

Putting My Foot in It / *Les Pieds dans le plat*, 123, 125, 128

Reclining Woman / *Femme couchée*, 66

Reclining Woman who Dreams / *Femme couchée qui rêve*, 66, 67, 86

Seated Woman / *Femme assise*, 170

Spoon Woman / *Femme cuillère*, 60, 64, 69, **195**, 277

Square, The / *La Place*, 193

Stele / *Stèle*, 54

Surrealist Composition / *Composition surréaliste*, **127**

Suspended Ball / *Boule suspendue*, 81, 84, 86, 91, 123, 140, 178, 182, 295

Table / *Table*, 124, 125, 126

Tall Thin Head / *Grande tête mince*, 219

Tall Woman / *Grande femme*, 263, 265, 269

Tall Woman IV / *Grande femme IV*, **267**

Three Eyes, Two Arms / *Trois yeux, deux bras*, 75

Three Figures Outdoors / *Trois personnages dehors*, 66, 74, 76

Three Men Walking / *Trois hommes qui marchent*, 185, 193

Torso / *Torse*, 49, 50

Two Oppressed, The / *Les Deux Opprimés*, 139

Walking Man / *L'Homme qui marche*, 176, 178, 185, 194, 204, 263, 265, 266

Walking Woman / *Femme qui marche*, 107, 108, 124, 131, 132, 142, 144, 163, 169

Woman, Head, Tree / *Femme, tête, arbre*, 95

Woman with Chariot / *Femme au chariot*, 169, 198, 274

Woman with Her Throat Cut / *Femme égorgée*, 95, 107, 108, 155, 178, 193

Women of Venice / *Femmes de Venise*, 228, 290

Index of Proper Names

Alechinsky, Pierre, 246
Alvéar, Josephina, 71
Amiet, Cuno, 17, 25, 26, 27
Apartis, Athanase, 47
Aragon, Louis, 81, 93, 94, 98–100, 102, 106, 123, 130, 139, 140, 142, 145, 173, 214
Aron, Raymond, 173
Arp, Jean (Hans), 69, 70, 75, 76, 81, 86, 102, 110, 128, 136, 142, 143, 155, 202
Artaud, Antonin, 139, 168, 187
Auriscote, Emmanuel, 56

Bacon, Francis, 278, 279
Balthus (Balthasar Klossowski de Rola), 17, 139, 152, 159, 161, 166, 174, 187, 199, 203, 208, 216, 223, 224, 247
Balzac, Honoré de, 166
Bänninger, Otto, 40, 49, 54, 138, 154, 155
Bataille, Georges, 166, 173, 181, 185, 212, 214
Baudelaire, Charles, 237
Beauvoir, Simone de, 152, 153, 166, 168, 173, 174, 179, 187, 207, 216, 239, 259
Bechtler, Hans C., 294
Beckett, Samuel, 9, 147, 158, 173, 185, 214, 216, 273
Bellini, Giovanni, 27
Bérard, Christian, 71, 72, 82, 102, 105, 109, 112, 113
Bérard, Simon, 19
Bernini, Gian Lorenzo, 28
Berthoud, Francis, 154, 156
Berthoud, Silvio, 154, 156, 159, 161, 275
Beyeler, Ernst, 282, 294
Boccioni, Umberto, 87
Boiffard, Jacques-André, 80
Boissonnas, Édith, 297
Bonnard, Pierre, 213, 224
Born (family), 114, 152
Born, Jorge, 145

Born, Matilda, 145
Bourdelle, Antoine, 10, 37, 38, 40, 43, 44, 45, 46, 47, 48, 49, 50, 54, 56, 57, 67, 76, 110, 221
Bousquet, Joë, 131
Bracelli, Battista, 91
Brancusi, Constantin, 10, 50, 60, 64, 76, 84, 109, 232
Braque, Georges, 84, 112, 125, 201, 216, 225, 284
Brassaï (Gyula Halász), 128, 222, 298
Brauner, Victor, 104
Breton, André, 10, 70, 75, 81, 83, 84, 86, 93, 99, 100, 115, 117, 123, 125, 126, 128, 130–32, 135–40, 144, 148, 158, 173, 181, 182, 184
Brignoni, Serge, 50, 53, 71
Bucarelli, Palma, 276
Bucher, Jeanne, 70, 71, 72, 101
Buffet, Bernard, 203, 224, 248
Bunshaft, Gordon, 265, 266, 268, 269
Buñuel, Luis, 84, 99, 100, 104, 105, 106

Cahun, Claude, 128
Calder, Alexander, 101, 103, 135, 143, 202
Callot, Jacques, 162
Campigli, Massimo, 47, 49, 56, 58, 60, 62, 63, 71
Camus, Albert, 158, 207, 239
Capa, Robert, 145
Carluccio, Luigi, 273
Carola, Paola, 272
Caroline (Yvonne-Marguerite Poiraudeau), 255–60, 271–74, 278, 287, 291, 293, 295, 297, 299
Carrière, Eugène, 247
Cartier-Bresson, Henri, 273, 222
Cartier-Bresson, Nicole, 273
Cézanne, Paul, 17, 18, 58, 64, 149, 232, 237, 245, 246, 251

Chagall, Marc, 203, 292
Chanaux, Adolphe, 82, 112, 113
Char, René, 173, 216
Cingria, Charles-Albert, 79, 161
Clay, Jean, 260
Clayeux, Louis, 201, 208, 220, 261, 273, 276, 278, 290, 295
Cocteau, Jean, 51, 61, 62, 71, 79, 88
Colle, Pierre, 100, 101, 104, 106, 123, 124, 125, 204
Colomb, Denise, 189
Corot, Jean-Baptiste Camille, 231
Crevel, René, 94, 123, 124, 125, 139, 140, 225
Crosby, Caresse, 47
Cuevas, Tota, 123
Csaky, Joseph, 63

Dalí, Salvador, 81, 83, 84, 87, 91, 93, 102, 104, 105, 106, 107, 108, 112, 119, 123, 124, 125, 130–31, 135, 136, 137, 177
David-Weill, Pierre, 74, 77, 80, 82
De Chirico, Giorgio, 60, 61, 63, 65
De Kooning, Willem, 295
Deharme, Lise, 110
Delmer, Isabel. See Nicholas, Isabel, 140, 141, 151
Delmer, Sefton, 142, 151
Derain, Alice, 225
Derain, André, 140, 147, 149, 152, 216, 224, 225, 251, 253
Desnos, Robert, 70
Desny (Clément Nauny), 80, 110
Despiau, Charles, 50, 76
Dietrich, Marlene, 258
Dostoyevsky, Fiodor, 70
Drot, Jean-Marie, 284
Du Bouchet, André, 216, 297
Dubuffet, Jean, 224
Duchamp, Marcel, 84, 107
Duchamp-Villon, Raymond, 87, 225
Ducloz, Charles, 161
Dupin, Jacques, 216, 290, 291, 297
Dürer, Albrecht, 21, 43, 126, 128

Einstein, Carl, 70, 72, 76, 80, 83, 95, 98, 102
Éluard, Paul, 93, 94, 123, 125, 131, 135, 136, 139, 144, 208, 225
Epstein, Jacob, 140
Ernst, Max, 81, 84, 93, 99, 108, 124, 128, 130, 135, 136, 142, 216
Estienne, Charles, 203

Faulkner, William, 239
Ferlov, Sonja, 246
Flaubert, Gustave, 35
Fougeron, André, 248
Fraenkel, Théodore, 83, 212, 216, 281, 291
Frank, Jean-Michel, 82, 83, 98–100, 106, 109, 110–13, 116, 123, 145, 146, 152, 155, 156, 160
Freud, Sigmund, 98, 118, 279

Gala (Elena Ivanovna Diakonova), 123
Gauguin, Paul, 26
Geissbuhler, Arnold, 41, 45
Genet, Jean, 10, 173, 213, 214, 216, 222, 230, 233, 234, 238, 255, 259, 260
Géricault, Théodore, 162
Giacometti (family), 13–15, 116, 255, 275
Giacometti, Annetta, 13, 15, 29, 47, 94, 119, 151, 154, 156, 160, 188, 204, 211, 212, 215, 220, 262, 265, 274, 275, 283, 289
Giacometti, Annette (née Arm), 5, 161, 166, 174, 175, 179, 181, 187–90, 202, 205, 206, 211–16, 219, 220, 222–24, 228, 232–35, 238–42, 250, 252, 255, 257, 258–63, 265, 266, 268, 271–76, 278, 281, 283, 284, 289, 291–93, 295–99
Giacometti, Antonio, 29
Giacometti, Augusto, 18
Giacometti, Bianca, 29, 52, 78, 177
Giacometti, Bruno, 13, 14, 17, 19, 21, 61, 78, 88, 121, 125, 153, 154, 172, 275, 299
Giacometti, Diego, 13, 15, 18, 25, 37, 44, 47–49, 54–56, 77, 79, 82, 83, 86, 88, 89, 102–4, 106, 109, 112–14, 117, 121, 125, 130, 138, 140, 144, 145, 146, 151, 152,

154, 155, 156, 165, 166, 168, 171, 174,
175, 179, 180, 187–91, 193, 198, 199,
202, 207, 211, 212, 219–22, 227, 228,
234, 235, 239, 242, 250–52, 257, 259,
262, 265, 266, 272, 275, 276, 278, 284,
289, 293, 295, 296, 299, 300
Giacometti, Giovanni, 13–19, 21, 25–30,
37, 42, 43, 49, 58, 60–62, 79, 101, 125,
130, 159
Giacometti, Odette, 205, 275, 299
Giacometti, Ottilia, 13, 15, 50, 121, 154
Giacometti, Otto, 13
Gilot, Françoise, 187, 208, 228, 259
Giotto di Bondone, 27, 28, 154, 253
Gleizes, Albert, 60
Goethe, Johann Wolfgang von, 19, 237
González, Julio, 85
Goya, Francisco de, 162
Griaule, Marcel, 94
Gruber, Francis, 147, 165, 168, 174, 185,
187
Gueyfier, Rita, 144
Guggenheim, Peggy, 144, 148, 155, 160,
215

Hartung, Hans, 142, 246
Hayter, William, 135
Hélion, Jean, 86, 142, 174, 250
Hesse, Hermann, 19
Hjorth, Bror, 41, 54
Hodler, Ferdinand, 17
Hugnet, Georges, 136, 139

Ibsen, Henrik, 19
Iliazd (Ilia Mikhailovich Zdanevic), 203
Ingres, Jean-Auguste-Dominique, 43,
46

Jacob, Max, 72, 100
Jean, Marcel, 136, 139
Jourdan, Robert, 95
Judd, Donald, 276

Kahnweiler, Daniel-Henry, 70, 191, 201,
207
Kandinsky, Wassily, 142

Kaufmann, Edgar Jonas, 228
Keller, Gottfried, 19
Kinosuke, Ebihara, 60
Kirchner, Ernst Ludwig, 62
Klossowski, Pierre, 224
Kochno, Boris, 111
Kotchoubey de Beauharnais, Diane
(Diane Bataille), 166, 168, 181

Lacan, Jacques, 98, 173
Lacloche, Jean-Pierre, 255
Larronde, Olivier, 216, 255
Laurens, Henri, 50, 64, 76, 102, 125, 162,
186, 202, 216, 225
Lautréamont (Isidore Lucien Ducasse,
Count of), 73, 104, 108
Le Corbusier (Charles-Édouard Jeanneret-
Gris), 155
Lebel, Robert, 296
Leclercq, Léna, 216, 255
Léger, Fernand, 50, 60, 63
Leiris (Louise and Michel), 276
Leiris, Louise, 187, 190
Leiris, Michel, 10, 70, 72–75, 79, 94, 119,
142, 166, 169, 173, 177, 204, 207, 255,
259, 295
Lelong, Lucien, 112
Levy, Julien, 102, 136, 144
Lhote, André, 64
Liberman, Alexander, 189
Lichtenhan, Lucas, 19, 24
Limbour, Georges, 170, 173
Lipchitz, Jacques, 10, 50, 53, 64, 65, 66, 69,
71, 74, 76, 102, 180, 202
Lloyd Wright, Frank, 228
Loeb, Pierre, 71, 72, 85, 101, 142, 165, 168,
187, 189, 201, 203
Lord, James, 293, 294
Lorjou, Bernard, 203
Lotar, Eli, 157, 161, 292, 293, 297, 300
Lurçat, Jean, 74

Maar, Dora (Henriette Theodora
Markovitch), 146
Macé, Jean, 166
Maeght (family), 212

Maeght, Aimé, 191, 201, 203, 211, 212, 261, 275, 289, 290
Maeght, Bernard, 212
Maeght, Galerie, 184, 201, 204, 205, 212, 221, 222, 246
Maeght, Marguerite, 211, 212, 289, 290
Maillol, Aristide, 48, 76, 138
Maisonneuve, Denise, 83
Mallarmé, Stéphane, 237
Malraux, André, 290
Man Ray (Emmanuel Radnitsky), 73, 80, 88, 102, 104, 107, 117, 128, 145
Mancoba, Ernest, 246
Manessier, Alfred, 279
Manet, Édouard, 249
Mann, Thomas, 19
Marini, Marino, 155
Martins, Maria, 180
Masson, André, 69, 70, 73–75, 87, 104, 108, 110, 142, 202, 247
Matisse, Henri, 98, 143, 165, 205, 213, 224, 276, 295
Matisse, Patricia, 176, 194, 262, 274, 276, 295, 298
Matisse, Pierre, 143–44, 165, 174–76, 179, 180, 182, 184, 187–89, 190–204, 206, 207, 210, 211, 215, 221–23, 227, 234, 261, 262, 265, 268, 272, 274, 275, 278, 282, 283, 290–92, 296, 299
Matisse, Teeny, 178
Matta, Patricia. See Matisse, Patricia
Maupassant, Guy de, 35
Mauriac, François, 82
Mayo, Flora, 51, 53, 78, 121
Medici Chapel, 28
Merleau-Ponty, Maurice, 173
Michelangelo, 28
Milunović, Milo, 49
Miró, Joan, 70, 81, 82, 84, 93, 94, 111, 135, 136, 142, 201, 216, 224, 232, 247, 261, 290
Modigliani, Amedeo, 61
Mondrian, Piet, 107, 224, 232
Montandon, Roger, 160, 174, 181, 187
Moreau, Gustave, 247
Motherwell, Robert, 295
Müller, Josef, 27, 53, 69

Negri, Mario, 273
Nicholas, Isabel (then Delmer), 140, 141, 151
Nicholson, Ben, 142
Nicholson, Winifred, 142
Nietzsche, Friedrich, 70
Noailles, Villa, 89, 105
Noailles, Viscount Charles de, 71, 72, 74, 77, 78, 82, 88, 89, 91, 104–6, 110, 125, 168
Noailles, Viscountess Marie-Laure de, 71, 72, 74, 77, 78, 82, 88, 89, 91, 104–6, 110, 125, 168
Noguchi, Isamu, 47

Oppenheim, Meret, 128, 141, 142

Parks, Gordon, 222
Paulhan, Jean, 173
Penn, Irving, 222
Penrose, Roland, 142, 144
Péret, Benjamin, 136
Péri, Gabriel, 166, 169
Pevsner, Antoine, 202
Picasso, Pablo, 46, 48, 64, 72, 84, 85, 90, 94, 95, 101–2, 108, 111, 125, 135, 146, 152, 156, 165, 168, 173, 185, 187, 199, 201, 203, 205, 207–9, 224, 225, 232, 246, 247, 251, 252, 259, 292, 293
Poiraudeau, Yvonne-Marguerite. See Caroline
Ponge, Francis, 173, 207, 216, 224
Prévert, Jacques, 73, 88

Queneau, Raymond, 70, 173

Rauschenberg, Robert, 295
Rembrandt van Rijn, 22, 224, 230, 232
Reverdy, Pierre, 225
Richier, Germaine, 155
Riopelle, Jean-Paul, 224, 246
Rivière, Georges-Henri, 72, 74, 77, 80, 82
Rockefeller, Nelson, 145
Rodin, Auguste, 19, 38, 110, 141, 207, 221
Rodo (Auguste de Niederhausern), 19
Rodocanachi, Paul, 112, 113

Rogi André (Rosa Klein), 80
Rollier, Charles, 161
Rol-Tanguy, Henri, 173
Rosenberg, Paul, 46
Rothko, Mark, 295
Roux, Gaston-Louis, 73, 173
Rubens, Peter Paul, 29
Russolo, Luigi, 87

Sade, Donatien Alphonse François,
 Marquis de, 70, 73, 74, 108, 126
Sadoul, Georges, 81, 94, 100, 106, 179
Sainsbury, Robert, 216
Sarkissoff, Maurice, 26
Sarraute, Nathalie, 173
Sartre, Jean-Paul, 152, 166, 173, 174,
 178–80, 184, 185, 187, 207, 212–14,
 216, 232, 237, 239, 260, 263, 291
Savinio, Alberto, 63, 65
Scheidegger, Ernst, 222, 223, 297
Schiaparelli, Elsa, 112, 145
Seligmann, Kurt, 37
Selz, Peter, 263, 264
Sert, Josep Lluís, 289
Severini, Gino, 61, 64
Shakespeare, William, 19
Simon, Michel, 161
Skira, Albert, 135, 160, 161, 162, 166, 174
Skira, Rosabianca, 161
Soavi, Giorgio, 287, 292
Spitzer, François, 110
Stahly, François, 148
Starobinski, Jean, 161
Stendhal (Henri Beyle), 237
Stocker, Hans, 37
Stojanović, Sreten, 41
Stravinsky, Igor, 79, 187
Sylvester, David, 215, 252, 295

Taeuber-Arp, Sophie, 142
Taillandier, Yvon, 231
Tailleux, Francis, 174, 208
Tal-Coat, Pierre, 139, 174
Tanguy, Yves, 81, 84, 93, 94, 99, 104, 108,
 110, 136, 142, 173, 192
Taro, Gerda, 145

Taslitzky, Boris, 168, 185, 247
Tériade (Stratis Eleftheriadis), 101, 135,
 165, 173, 187, 203, 205, 208, 272
Terry, Emilio, 82, 110, 112, 113, 123
Tintoretto (Jacopo Robusti), 27, 28, 230
Titian (Tiziano Vecellio), 27
Thompson, George David, 215, 216, 282,
 294
Tozzi, Mario, 61
Tual, Roland, 73
Tzara, Tristan, 81, 83, 84, 121, 123, 125,
 131, 137, 152, 173, 203, 208, 216

Unik, Pierre, 106

Van Doesburg, Theo (Christian Emil
 Marie Küpper), 64, 86
Van Gogh, Vincent, 48, 187
Van Meurs, Pieter, 33–35, 37, 98, 181
Vaux, Marc, 73, 80, 171
Veronese, Paolo, 27
Vibert, James, 25, 26
Villon, Jacques, 227
Visconti, Countess Madina, 121

Waldemar-George (Jerzy Waldemar
 Jarocinski), 101
Watson, Peter, 216
Weber, Hugo, 161
Weiss, Sabine, 175, 223, 299
Weyergans, François, 217
Wotruba, Fritz, 155

Yanaihara, Isaku, 227–35, 237–43, 247,
 250, 251, 255, 256, 257, 259–62, 266,
 271–74, 292

Zadkine, Ossip, 10, 48, 50, 53, 60, 65, 66,
 74, 76, 202
Zervos, Christian, 72, 101–3, 106–7, 231